GREAT PLAINS

FOR MOM AND DAD, whose generous and kind hearts
were cut from the fabric of the Plains –MF

IN MEMORY OF John J. Dinan; Grandma Hildur Forsberg; Richard D. Luehrs –MF

IN MEMORY OF Elaine Ebbert, who loved the Great Plains and showed
so many of us where to look to find the tiny mysteries –DO'B

 THE NATURE CONSERVANCY (TNC) provided funding and fieldwork assistance without which this book would not have been possible — a special thank you to The Nature Conservancy's Nebraska Chapter and Central US Regional Office.

WE EXTEND OUR HEARTFELT THANKS to the following benefactors:
Margery Nicolson, Angus and Margaret Wurtele, Pat and Ken Beebe,
Mary and Joe Daugherty, Barbi Hayes, Nancy and John Webster,
Judy and Ron Parks, and, Gail and Michael Yanney.

WE ALSO WISH TO THANK Jim and Chris Weaver of the Grasslans Charitable
Foundation for their generous support during the development of this book.

Previous Page:

BUFFALO GAP NATIONAL GRASSLAND, SOUTH DAKOTA

A thick hide of buffalo grass *(Buchloe dactyloides)* grows in soil built by its ancestors thousands of years ago. Like the world's forests, these kingdoms of grass protected from the plow act as huge "carbon sinks," capturing and storing carbon to help mitigate the effects of global warming.

CHERRY COUNTY, NEBRASKA

A strong ranching tradition protects the 20,000 square mile Nebraska Sandhills, among the nation's largest intact native grasslands and the largest dune formation in the Western Hemisphere. Here, windmills draw up water from the underlying Ogallala Aquifer, one of the Plains' most precious resources.

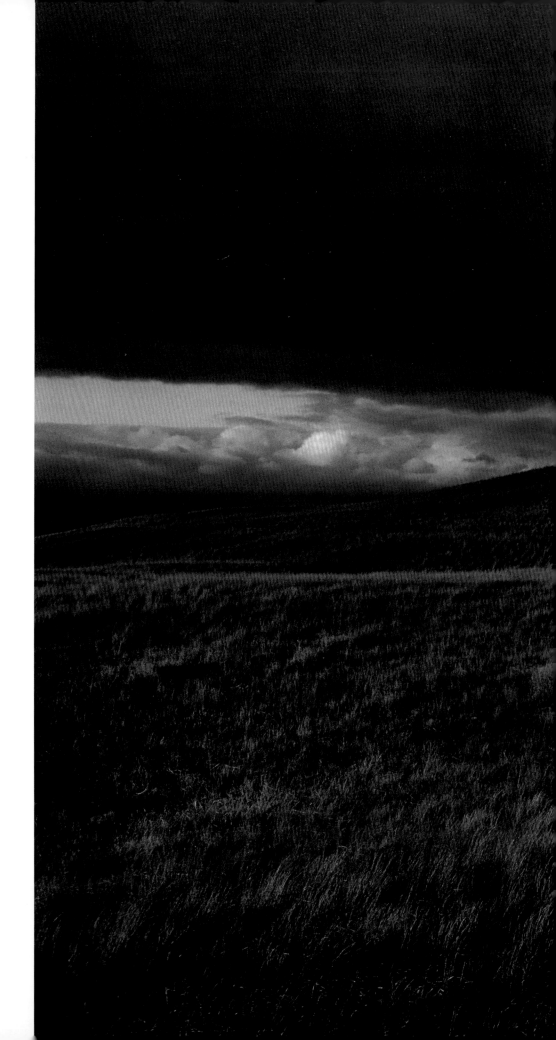

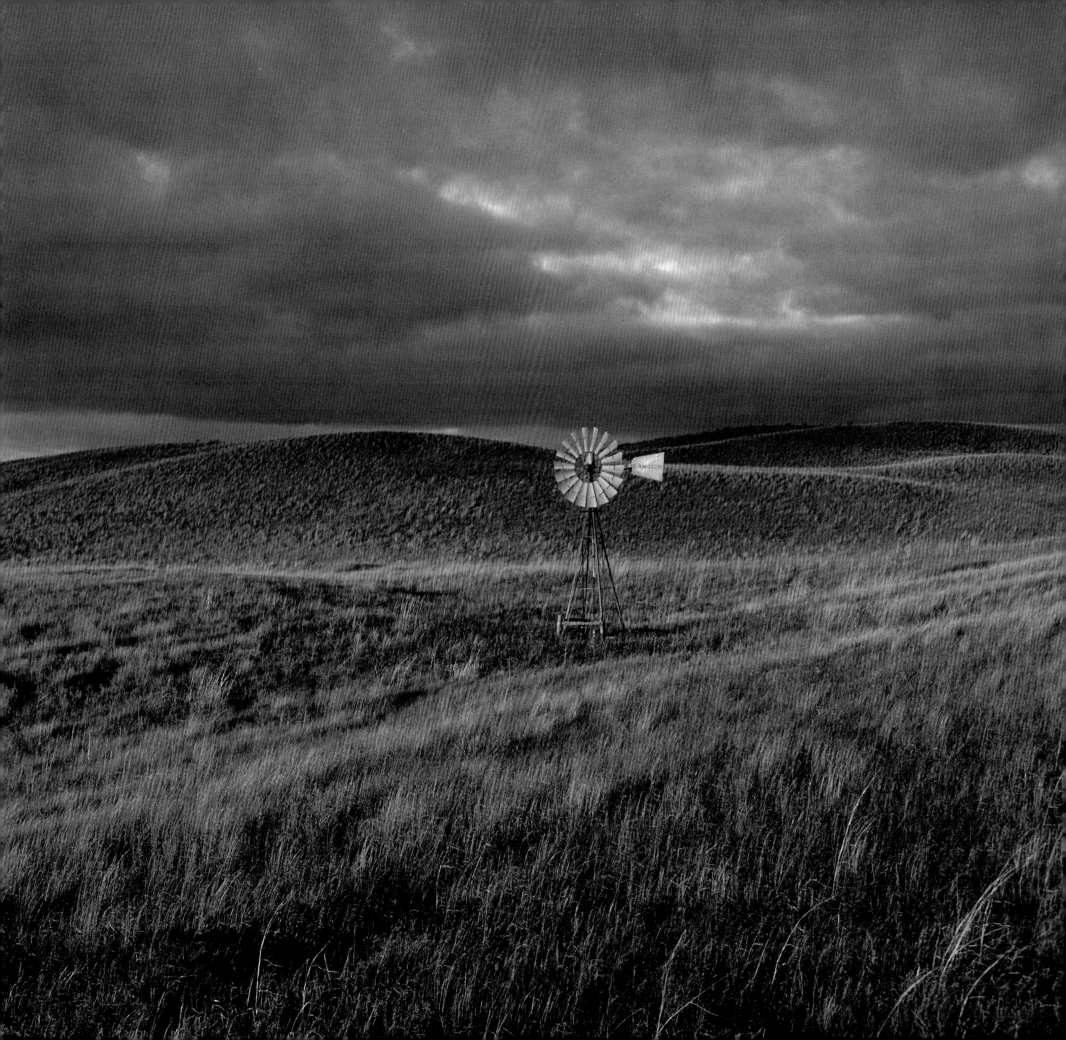

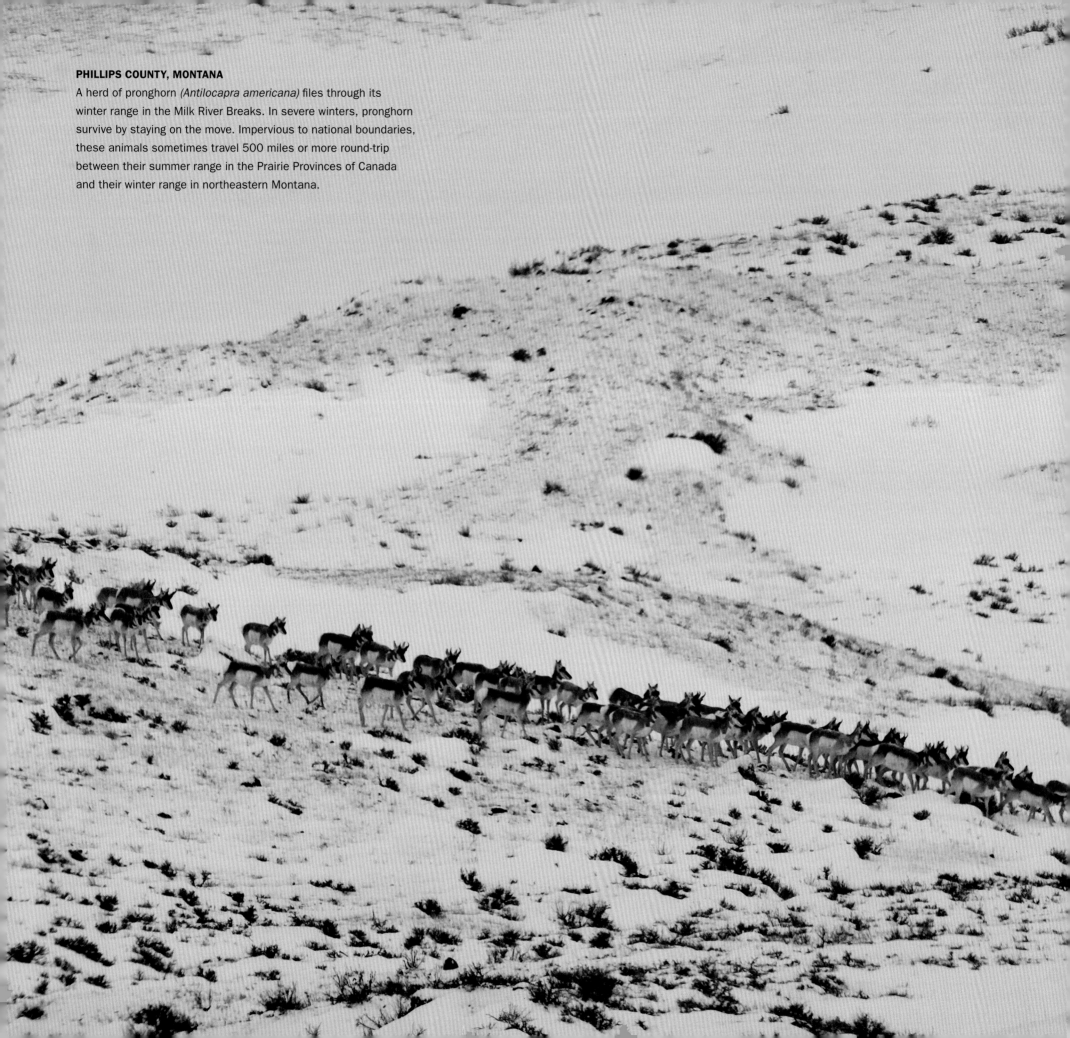

PHILLIPS COUNTY, MONTANA
A herd of pronghorn *(Antilocapra americana)* files through its
winter range in the Milk River Breaks. In severe winters, pronghorn
survive by staying on the move. Impervious to national boundaries,
these animals sometimes travel 500 miles or more round-trip
between their summer range in the Prairie Provinces of Canada
and their winter range in northeastern Montana.

AMERICA'S LINGERING WILD

GREAT PLAINS

MICHAEL FORSBERG

WITH

TED KOOSER FOREWORD

DAN O'BRIEN ESSAYS

MICHAEL FORSBERG FIELD JOURNALS

DAVID WISHART CHAPTER INTRODUCTIONS

THE UNIVERSITY OF CHICAGO PRESS

CHICAGO AND LONDON

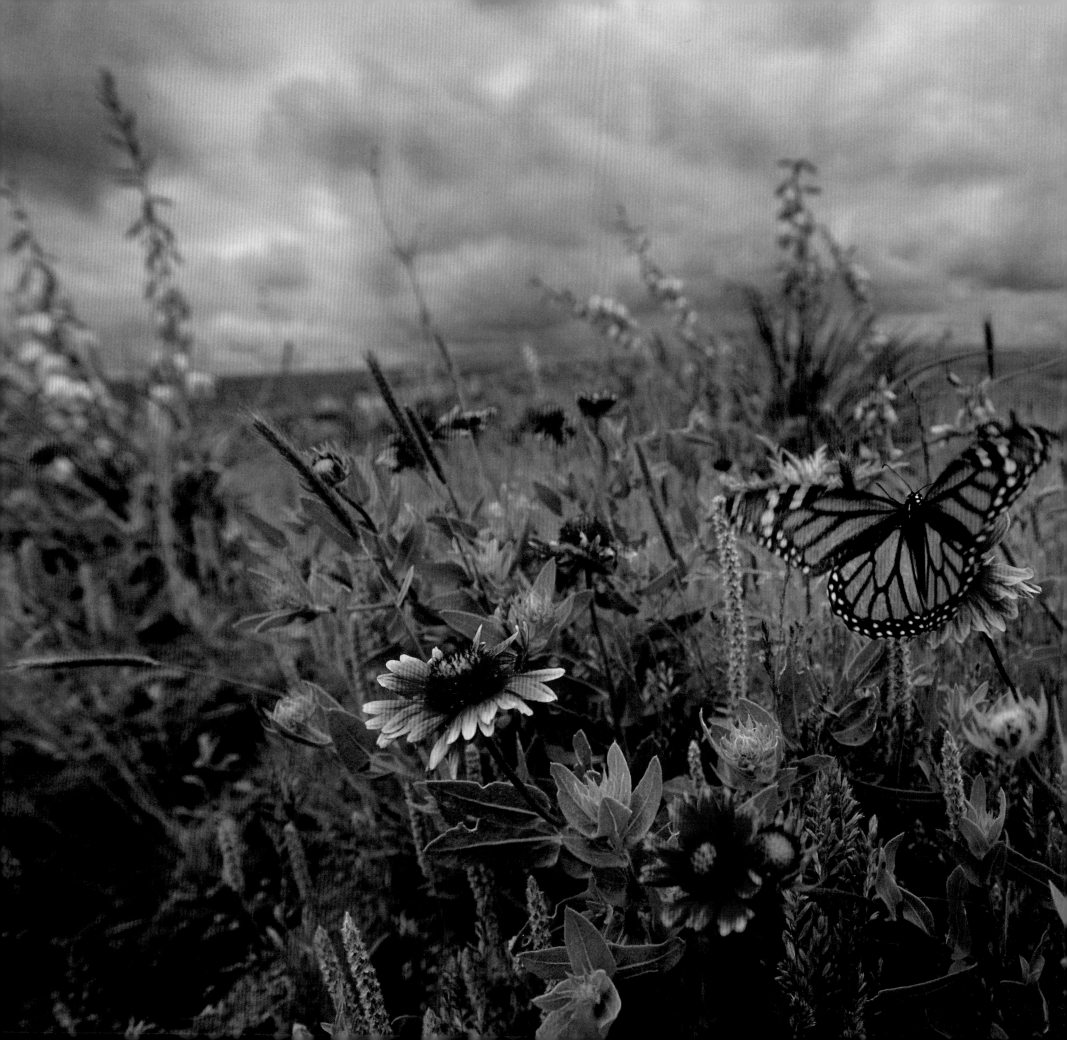

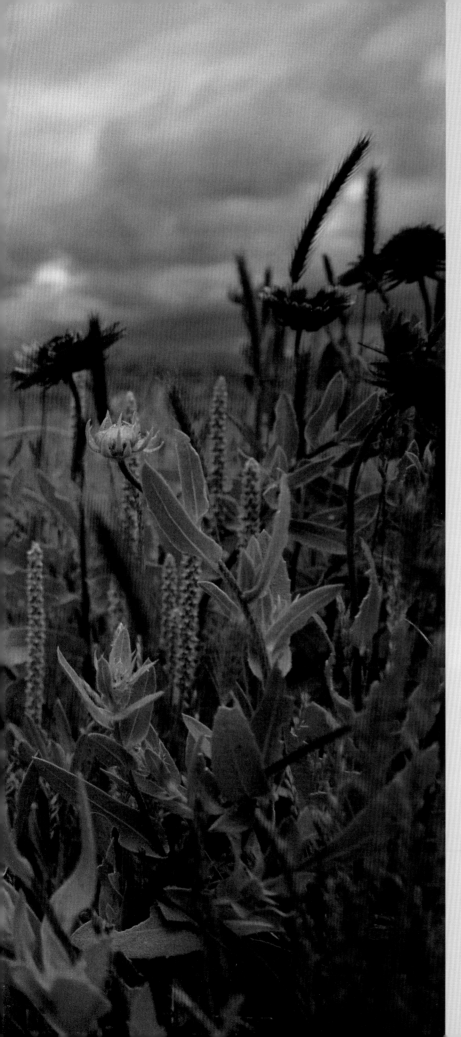

CONTENTS

WEBSTER COUNTY, NEBRASKA

A monarch butterfly *(Danaus plexippus)* gathers nectar from Indian blanket flowers *(Gaillardia pulchella)*. Each spring succeeding generations of short-lived monarchs move up the Great Plains as far north as Canada, following the prairie bloom. In fall they make an astonishing long-distance migration to the forests of central Mexico.

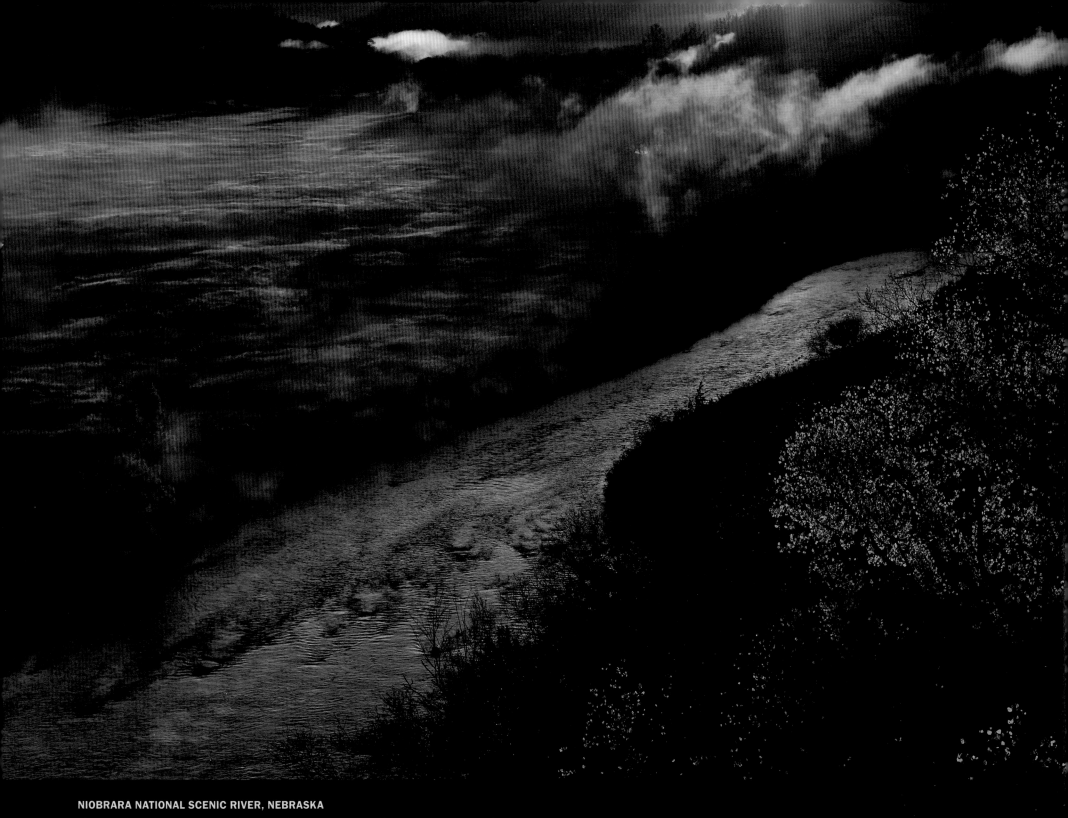

NIOBRARA NATIONAL SCENIC RIVER, NEBRASKA
Morning fog gathers along the Niobrara River, considered a "biological crossroads" of
the Great Plains. Six distinct ecosystems converge in this narrow corridor of diversity,
supporting 600 different plant species, 200 bird species, and 85 species of butterflies.

FOREWORD

Ted Kooser
13TH POET LAUREATE OF THE U.S.

IN THE MID-1960s, a driving winter wind pushed five empty boxcars ninety miles east along a track in North Dakota. Wouldn't you love to have been peering through the frost on a kitchen window, warming your hands around a cup of coffee, seeing that rolling along the horizon? Tons and tons of frozen steel, headed east, not west, you'll notice, as if to suggest that we all pack up and head back to where we came from, for the winters can be bitter on the Plains.

The vision of those empty boxcars rolling through a desolate winter landscape may be just the image that many people have of our Great Plains: an empty, forbidding place.

But, as it happens, many of us like it here and have not tried to jump into the first empty boxcar and head back to Newark. We've stayed on these prairies, or several million of us have, bent into those frigid Alberta clippers the way the trees along the highways bend into the north, shaped by warm southerly winds as they push against the summer foliage. Here on the Great Plains both people and trees and everything else are in some way shaped by wind and weather. This book, too, has been shaped by where it comes from, and that's just a part of its beauty.

Boxcars. As I linger over these pages, I am reminded of a poem by David Allan Evans, the poet laureate of South Dakota. It's called "Freight Trains" and in it Evans waits at a rail crossing, watching a string of empty boxcars pass.

...each wide door was open,
I looked through the box cars:
frame after frame...

The passing freight cars are, as the poem shows us, like a camera's shutter, capturing an image, a rectangular glimpse of a place, caught in a flash. A book of photographs such as this is like that — Mike Forsberg's images give us bright openings onto a world. And the essays by Dan O'Brien and David Wishart, they too are clear windows into and onto a place, pictures constructed of words, vistas sharing a common horizon. All three of these men are stopped at a railroad crossing, looking with keen interest through those boxcar doors, and not one of them is in any way impatient for the train to pass on. They've shut off their engines and are happy to look.

This book, this particular string of boxcars with their flashing doors, won't roll past you just this once. I'm certain you'll want to back it up, against the wind of time, and run it past again and again, looking into and through the marvelous windows of Mike's photographs, rereading the thoughtful words of Dan and David, enthralled by these shutter-glimpses of life, of nature, these passing openings onto our own Great Plains, which may have never looked quite so good before.

In previous books, all three of these men have made substantial and significant contributions. Mike Forsberg's photographs have been widely published, and his book on Sandhill cranes is a classic. If nature can imitate art, then the Plains have begun to attempt to look like Mike's photographs. Dan O'Brien is both novelist and essayist, with many titles in print. He raises bison, he hunts with a falcon, he tells marvelous stories. Seemingly tireless, David Wishart has published notable works about the fur trade, about Native Americans and, like a bison, has set his brow into the wind and shouldered forward to compile and edit the magnificent, monumental, and essential *Encyclopedia of the Great Plains*. To have the work of these three assembled here is a gift.

As you read these words of mine, you are just arriving at that railroad crossing. The long train of boxcars is beginning to pass, the doors open, the bright plains flashing through. Shut off your engine and let these images and words roll past. What will you carry away when the last car is gone and you bump across the rails and on down the road? I expect that, like me, it will be admiration and respect, for the wide open doors of these pages, for what this photographer and these writers have offered us: their love and concern for an incomparable place.

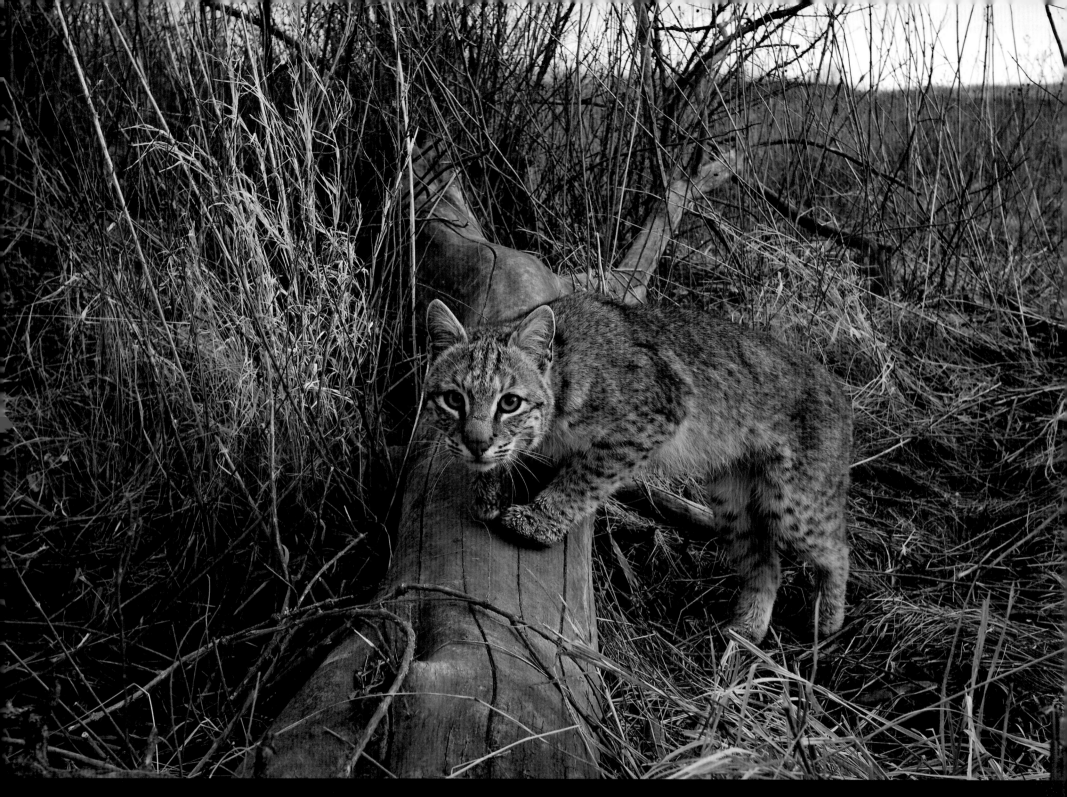

AUDUBON SPRING CREEK PRAIRIE, NEBRASKA

Captured on film by a "camera trap," a female bobcat *(Lynx rufus)* pauses along a creek drainage in tallgrass prairie. Though relatively common in parts of the Plains, these cats are seldom seen, a tribute to their solitary habits and to the way their coats perfectly match their surroundings.

THE ROOTS OF HOPE

Michael Forsberg

SEVERAL YEARS AGO my four-year-old daughter Elsa and I were sitting on the couch reading *Phantom of the Prairie,* a children's book about a black-footed ferret. The story is set in a prairie dog town and loosely follows one ferret through its first year of life as it encounters a menagerie of Plains wildlife, from bison to burrowing owls. When I finished the story, Elsa, a very contemplative child, looked up at me and said, "Daddy, when I get grown up, will I be able to see all those animals on the prairie?" I had to think about it for a minute before I answered. "I hope so, honey." "I hope so too, Daddy," she said.

Hope is a powerful thing. I used to take pictures for myself. Now I photograph mostly for my kids, driven by the hope that in some small way what I do may help keep these native Great Plains landscapes and creatures from disappearing before my daughters' eyes. I want my daughters Elsa and Emme to experience the wonder and connection to the natural world that I have experienced. I want them one day to sit with their own children on the banks of Nebraska's Platte River in spring—as my wife, Patty, and I have—and take in the riot of sight and sound as scores of cranes and geese descend en masse to the river. I want them to get happily lost in a tallgrass prairie and curl up in a deer bed surrounded by big bluestem towers on a crisp autumn day.

I have spent a good share of my time trying to make pretty pictures, because I think pretty pictures are important. They're particularly important here on the Great Plains, where most people on the outside looking in still think this holds nothing but flat land and a monoculture of corn, and where progress and value too often have been measured by how much can be extracted from the land rather than by the enduring value of the land itself. If I can capture the wonder and beauty of a prairie landscape or a prairie creature through my photographs, my hope is that you, too, will be moved by it and more likely to protect and preserve it.

Granted, the beauty here is often subtle. It doesn't knock you off your feet at a glance, the way the snow-capped Colorado Rockies or the rugged coastline of the Pacific Northwest do. But it can be every bit as remarkable. On the Plains the massive cloudscapes are our mountains and the rolling prairie our sea. This is a place of constant motion. The great nexus of life that evolved here requires freedom to roam, often over great distances, in response to a harsh climate and the ever present battle between grasses and trees, fire and flood, bitter cold, intense heat, and extreme drought. Right angles do not contain the wildness or the character of this landscape. There are no hard edges here. That is why it has always been difficult to delineate on a map where the Great Plains stop and start, but you know it when you are here because you can feel it deep in your bones.

Lately, I've begun to think that pretty pictures can be a trap, so I just as often include the power lines and fences, drained wetlands, invasive species, and development. I want people to understand that I'm photographing remnants, mere shadows of what had been perhaps the greatest grassland ecosystem on Earth. When I'm photographing wildlife, I often feel that I'm chasing ghosts, capturing surviving wild spirits of species whose numbers have been decimated or all but eliminated from these wide-open spaces. Even on the Platte, where 500,000 Sandhill cranes, millions of waterfowl, and other migratory birds find critical refuge each spring, there is the underlying reality that only a fraction of the habitat from a century ago remains. Its future role for wildlife is uncertain, forever dictated by the shifting winds of power and politics. It is a story line that plays out over and over again up and down the Plains.

Elsa is eleven years old now and growing up quickly. Her questions are less innocent these days. When she looks me square in the eye, I know that time is short. I tell her there are no easy answers. But I take hope from the diverse collective of people—young and old, rural and urban, scientists and clergy—who are asking the same questions as Elsa and finding common ground for discussion regarding the land and our responsibility to take care of it. Effective conservation here will be in the spirit of renewal, led by a community of people as firmly rooted in the land as the grass is rooted in the soil—a true grassroots movement.

Hope looks forward. And it is my hope that someday, future generations will thank us for the courage we had and the efforts we made, each in our own way, to preserve and restore these treasures for their future. We certainly owe it to them, we owe it to the land and its wild inhabitants, and ultimately, we owe it to ourselves.

RARITY BY THE NUMBERS: SPECIES OF CONCERN IN THE GREAT PLAINS

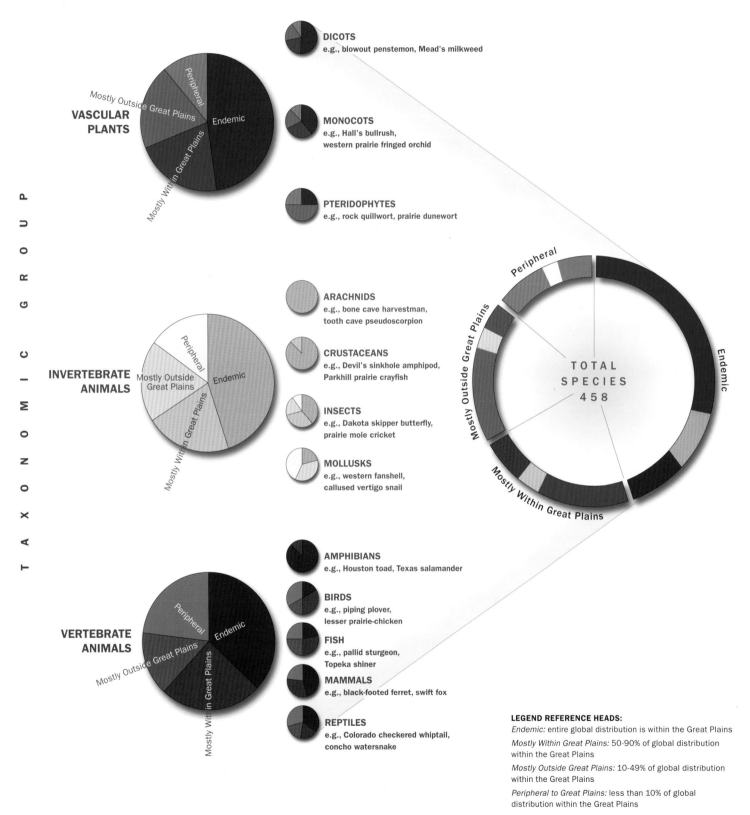

DICOTS
e.g., blowout penstemon, Mead's milkweed

MONOCOTS
e.g., Hall's bullrush,
western prairie fringed orchid

PTERIDOPHYTES
e.g., rock quillwort, prairie dunewort

ARACHNIDS
e.g., bone cave harvestman,
tooth cave pseudoscorpion

CRUSTACEANS
e.g., Devil's sinkhole amphipod,
Parkhill prairie crayfish

INSECTS
e.g., Dakota skipper butterfly,
prairie mole cricket

MOLLUSKS
e.g., western fanshell,
callused vertigo snail

AMPHIBIANS
e.g., Houston toad, Texas salamander

BIRDS
e.g., piping plover,
lesser prairie-chicken

FISH
e.g., pallid sturgeon,
Topeka shiner

MAMMALS
e.g., black-footed ferret, swift fox

REPTILES
e.g., Colorado checkered whiptail,
concho watersnake

VASCULAR PLANTS

INVERTEBRATE ANIMALS

VERTEBRATE ANIMALS

TAXONOMIC GROUP

TOTAL
SPECIES
458

LEGEND REFERENCE HEADS:
Endemic: entire global distribution is within the Great Plains
Mostly Within Great Plains: 50-90% of global distribution within the Great Plains
Mostly Outside Great Plains: 10-49% of global distribution within the Great Plains
Peripheral to Great Plains: less than 10% of global distribution within the Great Plains

CAPTION BY STEVE CHAPLIN, SENIOR CONSERVATION SCIENTIST,
THE NATURE CONSERVANCY
DATA SOURCE FOR GRAPHIC: NATURESERVE

NORTH AMERICA'S GREAT PLAINS
contain tens of thousands of species that are members of hundreds of diverse natural communities. The number, nature, and geographical distribution of these species are the product of the region's unique environment and history.

The Great Plains grasslands are a very young ecosystem. As recently as 12,000 years ago, the Northern Plains were covered by glacial ice, lakes, and coniferous forests, while the Southern Plains were dominated by deciduous forests. Relatively few species have had time to evolve in the new grasslands environment of the Great Plains, but those that have established themselves tend to be broadly adapted, wide-ranging species, often with large populations—all characteristics that buffer species from extinction.

Prior to European-American settlement, the Plains were a vast expanse of temperate grasslands and shrublands, extending from Canada to Mexico. Shaped by a harsh continental climate, the region held few major barriers to restrict the movements of organisms, so genes could move freely, reducing the evolution of local variation and new species. Now, however, agriculture and development have fragmented that vast natural expanse, and many Plains species are left compromised, some now threatened with extinction.

Although the region does not possess a great number of rare species relative to other major ecosystems in North America, there are still many rare species found only on the Great Plains. These endemic and near-endemic species make up roughly 70 percent of the species of concern shown here. The other 30 percent are species whose ranges are mostly outside, or peripheral to, the Great Plains. The majority of these peripheral species' populations are found elsewhere on the continent, but the portions of their ranges that extend into the Plains are important to the overall genetic makeup and adaptability of the species.

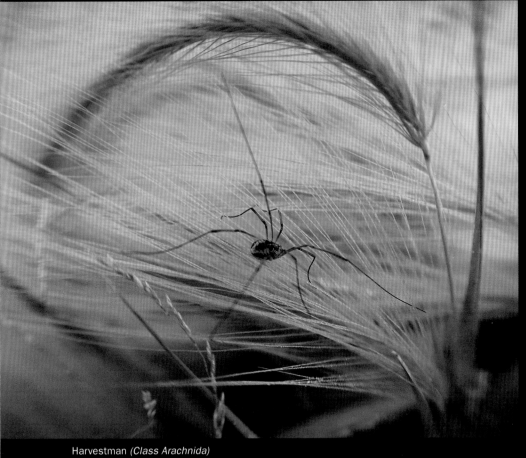

Harvestman *(Class Arachnida)*

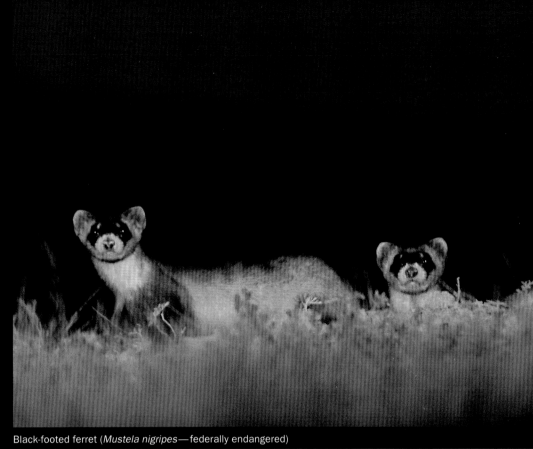

Black-footed ferret *(Mustela nigripes—federally endangered)*

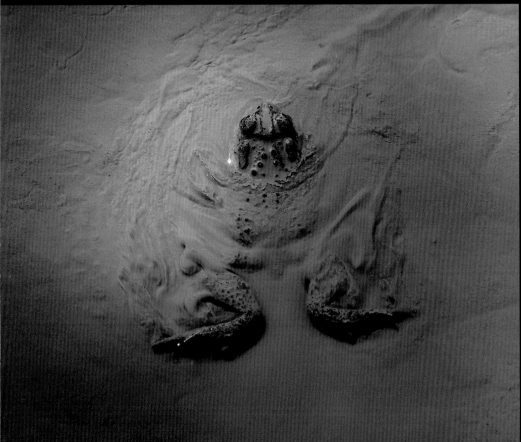

Woodhouse toad *(Bufo woodhousii)*

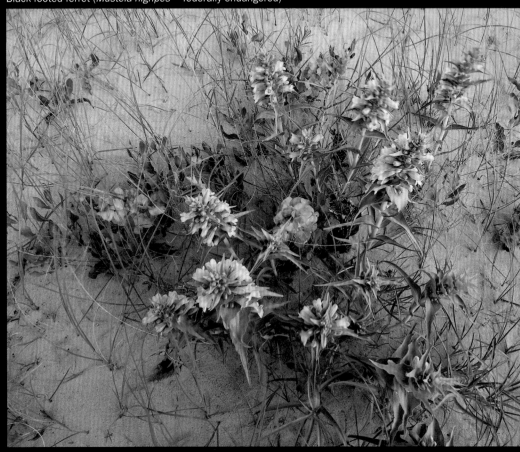

Blowout penstemon *(Penstemon haydenii—* federally endangered) and wild begonia *(Rumex venosus)*

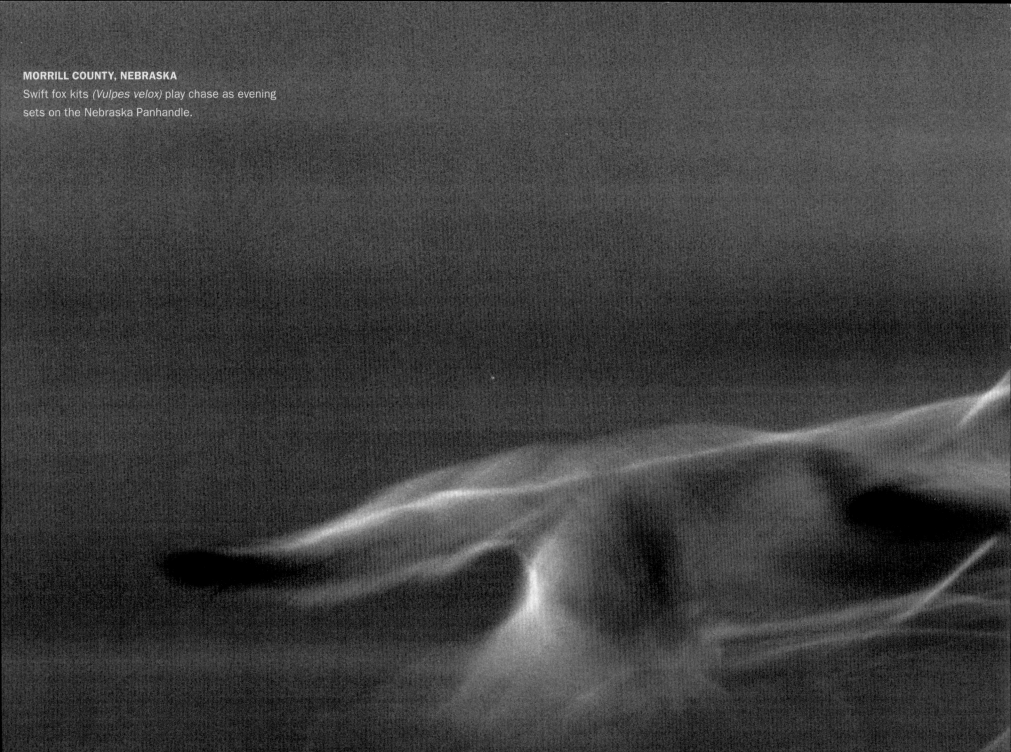

MORRILL COUNTY, NEBRASKA
Swift fox kits *(Vulpes velox)* play chase as evening
sets on the Nebraska Panhandle.

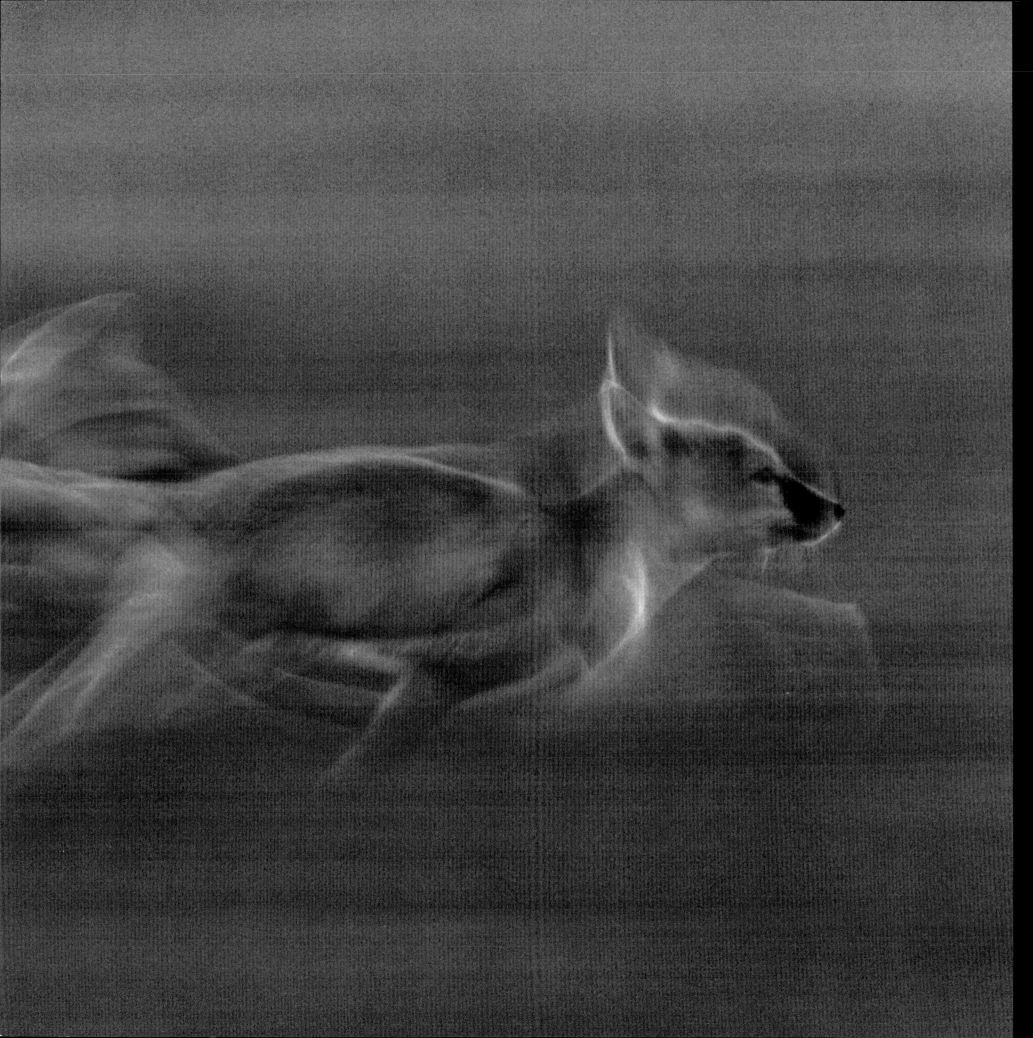

ME AND MIKE

Dan O'Brien

THE FIRST TIME I MET MIKE FORSBERG he was dressed like a tree stump. We had both been asked to speak at a meeting of central-region directors for The Nature Conservancy, and, though we knew each other's work, we'd never met. A couple of weeks before the meeting, Mike found my e-mail address and sent a short note asking if I'd reserve a little time to talk to him about a project. Sure, I answered. What the heck. I would be traveling alone and my agenda was not exactly full.

I spoke on the first day of the meeting, and afterward I bumped into Mike in the lobby just as I was about to enter the hotel bar. I'd seen his picture on the back of his very fine book on the Sandhill cranes of North America, but even if I had known him for years, I wouldn't have recognized him. He was camouflaged head to toe and spoke through an opening in his mask that looked like a knothole. "You're Dan O'Brien."

I nodded my head thoughtfully. I felt silly talking to a 170-pound log. He thrust out his camouflaged limb and a hand wriggled toward me. "I'm Mike." I took the hand and was a little surprised by the strength in it. "I have to give my talk right now," he said, "but could we get together tomorrow morning for breakfast?"

"Sure," I said. I could tell he was in a hurry. "I'll meet you in the restaurant about eight?"

"Great," the tree said. He lurched down the hallway, and I was left feeling like I had just met a character from *Lord of the Rings*.

In fact, it was not unusual for me to feel like something plopped down in a fantasyland peopled by odd and dangerous forces. At that time, I had lived on Great Plains ranches for 35 years. I was at the meeting to give the directors my take on the state of the Plains. The honcho director had read one of my books and asked for a reading of "some of the funny parts." I guess cynicism is a form of humor, and he thought his board could benefit from a pessimistic view of what was happening on the Great Plains. At least that was the way I saw what I had talked about.

To the roomful of bright and earnest directors, I had described the 200 miles I had just traveled along the Missouri River. Where Lewis and Clark had found elk, bison, wolves, and lots of prairie-chickens, I had found drained, black, cultivated fields where nothing was allowed to live but corn and soybeans. I told them that the fever for ethanol was killing off the last of the biological diversity of the northeastern Great Plains. I described what Lewis and Clark might have seen from their flatboat as a river as wild and dynamic as life itself. I ran down a partial list: beavers and otters, loads of fish, piping plovers and least terns, the skies filled with cranes and ducks and geese. But from the window of my pickup truck, I had been subjected in the last hundred miles to a channelized river threading a flat, sterile wasteland.

I had been paying close attention on my drive along the Missouri, the main artery of the Great Plains, and I had seen only a couple of pairs of geese, a few deer, and a road-killed raccoon. The mighty "river of the Great Plains"—what had been a river of life—was now a drainage ditch for a landscape degraded in the most diabolical way. I told the directors we were on the edge of hopelessness and peering into the abyss.

Sitting in the bar and now on my second Crown Royal and water, I wondered if I had come on too strong. I had tried for a little of that humor the director was looking for but had only managed the darkest variety. I dwelt on the case for gallows humor—when you can no longer cry, you must laugh. The gallows got me thinking about how the condemned and the executioner both wore hoods. Why was that? And that got me thinking about Mike Forsberg and his camouflaged hood.

I ordered the third Crown and water in a to-go cup and ambled down the hallway to the meeting room where he was speaking. I stood at the back and sipped as truly gorgeous images rolled onto a large screen and perfectly matched music swelled from the speakers in the walls. People ooed and ahhed with each new image. Yet where they saw flocks of tens of thousands of migrating birds, I saw the last of a breed. Where they saw rolling grassland under a wild roiling sky, I saw deteriorated pasture and the creep of global warming.

But when Mike started to speak, my attention focused. He was still dressed in his camouflage suit, and it took only a second to understand his intent. This green-and-gray, baggy get-up was his serious photographer's uniform. These were his work clothes. This is what he had worn for the years it took to capture the images that now projected behind him. He described the challenge

of his work, the early mornings, the cold and heat, the loneliness. He talked about the images and how he had achieved them. He gave great details about the subjects of the photographs. The cranes had been making the same migration since before man set foot on the North American continent. Because of agricultural demands, the Ogallala Aquifer had fallen by as much as 200 feet. Cowbirds should actually be called buffalo birds, and they are parasitic nesters. The images and the information were inspiring, but I had seen it all in person. What got my attention was the sincerity and, even more, the joy in his voice. What sort of man was I scheduled to eat breakfast with in the morning?

After five minutes he pulled off the hood and smiled from a perspiring face. "Hot in this thing," he said. That line got him more laughs than my entire speech had garnered. I took another sip of the Crown and looked hard at the spirit inside the tree trunk. He was young and handsome. A dimpled chin with a nodding smile and gray eyes that showed the wheels in his head were turning at a pretty good rate. The audience loved him, and even I found myself falling under his sway. That was enough. I sipped the last of the Crown and slipped from the back of the room. I didn't sleep worth a darn that night. I lay in a dream pasture where kettles of Sandhill cranes descended on me all night. I wanted them to land, and their eerie calls increased as they came closer. Finally, the cacophony was delirious and the idea that, for centuries, the very atmosphere of the Great Plains had been synonymous with cranes and the sounds of cranes refused to let me sleep.

The next morning Mike Forsberg waited for me with an open copy of E. O. Wilson's *Biophilia*, a pot of coffee, and a couple of cups in front of him. He rose and smiled the smile I was already beginning to associate with him. His eyes flutter closed, and he nodded his head ever so slightly. "Great morning," he said. "Great light."

"You walk in the morning?" I asked.

"Always."

"Did you dress in camouflage this morning?"

The same smile. "No, just walking and thinking."

"Thinking?"

"About this project I wanted to talk to you about."

My turn to nod. "Which is?"

About that time the waitress showed up, and we both ordered without looking at the menu. Bacon and eggs over easy for me. Healthier stuff for Mike.

"I want to do a picture book about the Great Plains."

"Good idea," I said. "You'd be the guy."

I poured a cup of coffee and held the pot out toward his cup.

"Sure," he said and pushed the cup my way. "I want you to write the text."

I remained calm, even though my immediate thought was something like, "Sorry, I gave at the office." I had learned caution and skepticism from a precarious 35 years out on the Great Plains. I knew that there was no real money in writing the text for a picture book about the Great Plains, but I couldn't afford not to listen. And besides, it really was a good idea. "I'm pretty busy," I said.

Mike nodded, "I know, but this would be important." The gray eyes looked hard at me, and I hated myself for thinking they were naive.

"It's a big project," I said and felt saved by the bacon, eggs, and chatty waitress who appeared like a deus ex machina.

But Mike refused to be derailed. When the waitress left, the eyes were still on me. "Real big project," he said. "I figure three years of fieldwork."

Three years? I was incredulous and took refuge in my breakfast. I was beginning to wonder if Mike might not have a screw loose. "I'll need some special equipment," he said. "Lenses, remote cameras, gadgets for getting pictures that have never been taken before, an ATV."

I decided to humor him until I finished the eggs and then got out of there. "There would be a lot of travel expenses," I said. "Probably need a photo editor, a text editor, layout people. And how would we pay our personal bills for three years?" It was a rhetorical question. I was killing time.

"We'll have to get some grant money."

"You're talking a lot of money," I said.

"We can get it," he said. "People know how important this is."

He mentioned a number and I coughed a piece of bacon into my napkin. "Okay," I thought. "Time to head back to South Dakota." It was not that the figure was too much for the job. It was that the job was simply too big. I nodded my head as I finished up my breakfast and Mike talked on about the importance of the book. He spoke of things that I already knew but did not like to think about: How the Great Plains is the center of the country in many ways, how it was one of the world's more degraded ecosystems, how the land Mike and I lived in was part of us. I heard the passion in his voice. How it was our duty to do this thing, how we had to find a way to bring hope to the condition of the Plains. How it was all emblematic of the world at large.

I drove back to South Dakota as if demons were on my trail. When I left, I had told Mike that he had a wonderful vision and that he should call me when he had secured the financing. I did not believe that there was a chance in hell he could find the money he needed for his project. I did not believe that

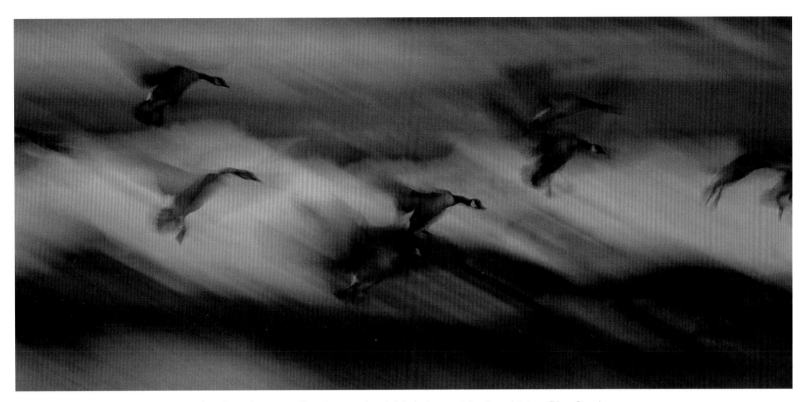

GARDEN COUNTY, NEBRASKA Wintering Canada geese *(Branta canadensis)* fly in to roost for the night on Blue Creek.

there was that sort of interest in the Great Plains. And as I drove through the Sandhills of Nebraska and across the Pine Ridge Indian Reservation, I was alternately angry and sad. When I passed Wounded Knee, I began to cry. Good God, I loved that tortured land.

Deep down, my passion was very much like Mike's, but I could not muster his hope. Through the rest of the reservation and across the corner of Badlands National Park, I tried to put Mike's idea out of my mind. I considered it one of those great ideas that are impossibly out of reach.

In fact, for a while I was able to force all thoughts of his book out of my mind. I went back to my little ranch and fussed and fumed as usual over the fate of the Plains. I gave real consideration to the idea of a book that would present this complicated landscape to a wider public. Then, several weeks after our breakfast, I got a call from Mike. "I got most of the funding," he said as if he had known all along that it would happen. I was speechless, thinking first of the huge opportunity and then of the responsibility. "We're going to make a difference here," Mike said.

And that was the first time it dawned on me that Mike's capacity for hope might be the only thing on Earth that had even a chance of saving the Great Plains from ignoble destruction. If I was going to work with this guy, I would have to find a way to hope for better outcomes than my cynicism had ever allowed me to hope for.

It hasn't been easy. Such a change of view is as profound an existential leap as any man can make. But I have tried. And now, after three years and lots of mornings together and lots of miles of gravel roads and lots of discussions, I've moved closer to Mike's point of view. Regrettably, he may have moved a little closer to mine. But there has been a dialogue and now there's a book.

The book may look like it's only pictures and words, but there's more than that between the covers. There is the eternal dialogue of the Great Plains: How are we humans to relate to the transient wonders we have seen? Has the hubris of humans condemned not only us but also the land itself? Is man's interest in something so fragile as the Plains a loving caress or a kiss of death? Can our intellect and our capacity for hope be an agent in the restoration and nourishment of this continent's enchanted heartland? We've tried to lay out here why these things matter. This book represents a body of evidence. The verdict is yours.

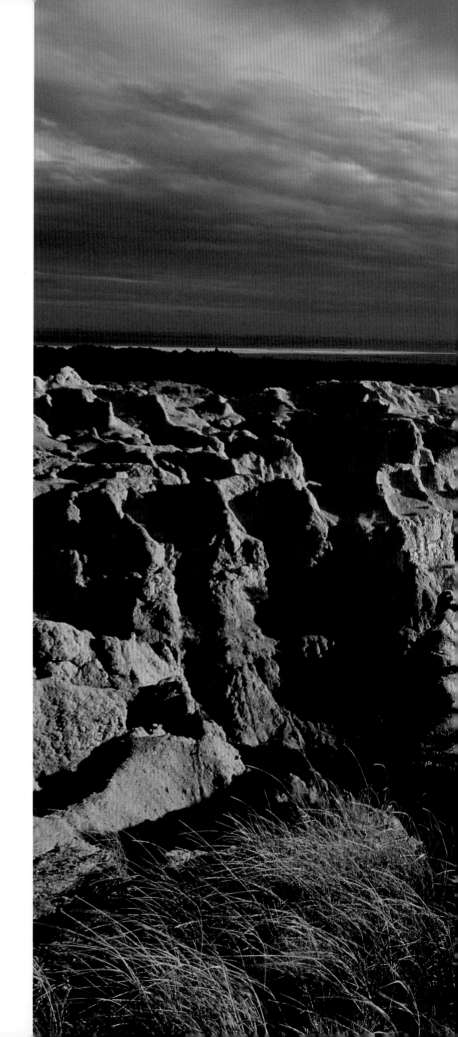

BADLANDS NATIONAL PARK, SOUTH DAKOTA
Cured prairie grass bows to the autumn wind as late
light cuts hard shadows across the Badlands Wall.

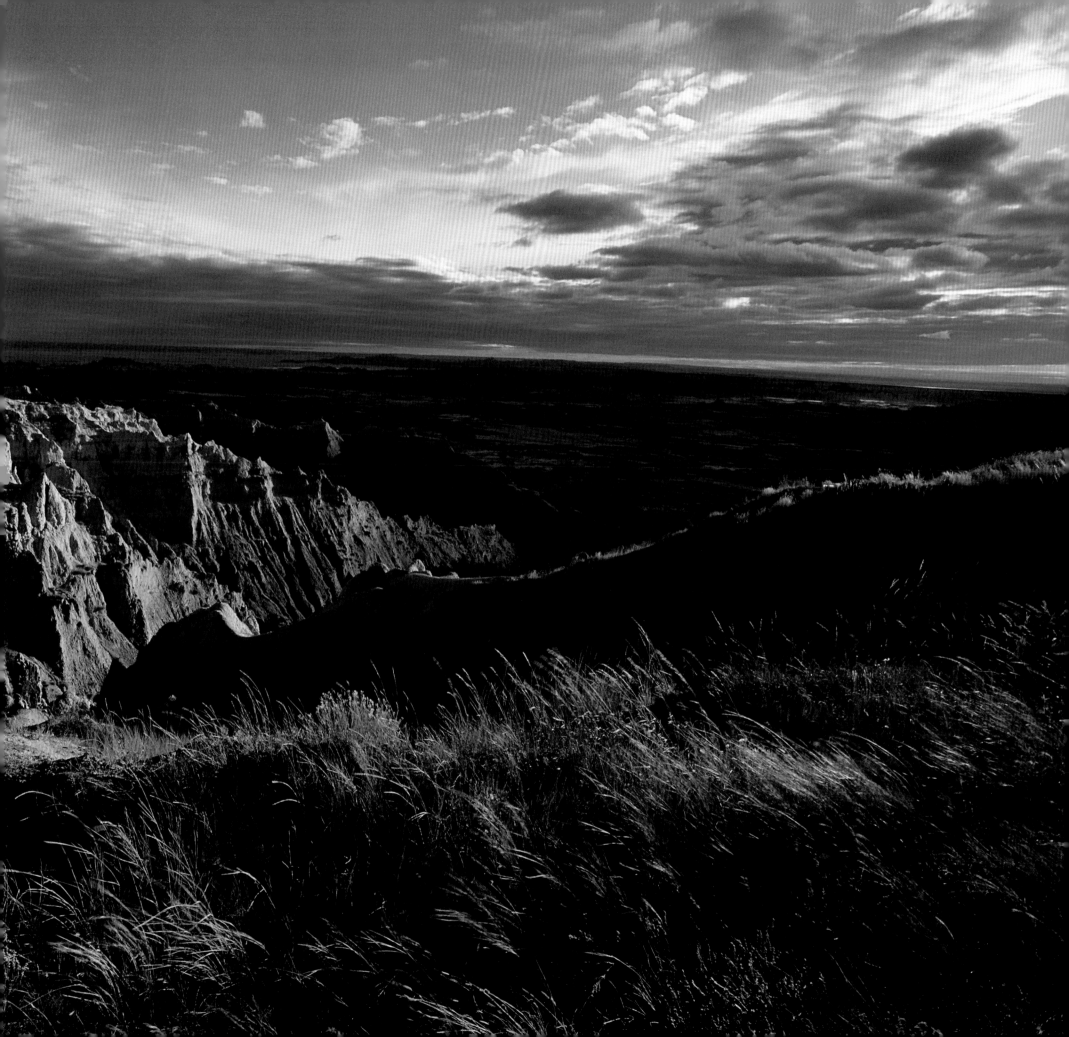

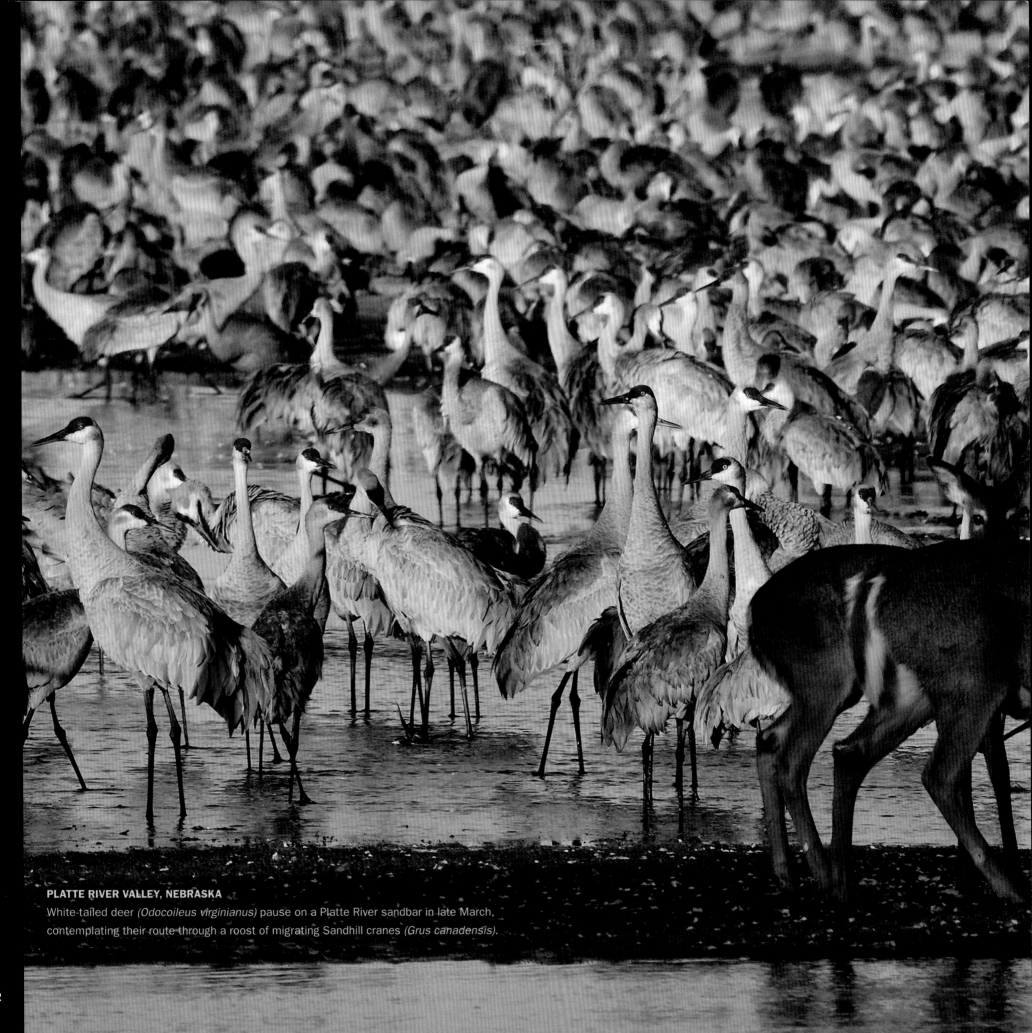

PLATTE RIVER VALLEY, NEBRASKA
White-tailed deer *(Odocoileus virginianus)* pause on a Platte River sandbar in late March, contemplating their route through a roost of migrating Sandhill cranes *(Grus canadensis)*.

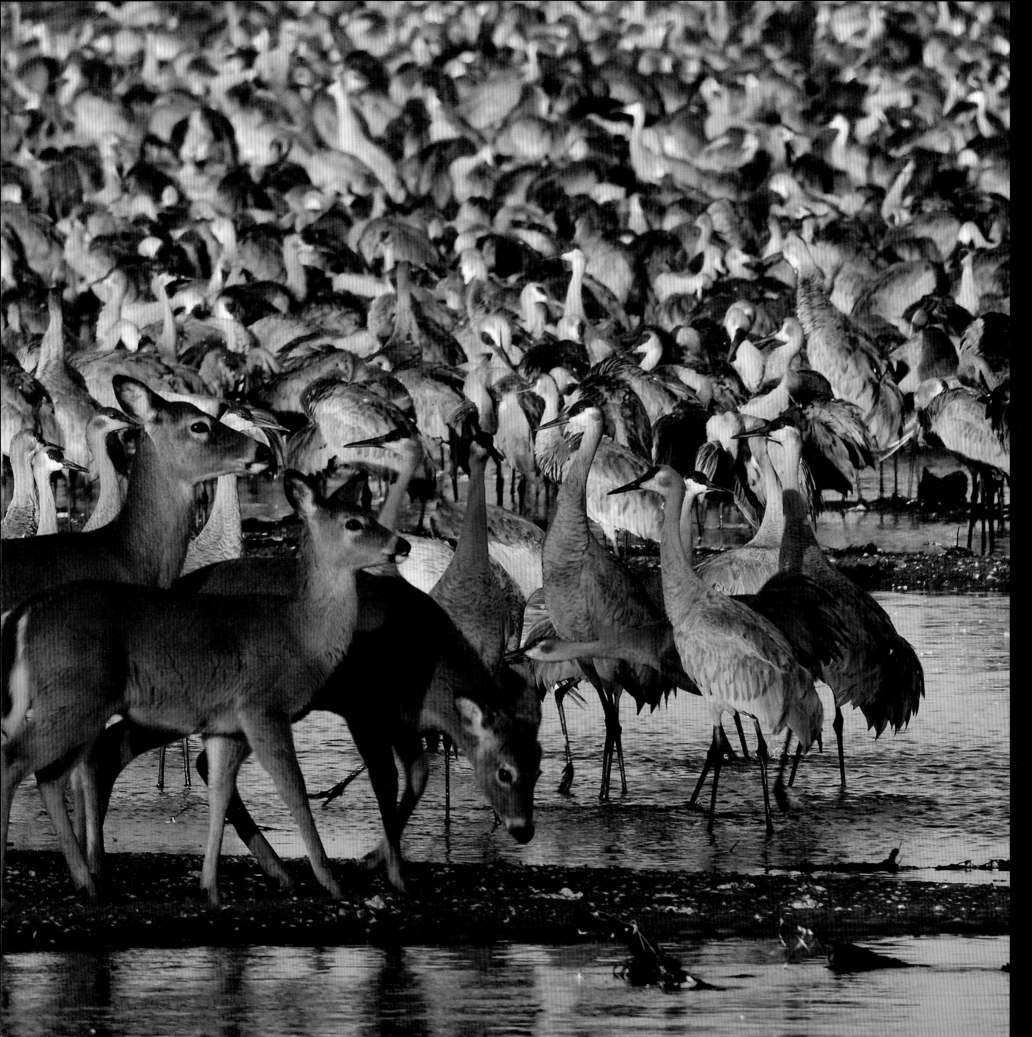

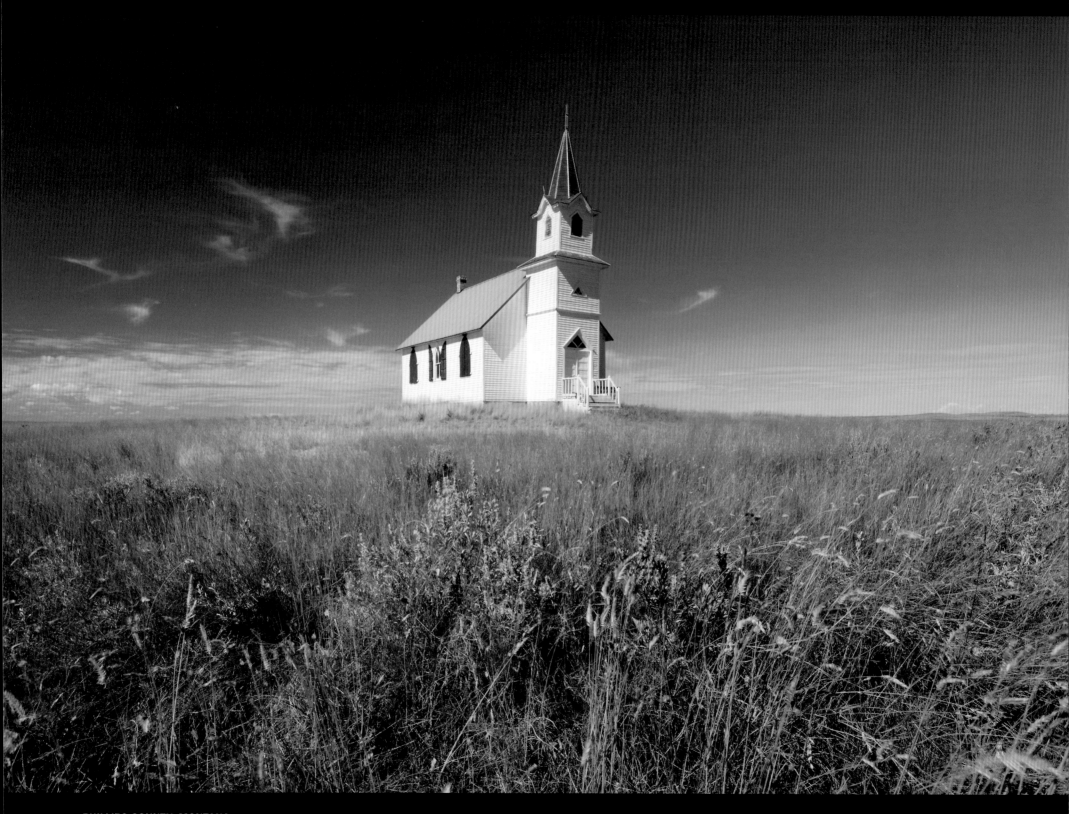

PHILLIPS COUNTY, MONTANA

The Scandia Lutheran Church rises above the prairie as it has since 1915, when Scandinavian homesteaders built it. These country churches served as important anchors for rural communities throughout the Great Plains.

Settling an Unsettled Land

David Wishart

THE CENTER OF NORTH AMERICA has been called the Great Plains since the mid-19th century, though the specific boundaries of the region have varied greatly, depending on who is doing the defining and for what purpose. Such geographic nebulousness has to do with the complicated nature of regions in general. Regions are recognized rather than found, human inventions as much as real places. The authoritative lines on the map belie the complexities on the ground. There are no signs at the Missouri River, for example, declaring that you are leaving the Midwest and entering the Great Plains, nothing as definitive as the highway sign that welcomes you to Nebraska. Yet within the disputed limits of the Great Plains lies a distinctive portion of the Earth's surface, a region shaped over time by the interactions of its inhabitants with the changing physical environment.

In adding yet another set of boundaries to that nest of lines, this book takes an expansive view of the Great Plains. The northern limits are set in central Alberta and Saskatchewan, where the crescent of the aspen Parkland Belt forms a transitional area between the open prairies to the south and the boreal forests of the north. The western boundary, tracing the Rocky Mountain Front, is the least ambiguous, although even this line is blurred in places, where such mountain outliers as the Black Hills sit like islands in the Plains. The eastern boundary, always the most elusive, extends into present-day western Minnesota, western Iowa, and northwestern Missouri in recognition of the original distribution of that almost vanished ecosystem, the tallgrass prairie. And the southern boundary, generally drawn at the Balcones Escarpment and the Rio Grande in Texas, is projected farther south in this book to recognize the desert grasslands of northern Mexico. This area is the threatened wintering and breeding grounds for many species of birds that, through their migrations, integrate the Great Plains from north to south.

THE SHAPE OF THE LAND The Great Plains are the issue of the Rocky Mountains. About 65 million years ago, at the beginning of the Tertiary Period, the Rockies were thrust up in the most recent in a series of cycles that have seen mountains uplifted then worn down by erosion throughout the course of geologic history. Over time the erosion of the Rockies yielded sands, silts, and gravels that were carried eastward by overloaded streams to coalesce on the Plains into expansive deltas, laying down an alluvial cover that extended from the mountains to beyond the Missouri River.

This Tertiary mantle is permeable, and water filtering into its layers of sandstone and gravel created the High Plains — or Ogallala — Aquifer, a slow-moving subterranean lake of fossil water that extends from southern South Dakota to the Texas Panhandle. One of the region's most valuable assets, the aquifer provides the bulk of Great Plains irrigation water, and since 1940 the rate of discharge has far exceeded any recharge through precipitation.

The Plains mantle, sloping gently eastward at the rate of about ten feet a mile, is resistant to erosion on its surface, which, unless plowed up or overgrazed, is protected by a thick thatch of deeply rooted grasses and by a hard layer of calcium carbonate called the caprock. But erosion has eaten back the mantle on all of its sides, wherever the protective cover has been removed, leaving what Willard Johnson in his classic 1900 report for the US Geological Survey called "an upland of survival" — the High Plains. This upland extends from the Pine Ridge Escarpment in northwestern Nebraska through the Llano Estacado of northern Texas. Smaller uplands of survival are evident in the Cypress Hills of southern Saskatchewan and Alberta and in the lonely towers of Chimney Rock and Scotts Bluff, famous landmarks on the Oregon Trail. The remainder of the mantle has been eroded over geologic time, so that today erosion from the Rockies is deposited on the surface of the Great Plains only along what is called the Gangplank in southeastern Wyoming. This half-mile sliver of land, an uncut umbilical cord from the mountains to the begotten Plains, now carries the Union Pacific Railroad and Interstate 80, cramped side by side.

To the west of the High Plains, the Arkansas and Platte Rivers burrowed through the Tertiary mantle in eastern Colorado. That is why, when traveling west across the Plains, you descend to Denver before rising steeply to the mountains. In a similar fashion, although in different geologic circumstances, the Pecos River in eastern New Mexico carved its way through the mantle that once extended to the mountains, leaving the eroded western edge of the High Plains towering 800 feet above the river valley floor.

The High Plains are also losing ground to the north. The majestic Pine Ridge

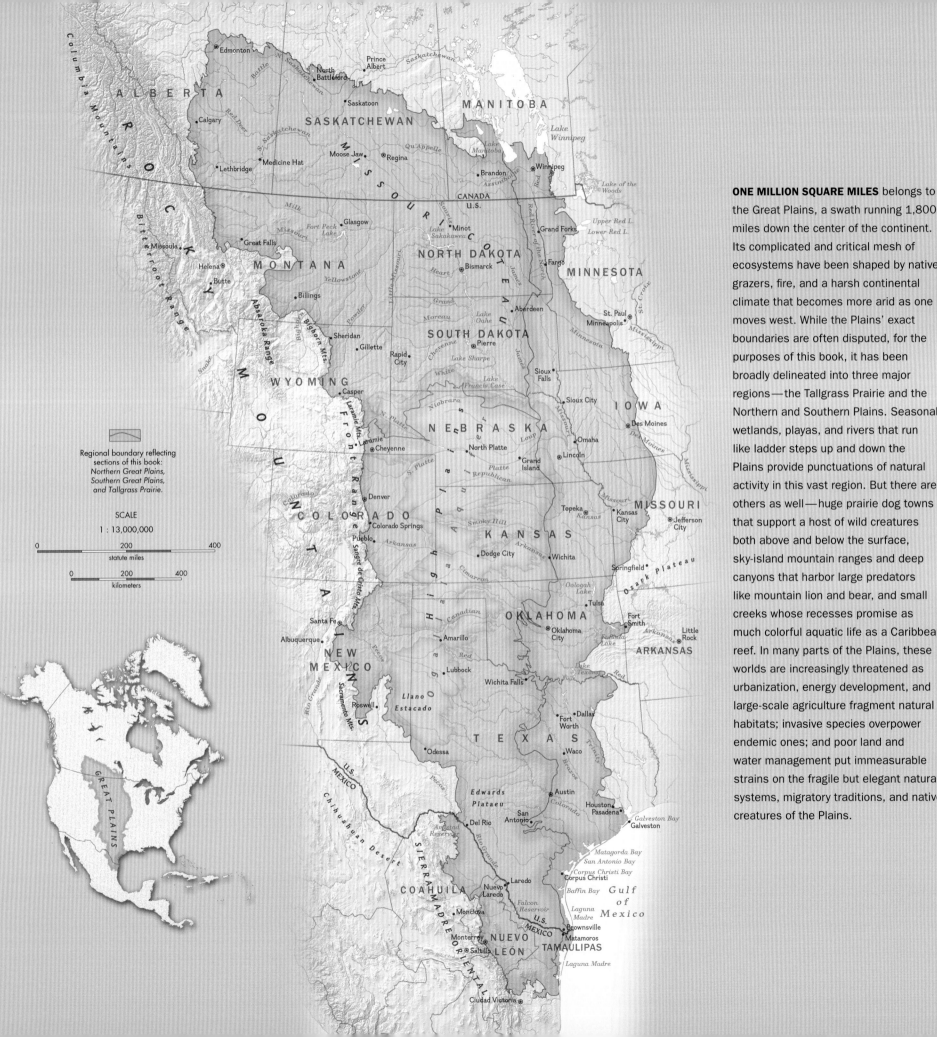

ONE MILLION SQUARE MILES belongs to the Great Plains, a swath running 1,800 miles down the center of the continent. Its complicated and critical mesh of ecosystems have been shaped by native grazers, fire, and a harsh continental climate that becomes more arid as one moves west. While the Plains' exact boundaries are often disputed, for the purposes of this book, it has been broadly delineated into three major regions—the Tallgrass Prairie and the Northern and Southern Plains. Seasonal wetlands, playas, and rivers that run like ladder steps up and down the Plains provide punctuations of natural activity in this vast region. But there are others as well—huge prairie dog towns that support a host of wild creatures both above and below the surface, sky-island mountain ranges and deep canyons that harbor large predators like mountain lion and bear, and small creeks whose recesses promise as much colorful aquatic life as a Caribbean reef. In many parts of the Plains, these worlds are increasingly threatened as urbanization, energy development, and large-scale agriculture fragment natural habitats; invasive species overpower endemic ones; and poor land and water management put immeasurable strains on the fragile but elegant natural systems, migratory traditions, and native creatures of the Plains.

Regional boundary reflecting sections of this book: *Northern Great Plains, Southern Great Plains, and Tallgrass Prairie.*

SCALE
1 : 13,000,000

0 200 400
statute miles

0 200 400
kilometers

Escarpment, worn back from the north at least 200 miles, overlooks the Missouri Plateau, which stretches all the way to the Prairie Provinces of Canada. North and east of the Missouri River, the land has been smoothed by repeated waves of glaciation. The course of the river itself is an outcome of glaciation: Its previous passage to Hudson's Bay was blocked by thick sheets of ice, causing it to drain southeast instead of northeast. The ice also impounded glacial meltwater in the Red River Valley, forming Lake Agassiz. At its maximum extent the lake covered 135,000 square miles of what is now South Dakota, North Dakota, Minnesota, Saskatchewan, Manitoba, and Ontario. Lake Agassiz began its final drainage only 9,000 years ago, long after humans had entered the scene.

South and west of the Missouri River, the unglaciated Missouri Plateau is much rougher country, distinguished by the fantastic, dissected landscapes of the Badlands and by Rocky Mountain fragments like Montana's Little Belt Mountains and the Black Hills of South Dakota, an upthrusted dome with a core of ancient granites that are some of the oldest in the world. On the Black Hills' Mount Rushmore, the recent sculpturing has been more by human hand than by wind, water, and ice.

Contrary to popular conception, the physical geography of the Great Plains is diverse. That diversity ranges from the limestone country of the Pecos River Valley, with its massive and still incompletely explored Carlsbad Caverns; to the volcanic landscapes of northeastern New Mexico, where Capulin volcano rises a thousand feet above the surrounding country, its last eruption perhaps only 4,000 years ago; to the rolling Nebraska Sandhills, the largest dune field in the Western Hemisphere.

The widely held misconception of the Great Plains as flat may have begun with the early European-American settlers, who crossed the Plains via the most level routes — most notably the Platte River Valley — and assumed that the entire region was similarly flat. Or perhaps the Plains' apparent flatness results from a perceptual mirage: The overarching dome of the sky is so dominant that the eye is carried to the low seam of the horizon, skimming over all the details in between. In reality, less than 25 percent of the Great Plains is flat, while more than 50 percent consists of irregular plains and tablelands and the remainder of hills and mountains.

Of all the aspects of the physical environment, the shape of the land is surely the most unchanging, its evolution calibrated to geologic rather than human time. If a 19th-century Pawnee Indian were projected into the present, he or she would still recognize the configuration of the surface of the Plains, though just about everything else in the landscape would have changed. But even the shape of the land is now sometimes metamorphosed overnight, as it has been in the coal-mining country of Wyoming's Powder River Basin. There, as writer Ian

Frazier lamented, the slow accumulations of geology, together with the layers of past human occupancy, are jumbled together by massive strip-mining machines into waste heaps, where "the dinosaur vertebrae drift in chaos with the sandstone metate, the .45 – .70 cartridge, the plastic-foam cup."

AN INCONSTANT CLIMATE That same Pawnee Indian, given long enough, would also recognize the contemporary climate, the extremes of hot and cold, the periodic droughts, the violent episodes of hail, blizzards, and tornadoes. The droughts, guaranteed but unpredictable, are a crucial part of the regional identity. The Great Plains region lurches wildly between periods of sufficient and insufficient precipitation, causing boom-and-bust cycles of human settlement that continue today.

The main controls of the Great Plains climate are the dry, cool Polar Continental air masses that develop over Canada and the moist, warm Tropical Maritime air masses that originate in the Gulf of Mexico. Where the air masses meet, the lighter Tropical Maritime air rises over the Polar Continental air, causing cooling and precipitation. This same convergence, under varying meteorological conditions, can also produce winter blizzards, spring and summer thunderstorms, hail, and tornadoes. Because the main convergence zone is to the east of the Great Plains, annual rainfall decreases as you head west, from 35 inches in Kansas City to as low as 12 inches in eastern Colorado.

The dryness of the Western Plains is also exacerbated by the rain shadow effect of the Rocky Mountains: Pacific air masses moving eastward lose their moisture on the western slopes of the mountains, leaving only dry air to descend to the Plains. Rainfall also decreases as you move north up the Plains and away from the main source of moisture in the Gulf of Mexico. Southern Saskatchewan and southern Alberta, like eastern Colorado, receive barely 12 inches a year.

Throughout the Great Plains, the collision of air masses causes deluges, and it's not unusual for as much as a third of the annual total to fall in a few hours. These rainstorms are often localized, and while one farmer's crops might be amply watered, a neighbor might see only dry lightning on the horizon.

At any place on the Plains dry periods of 35 consecutive days can be expected each year, and protracted droughts of 70 days are virtually assured every decade. Since European-Americans first settled the region, major droughts have occurred: In the 1870s, halting the Dakota boom; from 1892 to 1896, reversing the 1880s great advance in the westward settlement of the High Plains; in the 1930s, bringing to a close the era of Plains pioneering; in the early 1950s and early 1970s; and from 1999 to 2006, when there was a drought so severe there was not enough spare corn, symbolically at least, to replace the decorative veneer of the Corn Palace in Mitchell, South Dakota.

Compared to earlier droughts, however, the droughts of the last century and a half have only been dry spells. According to evidence etched in tree rings, around A.D. 1330 a 37-year drought followed close on the heels of successive 12- and 13-year droughts, causing the abandonment of well-established Indian villages in the Missouri River Valley of North Dakota. The lesson of this record shows that in future, the Great Plains could expect to suffer far more devastating droughts than those of the recent past, even without the new complication of global warming.

Drought is not the only aspect of the climate that has bedeviled Great Plains settlers from the earliest times to the present. Most immigrants were unprepared for the annual extremes of temperature, which occur because the area is far from the moderating effects of the oceans. In 1893 Glendive, Montana, suffered through a February low of minus 47°F and a July high of plus 117°F, a range of 164 degrees. Hailstorms have reduced many a field of crops to stunted stalks, especially in eastern Colorado and western Nebraska, where hail insurance rates are the highest in the nation and automobile dealers shelter their cars under canopies. Tornadoes frequently tear through "tornado ally," from northern Texas to Nebraska, sometimes erasing entire towns from the land. Their incidence decreases northward from a peak of nine major tornadoes annually in central Oklahoma and north-central Texas, but even the Canadian Prairie Provinces can expect a couple of serious events each year.

Severe winters are the material of folklore here and have brought entire eras to a close. In the winter of 1906-7, extreme cold and blizzards killed about a third of the cattle in Saskatchewan's Cypress Hills, turning open range ranchers into stock farmers overnight.

The Great Plains climate has its benefits, though. Rainfall is concentrated in the spring and summer growing season. When it's plentiful, crop yields are abundant. The western Great Plains, in the lee of the Rockies, are blessed with chinooks, descending warm winds that devour the winter snow. On January 22, 1943, a record-setting chinook caused a temperature surge of 41°F in two minutes in Spearfish, South Dakota.

The bright sun and clear skies psychologically mitigate the impact of winter cold and promise much for the development of solar energy. Wind energy is a particularly strong prospect. Ten of the twelve top states in development potential are located in the Plains, including the leader, North Dakota, where the average annual wind speed is a relentless 16 miles an hour. Texas now leads the nation in developed wind energy.

In the past, Plains residents, perpetual optimists in this "next year country," have haplessly tried to change the climate for the better, especially through experiments aimed at increasing the rainfall. But now people everywhere are inadvertently contributing to changing the Plains climate through carbon emissions and the resultant global warming. According to the 2001 national assessment of climate change, temperatures over parts of Montana and the Dakotas have increased 5.5°F since 1900, while precipitation over the eastern portions of Montana, Wyoming, and Colorado, as well as most of North Dakota, has decreased by 10 percent. The report predicts further increases in temperature, especially on the western Great Plains, reductions in soil moisture, and greater climatic variability over the coming century. As with the shape of the land, Plains climate is increasingly subject to change through the agency of humans.

CHANGING GEOGRAPHY The iconoclastic Kansas historian James C. Malin once wrote that every vegetation map needs a date, because vegetation is in constant flux, responding to climate change and human intervention. During the late stages of the last glaciation, from about 14,000 to 20,000 years ago, the central Great Plains were covered by spruce forests. These were replaced by prairie about 10,000 years ago as the climate warmed. This rapid change in climate and vegetation resulted in the extinctions of Plains megafauna — camel, mammoth, musk ox, horse, and others — which could not make the necessary dietary and physiological adjustments. Overhunting by Paleo-Indians may have also played a role. On a smaller scale, the heat and aridity of the 1930s suppressed the less drought-resistant grasses and forbs and even xerophytic plants — those equipped to withstand such stresses — were thinned out. When the rains returned after 1940, the vegetation cover re-established itself through stages of plant succession.

This constant motion notwithstanding, by 1850, before the plow-up of the eastern Great Plains, three broad longitudinal zones of grassland had developed over 10,000 years, mainly in response to climate. In the east, tallgrass prairies of big and little bluestem swayed in the wind, in some places as high as a horse's back — a verdant rolling meadow that evoked inevitable comparisons to the swell of the ocean. As rainfall declined westward, tallgrass species yielded to a mixed-grass prairie, where western wheatgrass and other medium-height grasses formed a canopy two or three feet above a mat of short grama and buffalo grasses. West again into increasing aridity, from the Texas Panhandle to the Canadian prairies, the mid-grasses in turn gave way, leaving only the shortgrass sod of grama and buffalo grasses that gave the impression of a closely grazed pasture. Woodlands of cottonwood, elm, hackberry, and juniper were restricted mainly to the Missouri River floodplain, with fingers of extension westward along tributaries like the Arkansas, Platte, and Niobrara Rivers. Forests of Douglas fir and ponderosa pine darkened the slopes of the Black Hills and other Rocky Mountain outliers.

Beneath this vegetation cover, soils developed initially in accordance with

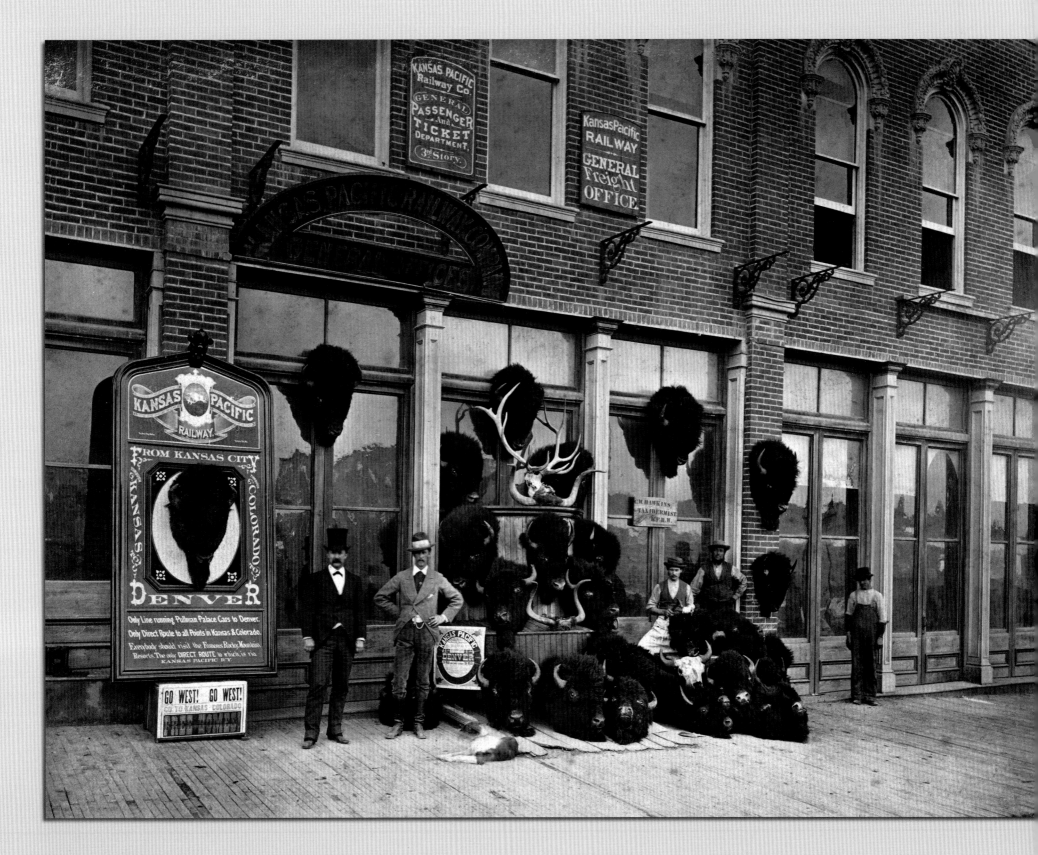

DODGE CITY, KANSAS

An 1873 photograph of a Kansas Pacific Railroad station shows it festooned with bison heads,
iconic tribute to America's taming of the Plains and its dreams of Manifest Destiny.

PHOTOGRAPH BY ROBERT BENECKE

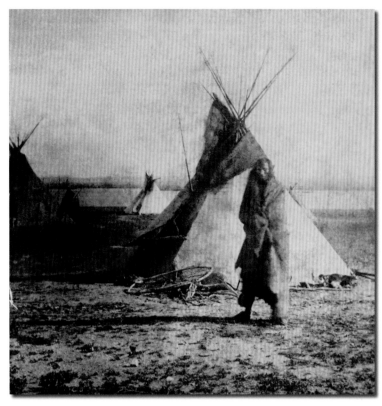

SIOUX VILLAGE, NORTH FORK OF THE PLATTE
The earliest known photograph of a Lakota Sioux village, this image was taken by artist Albert Bierstadt, one of the cadre of artists and photographers on the Frederick W. Lander Expedition of 1859, which documented the Great Plains.

the parent geologic material, then later under the controlling influence of the climate. By 1850, especially in the eastern Plains, soils were rich and deep from the accumulation of organic matter. Farmers coming from Europe and the eastern United States, often from areas of stony, acidic soils, marveled at the fertile promise. Per Hansa, for example, the protagonist in Ole Rölvaag's *Giants in the Earth*, an epic novel of Norwegian settlement in southeastern Dakota Territory in the 1870s, gratefully picked up handfuls of the dark soil and let it fall through his fingers like gold. Within a few decades, though, the stored nitrogen in the soil was drained by farming, and yields fell unless the nitrogen was replaced by manure, legume cultivation, or increasingly after 1940, large doses of synthetic fertilizers.

Wildlife also evolved in dynamic association with the climate and vegetation. By 1800 the grasslands supported as many as 30 million bison. These vast herds may have been partly responsible for the extent of the shortgrass prairie, because grama and buffalo grasses tolerate grazing better than the mid-height species. Efficient grazers, bison may also have contributed to the postglacial extinction of the other megafauna by depleting their food supplies. Early

travelers through the Plains were astounded by the size of the herds and by the multitudes of elk, deer, and pronghorn antelope, the haunting presence of grizzly bears and gray wolves, the colorful variety of birds, the teeming rivers of fish. Even the naturalist John James Audubon, who surveyed the quadrupeds of the northern Great Plains in 1843, was nonplussed by the horizon-to-horizon magnitude of the bison herds, writing in his journal that they were simply "*impossible to describe or even conceive.*" This was not the reputed Great American Desert that the explorers Zebulon Pike (1806-7) and Stephen Long (1820) had encountered, or imagined.

EARLY INDIAN OCCUPANCY The Indians that early European explorers of the Plains encountered were the descendants of migrants who had crossed the Bering Sea land bridge connecting Asia and North America some time between 11,000 and 30,000 years ago. Their presence on the Great Plains went back at least 18,000 years, a time scale likely to be extended with new archaeological discoveries. They were hunters and gatherers, thinly spread in small family bands, moving their campsites frequently throughout the year. Their distribution is marked by the stone tools and weapons they left behind at sites like Clovis and Folsom, New Mexico, and at such bison kill sites as Hudson-Meng in northwestern Nebraska and Hell Gap in eastern Wyoming.

Scholars conventionally doubted that these pedestrian hunters and gatherers could have permanently occupied the High Plains, with their vast spaces, erratic rainfall, severe winters, and scarcity of timber. But anthropologist Waldo Wedel clearly demonstrated that the two essentials of life—bison and water—were readily available. Bison were everywhere, and water could be found in perennial streams like the Platte and Arkansas Rivers, as well as below the dry beds of seasonal streams; in the many depressions that pock the surface of the Plains and fill with water after storms; and in numerous springs along the sides of valleys where the High Plains Aquifer flows into the daylight. Hospitable wintering sites, with shelter, water, wood, and game, were located along rivers and in canyons on the Western Plains. The "big timbers" along the Arkansas River as it crosses the Kansas-Colorado border were particularly attractive. Distance was a problem (as it is today), but a dog harnessed to a travois could carry a load of 50 pounds over 10 miles each day, enough to reach the next water source.

In the 17th and 18th centuries the reintroduction of the horse, gone from the Great Plains for 10,000 years, diffused out from Spanish settlements on the Rio Grande. The horse revolutionized Plains life. With it, Indians could raid widely, securing their subsistence by transporting bison meat and hides. The horse also made it possible to increase the amount of possessions that could be carried. On the Southern Plains particularly, where horses were most plentiful,

life was radically changed. The Comanches became specialized horse traders and raiders. Emboldened by their new mobility, wealth, and power, they established an empire, extending from Kansas to Mexico and lasting more than a hundred years. Farther north up the Plains, away from the Spanish settlements, the number of horses diminished, but even there the attraction was so strong that the Lakotas (Sioux) had crossed to the west side of the Missouri River by 1750, abandoning their increasingly contested homeland in the Midwest and becoming equestrian hunters ruling over their own expanding empire.

Farming came relatively late to the Great Plains, spreading west from more humid areas after A.D. 900, when moist, warm, Tropical Maritime air dominated. Agricultural earth-lodge villages were firmly established in the Dakotas, on the lower terraces of the Missouri, by that date and in the river valleys of central Nebraska by 1100. Indian women interplanted beans, corn, squash, and melons on the rich alluvial soil, with timber and water readily available. Villages were moved as the local timber (so necessary for winter fuel and lodge construction) was depleted. The presence of massive amounts of bison bones in excavated sites suggests that hunting may have provided as much as half of the food supply.

These ancestors of the Mandans and Hidatsas in the north and the Pawnees in the south divided their year between farming in the villages and extended bison hunts to the west, gathering wild foods as well whenever opportunity arose. Their food supplies were diverse, the areas they were drawn from extensive. Their system clearly worked, because it supported more than 10,000 Pawnees by the 18th century.

All the Indians were integrated into a trading network that spanned the Great Plains and connected to other regional networks, which together extended across the continent. On the Plains, the trade was mainly an exchange of products of the hunt. Dried and fresh bison meat, provided by equestrian nomads like the Lakotas, would be exchanged for products of the soil, grown in the eastern villages. By the 18th century European products were filtering into this system, most important horses from the south, which brought independence to the Indians, and guns from the east and north, which brought dependence on the Europeans because ammunition was always needed. Diseases like smallpox also moved along these trade routes, tearing societies apart, sometimes even before the Indians had laid eyes on a European. These foreigners were soon to be seen, however, initially as explorers and fur traders who set in motion forces that would change the Indians' worlds and the Great Plains forever.

EXPLORATION AND THE FUR TRADE European explorers and traders—the two categories overlapped—pushed onto the Great Plains from most directions. Spaniards explored from the Southwest, starting in 1541 with Coronado's foray

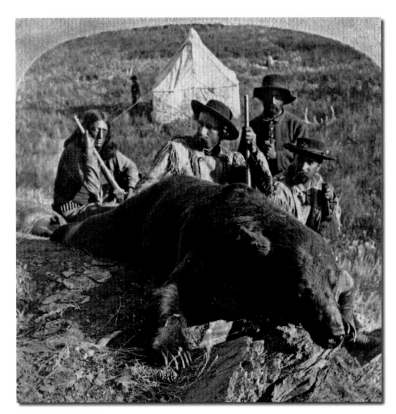

BLACK HILLS, SOUTH DAKOTA
On an 1874 expedition into the Black Hills, Lt. Col. George Armstrong Custer took down a Plains grizzly *(Ursus arctos horribilis)* and found another trophy— gold—spawning a rush on the Black Hills and a subsequent war with the Northern Plains Indians. PHOTOGRAPH BY WILLIAM ILLINGWORTH

into the Southern Plains in search of the mythical kingdom of Quivira. Like the French, who approached from bases in the lower Mississippi River Valley, the Spaniards were deflected by the growing might of the Comanches. The Southern Plains were in any case a poor prospect for the fur trade, not least because there were no navigable rivers to solve the transportation problems. French and Spanish traders also worked up the Missouri River from St. Louis in the second half of the 18th century, clarifying the geography as far north as the Mandan villages, near present-day Bismarck, North Dakota.

In the Prairie Provinces of Canada, British traders associated with the Hudson's Bay Company and the rival Northwest Company established more than a hundred posts along the rivers threading between the prairies and the boreal forests from 1779 to 1821. Their trade focused on beaver pelts and other small furs, because transportation problems—including frequent portages—precluded trading heavy bison robes. Dried bison meat, however, was traded in large quantities by Plains Indians at the posts. The Mandan villages' trade hub was also a magnet for the British, and as many as 35 expeditions were sent there from 1770 to 1800.

In 1804 President Jefferson dispatched Meriwether Lewis and William Clark to find a route to the Pacific, to survey Indian populations, and to establish American sovereignty in the wake of the Louisiana Purchase. The two men and their Corps of Discovery were relative latecomers to Plains exploration and theirs was a different kind of expedition, scientific rather than economic and larger than Plains Indians had previously seen. Still, it was Lewis's and Clark's revelation of the area at the headwaters of the Missouri, "richer in beaver and otter than any country on earth," that sparked the American fur trade.

After repeated attempts by St. Louis companies to trap the area — attempts thwarted by the Blackfeet, who did not appreciate their wealth being appropriated — a successful system was implemented by the American Fur Company in the late 1820s. This was indeed a fur trade. The main product was bison robes, though any profitable fur or skin would be taken; the labor was provided by the Indians, with the men as hunters and the women as processors of the robes; the furs were exchanged for manufactured goods like blankets, metal pots, and guns at the trading posts in the spring; and the Missouri River was the artery for the trade, connecting the Northern Plains to St. Louis. From there the furs were transported to markets in the eastern U.S. and Europe.

By the early 1830s every Indian group on the Northern Plains, even the Blackfeet, was served by a trading post. The Indians were not slaves to the fur trade but willing participants and intelligent traders. They knew which trade goods they specifically wanted, and they believed they were getting a bargain.

But the bargain was also a curse. Smallpox moved through the trade network, most catastrophically in 1837. The epidemic could have been avoided, because the American Fur Company knew that the disease was being carried upriver on their supply boat, the *St. Peters*. But the traders did not want to lose a season's profit, and an estimated 17,200 Indians died from the Platte to the Saskatchewan. The Mandans were reduced from 1,600 people to 31 in a single savage winter. They died so fast that their trader, Francis Chardon, gave up counting. The trade moved north and west into Blackfeet country.

The fur trade was also a curse because it created dependency. When the furs gave out, the Indians were left with wants and no means to satisfy them. Unlike in Canada, where the Hudson's Bay Company implemented such conservation strategies as rotating trapping grounds, the American fur trade was a rapid resource grab, and places and peoples were used up and discarded. By 1833, according to the German naturalist Prince Maximilian, fur-bearing animals were "greatly reduced in number" all along the Missouri River. Beaver would return to Plains rivers when the market demand declined after 1840, but the fur trade, with its attitude of short-term exploitation, set the pattern for subsequent use and abuse of the Great Plains.

RESETTLING THE GREAT PLAINS By the 1840s the American presence was diversifying on the Great Plains. In 1849 alone more than 100,000 immigrants to Oregon, Utah, and California crossed the Central Plains along the Platte corridor, splitting the bison herds in two and precipitating a decline that would culminate in near-extinction by the 1890s. After 1821 and continuing into the 1850s, thousands of wagons trundled each year along the Santa Fe Trail from Missouri to New Mexico. And missionaries and Indian agents were assigned to Christianize and Americanize Plains Indians in order to assimilate them, because it was increasingly clear that their lands would soon be needed by European-American settlers.

Some Indian leaders understood the consequences. Big Elk, for example, the able chief of the Omahas, visited Washington, D.C., in 1853, desperately seeking to sell Omaha lands in return for government annuities (food, blankets, and other supplies). Back in his Nebraska village, a saddened and chastened Big Elk warned his people of the "coming flood" that would soon sweep away everything they had known.

Settlers were already backed up at the western borders of Iowa and Missouri when the Kansas-Nebraska Act of 1854 extended territorial government to the Central and Northern Plains. Because legal title to the land remained in the hands of the Indians, treaties were negotiated and homelands were sold, beginning immediately in eastern Kansas and Nebraska then later across the Plains to the west and north. By 1890 all that remained of "Indian Country" were scattered reservations on the Northern Plains, home to Lakotas, Crows, Blackfeet, and others, and a concentration of reservations in Indian Territory (after 1907 Oklahoma), where nations like the Cheyennes, Pawnees, and Poncas had been forced to relocate. Most of the process was legal, as defined by the U.S., although the expropriation of the Black Hills from the Lakotas in 1877 was one important exception. But being legal does not mean that it was fair. The Indians sold their lands against a backdrop of starvation and disease, and the U.S. paid them as little as possible — a paltry average of ten cents an acre for the Central and Northern Plains. North of the 49th parallel, which defined the boundary between the U. S. and Canada after 1818, Indian lands were acquired through seven treaties from 1871 to 1877, and Ojibwas, Blackfeet, and others were restricted to reserves and subjected to assimilation policies designed to dismantle their cultures and make them disappear.

The first step in the European-American settlement process was for surveyors to extend the grid of the township and range system into the Great Plains. In a country where there had been no straight lines, there was now a remorseless rectangular geometry. The first stop for expectant settlers was the local land office, where they could each obtain a piece of that grid through a variety of land laws. Before 1862 most land was sold through the Preemption Act of 1841,

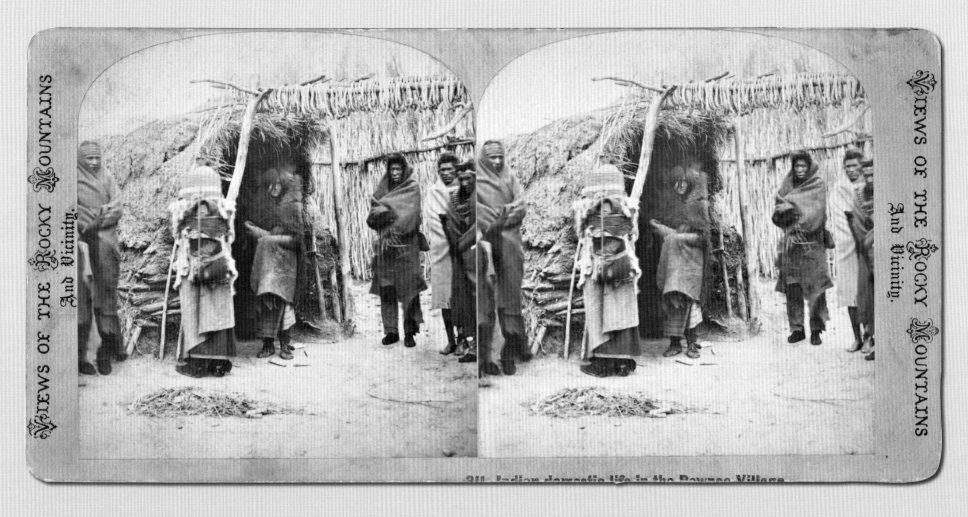

VIEWS OF THE ROCKY MOUNTAINS And Vicinity.

VIEWS OF THE ROCKY MOUNTAINS And Vicinity.

311. Indian domestic life in the Pawnee Village.

NEAR PRESENT-DAY GENOA, NEBRASKA

Above: The Pawnee, long hospitable to European-Americans, allowed photographer John Carbutt to record images of their domestic life in 1867. Within eight years, they were tragically reduced by disease and eventually removed to reservations in Indian Territory, now Oklahoma.

LOUP COUNTY, NEBRASKA

Right: The stack of elk antlers piled outside the sod house of the W.I. Cram family in 1886 is testament to the radical reshaping of the Plains that came with European-American settlement. Elk *(Cervus elaphus)*, like Plains bison and grizzly, quickly disappeared. PHOTOGRAPH BY SOLOMON D. BUTCHER

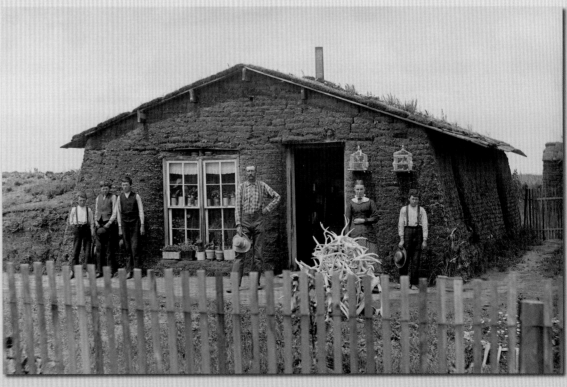

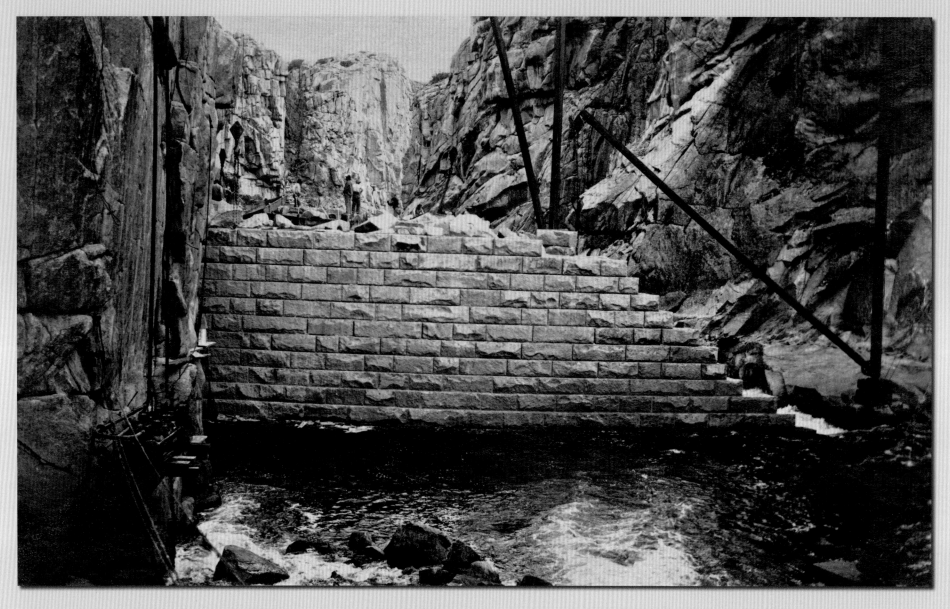

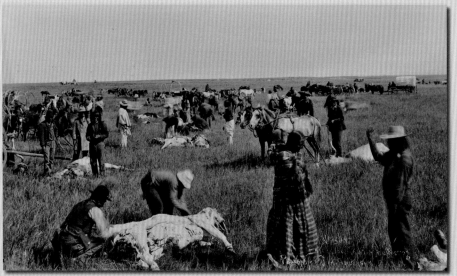

Above: **NATRONA COUNTY, WYOMING**
Completed in 1909, Pathfinder Dam arches across a granite canyon on the North Platte River southwest of Casper, Wyoming. It was one of the first large dams created under the 1902 Reclamation Act, which redirected water from the great rivers and gave it to the thirsty farms of the West.

Left: **ROSEBUD INDIAN RESERVATION, SOUTH DAKOTA**
After receiving their issue of beef, Lakota Sioux Indians butcher longhorn cattle out on the range. In demand by beef-hungry European-Americans, cattle were issued by the government to American Indians left subjugated and impoverished when the bison were eliminated. PHOTO BY JOHN A. ANDERSON

which allowed an adult to secure title to 160 acres by making improvements and paying $1.25 an acre within 12 months. The 1862 Homestead Act (and similarly, though not identically, the 1872 Dominion Lands Act in Canada) inaugurated the era of virtually free land, providing 160 acres for a minimum registration fee and the promise to live on the land and improve it for five years before receiving title. The addition of the Timber Culture Act of 1873, designed to promote tree planting, gave settlers another opportunity to acquire 160 acres free. So after 1873 a settler could obtain 480 acres for $200, an extraordinary attraction to most Europeans and urban Americans for whom land ownership had previously been only a dream. Later land laws, like the Enlarged Homestead Act of 1909, increased the amount of land that could be acquired under homestead provisions to 320 acres and eventually 640 acres, in recognition of the need for larger tracts on the drier Western, Northern, and Southern Plains. About 10 percent of those taking out homesteads were women (single, divorced, or head of household), though the proportion varied considerably across space and time.

American and Canadian settlers migrated to the Great Plains along a series of largely latitudinal flows. Most Canadian-born migrants to the Prairie Provinces came from Ontario. The Dakotas attracted many settlers from southern Wisconsin, the children of earlier pioneers from New York and New England who had moved west in steps. Kansas and Nebraska drew much of their populations from Pennsylvania via Ohio, Indiana, and Illinois. Texas and Oklahoma were substantially extensions of the southern frontier. African Americans moved in too, especially to Kansas. "Exodusters" fleeing the ignominies of Reconstruction in the 1870s, they saw the Great Plains as a Canaan. Some moved north into the Prairie Provinces after 1900, following a dream of greater freedom that never materialized.

With the acquisition of Texas in 1845 and New Mexico in 1848, following the war with Mexico, the American Great Plains inherited a deeply rooted Hispanic population. Mexicans were added after 1900, recruited to build the railroads and work in the meat-packing plants of Omaha and Kansas City and the sugar beet fields of Colorado.

Europeans added more diversity to the mix. Germans, for example, settled in the Central Plains in the 1860s and 1870s, and Norwegians and the prized Germans from Russia (prized because they were pre-adapted to the grasslands) moved into the Dakotas in the 1870s and 1880s. The Prairie Provinces, much more a mosaic than a melting pot, attracted Ukrainians, Icelanders, Mennonites, and a myriad of others to the "last best west" in the early 20th century. In general, the European ethnic presence declined from north to south: fully 71 percent of North Dakota's population in 1910 was foreign born, but many of the towns in Kansas and Nebraska and as far south as the German Hill Country of Texas still

take their identities from that initial European transplantation.

Asians, at first Chinese then later Japanese, entered the Great Plains in much smaller numbers from the west, recruited to work on the railroads and in the sugar beet fields of eastern Colorado. But in 1882 and 1907 discriminatory immigrant legislation brought that wave to an abrupt halt.

Many of the settlers, especially native-born Americans and Canadians, were primarily speculators who took advantage of the pliable land laws at every opportunity. Speculation was so rife that both the Preemption and Timber Culture acts were repealed because of blatant abuse. Other settlers were genuine farmers who became rooted in place in the Plains and wrested a lifelong livelihood from its soil. Many capitalized on rising land values, selling their improved acreages at a profit, then moving on to the next area of free or cheap land or to some other economic endeavor in the fluid frontier economy. Countless numbers came with little capital and even less experience and failed. The region was a swirl of population turnover. Historian James Malin found that in eastern Kansas only 35 percent of the farmers in 1860 were still there in 1865, and in western Kansas only 39 percent of those farming in 1905 remained in 1915. Turnover was even more rapid in the towns. In Sioux City, Iowa, 80 percent of the men present in 1870 were gone by 1880. Working-class men with few resources tended to be the most mobile.

It is no wonder, therefore, that land was brought under cultivation slowly. Before the widespread use of the tractor in the early 20th century, it was hard to turn the tough prairie sod with only a moldboard plow and a horse; also, many settlers were not serious farmers. More attracted to a process than to a place, they were always on the alert for the next opportunity.

Before the railroads extended into the Plains, beginning in the 1860s and reaching maximum mileage in the 1920s, European-American settlement was largely restricted to the Missouri River Valley. Beyond this corridor, commercial farming was precluded by lack of access to supplies and markets. The railroads overcame this problem and more than any other factor shaped the emerging human geography of the Great Plains.

Railroads confirmed the primacy of "Gateway Cities" like Winnipeg, Omaha, and Kansas City, and ultimately Chicago, all of which controlled the settlement of their Plains hinterlands. Railroads recruited settlers for their land grants—Americans for the towns, Europeans for the land because, as geographer John Hudson put it, the Europeans would work harder and complain less.

Railroads also determined the spacing of the towns, which were platted every ten miles or so along the tracks to control space and eliminate competitors. The spacing of the towns also reflected the distance a farmer could haul a crop to the elevator, buy supplies, and return home the same day. These towns were trade centers, providing goods and services to a surrounding farm population, so town

and country settlement were contemporaneous. Even the plans of the towns—often a T-shape, with the main street perpendicular to the peripheral tracks—were the design of the railroads and their town-building associates.

Pushing across Kansas and Nebraska in the 1860s and '70s, the railroads also provided shipment points to eastern markets at places like Abilene, Dodge City, and Ellsworth, which were the destinations for the fabled cattle drives from Texas. The drives came to an end in the 1880s, when farmers and their barbed wire finally choked off the trails.

Ultimately, the railroads built too many towns. After 1900, with the increasing mechanization of farming, there were fewer farmers to serve, and farmers with trucks did not have to patronize the nearest town but could travel farther afield to obtain better deals. Towns disappeared from the map and faded from the land, leaving only crumbled foundations and perhaps a cemetery to recall a once vibrant world of baseball teams, opera houses, and aspirations. Kansas alone has an estimated 6,000 ghost towns—and their ranks are growing.

As European-Americans moved on into eastern Montana, the southern Plains, and the Prairie Provinces after 1900, the stages of the settlement process became compressed, speeded up by railroads, automobiles, tractors, faster information flow, and a sense that the good land was running out. This was nowhere more evident than in the Cypress Hills of Saskatchewan, which remained a refuge for open range cattle ranching until that killing winter of 1906-7. There, as Wallace Stegner vividly recalled in his memoir, *Wolf Willow*, the "historical parabola" from "grizzlies, buffalo, and Indians still only half-possessed of the horse and gun…to Dust Bowl and near-depopulation" spanned only 60 years. This was the "Plains frontier in a capsule," Stegner wrote, "condensed into the life of a reasonably long-lived man."

Even before the outmigrations of the 1930s, many Plains counties had already reached their peak populations. In western Nebraska and Kansas, some counties never completely rebounded from losses of more than 50 percent of their populations during the drought of the 1890s. In eastern Montana, the peak year was 1916, before a quarter century of economic downturn and climatic reversals drove disillusioned settlers out, once more heading west. Traveling through that thinned-out land in the 1990s, writer Jonathan Raban saw only a graveyard of a landscape, "strewn with the relics of the dead." The Great Plains had been over-settled, and the region has been adjusting ever since.

ADJUSTING TO NEW REALITIES By the early 20th century, a relatively brief period of European-American settlement had changed the face of the Great Plains far more drastically than the previous 18,000 years of human occupancy. Grizzly bears and gray wolves had been exterminated from the region in yet another round of megafauna overkill. About 50 percent of the tallgrass prairie had been plowed up, and grazing, roads, and towns had substantially altered the rest. Wetlands, sanctuaries for birds, fish, and other wildlife, had been drained and eliminated. North Dakota had lost 49 percent of its wetlands, Kansas 48 percent, Nebraska and South Dakota both 35 percent. In the eastern Great Plains, 89 percent of Iowa's original wetlands and 50 percent of Minnesota's were lost by 1980. Where once a single acre of tallgrass prairie had nurtured about a hundred species of grasses and forbs, 80- and even 160-acre fields were now devoted to a single crop, an ecosystem as humanized as a city block. To the west, a massive plow-up for wheat removed millions of acres of shortgrass prairie in two waves—the first during the "parity years" of World War One, when farmers' incomes were on a par with those of city dwellers, and the second in the 1920s, when tractors and combines became ubiquitous. Farmers continued to plow up extra land during the bad years of the 1930s, hoping to recoup their losses in a single bountiful harvest. In doing so, they exposed even more bare soil to wind erosion.

By 1936 the vegetation cover of the Dust Bowl area (southeastern Colorado, southwestern Kansas, northeastern New Mexico, and the panhandles of Texas and Oklahoma) had been depleted by more than 70 percent as a result of cultivation, overgrazing, and drought. Only in the Nebraska Sandhills—where ranchers were (and are) obliged to tread lightly because the land immediately turns into shifting sand dunes when too much vegetation cover is removed—was the range still healthy.

The ecological and economic disaster of the 1930s radically changed the context of Great Plains farming and life, causing the Canadian and U.S. governments to become involved as stabilizing forces. The US Agricultural Adjustment Act of 1933 initiated the practice of paying American farmers not to plant in order to limit production and protect prices and the soil. The initial reluctance to this by independent Plains farmers was quickly overcome. The policy of paying farmers to set aside land from cultivation, especially erosion-prone land, has continued through the Soil Bank (1956) and the Conservation Reserve Program (1985) to the present. Today, subsidies account for 50 percent of a farmer's income in many years, and in some years, subsidies are the only income a farmer harvests. In Canada the Prairie Farm Rehabilitation Administration was established in 1935 to revive the drought-stricken region, and it has since evolved into a comprehensive conservation and rural development agency. Such support systems were not available during the previous drought of the 1890s, when farmers were left alone to sink or swim, apart from minor state aid and widespread charity.

Without a doubt, these programs—together with the 1930s establishment of national grasslands created from federally purchased lands too marginal for

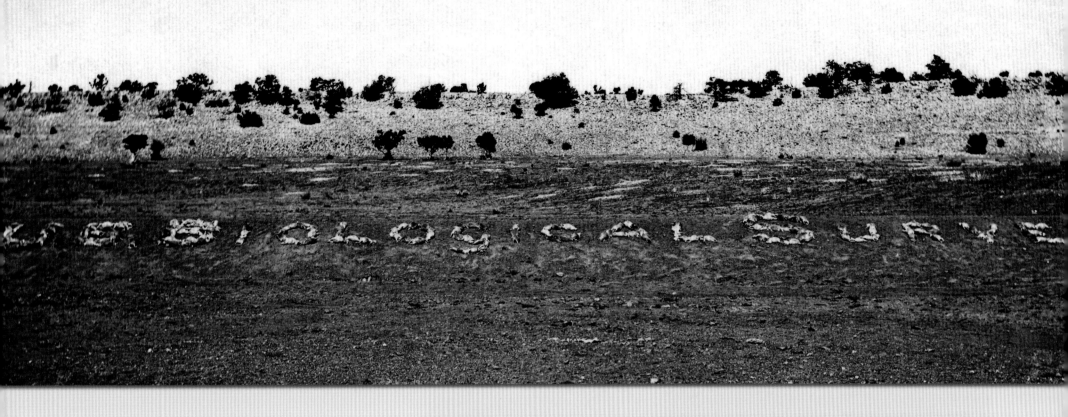

EASTERN ARIZONA

Above: The US Biological Survey, in charge of poisoning operations in the West, spelled out its own name with the carcasses of over 1,600 prairie dogs *(Cynomys ludovicianus)* poisoned in 1933.

NEAR THE HIGHWOOD MOUNTAINS, MONTANA

Right: Hunter Barney Brannin poses in 1928 before his season's take of wolf *(Canis lupus)* and coyote *(Canis latrans)* hides.

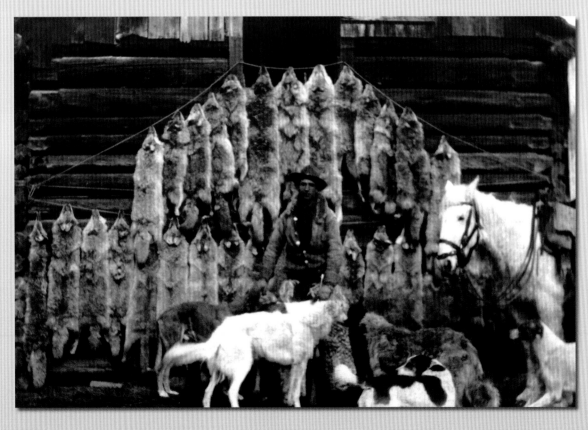

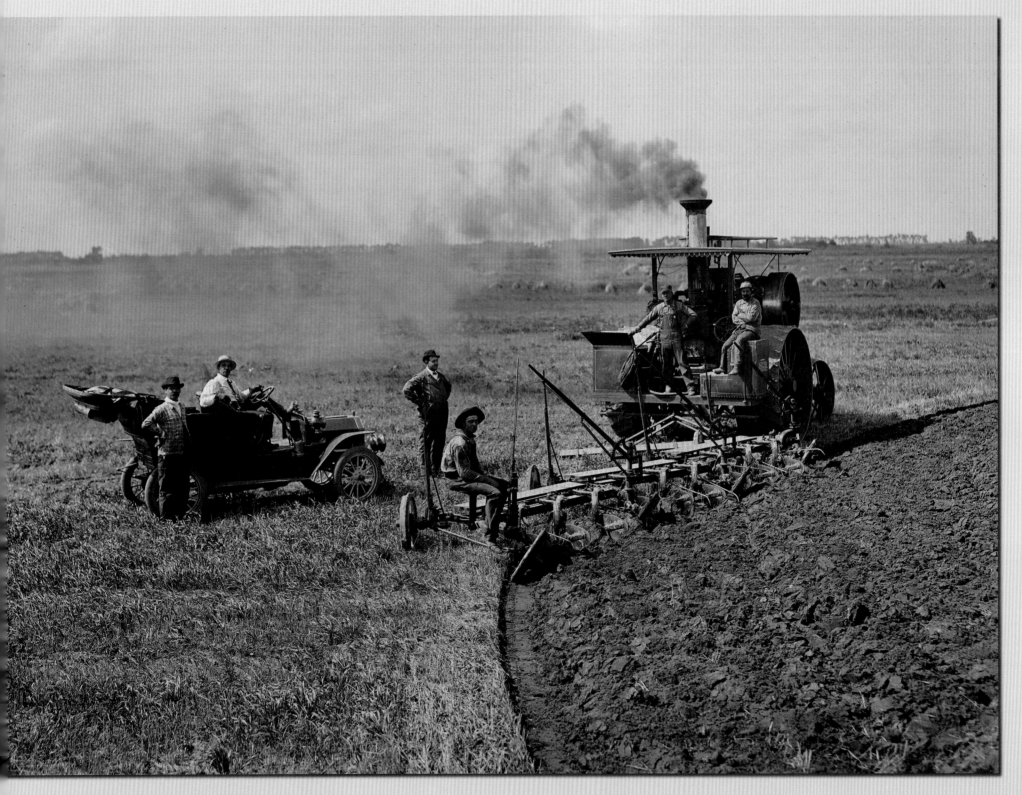

KEARNEY COUNTY, NEBRASKA
In this 1910 photograph, the firm of Radford & Sons proudly displays the muscle that plowed up the prairie sod—a steam tractor that could easily pull an eight-bottom plow, making it possible to farm tracts whose size would have been previously unimaginable. PHOTOGRAPH BY SOLOMON D. BUTCHER

farming or grazing—marked a new departure in the settlement of the Great Plains: an emerging ethic of managed use.

Despite the new ethic, however, the reduction in Plains wildlife diversity continued. An analysis of breeding bird populations based on annual surveys from 1966 to 1993 revealed that 24 of 28 monitored species had suffered significant population declines, mainly because of agricultural intensification. Losses have continued since. The associated removal of woodland and windbreaks at the edges of fields reduced wildlife refuge space and truncated their corridors of movement. The damming and channelizing of rivers, along with siltation and chemical fertilizers, compromised fish populations. Over the past century endangered Great Plains flora and fauna have included at least seven different mammals (including the gray wolf and the grizzly bear, which had moved back in small numbers from the Parkland Belt and Rockies respectively onto the fringes of the Plains), thirteen birds (among them the piping plover, American peregrine falcon, and whooping crane), six fishes (including the pallid sturgeon), one amphibian (the Houston toad), one insect (the American burying beetle), and eleven vascular plants. The causes of the declines are many, but always associated with habitat change. The black-footed ferret, for example, has been virtually eliminated because its main food source, the black-tailed prairie dog (which numbered about five billon in the early 1900s) now occupies only two percent of its former range, the result of agricultural expansion, residential development, and deliberate poisoning.

Plains human populations declined too, their plummeting in the 1930s accelerating a trend already underway. Outmigration and lowered fertility rates (birth rates drop when economic conditions and prospects are poor), meant that North Dakota, South Dakota, Kansas, and Oklahoma all lost population over the course of the decade, the only states in the nation to do so. Oklahoma led the nation with its net migration loss of 440,000, representing almost one-fifth of what its 1930 population had been. Most who left the Plains went to adjacent states; if they went farther afield, they mainly headed west, again in latitudinal flows. The majority of uprooted farmers, however, just retreated to the local county seat, hoping to eke out a living from their handiness.

This rural and small town depopulation has continued to the present. More than 60 percent of American Plains counties lost population from 1990 to 2000, including half of South Dakota's counties and all but seven of North Dakota's 53 counties. In Slope County, North Dakota, the population now stands at 767, compared to 4,945 in 1915; Amidon, the county seat, has 25 residents. In the absence of jobs, people tend to fall back on self-employment. The young in particular move away, looking for opportunity elsewhere. Their departure hampers future population and economic growth and leaves the coffee shops filled with tables

ROOSEVELT COUNTY, NEW MEXICO
A man holds out his arm to show where the level of the topsoil had been before clean tillage techniques left it vulnerable to the wind. By 1957, when the picture was taken, only this hummock of little bluestem *(Schizachyrium scoparium),* a native prairie bunch grass, had succeeded in holding the soil in place, the rest blown away.

of elderly men and women, generally clustered by gender. Schools close, stores are boarded up, county attorneys are shared among jurisdictions, and preachers again become itinerant, serving scattered congregations. If there is a new building in town, it is likely to be a retirement home, or perhaps a much-sought-after penitentiary, a sure way to capture jobs. Many towns are poised to join the ranks of ghost towns, that most numerous category of Plains towns.

Not all Plains counties are losing population. Everywhere, large towns are growing in both population and geographic extent. Calgary, for example, buoyed up by the oil boom, passed the one million mark in 2006 and is spilling over into the surrounding countryside. In North Dakota and Nebraska, more than half the state population now lives in Standard Metropolitan Statistical Areas, the

census term for cities of more than 50,000, together with adjacent counties. In Saskatchewan, the most agricultural of the Prairie Provinces, two-thirds of the population is urban. It is likely, however, that many of the new urbanites are only a generation removed from the farm and that many of them still go home to that farm for holidays.

The Indian reservations and reserves also stand out as islands of population growth in a sea of population decline. In contrast to surrounding areas, reservation populations are young, representing built-in growth. On the Spirit Lake Reservation in North Dakota fully 53 percent of the population (Wahpeton and Sisseton Sioux) is under the age of 19, the next generation of parents. The indigenous peoples are now an increasing proportion of Plains population. But their living conditions continue to be bleak. In 2000 four of the five poorest counties in the U.S. (as measured by per capita income) contained South Dakota reservations: Buffalo County, home to Crow Creek Reservation was the poorest, followed by Shannon County (Pine Ridge Reservation), Ziebach County (Standing Rock Reservation), and Todd County (Rosebud Reservation). The last county in this unenviable company was Starr County, Texas, located in the Rio Grande Valley at the southern extremity of the Great Plains and 97 percent Hispanic. Continued immigration and larger-than-average family sizes ensure that this diverse group will also constitute a higher proportion of Plains population in the future.

Making forecasts is risky, of course, especially in the unpredictable Plains, as the Great Plains Committee learned in 1936. This distinguished panel of politicians and scholars concluded that there was little potential for irrigation on the Great Plains. Then, just a few years later, centrifugal pumps brought the waters of the Ogallala Aquifer within economic reach. This vital resource is now seriously depleted in its southern reaches and just how the farmers, feedlots, and towns in southwestern Kansas and the panhandles of Texas and Oklahoma will adjust is not at all clear.

The risks of forecasts notwithstanding, it is also difficult to see how the overall trend of rural depopulation could be reversed. Jobs can be provided and communities revitalized by local initiative, as in New Rockford, North Dakota, with its North American Bison Cooperative Plant, the largest source of bison-meat products in the world. Nearby Carrington is now home to the Dakota Growers Pasta Plant, the third largest pasta manufacturing company in North America. Casinos on Indian reservations have also furnished employment opportunities for people who previously had none.

Such success stories are relatively few. Promising economic developments like wind energy will not require a major influx of people, and coal, methane gas, and oil towns just inflate and deflate with the turnings of the global economy, even as they wreak destruction on the natural environment. In an era of internet commuting, when jobs can be performed in most locations, people could choose to relocate in the Great Plains, drawn by low costs and other benefits, practical and aesthetic, of living in a sparsely populated area. A "New Homestead Act" that would provide financial incentives to relocate in the rural Great Plains has received considerable attention in Congress but has not yet been enacted into law. It seems that Deborah and Frank Popper were at least partially correct when they wrote in their controversial 1987 paper that the Western Plains were heading to "near-total desertion." They wanted the government to buy back the land and refashion it as a buffalo commons for Indians and bison, whereas in reality it is the government, through its subsidies, that is preserving at least a veneer of agricultural and small-town settlement.

In 2008, with widespread beneficent rainfall and record grain prices, "next year country" seemed to have arrived on the Great Plains. Farm incomes soared and implement dealers had a banner year. Marginal land and wetlands that had been sheltered under the Conservation Reserve Program for a decade were put back into crops to feed ethanol plants and burgeoning overseas markets.

One can hardly blame farmers, who are often burdened by debt and always faced with rising costs, for taking advantage of such favorable climatic and economic conditions. But what seems to be different now is that there is more of a balance between production and conservation on the Great Plains.

The designation of the Grasslands National Park in Saskatchewan in 1981 and of the Tallgrass Prairie National Preserve in the Flint Hills of Kansas in 1996 signifies a new concern for the precarious environments of the Great Plains. The acquisitional protection of hundreds of thousands of acres by The Nature Conservancy and other conservation groups and land trusts is further evidence of the growing conservation movement. Wetland losses have been slowed and even reversed in many parts of the Plains in recent years, thanks to federal, state, local, and private conservation efforts.

At the Land Institute in Salina, Kansas, research into the development of perennial grains that replicate the natural ecosystems displaced by agriculture promises much for the future of farming on the semiarid Plains. At the local scale many farmers and ranchers who care deeply for the land are speaking out against the environmental destruction wrought by methane-gas production, and they are diversifying their crop and livestock production, reducing their reliance on chemical pesticides, and in a multitude of ways striving to maintain long-term management techniques that yield profits while promoting sustainability and the health of the land.

There were no such counterforces to stem the tide of bison destruction in the 19th century or to restrain the massive plow-up of the shortgrass prairie in the 1920s. Hopefully, this marks a new stage in the resettlement of the Great Plains.

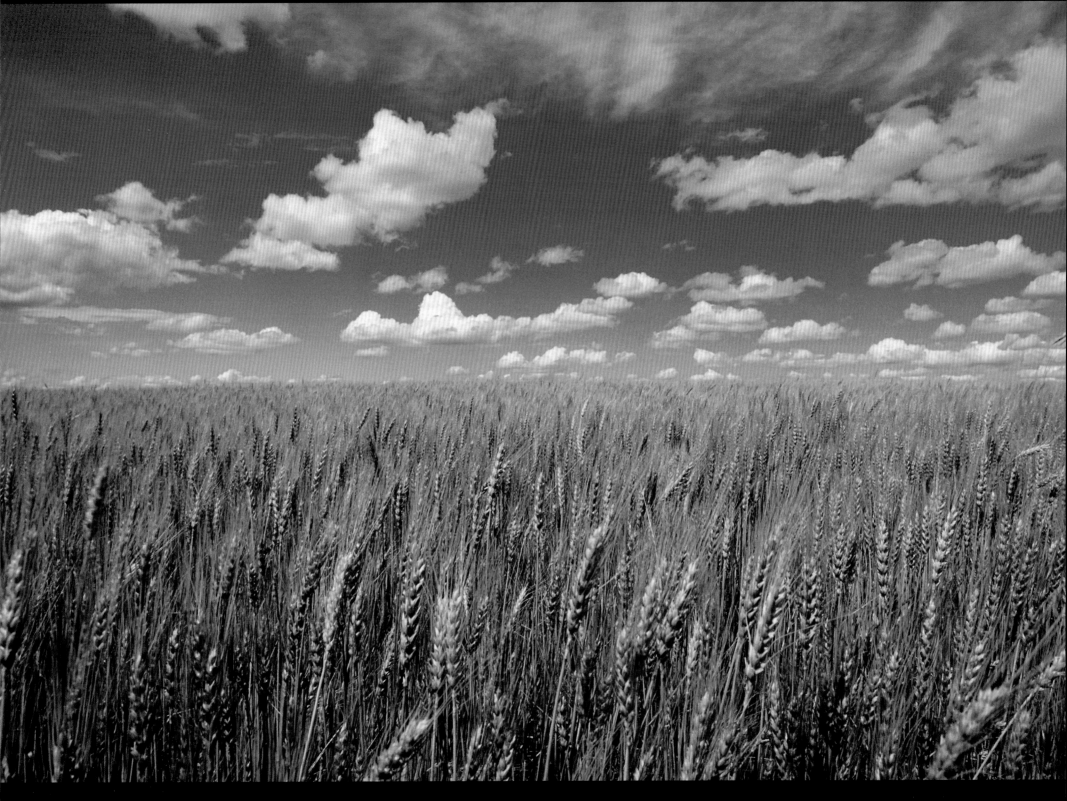

WESTERN KANSAS

Grain ripens in early June in the winter wheat belt of Kansas. The railroad, steamship, and large-scale agricultural technology helped transform these grasslands from the "Great American Desert" to a modern-day breadbasket to the world.

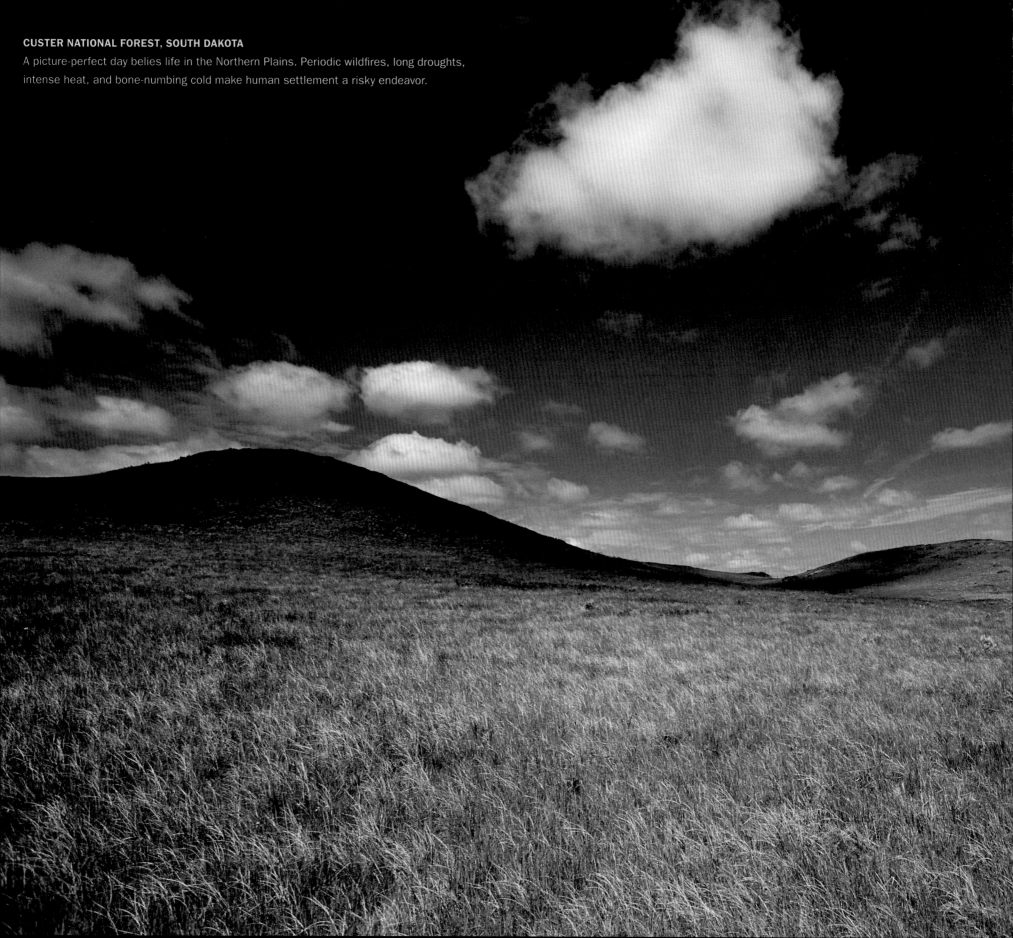

CUSTER NATIONAL FOREST, SOUTH DAKOTA
A picture-perfect day belies life in the Northern Plains. Periodic wildfires, long droughts, intense heat, and bone-numbing cold make human settlement a risky endeavor.

Ocean of Grass

FROM THE PINE RIDGE ESCARPMENT in northwestern Nebraska to the aspen Parkland Belt of the Prairie Provinces of Canada, the Northern Plains, as defined here, extend for a thousand miles. To the west, they reach the Rocky Mountains, while the eastern boundary follows a sinuous line that separates the mixed-grass from the tallgrass prairies. This is an austere land of temperature extremes and inconstant rainfall, but the wide horizons, diverse terrain, rich and varied wildlife, and dominating sky make it breathtakingly beautiful.

The northern Great Plains comprise two distinct areas—the region to the south and west of the Missouri River, which was never glaciated; and the land to the north and east, which was shaped by repeated glaciations. The division between the two is marked by the Missouri Coteau, extending from southern Saskatchewan to eastern South Dakota. This arc of grassy hills interspersed with water-filled potholes is a terminal moraine composed of debris that was pushed ahead of the glaciers as they advanced, then left behind when they retreated. The glaciated section of the Northern Plains was flattened and smoothed by the ice sheets and is now farming country, with 60 percent or more of the land in crops. The unglaciated land to the south and west is rugged, with deeply dissected badlands along the White and Little Missouri Rivers and isolated pine-topped mountain ranges like the Black Hills rising above the rolling shortgrass and sagebrush plains.

Much of the Northern Plains was initially settled by Americans and Europeans in the early 20th century. A large swath of eastern Montana, for example, was opened up to settlement in 1887, following the dissolution of the Great Northern Reservation, for which the Blackfeet and Gros Ventres received 28 cents an acre and smaller separate reservations. Blinded by trachoma and dying from tuberculosis, they lived in abject poverty in a country devoid of bison, once their lifeblood. Cattlemen moved in, locating along the waterways and using the rolling spaces in between as open range. The passage of the Enlarged Homestead Act and the completion of the Milwaukee Road railroad through the area in 1909 attracted settlers from Europe and the eastern U.S. Derisively called "honyockers" by the cattlemen, the settlers and their barbed wire quickly closed off the range. Six years of good rainfall and the gospel according to Hardy Webster Campbell's *Soil Culture Manual,* which advocated dryland wheat farming by making the most of the moisture, persuaded the settlers that this was indeed the Promised Land.

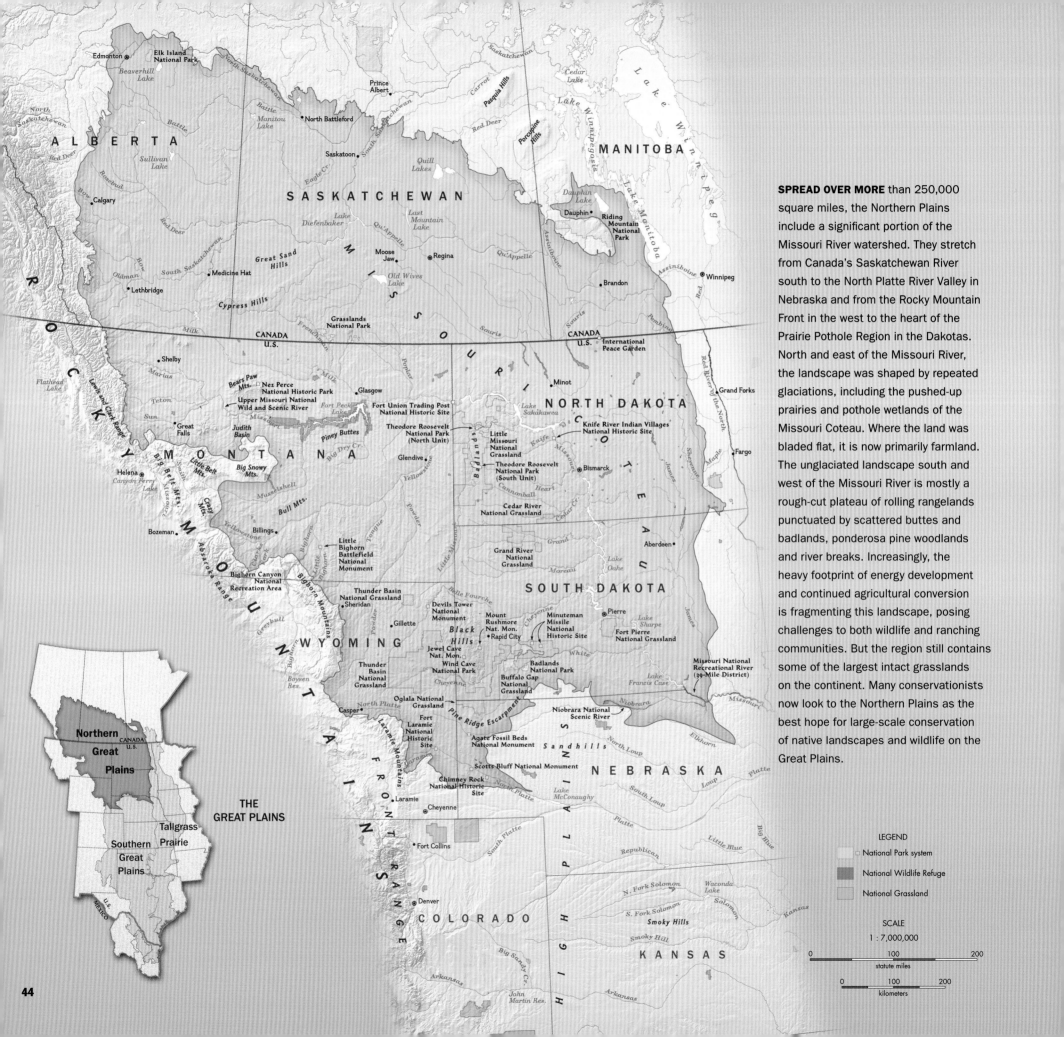

ALBERTA

Edmonton
Elk Island National Park
Beaverhill Lake
Calgary
Red Deer
Rosebud
Bow
Red Deer
Oldman
Lethbridge
Medicine Hat
Sullivan Lake
Battle
Battle
Lake Manitou Lake
North Battleford

SASKATCHEWAN

Prince Albert
Saskatoon
Lake Diefenbaker
South Saskatchewan
Eagle Cr.
Moose Jaw
Quill Lakes
Last Mountain Lake
Regina
Qu'Appelle
Qu'Appelle
Old Wives Lake
Great Sand Hills
Cypress Hills
Grasslands National Park
Frenchman
Milk
CANADA U.S.

MANITOBA

Cedar Lake
Lake Winnipegosis
Lake Winnipeg
Dauphin Lake
Dauphin
Riding Mountain National Park
Lake Manitoba
Porcupine Hills
Pasquia Hills
Carrot
Red Deer
Brandon
Winnipeg
Assiniboine
Assiniboine
Souris
Red
CANADA U.S.
International Peace Garden
Pembina
Red River of the North

MONTANA

Shelby
Bears Paw Mts.
Nez Perce National Historic Park
Upper Missouri National Wild and Scenic River
Glasgow
Fort Peck Lake
Milk
Poplar
Fort Union Trading Post National Historic Site
Marias
Teton
Sun
Great Falls
Judith Basin
Piney Buttes
Big Dry Cr.
Helena
Canyon Ferry Lake
Little Belt Mts.
Big Belt Mts.
Smith
Crazy Mts.
Big Snowy Mts.
Musselshell
Bull Mts.
Bozeman
Yellowstone
Billings
Little Bighorn Battlefield National Monument
Bighorn Canyon National Recreation Area
Tongue
Powder
Theodore Roosevelt National Park (North Unit)
Glendive
Little Missouri National Grassland
Theodore Roosevelt National Park (South Unit)

NORTH DAKOTA

Minot
Lake Sakakawea
Knife River Indian Villages National Historic Site
Knife
Bismarck
Heart
Cannonball
Cedar River National Grassland
Cedar Cr.
Missouri Coteau
Badlands
Grand Forks
Fargo
Sheyenne
Maple
James

SOUTH DAKOTA

Grand River National Grassland
Grand
Moreau
Aberdeen
Lake Oahe
Belle Fourche
Devils Tower National Monument
Black Hills
Mount Rushmore Nat. Mon.
Rapid City
Minuteman Missile National Historic Site
Cheyenne
Pierre
Lake Sharpe
Fort Pierre National Grassland
Jewel Cave Nat. Mon.
Wind Cave National Park
Badlands National Park
Buffalo Gap National Grassland
White
Lake Francis Case
Missouri National Recreational River (39-Mile District)
James
Missouri

WYOMING

Thunder Basin National Grassland
Sheridan
Gillette
Thunder Basin National Grassland
Bighorn Mountains
Greybull
Bighorn
Little Bighorn
Powder
Boysen Res.
Laramie Mountains
Oglala National Grassland
Pine Ridge Escarpment
North Platte
Casper
Fort Laramie National Historic Site
Agate Fossil Beds National Monument
Niobrara
Niobrara National Scenic River
North Loup
Laramie
Cheyenne
Chimney Rock National Historic Site
Scotts Bluff National Monument

NEBRASKA

Sandhills
North Platte
Platte
South Loup
Loup
Middle Loup
Elkhorn
Lake McConaughy
Platte

COLORADO

Fort Collins
Denver
South Platte

KANSAS

North Platte
Republican
Little Blue
Big Blue
N. Fork Solomon
Waconda Lake
S. Fork Solomon
Solomon
Smoky Hills
Smoky Hill
Kansas
Big Sandy Cr.
Arkansas
John Martin Res.
Arkansas

ROCKY MOUNTAINS
Lewis and Clark Range
Absaroka Range
Flathead Lake
North Saskatchewan
FRONT RANGE
HIGH PLAINS

SPREAD OVER MORE than 250,000 square miles, the Northern Plains include a significant portion of the Missouri River watershed. They stretch from Canada's Saskatchewan River south to the North Platte River Valley in Nebraska and from the Rocky Mountain Front in the west to the heart of the Prairie Pothole Region in the Dakotas. North and east of the Missouri River, the landscape was shaped by repeated glaciations, including the pushed-up prairies and pothole wetlands of the Missouri Coteau. Where the land was bladed flat, it is now primarily farmland. The unglaciated landscape south and west of the Missouri River is mostly a rough-cut plateau of rolling rangelands punctuated by scattered buttes and badlands, ponderosa pine woodlands and river breaks. Increasingly, the heavy footprint of energy development and continued agricultural conversion is fragmenting this landscape, posing challenges to both wildlife and ranching communities. But the region still contains some of the largest intact grasslands on the continent. Many conservationists now look to the Northern Plains as the best hope for large-scale conservation of native landscapes and wildlife on the Great Plains.

Northern Great Plains
Tallgrass Prairie
Southern Great Plains
CANADA U.S.
U.S. MEXICO

THE GREAT PLAINS

LEGEND
☐ National Park system
■ National Wildlife Refuge
■ National Grassland

SCALE
1 : 7,000,000
0 100 200
statute miles
0 100 200
kilometers

44

The farmers received titles to their claims after satisfying the mandatory five-year residency requirement (reduced to three in 1912). They immediately went into debt buying the latest farm equipment, using their land as collateral. Prospects looked good until the summer of 1917 when the rains stopped, leaving the crops desiccated in the fields. The rains didn't return until 1926, and then only briefly before the drought of the 1930s struck. When grain prices fell from the peaks of World War One, indebted and embittered farmers moved on west, leaving their homes and mortgages behind.

In 1917 the Children's Bureau of the US Department of Labor sent nurse Viola Paradise to report on maternity care and child welfare in eastern Montana's Garfield County. Her report vividly conveys the desperately poor conditions of life on this 20th-century frontier. Garfield County occupied 5,000 square miles, an undulating plain of "almost incredible distances" burned completely brown at the end of a "cruelly dry season." Only an occasional flax field, "looking almost as if painted on the landscape," gave variety to the dun-colored vista. Over vast areas there were no signs of human or animal life, except here and there "a flock of sage hens, or a prairie-dog town, or a coyote, or less often, a bobcat or some antelope."

The country was barely settled. Families who had been there for five years were considered long-term. They lived in sod houses or tar paper shacks or at best in one-room houses no bigger than 12 x 14 feet. There were no screens, so flies swarmed in. In the general absence of wells, water was hauled from streams, often over long distances; ice, too, was hauled and stored, then used for water as it melted in the spring, raising fears of typhoid in Paradise's mind.

The scattered towns offered little in the way of services or markets. Instead, settlers relied on mail-order purchases from thick catalogues that were dubbed "homesteaders' Bibles." Christmas presents often didn't arrive until Easter. Transportation was mainly by horse over trails that followed old bison paths. The county lacked a hospital or even a doctor.

Like most other rural hinterlands on the northern Great Plains, Garfield County has continued to struggle, with the population curve sloping relentlessly down since 1916. The railroad never came, and the "costs of space" — of operating one-room schools or transporting grain to railroad elevators — have only increased. How much longer, for example, will supporters of the Mustangs, the eight-man high school football team in the town of Jordan, be able to make 200-mile roundtrips to away games if gasoline costs keep rising? Still, many residents proudly embrace the isolation, preferring it to the complicated circumstances of life in densely populated America. They appreciate the low crime rates, the easy access to the outdoors, and commutes that are long but not congested.

Not all of the Northern Plains are sparsely populated agricultural hinterland, though. The same surge in oil prices that has made farming and transportation more expensive has stimulated the economies of the coal and methane-gas country of the Powder River Basin and the petroleum areas of Alberta, home of the booming modern metropolises of Calgary and Edmonton.

The Calgary-Edmonton corridor is a rarity on the Great Plains — a rapidly growing, affluent, urbanized swath extending across 185 miles of the Parkland Belt. Its burgeoning success is based on oil. The initial discovery was in 1924 in the Turner Valley, to the southeast of Calgary. But the beginning of the bonanza that has, with few interruptions, continued to the present was in 1947, when the Leduc field, 15 miles southwest of Edmonton, was drilled. Most recently, the rise in oil prices and the invention of new extraction techniques have also brought the Athabasca tar sands, lying to the north of Edmonton in the boreal forest, within economic reach.

Edmonton is the blue-collar oil town, and a major biotech center, while Calgary is headquarters for almost all of Canada's oil and natural gas corporations. Growth along the Calgary-Edmonton corridor has come at a cost, with urban sprawl, long commuting distances, rising housing costs, and a growing gap between rich and poor. Yet the economic success — Calgary has the highest number of millionaires per capita of any city in Canada — is celebrated in the cities' skylines. In 1969 only the spire of the Calgary Tower stood above the town. Now a forest of gleaming skyscrapers seems to aspire to match the towering Rockies 50 miles to the west.

A similar mix of economic stimulus and environmental despoliation is occurring on the high, rolling Powder River Basin in northeastern Wyoming and southeastern Montana. Here, the towns are much smaller than in Alberta and more dusty than gleaming. This is the site of the richest coal deposits in the U.S. Extracted through surface mining, Powder River coal accounts for about 70 percent of national production. The scale of the mining, as described by writer Ian Frazier, is impressive. Massive draglines tear out the earth, leaving canyons hundreds of feet deep and miles long. Steam shovels with cabs the size of large buildings separate the coal from the overburden, which is piled into spoil ridges then leveled in a pretense of reclamation. This can be spectacular, especially at night when the scene is an anthill of activity illuminated by walls of lights. But the aquifers will never recover from the radically rearranged geology.

The coal is converted into electricity at mine-mouth plants and transmitted to the nation's population centers. Or it is shipped down the gentle grade of the Plains in mile-and-a-half -long trains weighing 19,000 tons and powered by locomotives at the front, back, and middle. Driving through the Nebraska Sandhills along Highway 2, which parallels the tracks of the Burlington Northern and Santa Fe, you pass these behemoths every ten minutes or so. In a land where the roads are often empty to the horizon, the railroad tracks are as busy as freeways.

Two centuries ago in 1805, François-Antoine Larocque, the first European-American to venture into the Powder River Country, left with a few beaver pelts he got through trade with the Crow and Snake Indians. Now the Earth itself is being exported. It is not so much the coal, however, but coal-bed methane gas that has attracted the attention of mining companies and environmentalists in the past few years. The gas is in coal deposits and released when the coal seam is depressurized by pumping water out from the ground. Drilled wells bring the gas to the surface, where it is compressed and piped to market.

Gas is a relatively clean fuel and therefore much in demand, but the process of obtaining it is anything but clean. By 2005 about 17,000 mines had been drilled in the Powder River Basin and more are added almost every day. The result is a new Plains landscape characterized by noisy compressor stations, hissing methane leaks, newly leveled access roads carrying armies of trucks, pipes piled up alongside excavated trenches, and worthless saline water accumulating in reservoirs and ponds, sometimes overflowing or leaching back into the watershed. Groundwater levels are lowered, ranchers' wells dry up, waters are contaminated, and habitat for a number of animals ruined by fragmentation.

All this development has not gone unopposed. Ranchers generally own only the surface rights to their land and are unable to prevent mineral extraction, thanks to the 1916 Stock Raising Homestead Act. It gave settlers 640 free acres of land that was good only for grazing, but it did not give them the mineral rights. Today's ranchers, many of whom are conscientious stewards of the land, have taken a stand against the mining and CBM (coal-bed methane) development interests by forming grassroots organizations like the Powder River Basin Resource Council, which works to restrict environmental damage. But Wyoming, a state without a personal income tax, welcomes the revenues energy development brings in, and the gas companies, like the early trappers, see only the prospects for profits in the short run.

"One of the least protected places on earth" is how the World Wildlife Fund characterizes the Northern Plains. Perhaps this is the end result of what environmental historian Dan Flores calls the region's "perceived aesthetic deficiencies": Its assumed flatness, its apparent (but not real) lack of content, the preponderance of space over place, the undeniable horizontality. But it is also because so much land is owned and used for agriculture. Even with the population decline, the amount of land in crops just keeps going up. The acreage of new cropland increased by 28 percent in the Prairie Provinces from 1971 to 1996 and by 5 to 10 percent in north-central Montana from 1982 to 1997. On the Missouri Coteau, a refuge of natural grassland and vital breeding ground for waterfowl, 194,000 acres have gone under the plow since 1984, and in some sections as much as 90 percent of the pothole lakes are seriously degraded.

Protected land, where human intervention is restricted or restrained, is relatively scarce, with only three national parks in the U.S. and three in Canada, and only sections of each protected under the National Wilderness Preservation System. Protected—or at least managed—areas also include the three largest national grasslands in the U.S.: the Little Missouri (North Dakota), Buffalo Gap (South Dakota), and Thunder Basin (Wyoming). Designated for multiple use, they combine grazing, recreation, soil conservation, watershed protection, and mining. Often the multiple uses compete with each other. Thunder Basin contains five major coal mines, including Black Thunder, the largest surface mine in North America. Explosions from mining disturb the tranquility of the grassland, high-power electric lines bisect the landscape, and dust and smoke fill the air. On the Little Missouri grassland a spreading network of access roads leads to oil and gas wells. Now, less than 220,000 acres of the million-acre grassland are designated "roadless areas," and only 39,783 acres are classified as "suitable for wilderness." These areas are too small to support a fully functioning prairie grassland ecosystem. In fact, some of the managed public lands are not as ecologically healthy as adjacent private lands that have been carefully tended.

There have been success stories—notably the reintroduction of the black-footed ferret to the Buffalo Gap National Grassland. Yet for every success, there is a new threat to the ecological integrity of the Northern Plains. Climate models point to a future of warming temperatures over the entire region, while the western reaches, the area most susceptible to drought, will probably receive less rainfall. Rainfall may actually increase in the eastern portions of the Northern Plains, but this would be offset by higher evaporation rates caused by the higher temperatures. Invaluable wildlife habitat, already compromised by a century of agriculture, may see additional climate-induced desiccation.

More immediately, soaring grain prices, borne up by ethanol production and burgeoning markets in Asia, are persuading farmers to take land out of the Conservation Reserve Program (CRP). Since 1985 this program has paid farmers to keep their environmentally sensitive lands out of crop production. In addition to the environmental benefits from the CRP, the enhanced wildlife habitat has been a boon for the hunting industry. The World Wildlife Fund has set a goal to increase the amount of land managed for wildlife protection from the current 2 percent to 10 percent of the total area. Groups such as The Nature Conservancy and Ducks Unlimited are also dedicated to maintaining biodiversity and protecting endangered habitats on the Northern Plains, as indeed are many ranchers and farmers. But it's an uphill task, because ranchers and farmers, no matter how environmentally concerned, have to make ends meet. To be successful, conservation will have to be part of a larger rural development strategy that keeps people on the land while preserving its environmental integrity.

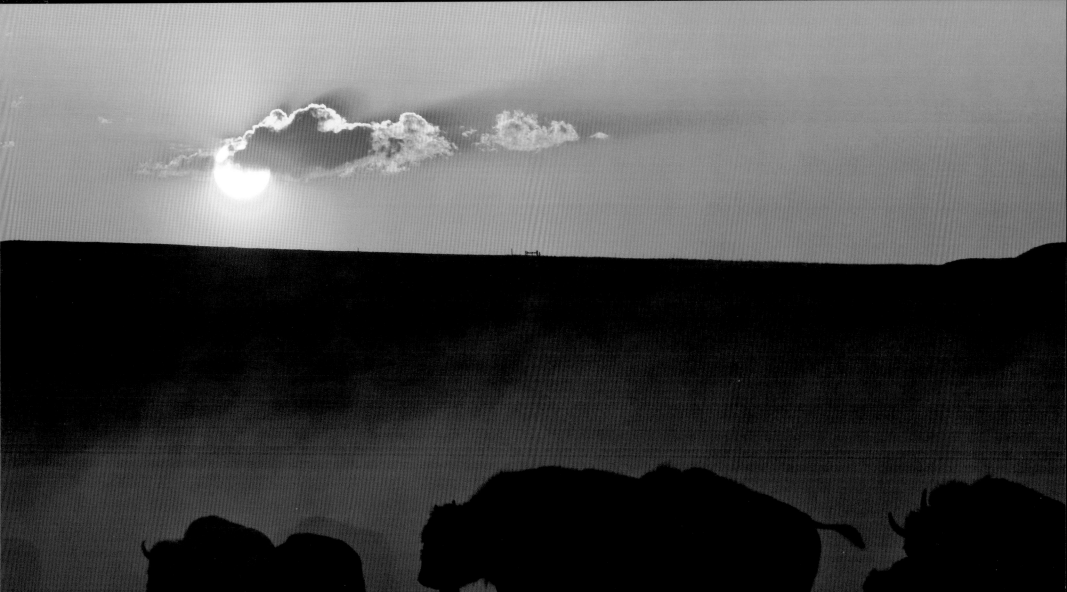

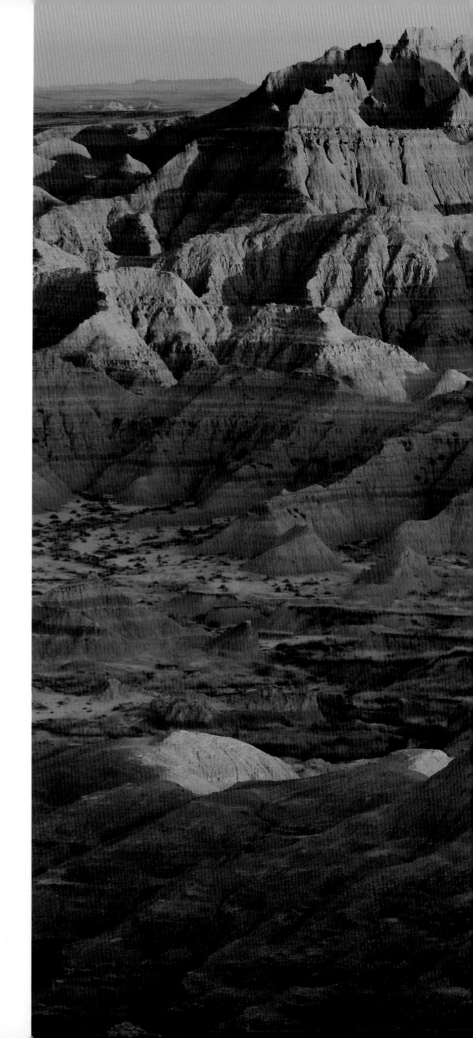

BADLANDS NATIONAL PARK, SOUTH DAKOTA

Peaks glow as bison bulls *(Bison bison)* graze in the shadowed valley below. Authorized as a national monument in 1929, Badlands was redesignated a national park in 1978.

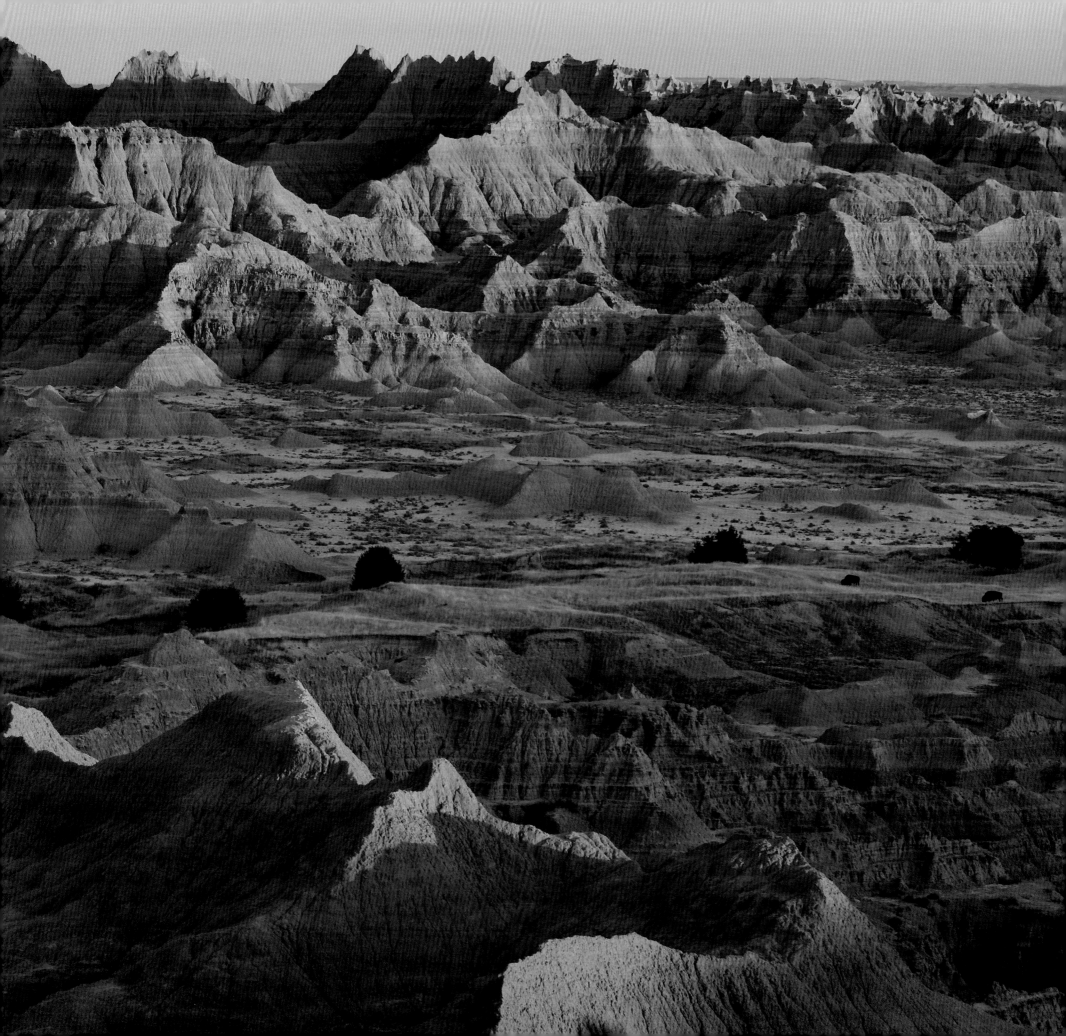

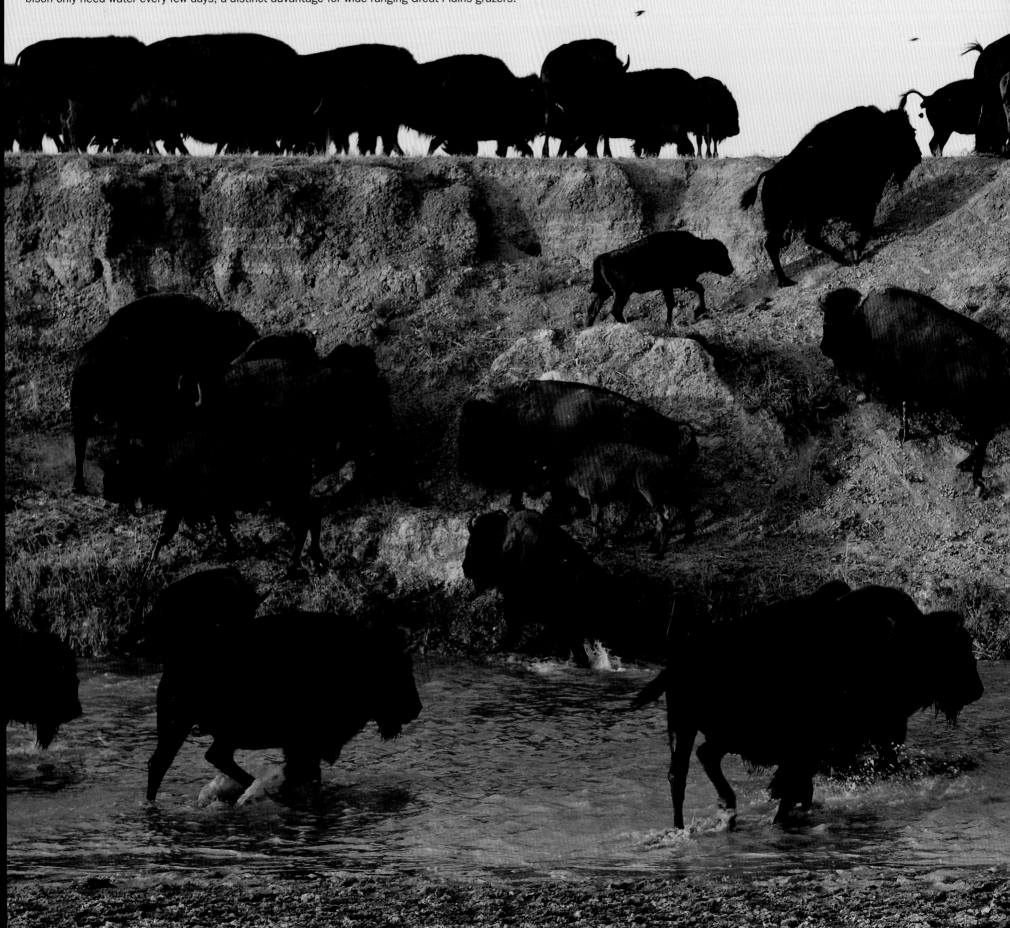

BUFFALO GAP NATIONAL GRASSLAND, SOUTH DAKOTA
A bison herd *(Bison bison)* moves across the shallows of the Cheyenne River. Even in extremely hot weather, bison only need water every few days, a distinct advantage for wide-ranging Great Plains grazers.

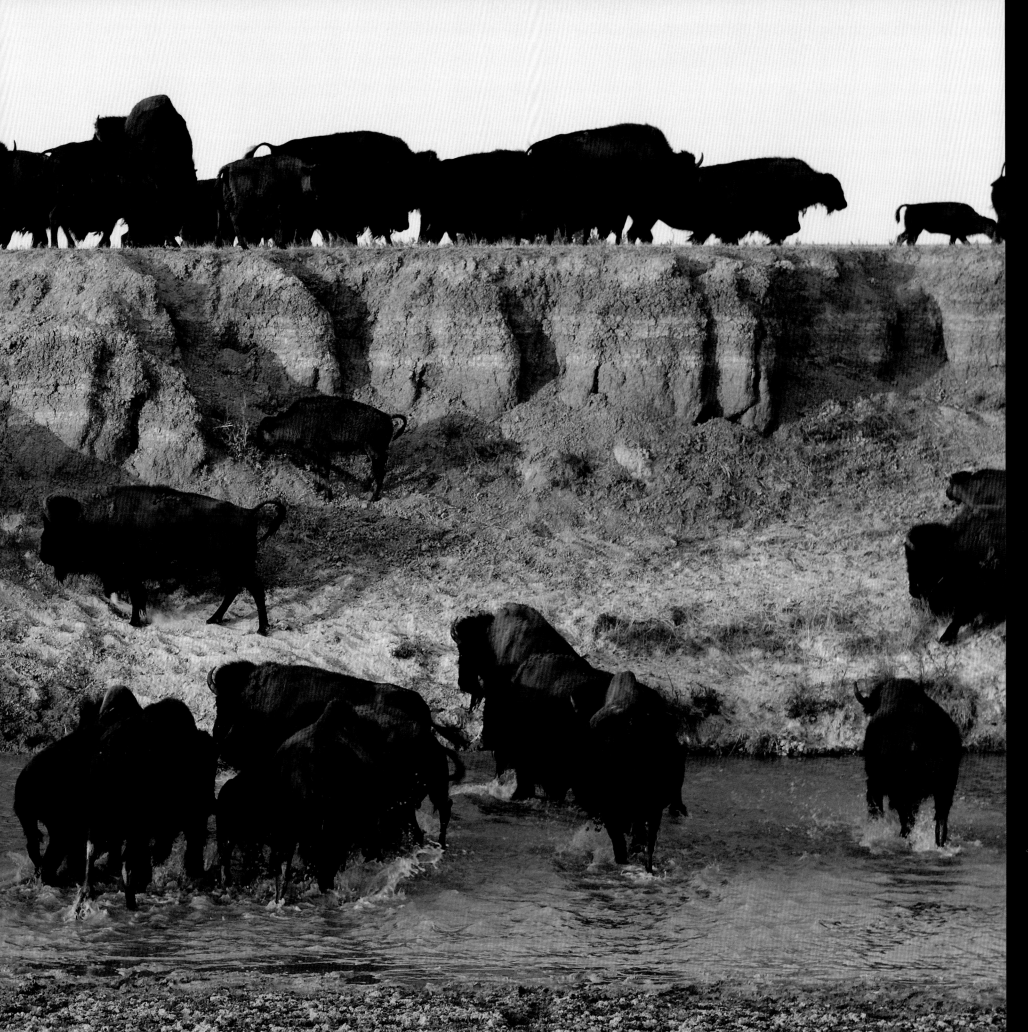

WIND CAVE NATIONAL PARK, SOUTH DAKOTA

Right: A lone cottonwood *(Populus sargentii)* on the exposed prairie
was a welcome sight for early travelers, providing them with shade,
fuel, and a sign that water was close by.

Above: Creatures of wide-open spaces, mule deer *(Odocoileus
hemionus)* are increasingly challenged in the parts of the Great Plains
where energy development and farming are fragmenting their habitat.

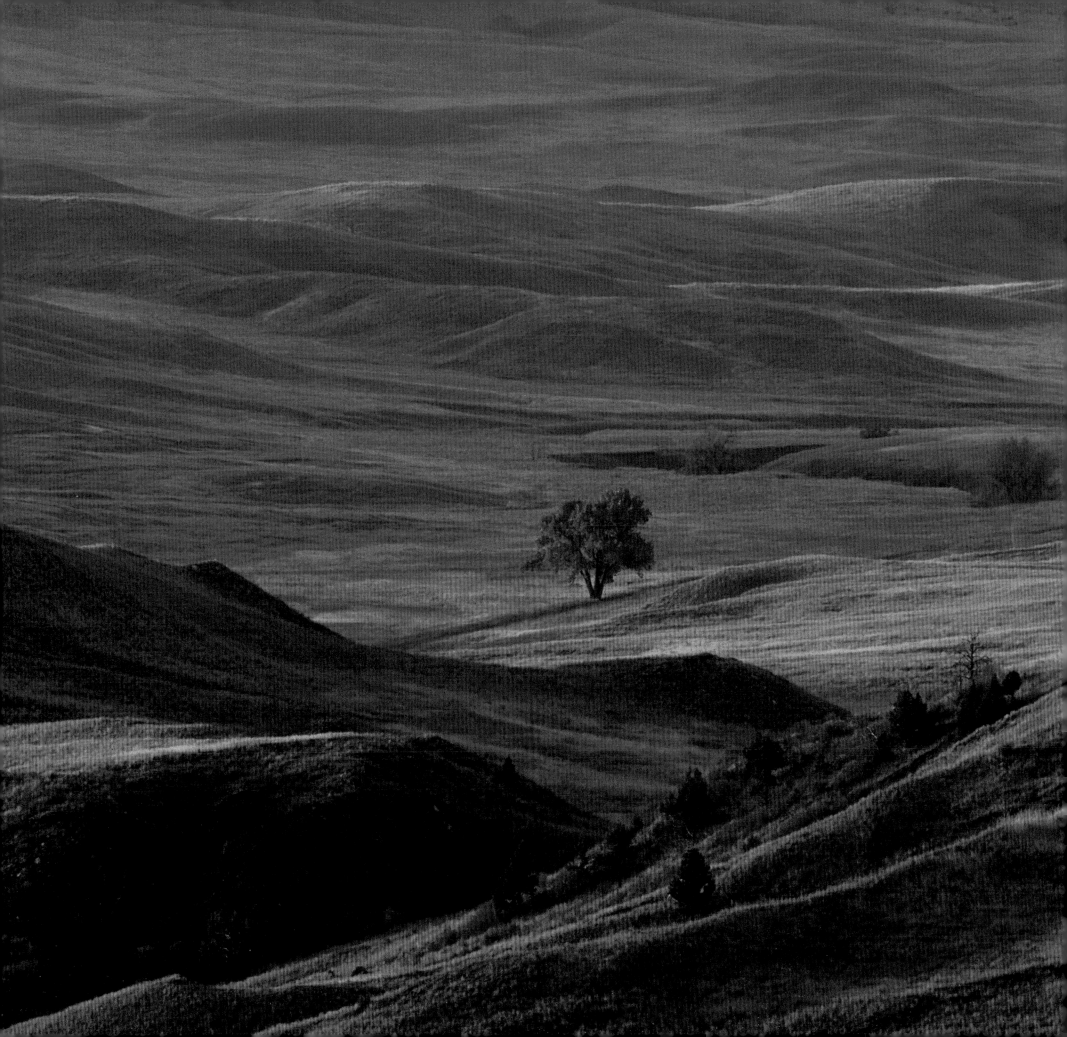

Right: **BLACK HILLS WILD HORSE SANCTUARY, SOUTH DAKOTA**
Fall color reveals the diversity of plant life in a Black Hills wetland.
Some 1,200 vascular plant species from four major ecosystems
converge in this island mountain range surrounded by plains.

Above: **CUSTER STATE PARK, SOUTH DAKOTA**
Stands of quaking aspen *(Populus tremuloides)* can be thousands
of years old. Lovers of sunlight, aspen evolved in a landscape where
periodic fires kept other trees that would shade them at bay.

KIDDER COUNTY, NORTH DAKOTA
At dusk a thunderhead lights up a prairie pothole in the Missouri Coteau, where millions of these wetlands, critical to prairie wildlife, nestle in depressions left behind by the last glaciation.

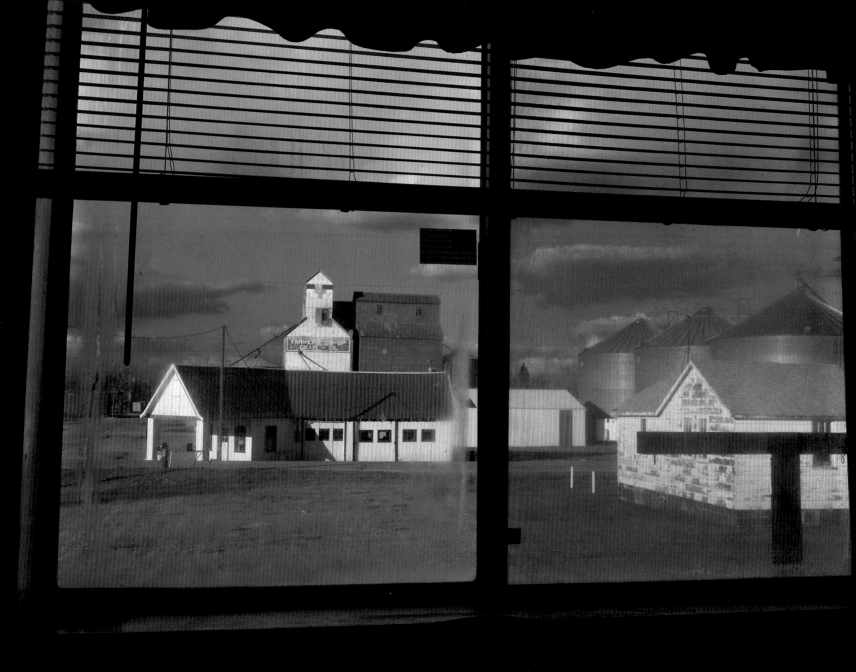

TUTTLE, NORTH DAKOTA

Like many rural towns in the Great Plains, Tuttle (pop. 100) faces daunting challenges.
As the young move to the cities, an aging population is left trying to hold together
communities whose fortunes have been fading for over half a century.

LIFE AMONG POTHOLES

Dan O'Brien

THE FIRST THING I SAW when I pulled into Tuttle, North Dakota, was a corner gas station that looked like it could have been the model for a Norman Rockwell painting. Everything was the way it might have been in 1958: the red-and-white frame building, the single mechanic's bay, the "bubble gum machine" gas pump, the public bench out front. The elements missing from that idyllic version of America's past were the things that made Rockwell, and perhaps America herself, famous throughout the world. When I drove slowly past that gas station—the only one in Tuttle—and into the half-deserted town I found no sense of pride remaining, no impression of enterprise, and no hope of prosperity.

Mike Forsberg had begged the use of a house across the quiet street from the gas station from Scott Stephens, the Great Plains director of conservation planning for Ducks Unlimited. Scott lives in Bismarck and his life is ducks. He studies them, he hunts them, he loves them. He purchased the deserted house for a song because it is in the center of the Missouri Coteau, the wetland-pocked plateau along the eastern side of the Missouri River Valley and perhaps the greatest duck incubator in the world.

I pulled into Scott's unpaved driveway and was not surprised to find Mike gone. The day was waning and, like a vampire drawn to darkness, Mike would be haunting the potholes and swamps in the buttery light of late afternoon. I tossed my bag, books, and notebooks into the spare bedroom and checked out the house. Nothing but duck and Labrador prints on the walls. Waders hanging from hooks on the back porch and decoys and a sneak boat in the garage. There was a small charcoal grill and a note from Mike. "Be back after dark. Start the coals. We got pork chops."

I stood in the yard and stared across at the gas station. I had not caught sight of a living person since I'd gotten to town, but the front door of the gas station was open so I strolled across the street without considering the possibility of traffic and walked in. This was not a convenience store. Not an In-and-Out. Not a Pack-and-Go. This was a gas station frozen in time and forgotten. The smell of the oil-soaked wood floor took me back to my boyhood, and I stood savoring the way the light slanted through the frame windows and across the empty shelves, dissolving in the scratched and worn glass of the countertop. An ancient till waited on the counter for a rare transaction and beside it a coffee can with an assortment of pens and an old yellow pencil.

I caught Truman taking a nap on a worn green sofa in the back. He sat up a little disoriented and smiled. "We're open," he said. "What can I do for you?"

Instantly, I felt bad. "I didn't come to buy anything, but you could tell me about your town."

The fact that I hadn't come to buy didn't seem to bother him. He motioned toward another couch, this one red and set opposite the one he preferred. "What can I tell you about this town?"

We started slow, and his answers came with something like reluctance. He was in his mid-70s and had lived his entire life in Tuttle or the surrounding rolling hills of the Coteau. He'd driven the school bus on and off for decades. The busses had once lined up in front of the school but now there were only a few students. A second layer of consolidations was imminent, and he suspected the big brick schoolhouse might be shut down completely soon, after 80 years of proud service. There was nothing really new in what he told me. Tuttle was like hundreds of other Great Plains towns. He talked about the four hardware stores that had once been there, the two car dealerships, and the competition between the implement dealers. I thought of how all those expensive implements had been used to alter the Coteau—drain the wetlands, plow the flat spots. I took the chance of cussing the government and from there it took only seconds to get to Franklin Roosevelt and the New Deal. "Last decent politician," Truman said with a sincere, slow shake of his head.

In the end I think Truman and I became something like friends. As I waited for Mike, I sipped whiskey, tended to the charcoal fire under a wild Great Plains sunset, and thought of all the people I knew who would consider a week in Tuttle, North Dakota, a vacation. When a trio of young screech owls appeared in the huge, silent cottonwood above me, I got as wild as the sunset and wondered why we couldn't use the technology that was driving us all crazy to bring people to this place and revitalize it. A fiber-optic cable could open this place up like the hard-surfaced highway had opened it in 1949. But I was dreaming, and one of the young screech owls moved his head fluidly and comically back and forth to underline that fact.

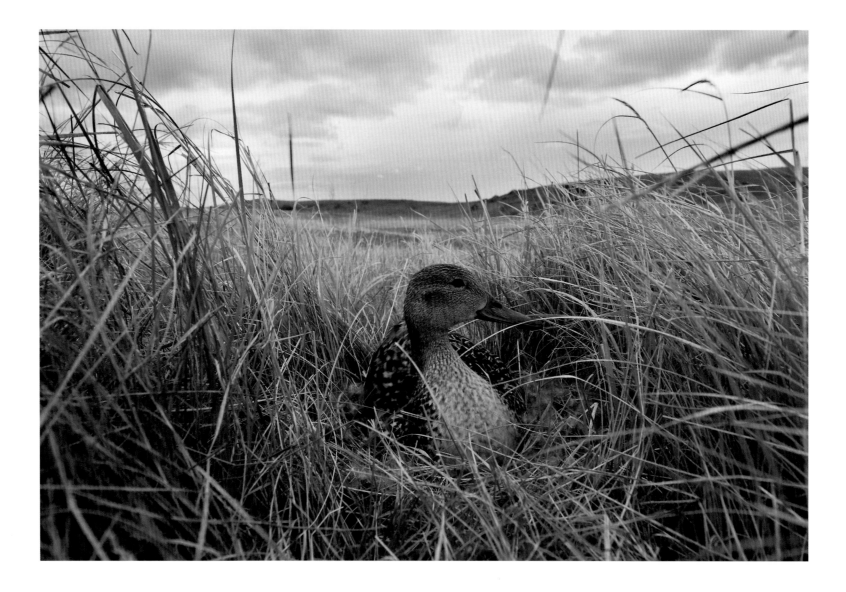

The sun was down and there was absolutely no sound, not a light on along the abandoned street that had once been home to scores of families. The starry sky pressed the stellar cold down on me, and the coals radiated heat from below. I thought of the enclave of deserted houses and the town that had been the center of a thriving farm community and of the Coteau that lay around it and the ducks cruising and chortling in its potholes as they have for many centuries. The town of Tuttle was never meant to be an economic hub. Perhaps it was never meant to be at all. Perhaps the real value of this place has always been the screech owls and the silence of the Coteau.

Mike was no doubt just now crawling from a wet and mucky blind where he had been documenting my thoughts. His touch was gentle on the land indeed.

The lights of his truck would be winding toward me soon. From above they would look like a pair of white snakes slipping along the edge of the potholes, toward a temporary town where I laid pork chops over charcoals as red as horseshoes fresh from the forge.

Above: A pintail duck *(Anus acuta)* incubates her clutch in a nest several hundred yards from water. Over half the ducks on the continent breed in the Prairie Pothole Region annually, producing fall flights of a hundred million birds. But pintails and other grassland species have declined dramatically in the past five decades as cropland has increasingly replaced their habitat in this region.

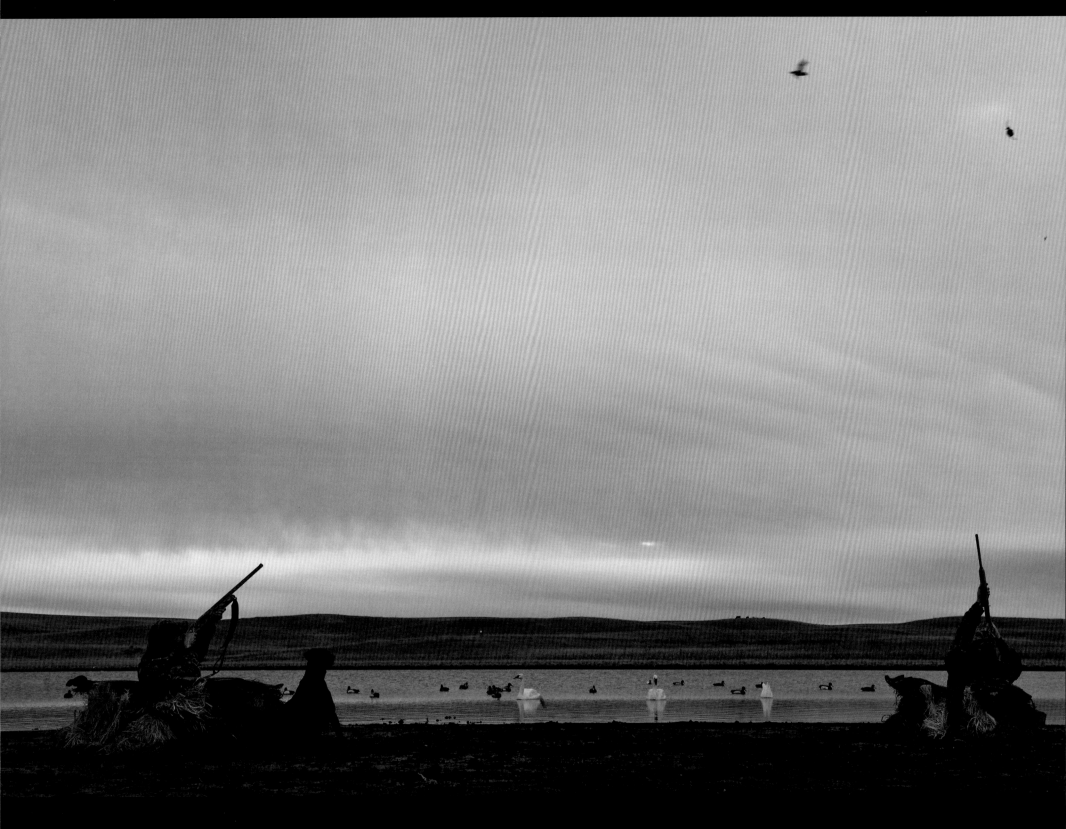

KIDDER COUNTY, NORTH DAKOTA

Waterfowl hunters take aim along the edge of a pothole lake in the Missouri Coteau.
To date, hunters have funded 3.26 million acres of protected habitat in the Prairie
Pothole Region of North and South Dakota through their purchase of federal duck
stamps and their contributions to conservation groups.

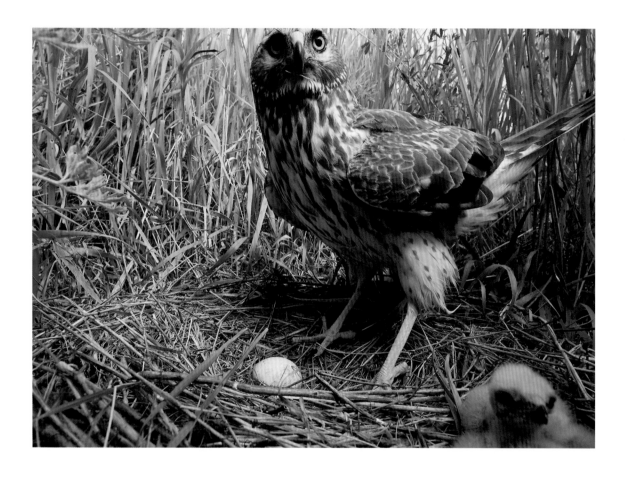

STUTSMAN COUNTY, NORTH DAKOTA

Right: An aerial view reveals the irregular patches of green that mark pothole wetlands in a former prairie landscape now overlain by fields of wheat and canola.

Above: A northern harrier *(Circus cyaneaus)* returns to her nest in a field of restored grassland protected under the Conservation Reserve Program (CRP). Since its inception in 1985, CRP has restored over seven million acres of marginal cropland to grassland across the Prairie Pothole Region.

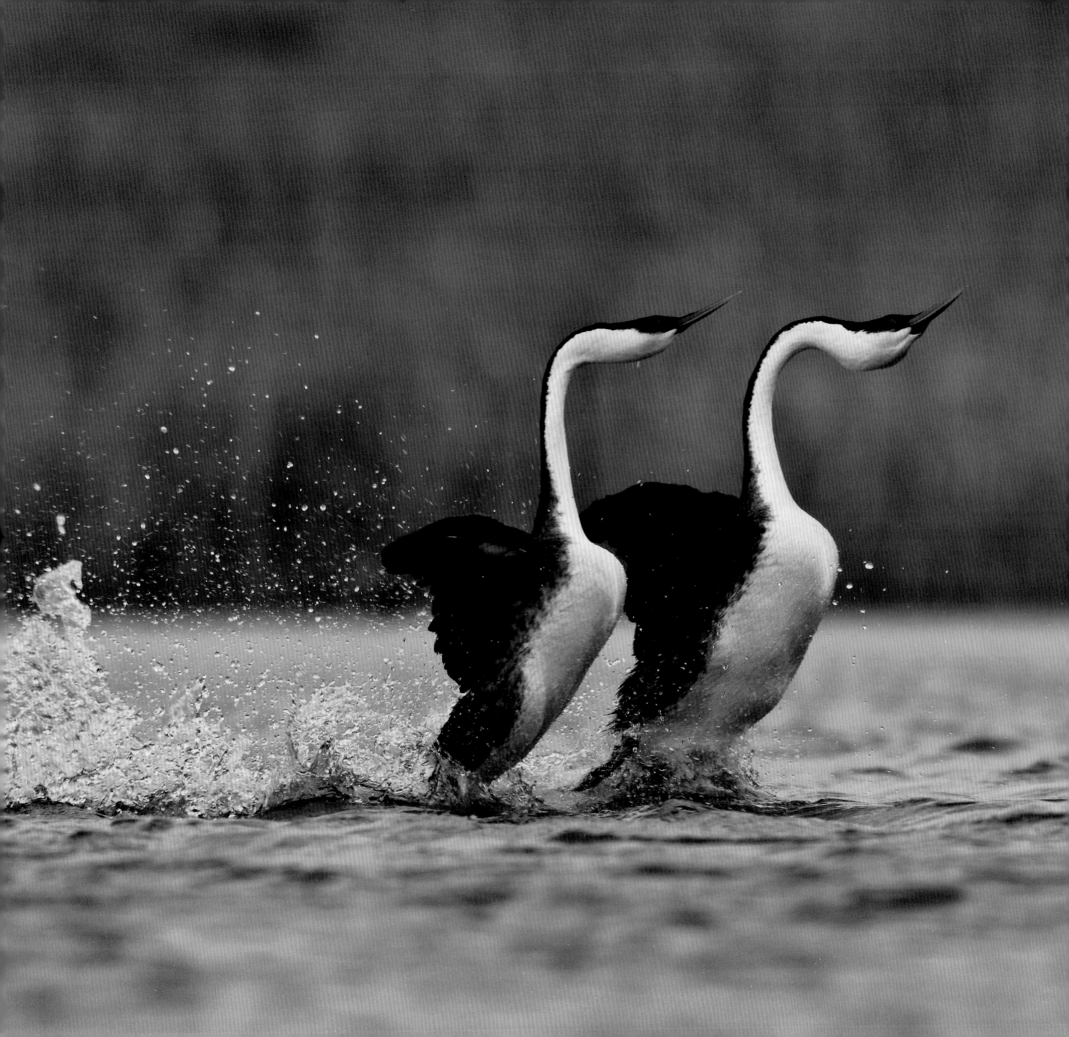

STUTSMAN COUNTY, NORTH DAKOTA

The largest grebe species in North America, western grebes *(Aechmophorus occidentalis)* engage in their elaborate "rushing" courtship display. Grebes and other water birds are particularly sensitive to changes in water quality on their breeding wetlands, changes that can result from grassland conversion and agricultural runoff.

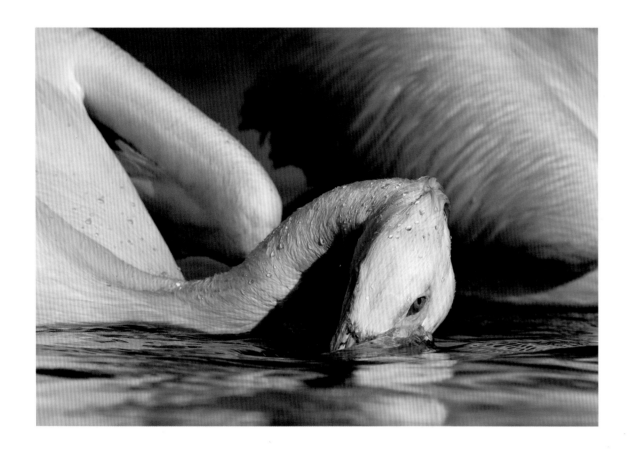

Right: **LOSTWOOD NATIONAL WILDLIFE REFUGE, NORTH DAKOTA**

In summer, as saline pothole wetlands dry up, their soils gleam white from the high salt content. When wet, they provide critical habitat for prairie shorebird species like piping plovers, American avocets, and killdeer.

Above: **CHASE LAKE NATIONAL WILDLIFE REFUGE, NORTH DAKOTA**

An American white pelican *(Pelecanus erythrorhynchos)* forages underwater for aquatic vegetation. Set aside in 1908 by President Theodore Roosevelt, this refuge is among the nation's oldest and supports one of the largest breeding colonies of these birds in North America.

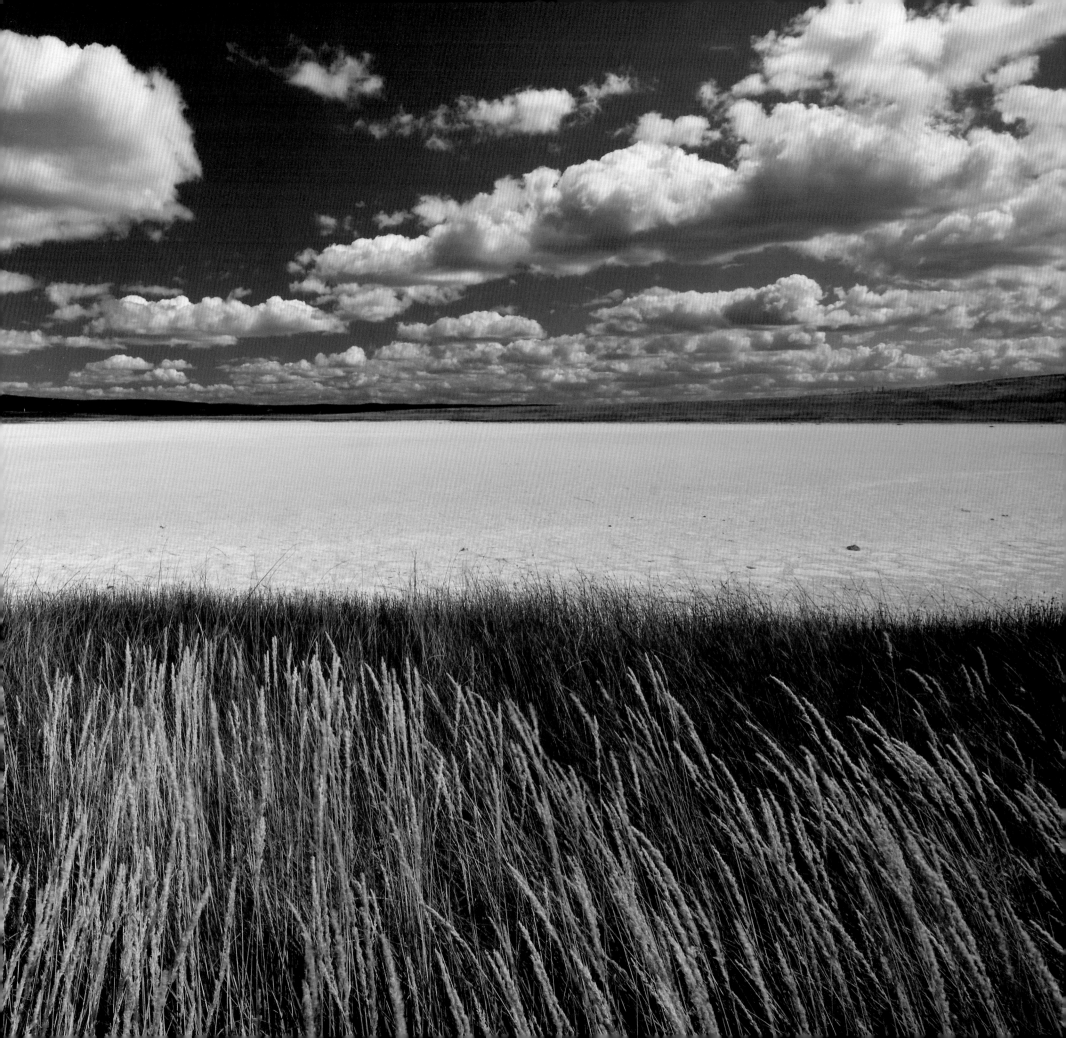

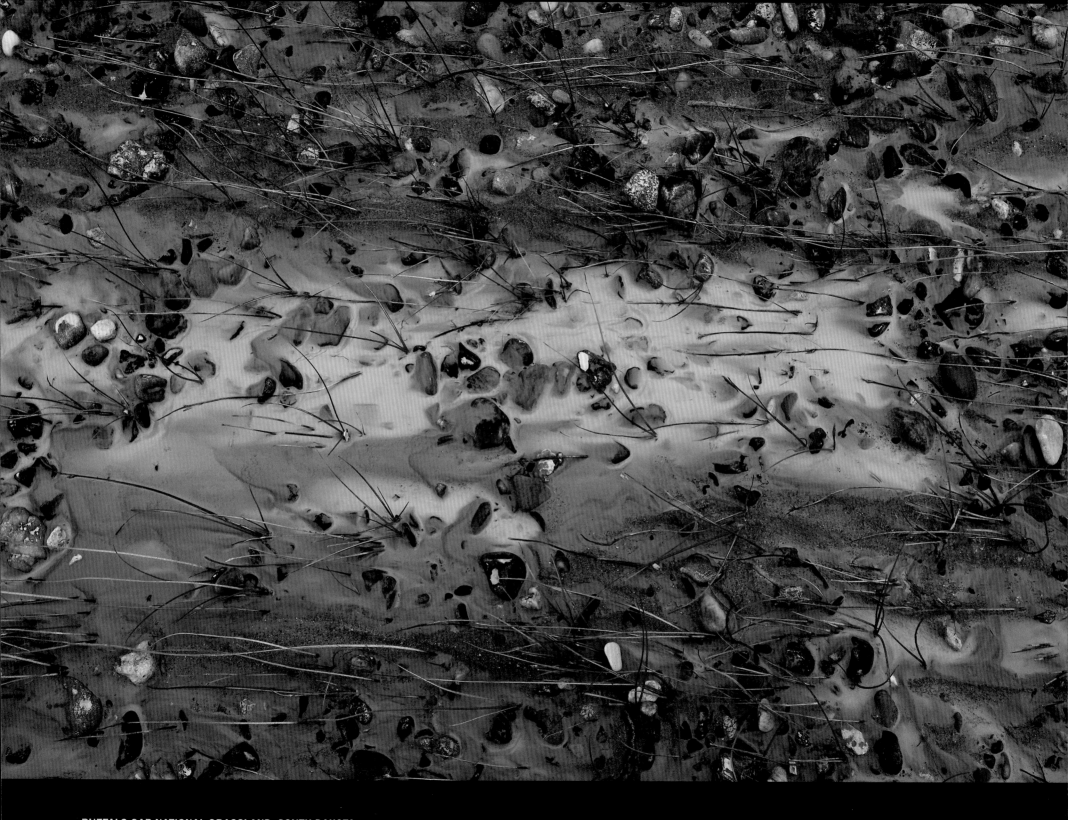

BUFFALO GAP NATIONAL GRASSLAND, SOUTH DAKOTA

In the Cheyenne River an abstract pattern of mud and rocks is
revealed after high waters caused by a spring thunderstorm recede.

WATER

Dan O'Brien

The sun, the wind, bring rain
And I know what the rainbow writes
across the east or west
in a half-circle:
A love-letter pledge to come again.

Carl Sandburg

MIKE AND I TALK about water a lot. Mike knows more about water than I do. He has a nearly encyclopedic knowledge about where it is on the Great Plains and which mammals, birds, and fish need it. He also knows what time of year those creatures have to have it to live. Mike knows about the abuses of irrigators and the fight between the Fish and Wildlife Service and the Corps of Engineers and how all of that negatively impacts the life cycles of the pallid sturgeon, least tern, and piping plover. He tells me about the incalculable value of the prairie potholes of North Dakota for nesting ducks. He talks about the playa lakes of the south-central Plains and names most of the migrating birds that depend on them. He says both the potholes and the playa lakes are threatened by federal farm policy. Mike is sort of a water specialist. I, on the other hand, am sort of a specialist in the lack of water.

The common metaphor for moisture on the Plains is blood. People see the water as a kind of reverse circulatory system. Rivers are described as arteries; the draws and intermittent streams are described as capillaries that move nutrients around. It is not a perfect metaphor, first because it is a huge simplification and second because the Plains do not die without water. The Great Plains might look dead and people might have to move away, but when the rains don't come, the Great Plains simply hunker down and wait.

I imagine the Great Plains as a vast battlefield with thousands of factions and millions of combatants vying over millennia for one strategic and rare prize. The prize is not Inca gold or the coal of Alsace-Lorraine. It is not African ivory or Middle Eastern oil. The strategic prize on the Great Plains of North America has always been water. The factions entangled in this perpetual struggle are species of plants and animals, executing their offensive and defensive strategies and making all manner of alliances with, and silent oaths against, each other. There will always be powers and superpowers, but the individual organisms will always be the foot soldiers. They are innumerable, vulnerable, and expendable. That is where my expertise with water resides. Trying, for 35 years, to make a living by raising animals on the Great Plains has made me a foot soldier.

I understand the field of conflict well, because, like Mike, I have been over most of it and know it as 1,125,000 square miles drained mostly by one river. The Missouri is America's largest watershed, but it's simplistic to think of the Great Plains as a huge tilted landscape that dumps the little rain it receives from one drainage to the next. The topography of the Great Plains is surprisingly rough, and that relative roughness determines the nature of the water and how it drains. In the few places where the land actually is flat, the water is placid. But where the relief is great, the water can be savage.

There is a rough spot like that in the west-central Plains that I want to show Mike. He's hosted me on the Platte River when hundreds of thousands of cranes, ducks, and geese cram onto the plentiful water, resting up for their last push back to nesting grounds. He's shown me marvelous, surprising prairie springs that gush thousands of gallons of water and attract trumpeter swans year round. Well, I'm going to take Mike to one of my secret spots. I first learned about it in a book about the Sioux wars, and it is a dry, dusty, sage flat above a rugged draw that leads to a famous river. Years ago I snuck onto that overlook because I had read about what happened there in the early summer of 1876. The river is the Little Bighorn and it is famous, of course, for a battle. The gully that draws me to that country is called Water Carriers Ravine, but it's not known for carrying water down to the river as God might have intended it to do. It's known for a heroic effort to bring water up the hill, to the small, tragic hill where I like to stand and imagine.

When I look down to the river on a hot June day like the one on which George Custer died, I am reminded that the route taken by Great Plains rain on its way to the Gulf of Mexico is circuitous, sometimes gentle and sometimes tumultuous. The rain is meant to race and to linger, according to the seasons and the inscrutable cycle of droughts. From the beginning, sudden rains or snowmelt have been both held back by natural impoundments and sluiced toward the

Gulf by the pull of the Earth. At one time nearly every trickle of Great Plains water slowed and spread at some point in its journey into wetland incubators for wildlife. Beaver dams, lakes, potholes, playas, backwaters, and the braids of sprawling free-flowing rivers have always conspired to withhold water from the Missouri, to dole it out slowly except in the wettest of times. It is in those natural, famously fertile pockets of wetland that species of the Great Plains have always gathered for protection and nourishment.

Mike is eloquent on this in his late night explanations, as we streak down Great Plains highways on our way to the next sunrise. In my mind I expand the list of fertile detours water takes as it passes through the Great Plains on its way to the sea, adding organisms to detours. In the darkness of the passenger's seat, I think of every mammalian, reptilian, avian, or floral consumer of water as another back eddy of life-giving water. Even man, I think of as a tiny oxbow where water pools just long enough to bestow life. And I think back to that draw that runs up from the Little Big Horn and of a soldier who served under Maj. Marcus Reno and Lt. Col. George Armstrong Custer. Private Mike Madden won the Congressional Medal of Honor by masterminding and carrying out a low-tech diversion of a little Great Plains water.

He died in the early part of the last century after dragging a peg leg for the last half of his life. But for most of the first half of his life he wore boots on both feet and spurs marked US 7th Cavalry. He likely rode among the playa lakes of the Texas Panhandle with Custer and bivouacked on the banks of a prairie pothole while stationed on the Missouri at Fort Lincoln in North Dakota. I have seen these places and listened to Mike Forsberg describe their infinite value, but we will never know if Private Madden marveled at those unique landscapes, the millions of cranes, ducks, geese, and shorebirds that those wetlands produced. One thing is sure. If he could come back today, he would be amazed at the way those reservoirs of life have diminished in number and in fertility. He would marvel at how playas and potholes have been filled and farmed. He would find it hard to believe that the infertile lake that lies below the bluffs at Bismarck is the same river that raged past Fort Lincoln.

He would be disoriented by all the rivers of the Great Plains, now that they have been dammed to supply water for irrigation and security against flood-ing. We don't know what sort of man Mike Madden was, so we don't know if he would applaud those changes or lament the loss of wildness. Would he have even known that, for the pronghorn, the bison, the duck, and the early human, the strategy for survival was not to horde the water but to chase it? Would he have noticed bison raise their heads at the sound of thunder as if called to a distant, unknown valley where the rains were falling? More likely, he would have taken all that for granted. As a young trooper, he probably did not notice or care how the different species obtained their water. But I'll bet he noticed, later in his life, that for the vast majority of Great Plains species (those with short legs or no legs at all) the strategy is to hunker down and wait.

After Custer's commanders were slaughtered by Sioux warriors and Reno's men had been driven to the bluffs above the Little Bighorn, the wounded learned that strategy quickly. They hunkered down in the shadeless swelter and waited for nearly two days, while the warriors of Spotted Tail, Gall, and Crazy Horse circled them like wolves. Tell *those* wounded men that the Plains is not a battlefield obsessed with water.

Reno's men dug in with metal plates and knives, trying somehow to fortify a hilltop that offered no other strategic attribute than its height. There they lay, the number of wounded and the pleading for water growing by the hour. Then, a full day into the siege of their hilltop, Mike Madden looked down the gully that ran through enemy lines to the river below and conceived that it might be a highway to bring water to the suffering.

He and some of the other men, under cover of darkness, began the descent to water. With 20 canteens between them and driven by the moans of the wounded and dying, the men wound down toward the river, like the progeny of a thunderstorm. They returned with water but not enough and all the next day the wounded cried out. Until brave Mike Madden led his band back to the river, where the Sioux waited for him. The soldiers managed to collect a little more water before Madden was shot, cruelly, in the leg he needed to scale back to the circle of besieged soldiers.

Somehow his men got him back up the hill where he lay, now with the other wounded, and where the surgeon sawed off his leg. And for another day Private Madden suffered and waited on that hill with the rest. I'll bet that is when he realized the value of Great Plains water.

I want to take Mike Forsberg to the spot where I figure Madden curled up under the blistering sun. I want to kneel down and try my best to see what Private Madden saw. I want to show Mike that, when you get the angle just right, your focus narrows and you can no longer see the yellow grass or the mare's tails in the dusty blue sky. Sometimes my tongue swells and all I can see is the dribble of water in the river below, slipping out of reach, on its way to the sea.

CHARLES M. RUSSELL NATIONAL WILDLIFE REFUGE, MONTANA
The second largest refuge in the contiguous U.S., the million-plus-acre Charles M. Russell
NWR is threaded by the Missouri River, meandering freely here across a floodplain.

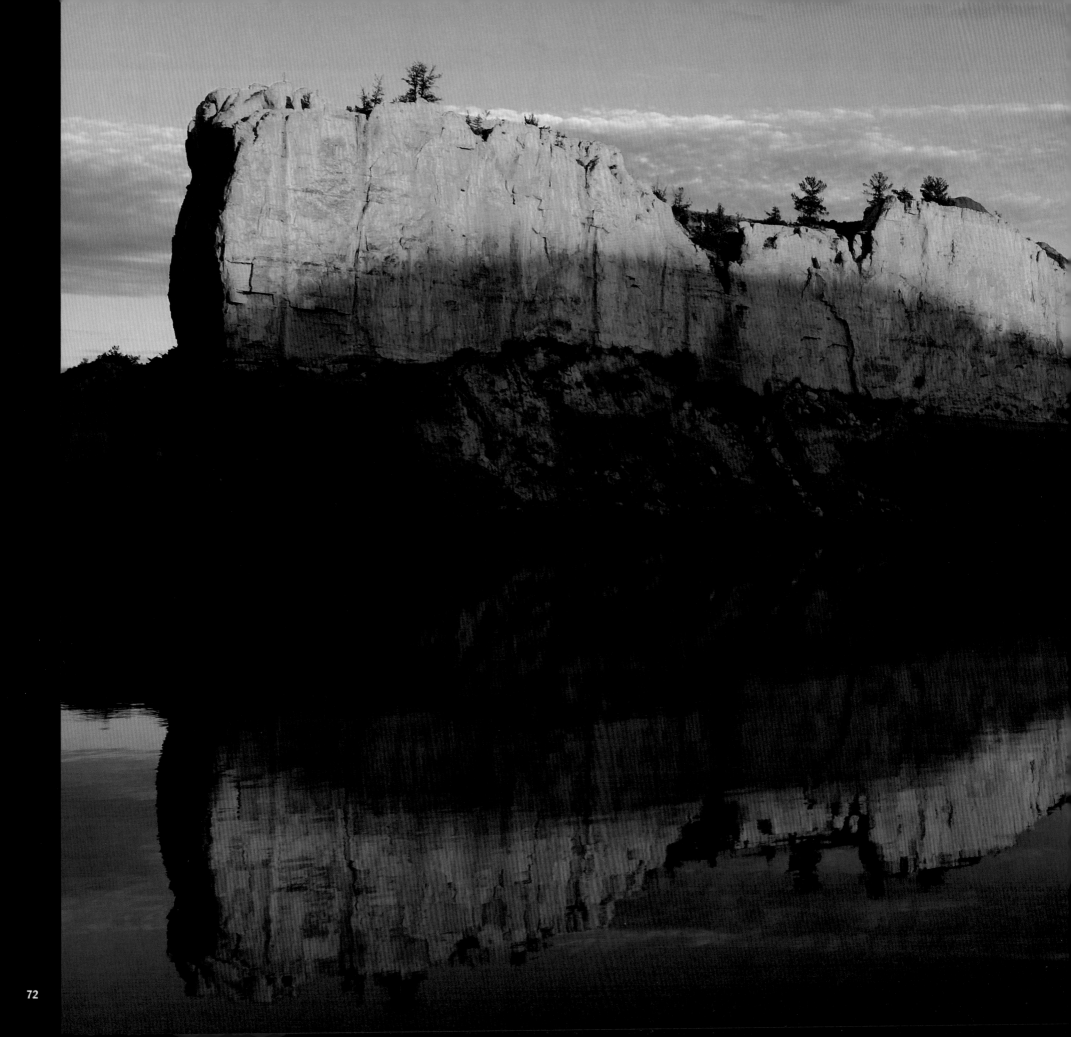

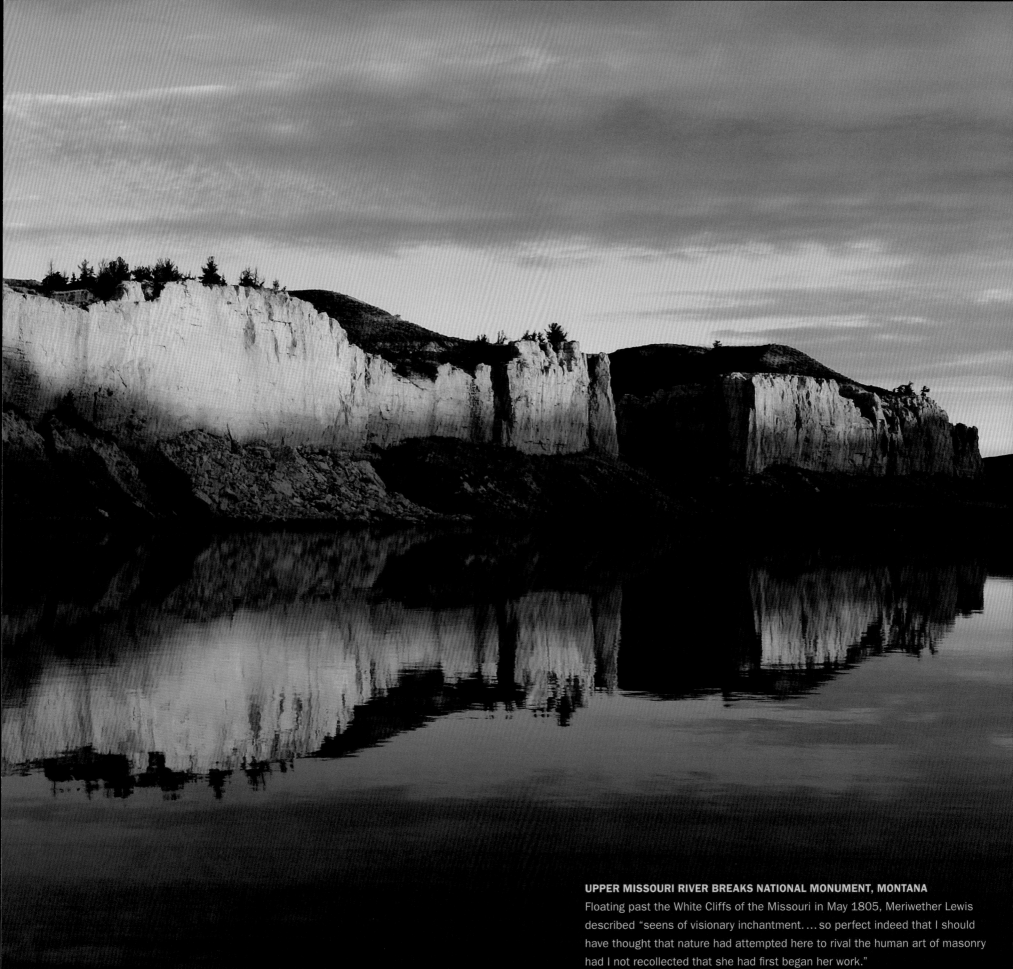

UPPER MISSOURI RIVER BREAKS NATIONAL MONUMENT, MONTANA
Floating past the White Cliffs of the Missouri in May 1805, Meriwether Lewis
described "seens of visionary inchantment. ... so perfect indeed that I should
have thought that nature had attempted here to rival the human art of masonry
had I not recollected that she had first began her work."

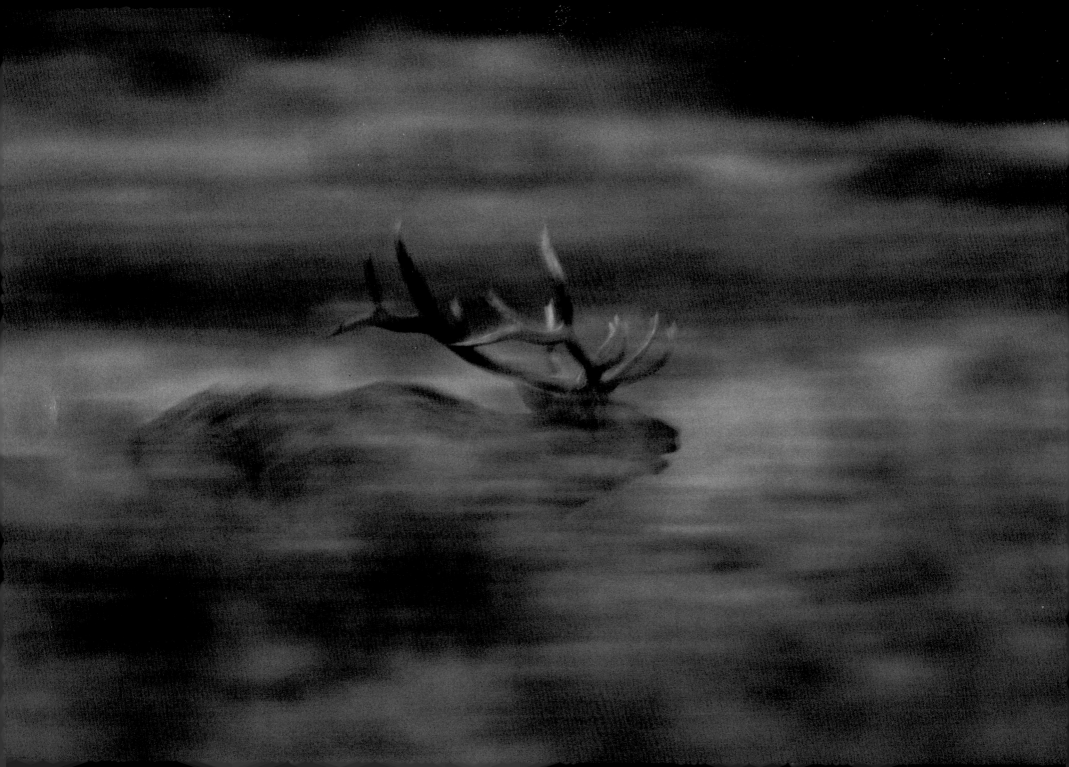

CHARLES M. RUSSELL NATIONAL WILDLIFE REFUGE, MONTANA

Left: A bull elk *(Cervus elaphus)* rushes across the valley floor along the Missouri
River to defend his harem territory during the fall rut. Reintroduced into the refuge
in 1951-52, elk by the thousands now roam the Missouri River Breaks country.

Above: Fog lingers in the morning twilight on the upper Missouri River Valley.

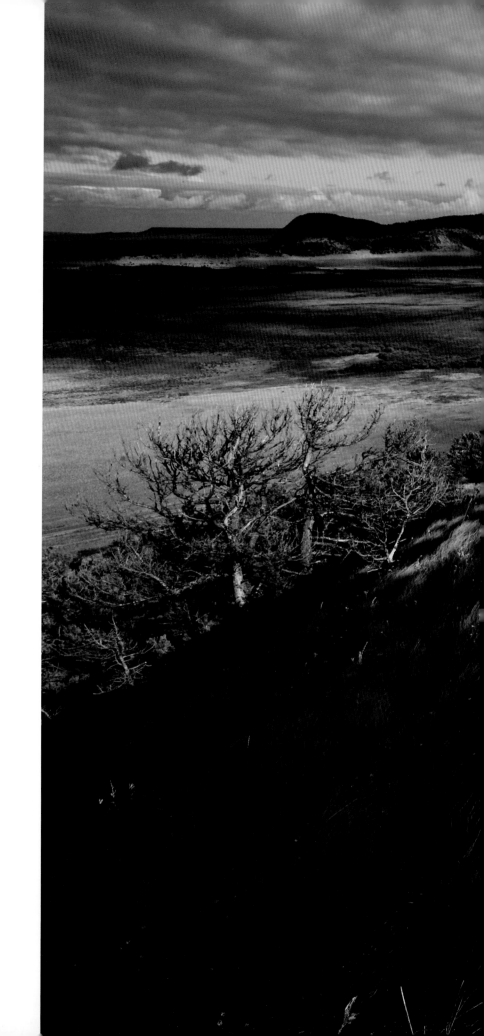

TNC PINE BUTTE SWAMP PRESERVE, MONTANA
Where the high country meets the Plains, rough fescue grasslands wash
through limber pine savannah and up the foothills of the Rocky Mountain
Front. In the distance, the sprawling fen wetland and river complex
anchors some of the best grizzly habitat in the continental U.S.

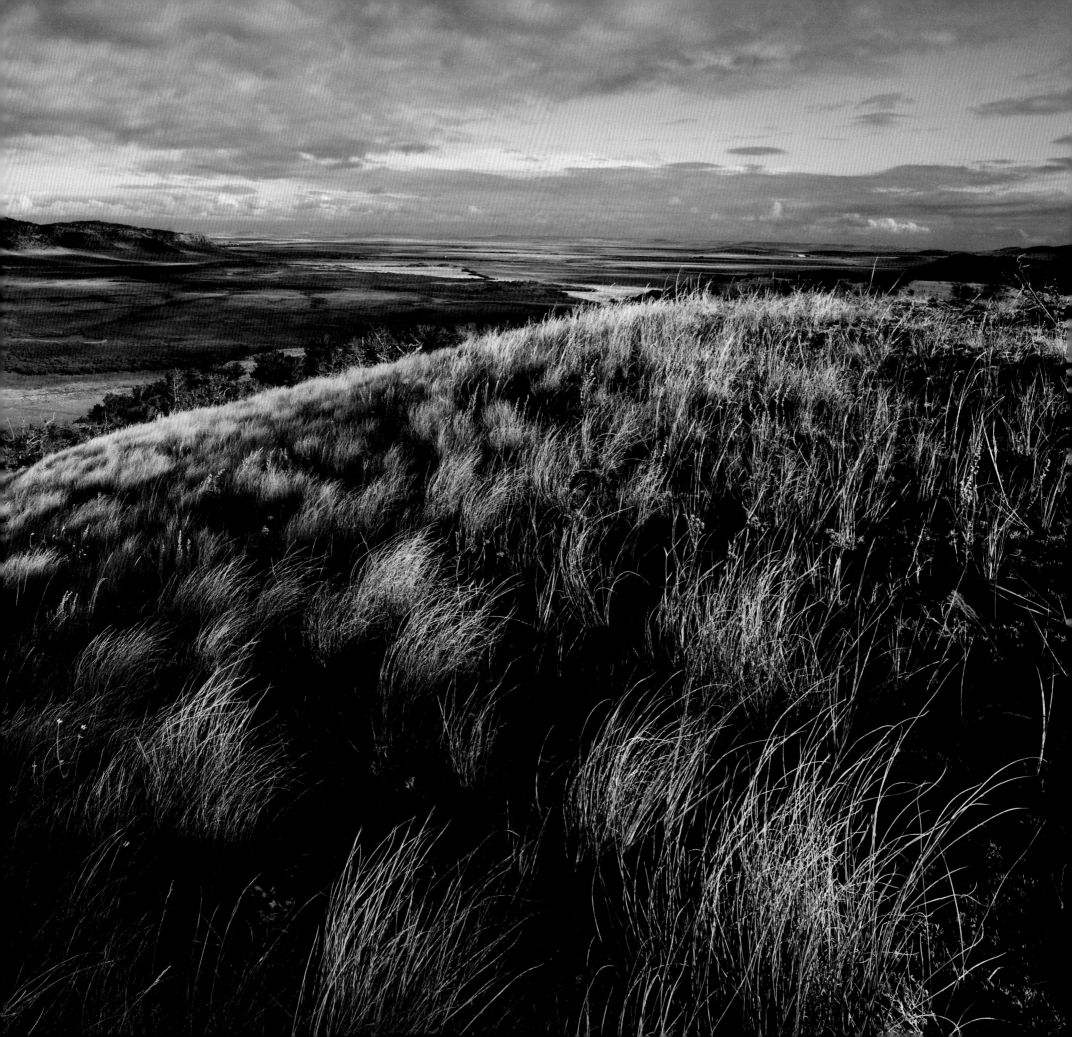

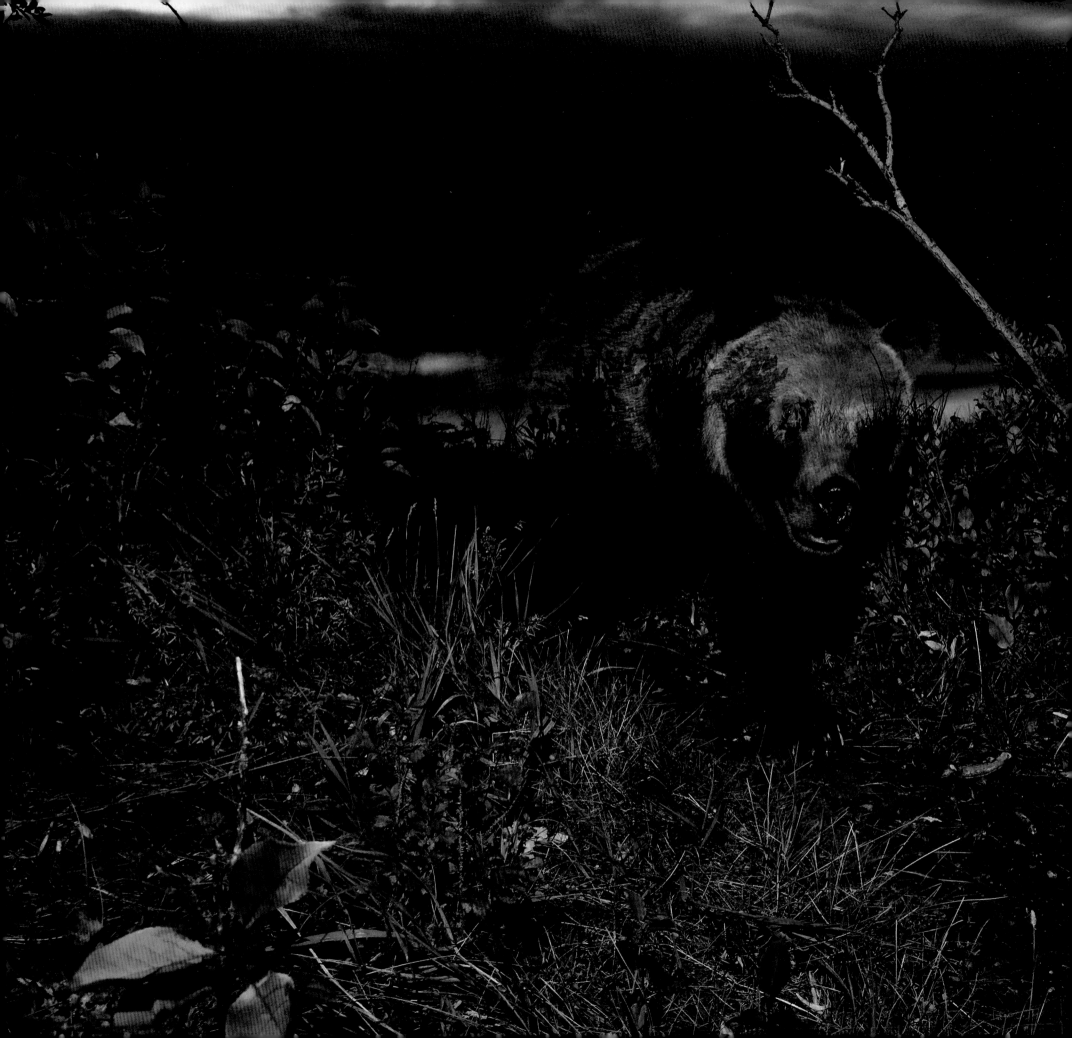

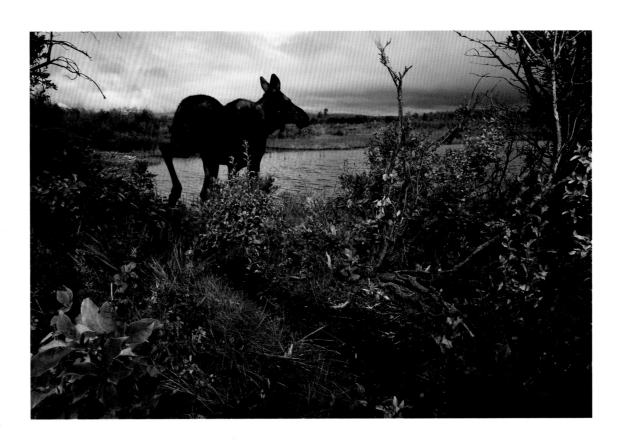

TNC PINE BUTTE SWAMP PRESERVE, MONTANA

Left: At twilight a grizzly sow *(Ursus arctos horribilis)* moves along a game trail connecting wetland and prairie. These bears once roamed widely across the Plains until extirpated in the early 20th century. Today, the secluded prairie and wetland habitats along the Rocky Mountain Front are their last prairie refuge. Protected by ranchers and conservation groups, the area provides food and daytime cover for bear, elk, and other species.

Above: A cow moose *(Alcus alcus)* moves along the same game trail at midday.

79

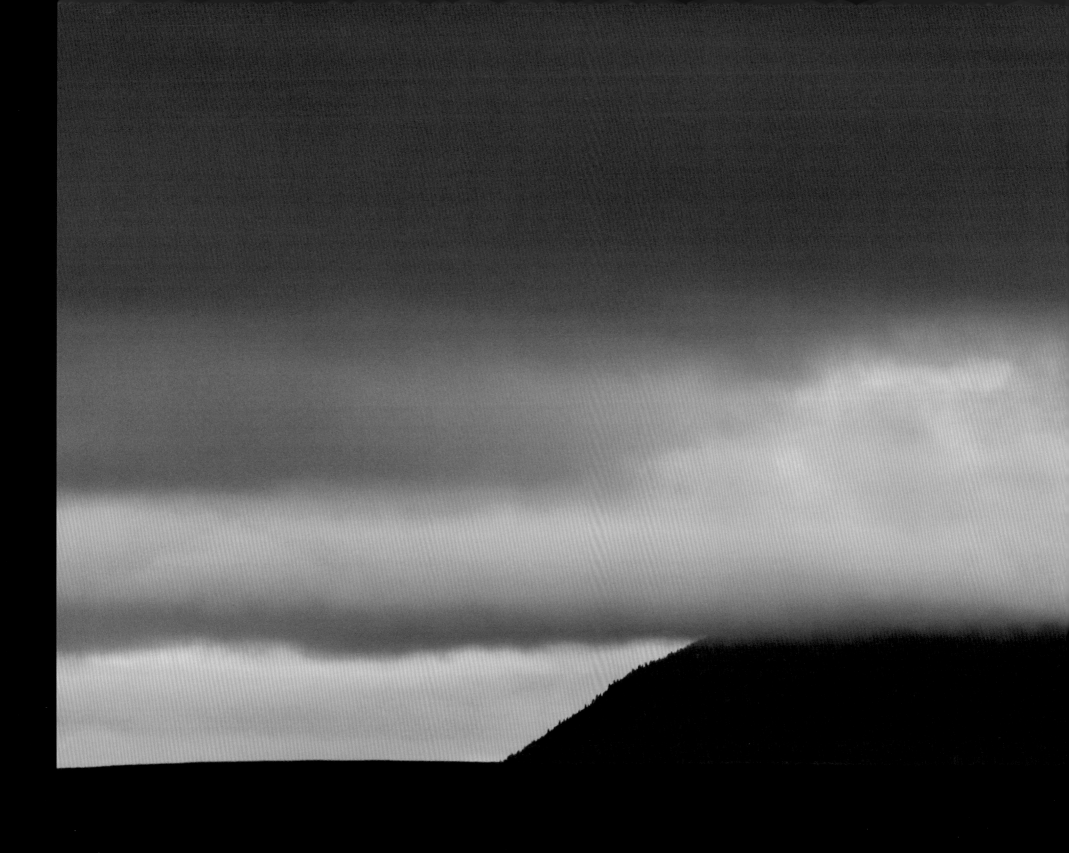

FERGUS COUNTY, MONTANA

Black Butte rises into the clouds above Montana's eastern plains. Such island mountain
ranges support a diversity of species more common in the Rockies and provide security
cover for species like elk, which once wandered widely across the prairie.

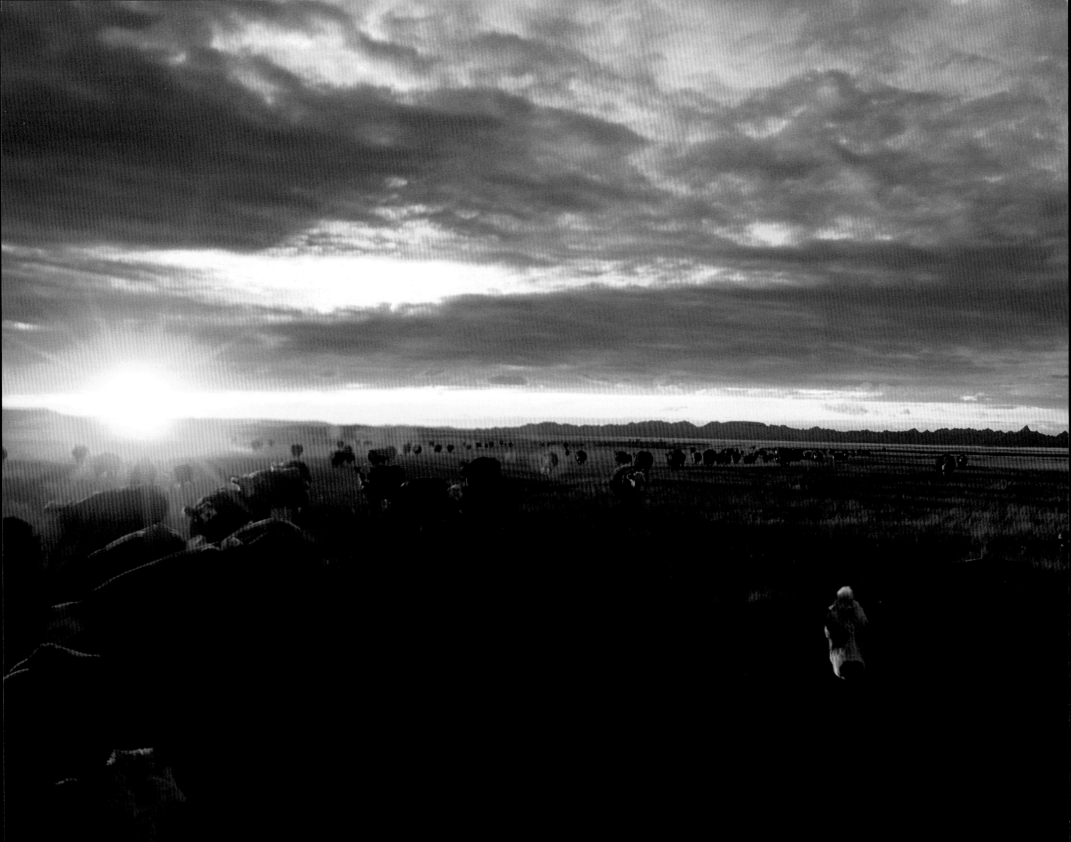

BUFFALO GAP NATIONAL GRASSLAND, SOUTH DAKOTA

Cattle graze the Conata Basin as they have since the open range days of the 1880s. Their seasonal grazing helps prairie dog populations by removing tall vegetation that may hide the rodents' predators. Prairie dogs are the critical food source for the black-footed ferret. Thanks to a dedicated group of biologists, the federally endangered ferret is recovering more extensively in the Conata Basin than anywhere else.

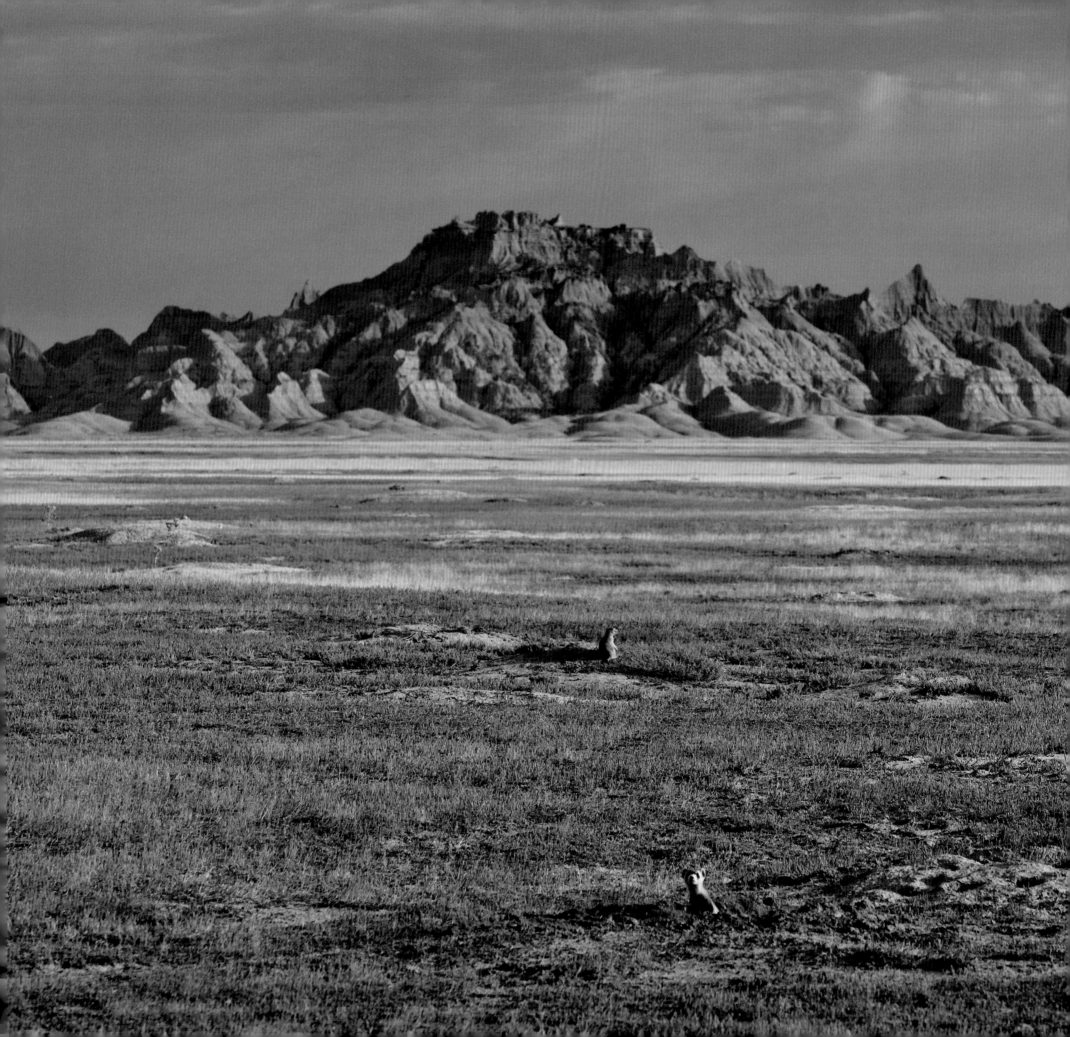

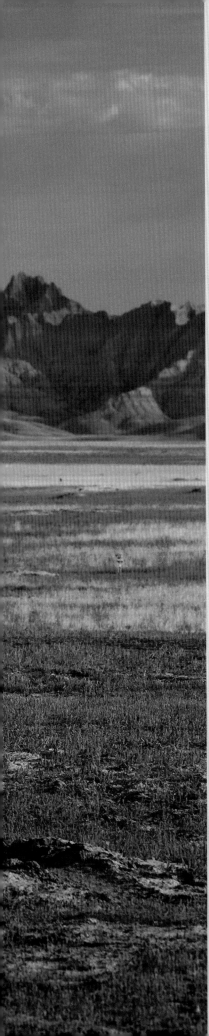

Field Journal: Black-footed Ferrets
CONATA BASIN, BUFFALO GAP NATIONAL GRASSLAND, SOUTH DAKOTA

AUGUST 1

Today I met with David Jachowski at a trailer he's renting in the town of Scenic. He's one of a very small group of scientists who oversees ferrets on the federal level. Pulling out a map, he showed me three different ferret litters he'd been watching in the western part of the Conata Basin, near a two-track dirt road heading toward Badlands National Park. It's the same two-track I've traveled every year for the last several—heart of the ferret range in Conata and the place where ferrets bred in captivity were released into the wild many years ago.

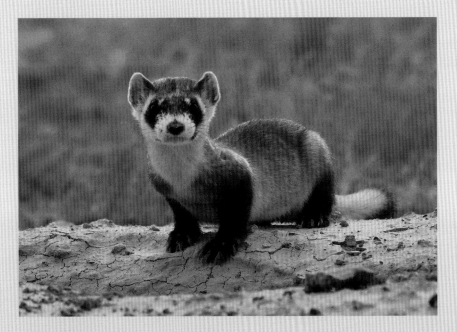

Above: A black-footed ferret *(Mustela nigripes)* stands at the entrance to a prairie dog burrow in the Conata Basin. Long thought extinct, the ferret was rediscovered in 1981, bred in captivity, and reintroduced into the wild beginning in the 1990s. *Left:* Usually nocturnal, a ferret surveys its surroundings while a black-tailed prairie dog *(Cynomys ludovicianus)* keeps a watchful eye. Feeding almost exclusively on the rodents, populations of ferrets require large prairie dog complexes to survive.

David said the litters are almost adult size now, so he was just beginning to see them more regularly aboveground, outside the burrow. He says the young ferrets are in a transition period, growing more independent. Over the next couple of weeks, the mom ferrets will begin using a strategy similar to what burrowing owls do with their chicks—they'll spread their litters out to different satellite burrows for safety.

Now the moms are relocating their burrows just about every time they kill a prairie dog. Instead of bringing the prey to their kits, the females bring the kits to the prey. When the kits were younger, the moms carried them individually by the scruff of neck. Since the kits are older and more mobile, David usually sees them follow their moms in a single-file "ferret train" to the new burrows.

AUGUST 2

Last night I set up a remote camera system on the middle one of the three ferret burrows David had shown me. All three were within a hundred yards or so of each other and all three had been plugged up with earth earlier in the day by prairie dogs, a sure sign ferrets were still in the burrow system.

The theory behind remote cameras is that they minimize human physical presence right at the scene. Kind of like being in the ferrets' living room without being there. Still, I was sure I was dumping all sorts of scent in the area while I set up. Birds can't smell. Ferrets can.

A prairie dog struggles to get out of its burrow as a ferret attacks from below.

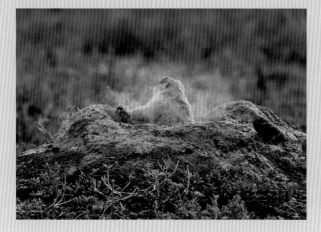

After the attack, the ferret emerges from the burrow with a bloody mouth.

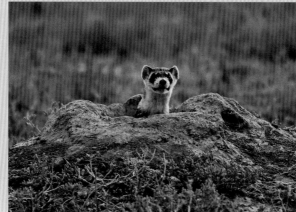

The bloodied prairie dog climbs out, trying to recover enough to escape.

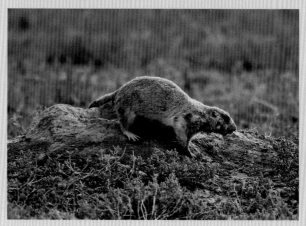

I watched the den all night on a small black-and-white TV monitor in the truck, a couple of hundred yards away from the den. The remote sends a wireless signal to the monitor and shows me what the camera viewfinder is seeing. I can fire the camera remotely with a modified remote airplane controller. Sound simple? Well, it's not. But it had worked on the grassland birds I'd been photographing. Problem with ferrets is that they're nocturnal. So the system was modified to "see" at night in infrared, capture images in infrared, and light up the scene with flashes of infrared light, keeping the stage dark.

In ten hours I saw only one ferret three different times, and that was between three and five in the morning. Popping up like a periscope from the burrow entrance it had unplugged from below, it would look around rather nonchalantly, staring into the night, sniffing the air, then after a moment disappearing again into the hole. That was it.

At 6:30 the next morning, I pulled the camera and was driving out of the prairie dog town when I saw an adult female ferret near one of the other two burrows. It was aboveground an hour after sunrise, which is very unusual, and peering over the lip of a prairie dog hole like a cat over a fish bowl. It sat motionless, alternatively scanning the surroundings and seemingly nodding off to sleep, then scanning some more. This went on for several minutes, until without warning it tensed up, reared back, and dived like a rocket into the hole. Dust started flying out of the burrow as if it were a steaming volcano. The sound coming out was the same wild evil snarl Bugs Bunny's nemesis, the Tasmanian Devil, made.

Then, all of a sudden up popped a big prairie dog, half out of the hole, struggling with its forelegs to climb all the way out. But each time it tried, it would get pulled back down, claws desperately trying to cling to the lip of the burrow, raking into the dirt on its way back down. Each time the prairie dog disappeared, there was more dust and more snarling. It happened twice, then quiet.

Dead quiet. A moment later the ferret who had dived into the burrow popped up out of the hole with mouth agape, panting heavily, teeth exposed. It ran about 30 feet to a burrow, probably where its kits were, and disappeared.

Had I just witnessed a ferret kill a prairie dog? I figured if I waited, the ferret would move the kits one by one over to the kill site, another opportunity to witness something seldom seen in the ferret world. The mom remained in the burrow belowground for several minutes. Then to my surprise, the attacked prairie dog struggled out of the hole, bloodied and battered, dragging itself away like a badly beaten fighter. It willed its way off behind some cactus and taller grass and tried to tend to its wounds. Its neck and haunches and groin were bloodied. Clumps of hair had been pulled out.

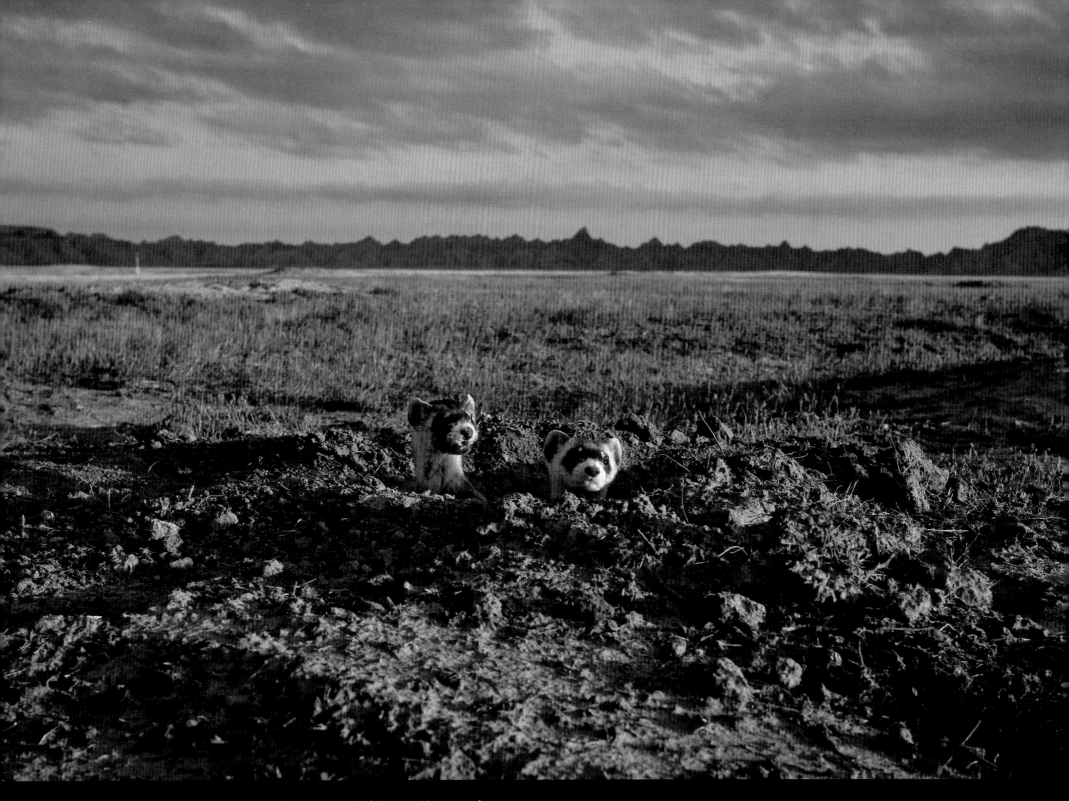

In early August, a black-footed ferret (left) and her nearly full-grown kit emerge from a prairie dog burrow just after dawn. Wild born in 2002, this adult female was a favorite of researchers. She lived to be a record five years old (equivalent to age 100 in humans) and successfully raised five litters of kits in as many years. In her final year, 2007, when this photograph with a remote camera was made, she raised four kits

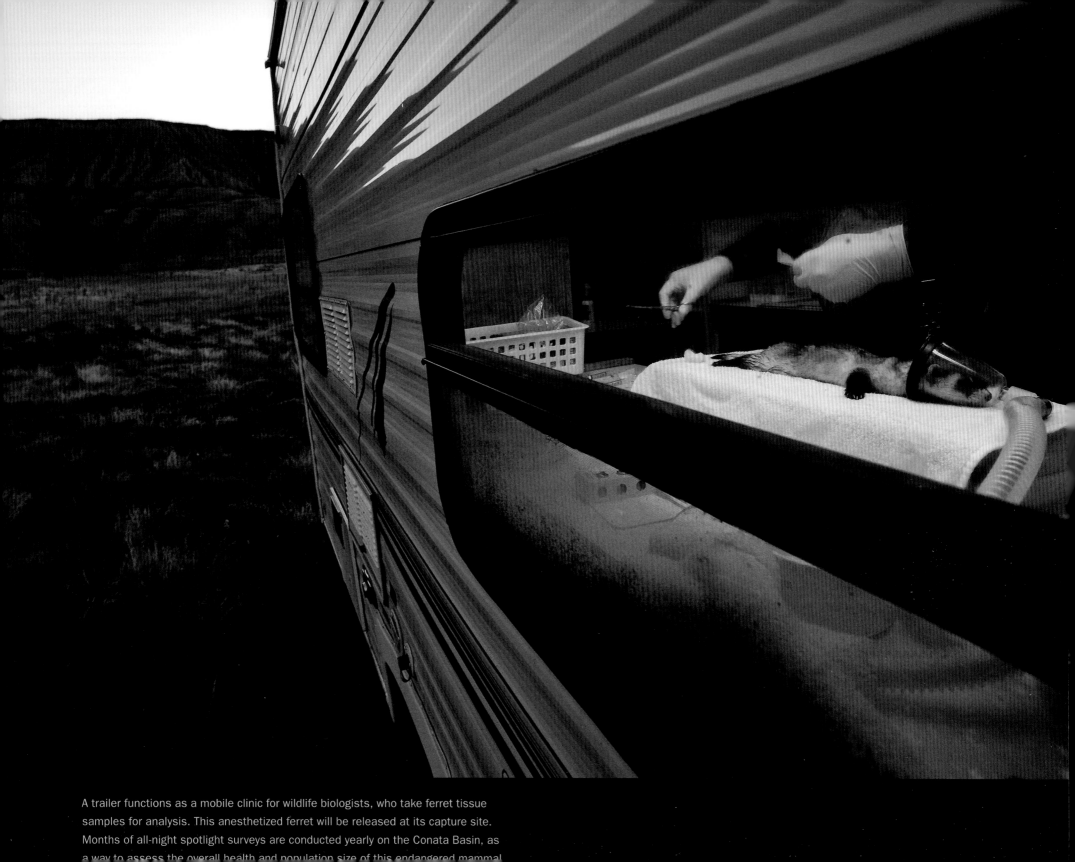

A trailer functions as a mobile clinic for wildlife biologists, who take ferret tissue samples for analysis. This anesthetized ferret will be released at its capture site. Months of all-night spotlight surveys are conducted yearly on the Conata Basin, as a way to assess the overall health and population size of this endangered mammal.

There were moments when it would just sit there wobbling, hunched over, barely able to keep upright. Other times it would manage to get a paw to its wounds to clean itself.

After about ten minutes, it had made its way some 40 feet from the attack point and out of sight. Which was good for the prairie dog, because the ferret came out of its hole rather proudly and ran back to where the attack had taken place to claim its prize. It entered the burrow and disappeared, then came up almost immediately. It looked in all directions, obviously agitated and confused, wondering where in the world its meal had gone. It inspected the hole once more, then ran to another burrow nearby and stuck its head underneath, then another, then another. Finally, it returned to the attack hole one more time, paused, scanned the surrounding prairie, then sprinted back to its own burrow and disappeared.

A moment later another prairie dog entered the scene and approached the ferret's burrow. It stood up on its hind legs peering into the hole about six feet away, almost as if to taunt it. The ferret rose out of the burrow immediately and bluff charged it, chasing it away with a hiss and a cloud of dust.

AUGUST 10

Dan is with me tonight on the Conata Basin. It's still hot, but the wind out of the south is shifting to the west and the breeze is picking up. We've spotted a mother ferret in the prairie dog town, in the same den she occupied last night. She came out at dusk and took off to the west hunting. We delayed moving in the remote camera because we didn't see the kits and wanted to make sure the mom hadn't moved them somewhere else. We watched and waited until it was too dark to see, then waited a bit longer.

An hour after sundown, Dan and I turned on the spotlight on top of the truck so we could see and moved in to set up the remote camera at the burrow. We hadn't been there more than a few minutes, down on our hands and knees setting the camera and strobes in places, when all of a sudden the mom appeared again. She just walked around us casually like we weren't even there, Then she disappeared into the burrow at our feet. You've got to be kidding me, I thought, but I said nothing, and, except for a sly grin, neither did O'Brien. We quickly finished the setup and were picking up a couple of things when she came back up out of the burrow, looked up for a moment, walked right past us again, and scampered off into the night. O'Brien looked at me again, and I think he asked if that was normal. "No," I said.

But I'm sure I know what he was thinking deep down inside, "Geezus, Forsberg, here we are, setting up all this fancy high-end crap so you can get a picture of a ferret and here she is literally walking through us, coming and going as if we don't even exist." I felt like an idiot. I also felt honored.

The rest of the night slipped away slowly. Dan and I took turns watching the monitor, while the other one of us napped or chewed on buffalo-roast sandwiches, good as only Dan's wife Jill can make them. A coyote howled at 10 p.m. A sliver moon showed itself just after midnight. The wind continued to be breezy, which keeps ferrets and other creatures less active aboveground at night. About 2 a.m. under a star-filled sky, a gust of wind came blazing across the basin hard enough to slam the open door of the truck, blow binoculars off the dashboard, and send chills up my spine with icy cold. But just like a train passing in the night, it was gone.

When morning came, still no sign of ferrets. Then, at 6:20, we watched on the monitor as the mom poked her head up. "Hell, she must have come back sometime during the night," Dan said. She looked as tired as we were, squinting in the half-light of the rising sun. Then junior popped up beside her and sniffed the air. For a moment, it made a nice family portrait with sun and shadow playing off the badlands wall behind. I took a picture, then another and another.

Mom came out of the den a few more times but never wandered more than a few feet away. She was more cautious today, eyes scanning the horizon, ears erect, nose on the alert. She would suddenly sit up at attention each time a prairie dog sent out an alarm call, something I hadn't seen her do on calm mornings previously. When both ferret and kit retreated back down the hole we knew it was probably for the day. I pulled the gear and left. But it was hard to leave.

It was hard to leave an animal that I had come to feel such great respect for. Respect for her unyielding spirit, easy character, and diligence as a parent. It was hard to leave the kits, hoping that one would be a female and successfully take over the mom's territory when the time came and be of the same cut and character as she was. It was also hard to leave this place, this dry, prairie dog-filled, badland landscape, as diverse and brimming with life as any place I'd ever been.

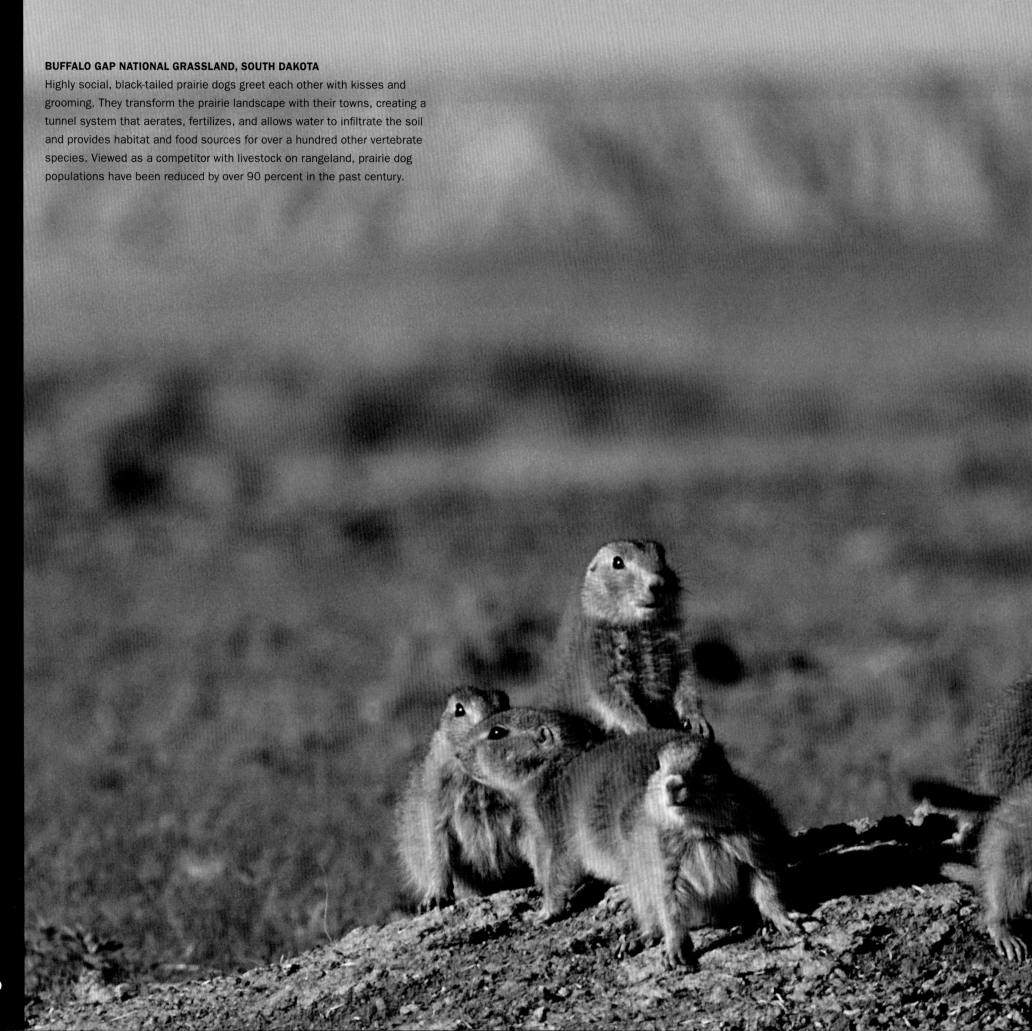

BUFFALO GAP NATIONAL GRASSLAND, SOUTH DAKOTA
Highly social, black-tailed prairie dogs greet each other with kisses and grooming. They transform the prairie landscape with their towns, creating a tunnel system that aerates, fertilizes, and allows water to infiltrate the soil and provides habitat and food sources for over a hundred other vertebrate species. Viewed as a competitor with livestock on rangeland, prairie dog populations have been reduced by over 90 percent in the past century.

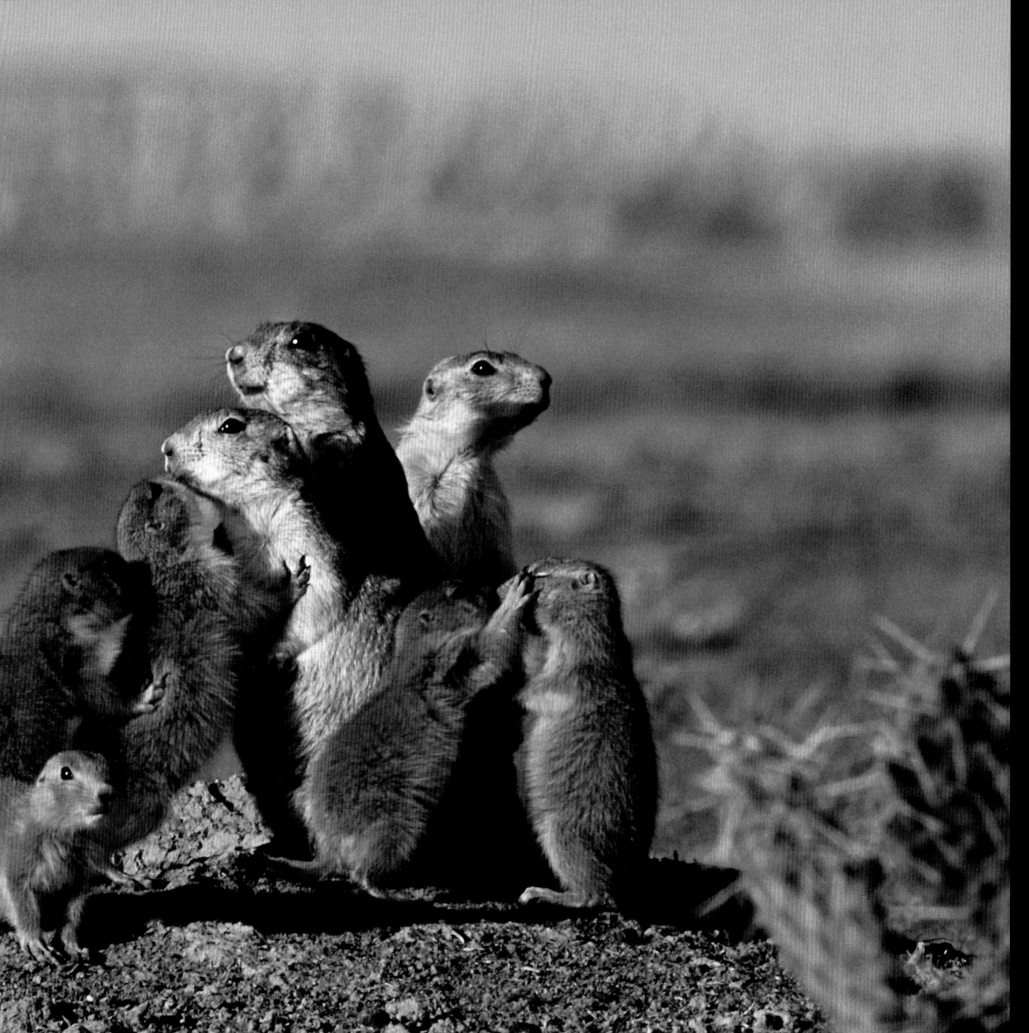

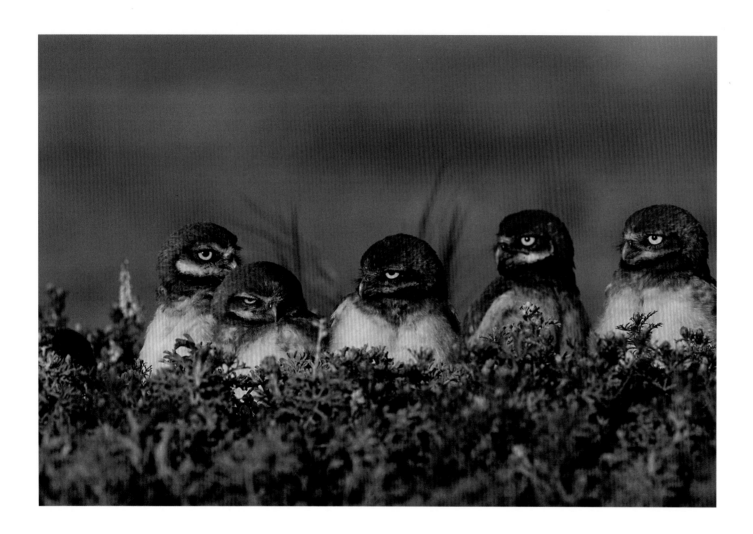

BUFFALO GAP NATIONAL GRASSLAND, SOUTH DAKOTA

Right: A burrowing owl *(Athene cunicularia)* stretches in the cool of the evening above a prairie dog town in the Conata Basin.

Above: At five weeks old, burrowing owl chicks patiently wait outside their nest burrow for adults to bring back food. Active day and night, these owls feed on small insects, snakes, and rodents; both parents constantly ferry food back to their chicks.

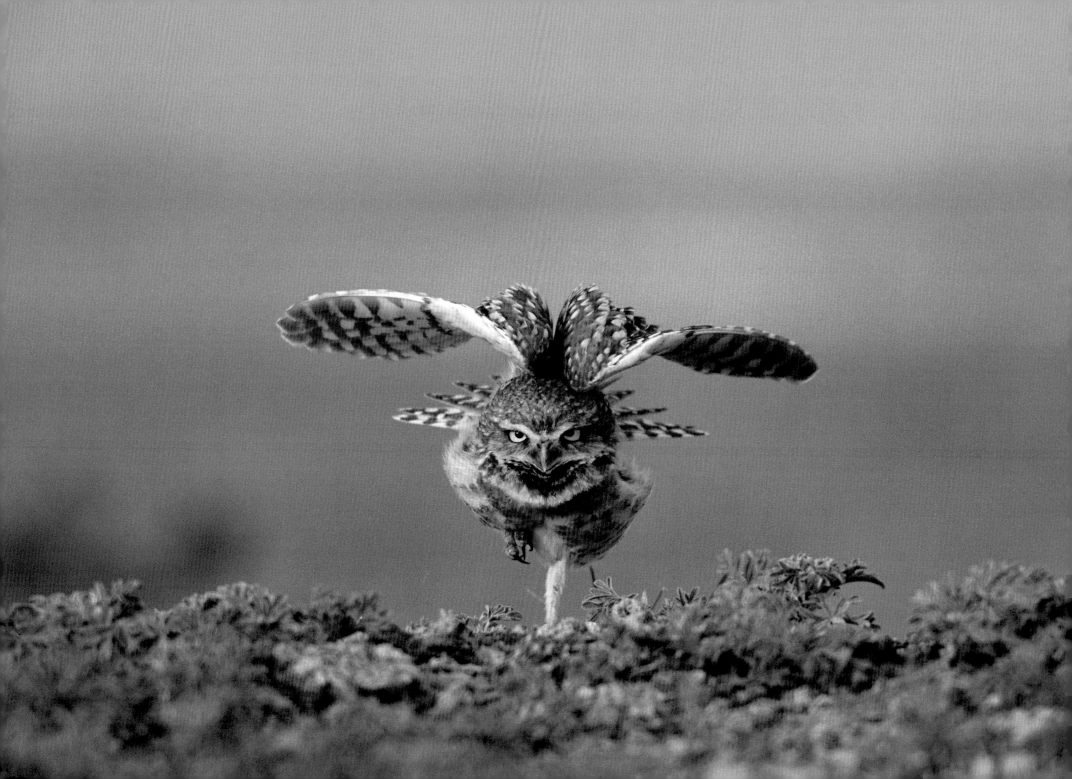

HARDING COUNTY, SOUTH DAKOTA

The only surviving species of their kind, pronghorn *(Antilocapra americana)* are a living remnant from the Pleistocene. They evolved on North America's grasslands and can outrun and outlast any predator that ever roamed here. Topping out at speeds of 60 miles an hour, they're one of the fastest land mammals on Earth.

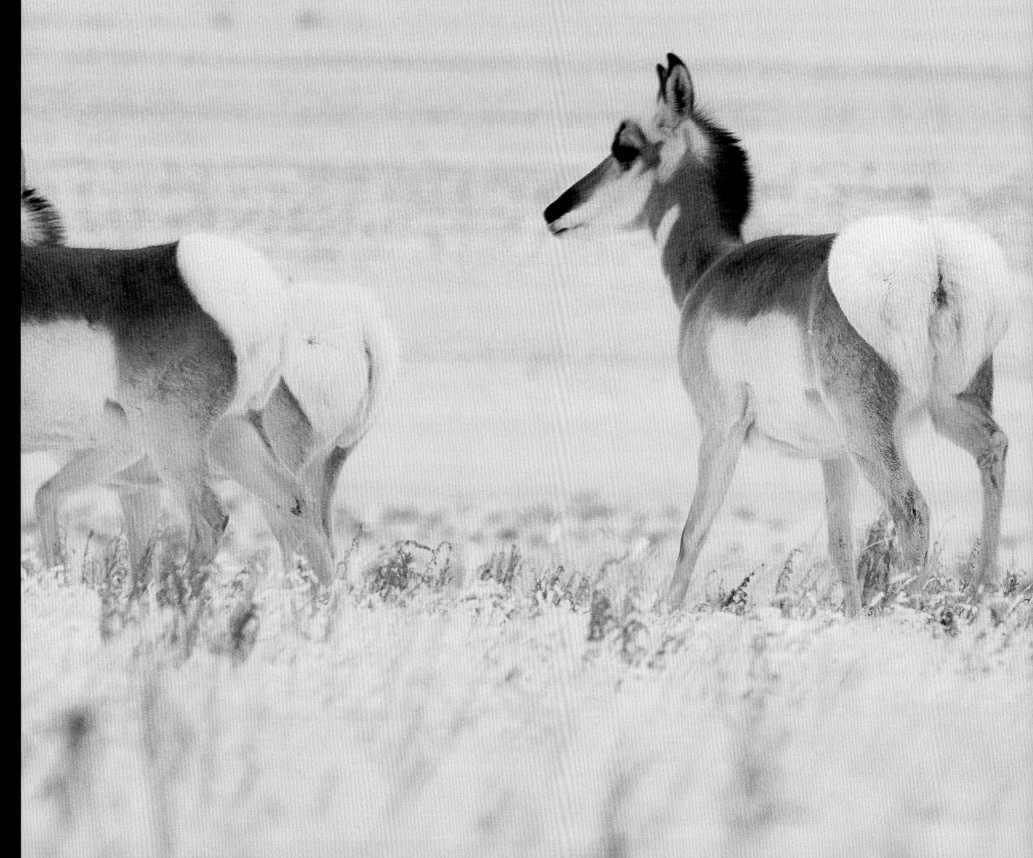

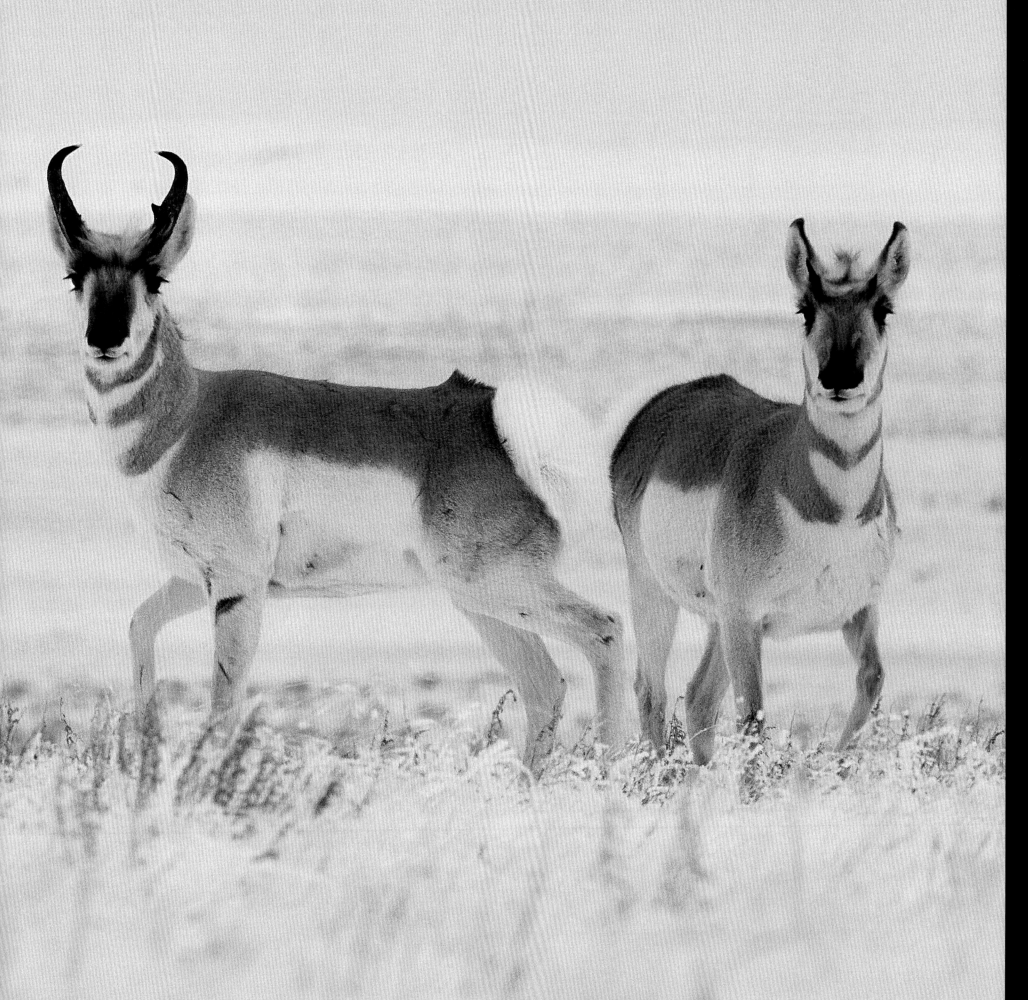

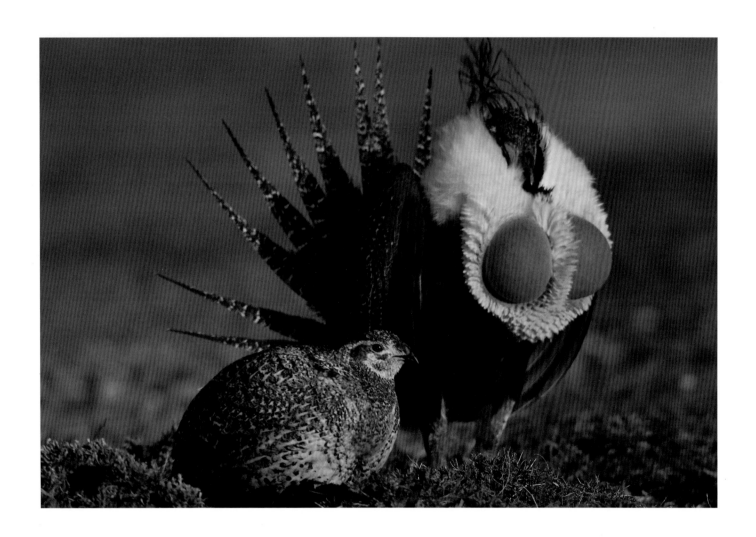

CHARLES M. RUSSELL NATIONAL WILDLIFE REFUGE, MONTANA

On a traditional mating ground called a lek, a male greater sage grouse *(Centrocercus urophasianus)* displays for a prospective mate. The sagebrush grasslands of central Montana provide some of the last strongholds for these grouse, North America's largest. Populations are declining as their sagebrush steppe habitat is fragmented, degraded, or destroyed, especially by energy development and overgrazing; the recently introduced West Nile virus, spread by mosquitoes, has also taken a toll.

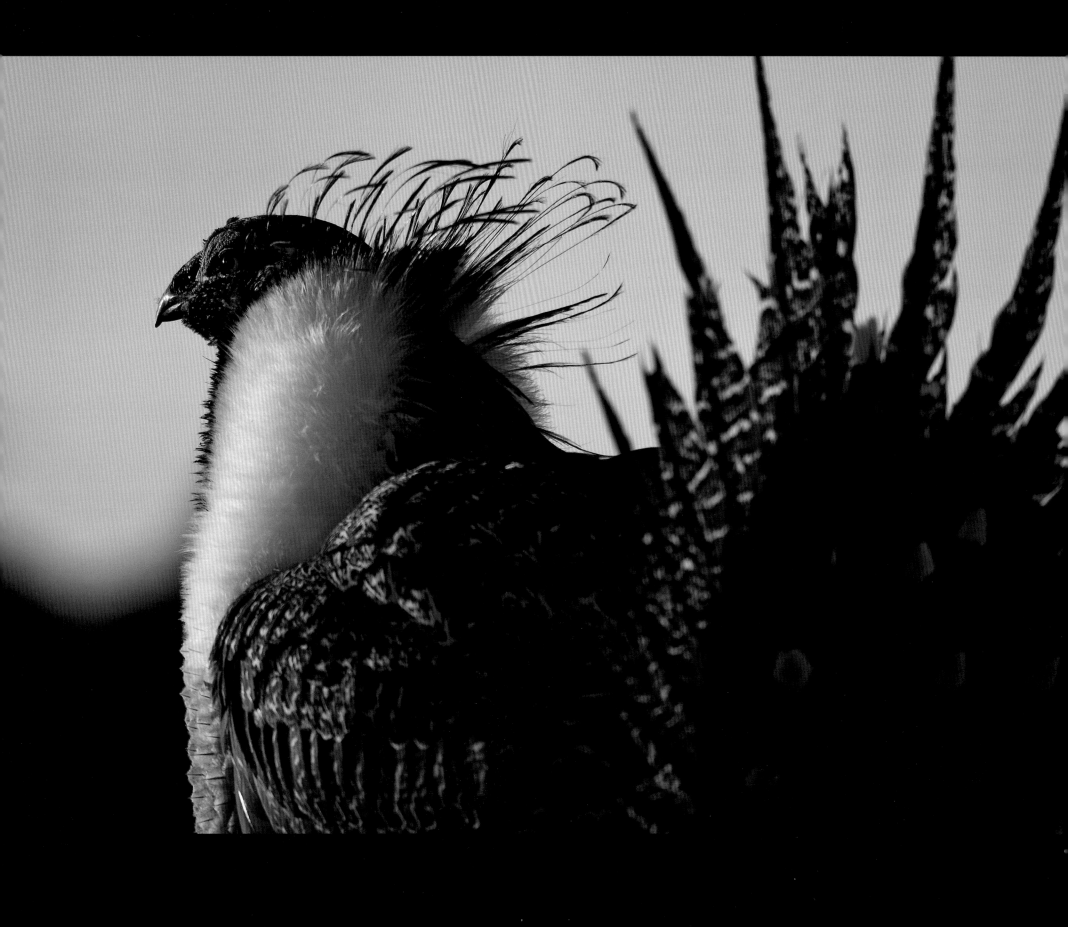

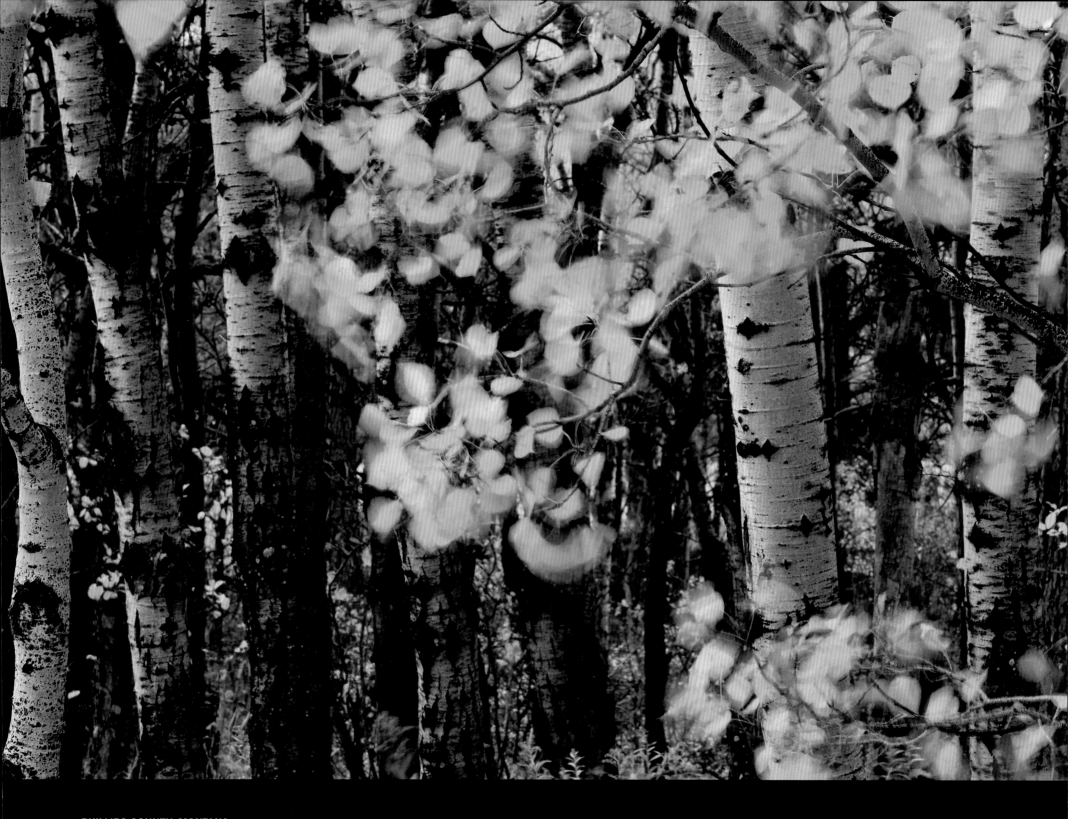

PHILLIPS COUNTY, MONTANA

A late September wind rushes through a stand of quaking aspens *(Populus tremuloides)*, tousling
their fall color. The unique design that allows the leaves to twist back and forth, or "quake," may

WIND

Dan O'Brien

IF THERE IS SUCH A THING as a normal Great Plains day, it has a lovely symmetry of wind. Mornings are usually still with the lingering cool of darkness and the air resting calm in the cottonwood leaves. But by ten o'clock the leaves begin to shimmy, and by two o'clock the limber branches of the higher reaches begin to whip. It is not uncommon to watch the whipping increase to a tempo that would tear any man-made object to bits. But on most days the branches whip moderately all day long, until the sun is far into its slide toward the western horizon. It is only when the temperature begins to dip toward darkness again that the prairie begins to still.

It is a rare day indeed that the wind does not blow, and common for the wind to blow with enough fury to scare the daylights out of the human inhabitants of the Great Plains. In the 1980s my setter Spud and I camped, unexpectedly, in the Slim Buttes of South Dakota — one ridge over from where the Lakota Chief American Horse was killed in battle a hundred years before. We were hunting with a wild-caught gyrfalcon that had ridden the Arctic wind to the Dakotas the winter before. Being a veteran of at least one transcontinental flight and the genetic heir to a kingdom of wind, he was a joy to watch hunt. A master at gauging crosswinds, beating grouse to their cover, lounging along behind them until the mind game was won and then, suddenly with the extra speed of the wind behind him, shifting to an overdrive that sealed all our fates. He was as wild as endless tundra, yet up close, as tame and genteel as innocence itself.

That day in the northwestern corner of South Dakota, he had pointed into the prairie gale as only a gyrfalcon can do and had risen a thousand feet without flapping a wing. But Spud and I muffed the flush, and the grouse, wind masters in their own right, beat him to a distant draw filled with stoic and omnipresent cottonwoods. He was right behind them when they put into the draw, and he shot vertically up, as if he had been launched from Earth and was heading for orbit. When he turned on his tail, I could tell that he had spotted something on the opposite horizon, and as I turned downwind, I saw a hapless rock dove winging unperturbed a half mile away. But when the falcon turned with the wind and tripled his wing beat, he blurred and I knew the dove was doomed. Spud and I found the falcon an hour later, enjoying his dove dinner on a rimrock ledge a hundred feet above the prairie.

The sun was setting into an oddly gray sky, and we tried in vain to entice the falcon to leave his prize and come down to a lure of inferior chicken meat. He paid no attention to us or to the ominous sky. He took most of the rest of the day to pluck nearly all the feathers from the dove before he began to eat in earnest. By the time he was full of dove meat, it was almost dark. Through the binoculars I could see that glassy, satisfied stare I had seen the year before when I first saw him sitting on a black steel power pole surrounded by a world of prairie white. It took an entire day for him to get hungry enough to be captured. This day, in the last shafts of sunlight, we tried again to lure him down, but he refused to even look at us, preferring instead to stare at the building bank of anvil-shaped clouds on the western horizon.

We were forced to pull the pickup truck onto the grassy shoulder of the falcon's butte, set up a dry camp, and wait for digestion and dawn. We tried to make the best of the situation. I dug cans of beans and spam from a forgotten foul weather cache in the back of the truck for me and a can of Alpo for Spud. I kept an eye on the falcon until it was obvious he intended to spend the night on his nifty little ledge, then I turned to making the camp comfortable and building a fire under the cans of food. From my human perch I had a wonderful view of the sunset and pointed out to Spud the mare's tails of clouds in the last, pink rays of light. "Looks like wind," I told him.

Wind? Holy cow. Let me tell you about the wind!

We crawled into that little tent early, because we planned to be up before daylight. As it turned out, we were awake long before sunrise, about an hour after we fell asleep, about the time the first tent peg was torn from the ground. I think I had been semi-awake for a while because, when I think back on that night, I hear the flapping of the nylon tent folds and the swish of air through the grass and up the curve of butte a hundred yards to the east. It began gently enough, and it soothed our sleep for an hour or so. But by nine o'clock the wind had increased and begun to gust with lashes of rain that had ridden in from who knew where.

I awoke with nervous laughter and piled all our gear into the tent corner where the peg had pulled. But Spud lay shivering, and my laughter moder-

ated as our gear was thrown back into my face. The tent corner rose again as a second peg popped from the ground, and the floor began to rise like a flying carpet. All flashlights on the Great Plains seem to be equipped with dying batteries. Their pale and fading beams have lit many an impending disaster. I scanned the interior of the tent once, then switched off the light knowing I should save any power I had left.

When the wind velocity doubled, we crawled to the upwind corners of the tent and held things down for a time with our body weight. But the aluminum poles buckled from the strain, and then the tent was little more than a rag flapping wildly against our prone bodies. Spud curled hard against me, and I spoke softly to him. There was just enough rain to be driven through the nylon, soaking me to the skin. It was one of those times that humans are reminded just how puny they are, just how tenuous is our purchase on Earth. We were many miles from a warm house of any kind, and I knew that the cold wetness was unrelievable. The feeling of futility was horrifying but nothing compared to the sound of that storm. The scream of the wind and the explosive flapping of the tent hard against my ears drove me to gasping for air that I didn't need. Finally, I bolted from the tent and into the maelstrom.

Like a continuous blast from an explosion, the wind pushed me back and made me kneel. Only on all fours could I move toward the truck and only with all my might could I pry open the door and slither inside. The pickup rocked like it was re-entering the atmosphere, and I took a minute to tremble at the idea of power and the lack of it. It crossed my mind that the pickup might not stay on the ground if I tried to move it, but of course it did. I pulled as close to the windward side of the tent as possible and was heartened, when I opened the door, to find that the violence of the nylon flapping had diminished. The flashlight did not finally die until I had Spud in the truck and the tent tied to the pickup bumper and frame. Before I shut the door against the wind, I looked up and was startled to find the sky alive with stars, the heavy wind invisible.

We spent the rest of the night on the pickup seat, buffeted by the wind, the dog trembling against my thigh and the man deep in thoughts of mortality and the seemingly inevitable loss of a very fine gyrfalcon. I didn't talk to Spud about my fear. I didn't need to because he could feel it in my thigh. He knew that ancient fear. It was the same fear that had gripped immigrant wives and children and had driven them to leave these plains when the chance presented itself. Wind, I decided that night, is one of the great depopulators. I vowed not to be cowed by it but to find a way to accept it and bring it into my life.

Once I had stumbled onto that thought, I had three more hours to think about what it might mean. The wind screamed to get into the pickup, its teeth whistling at the door seals. In a while I grew used to the rocking, and it reminded me of what a ship must feel like. Sea legs, I thought. The prairie morning breeze must be like the gentle chop of harbors. The violence of the night past, like a Caribbean hurricane. Always the deck rocking below. Human balance redefined to accommodate. As the gale subsided and the first hint of sunlight brightened the sky, I thought of that ability to balance. That ability to bend one knee and stiffen the other. Walking the deck of a sailing ship was a chosen life for many and not that much different from choosing to walk the prairie.

It was a cool and beautifully clear morning when I pushed the door of the pickup open. The sun was still beneath the eastern horizon but radiating dusty yellow from below and killing the last of the stars. The grass was laid flat, and the few cottonwoods along the drainage where the grouse had harbored the day before were bent and broken. As I looked at those trees through binoculars and waited for enough light to scan the ledge where the falcon had been, it dawned on me that wind was the great sculptor of cottonwoods. The trees accepted the beating, the bending, and the broken limbs and went on growing from there. The scars would never be erased and the forest would become as magical as any in the *Wizard of Oz*.

The ledge was still in shadows, but I searched with squinted eyes through ten-power lenses. The rock dove feathers of the night before were gone to who knew where—Oklahoma, Iowa? And the gyrfalcon? I wasn't absolutely sure for another five minutes and even then I wasn't sure that the intricate black-and-white check and the dark mustachio strip were not my imagination. Slowly, with the building light, he came into focus. A foot tucked up and puffed with relaxation, he turned to look down at me. Yawning, not noticing the twisted cottonwoods beyond, he lowered his sleeping foot and raised both wings above his back without spreading them. He stretched like a teenager and turned his nearly white breast to face me. I was dumbstruck with surprise but fumbled in my hawking bag for the lure.

When I swung the feathered breakfast, the falcon stepped to the edge of the ledge and pushed off into the tiny breeze. He held his wings half-extended because that was all he needed to descend bulletlike to my feet. He stood on the garnished lure, fluffed his feathers, and shook. He looked up at me and twisted his head, no doubt curious about the expression on my face.

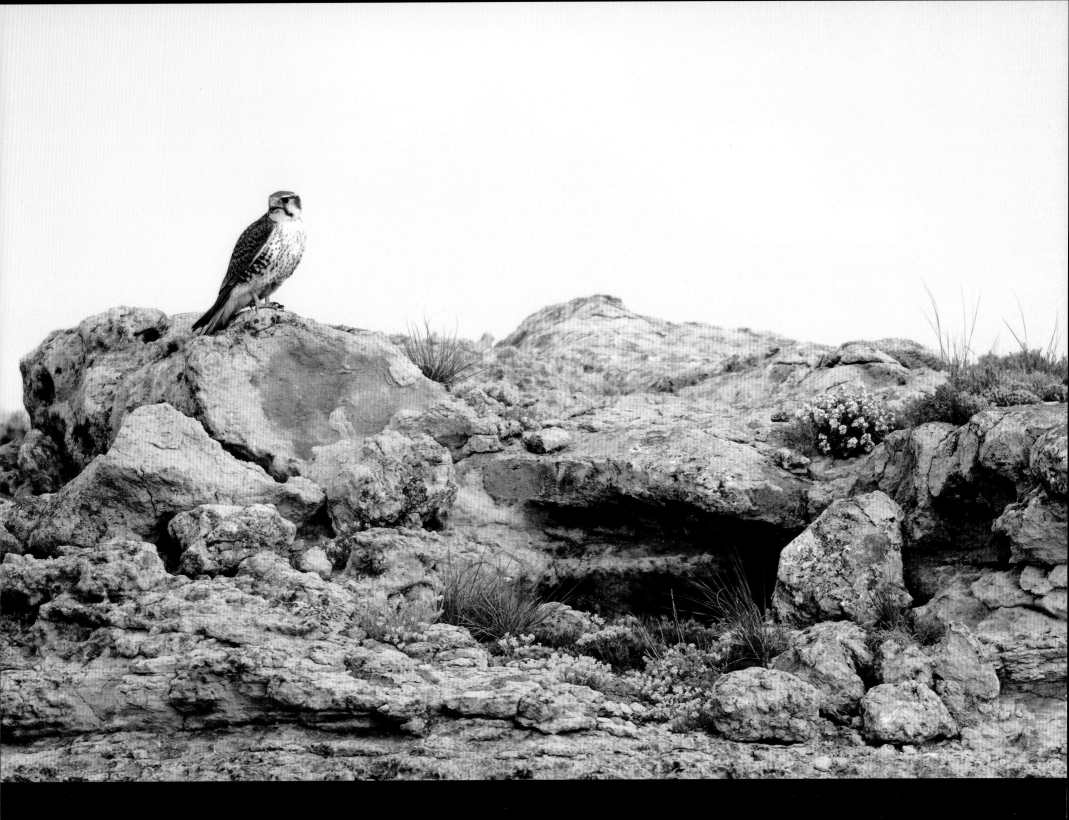

SIOUX COUNTY, NEBRASKA
Its underbelly stained from a recent kill, a prairie falcon *(Falco mexicanus)*

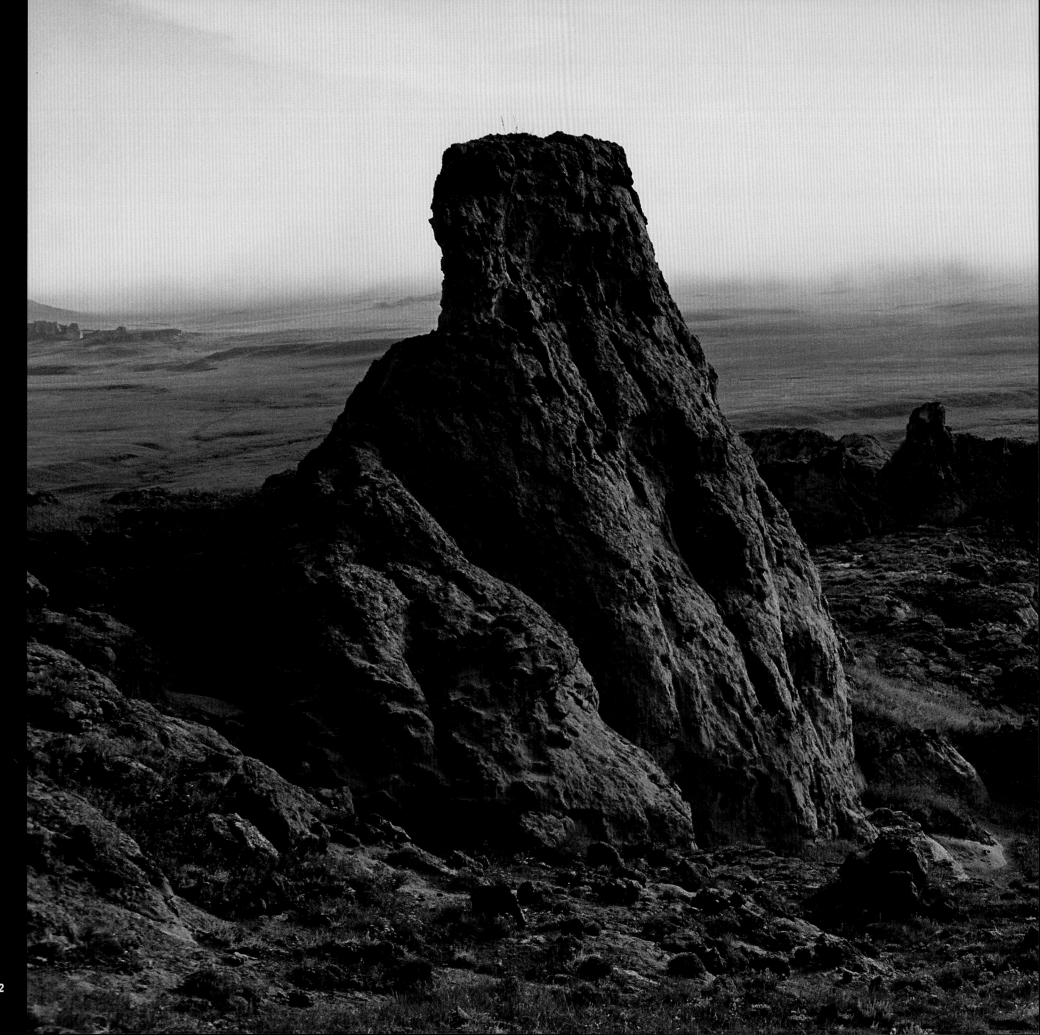

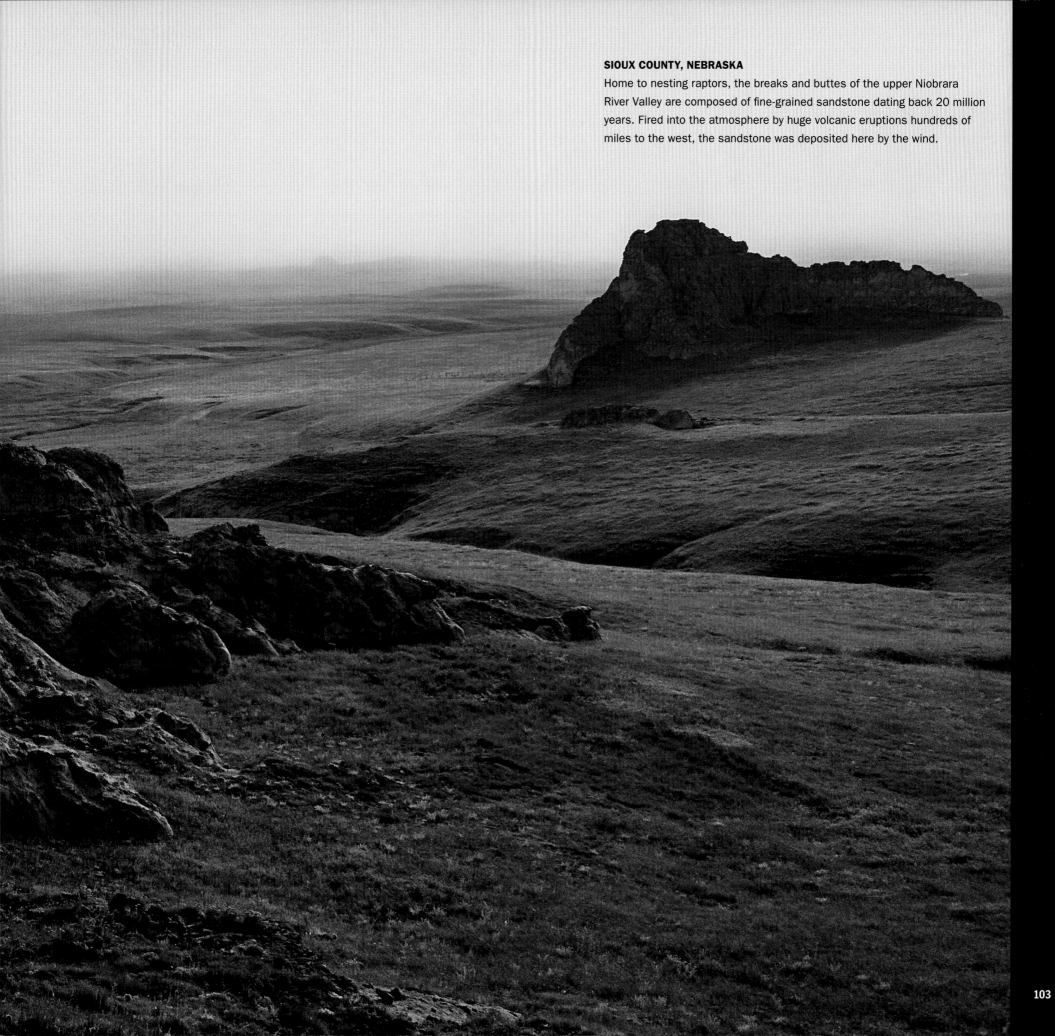

SIOUX COUNTY, NEBRASKA
Home to nesting raptors, the breaks and buttes of the upper Niobrara River Valley are composed of fine-grained sandstone dating back 20 million years. Fired into the atmosphere by huge volcanic eruptions hundreds of miles to the west, the sandstone was deposited here by the wind.

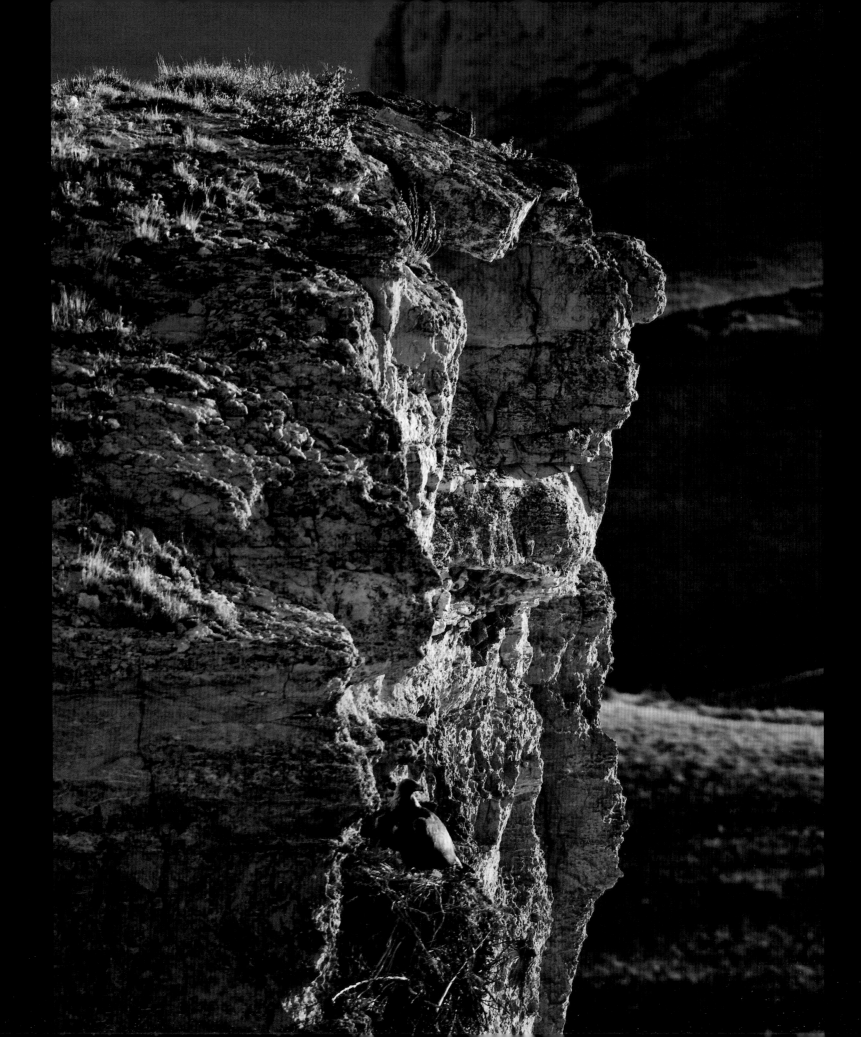

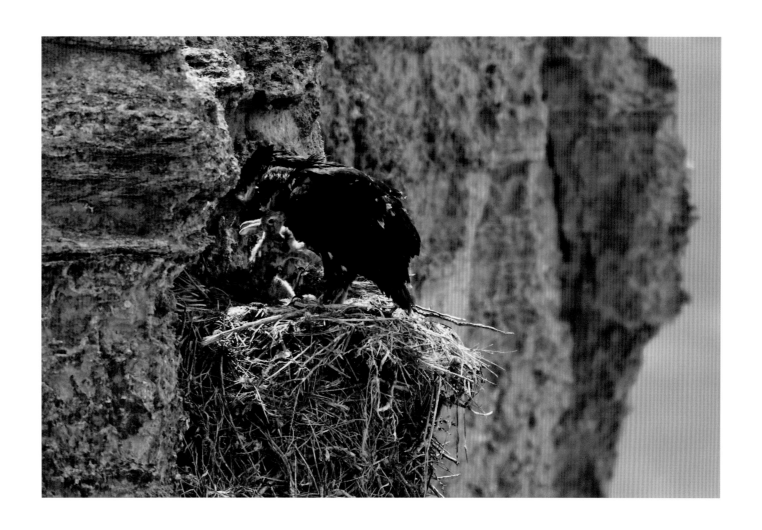

SIOUX COUNTY, NEBRASKA

Left: Sitting at her secluded cliff nest, a brooding golden eagle *(Aquila chrysaetos)* catches the last rays of sunlight on a calm spring evening.

Above: Nearly fledged, a pair of two-month-old golden eagle chicks feed on a desert cottontail *(Sylvilagus audubonii)* brought into the nest by a parent. By the time chicks are this age, the adults no longer linger at the crowded nest, keeping an eye on their young from a distance.

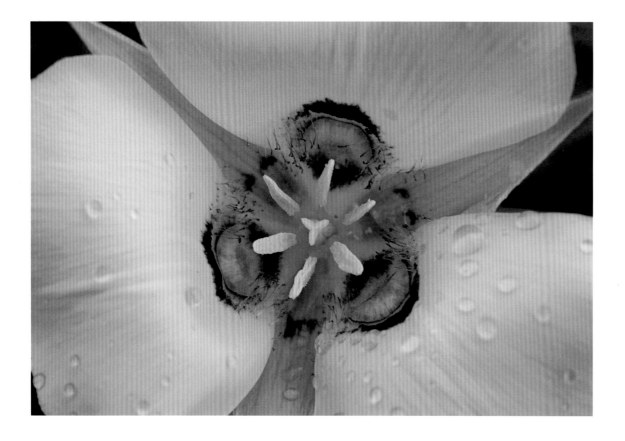

Right: **SIOUX COUNTY, NEBRASKA**

An early summer flush of prairie evening primrose *(Oenothera albicaulis)* nods in the breeze. Some years entire hillsides appear painted white, bursting with primrose that pop up after a drought breaks.

Above: **HARDING COUNTY, SOUTH DAKOTA**

A sego lily *(Calochortus nutallii)* opens after a summer rain in the southern Cave Hills. Adaptable to a variety of habitats, including dry shortgrass prairie and open woodlands, the plant was a staple in the diet of Plains Indians, who boiled or baked its bulb.

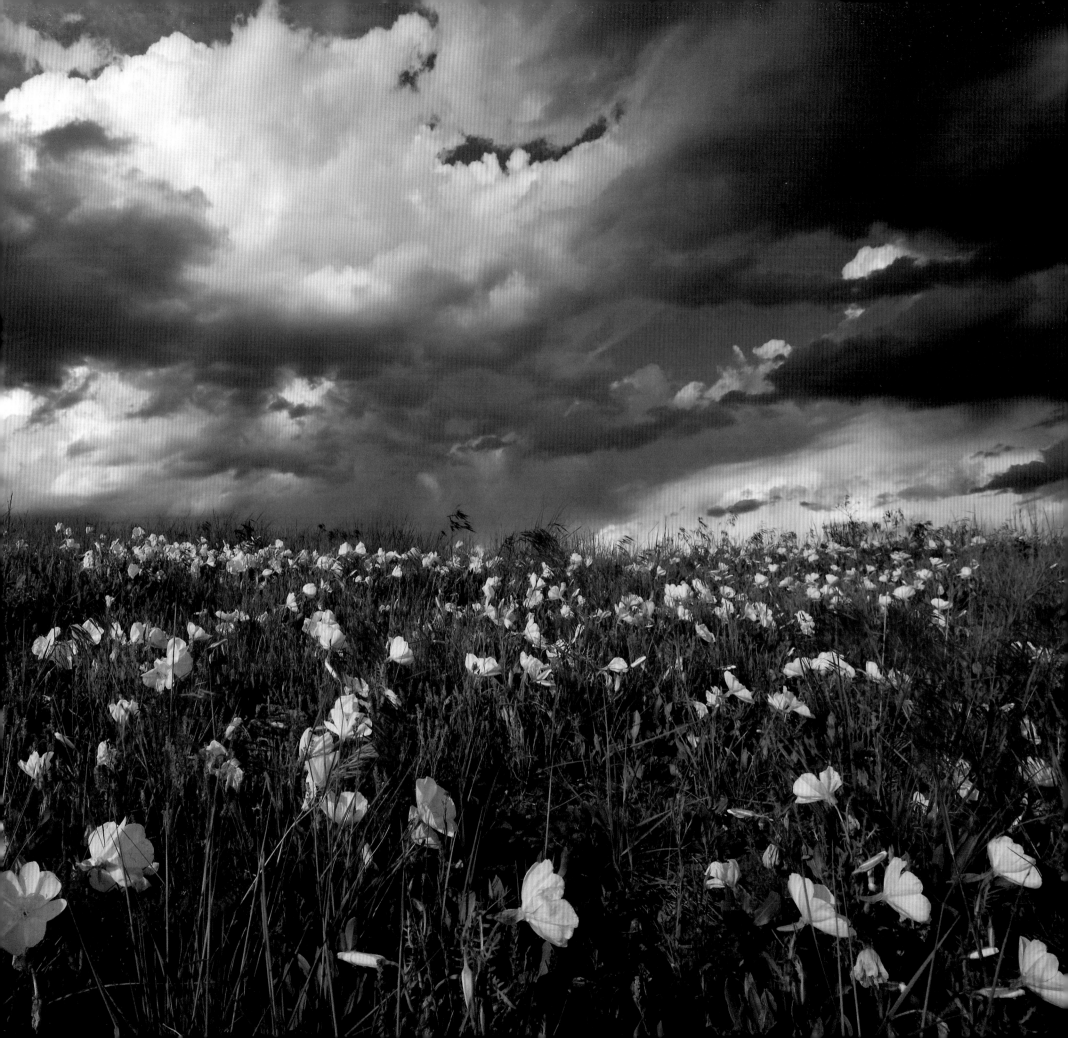

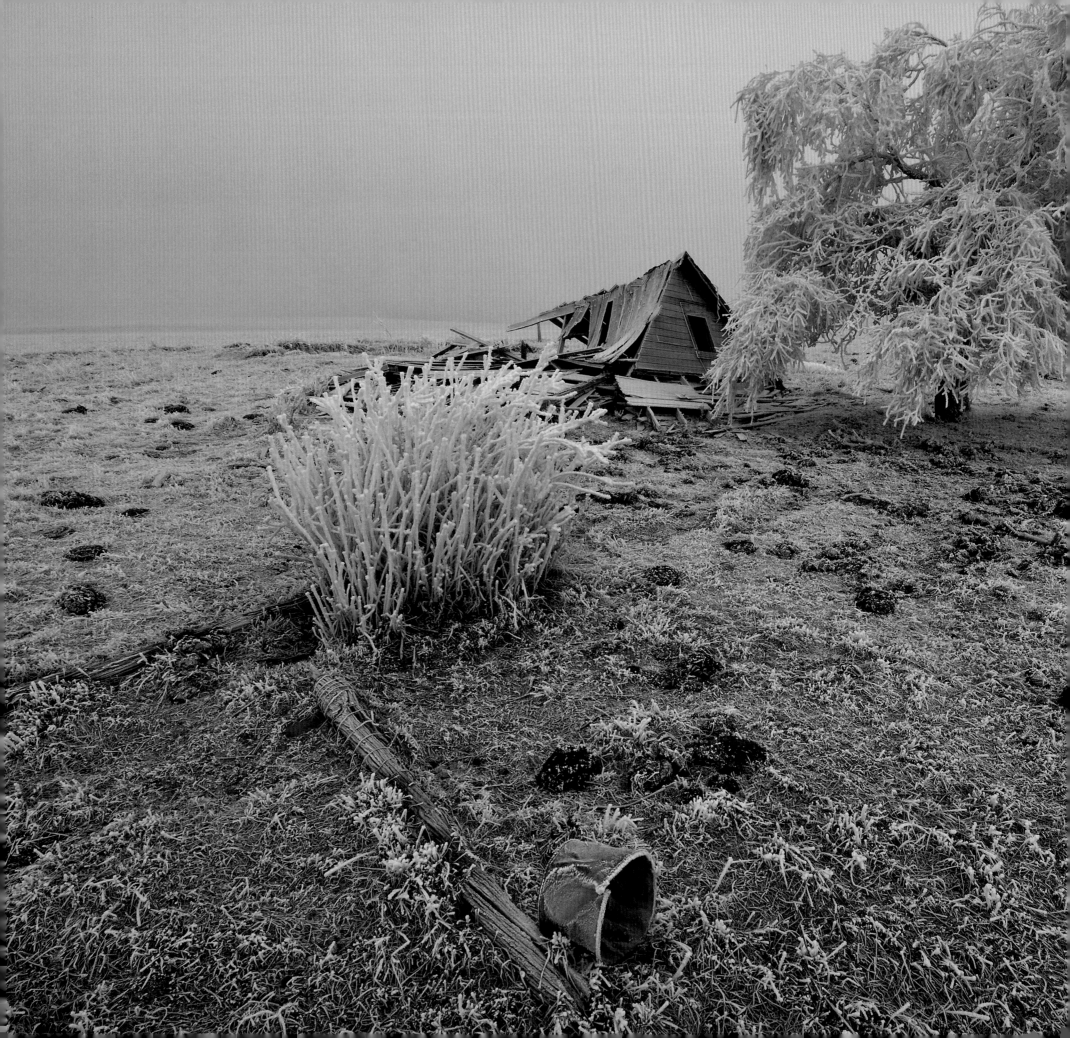

DAWES COUNTY, NEBRASKA

Left: A lone tree standing sturdy in an icy fog may well have been planted by the same early settlers who built this abandoned home. Widespread abandonment of homesteads and small farms reached a peak in the 1930s, but outmigration continues today.

Above: October hoarfrost clings to ponderosa pines *(Pinus ponderosa)* scorched in a late summer wildfire that swept through thousands of acres in the Pine Ridge. Wildfires can destroy or help heal natural communities, depending on the fuel load built up from years of fire suppression and the intensity of the flames.

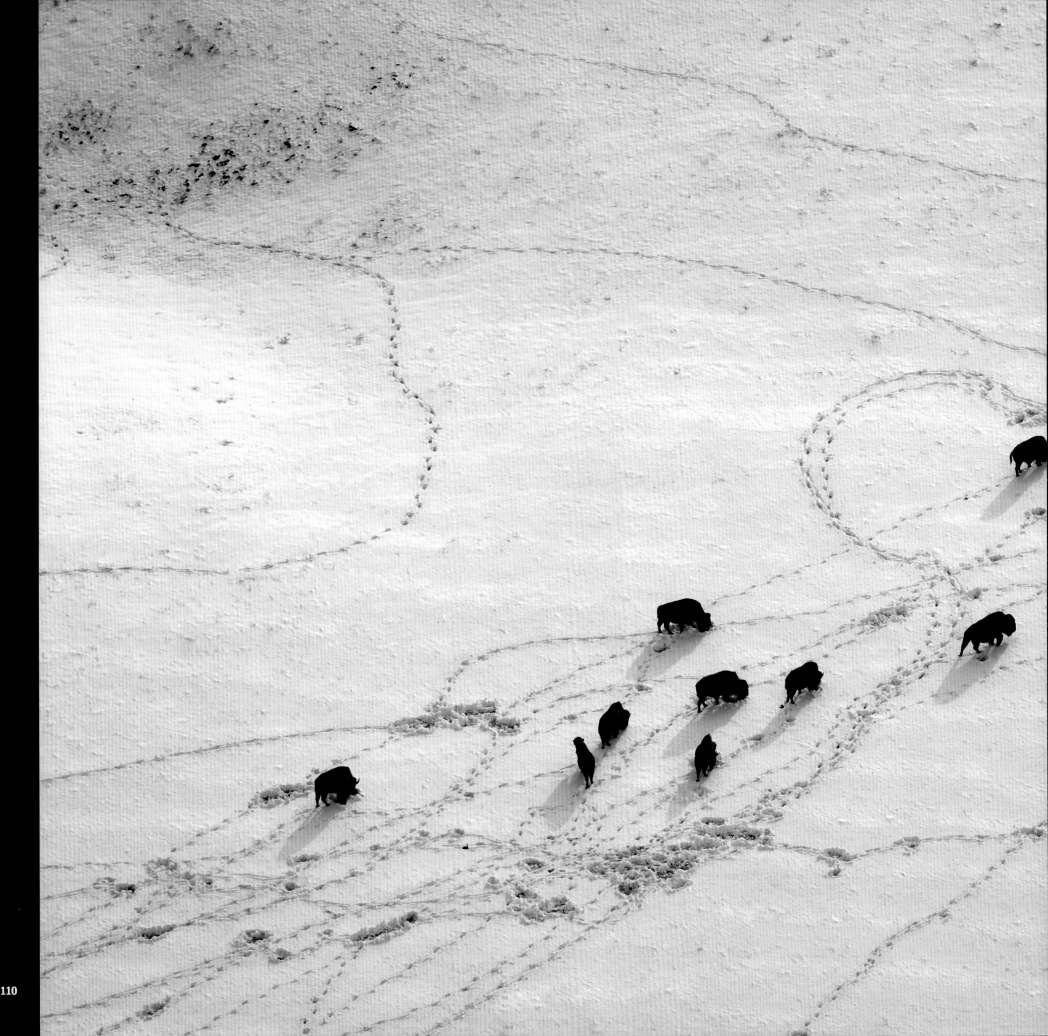

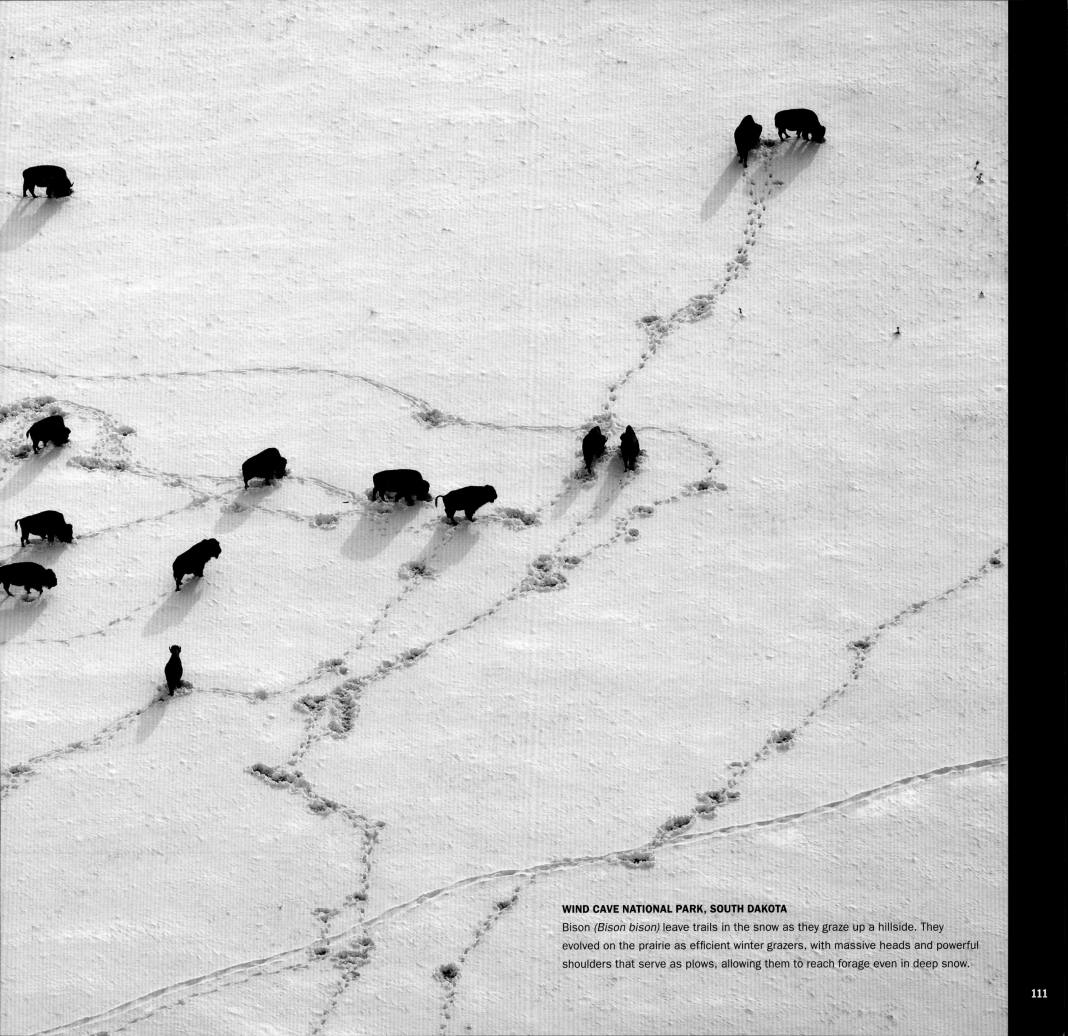

WIND CAVE NATIONAL PARK, SOUTH DAKOTA

Bison *(Bison bison)* leave trails in the snow as they graze up a hillside. They evolved on the prairie as efficient winter grazers, with massive heads and powerful shoulders that serve as plows, allowing them to reach forage even in deep snow.

MEADE COUNTY, SOUTH DAKOTA

A major source of protein to humans on the Great Plains for at least 10,000 years, bison *(Bison bison)* are not adapted for modern slaughter systems. Some Native and non-native buffalo ranchers have begun harvesting in pastures, as is being done here with Dan O'Brien's buffalo on the Broken Heart Ranch. O'Brien and others are working to re-establish bison herds in parts of their historic range.

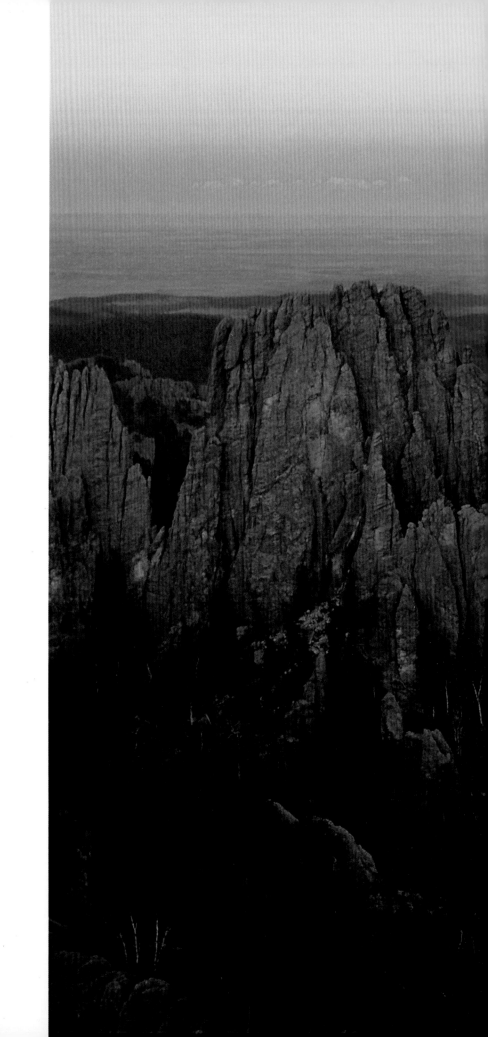

BLACK HILLS NATIONAL FOREST, SOUTH DAKOTA
The Lakota Sioux's *Paha Sapa*, "hills that are black," tower over the surrounding plains in western South Dakota and northeastern Wyoming. Considered the eastern outlier of the Rocky Mountains, the heart-shaped Black Hills range reaches a height of over 7,000 feet above sea level, the highest point in North America east of the Rockies.

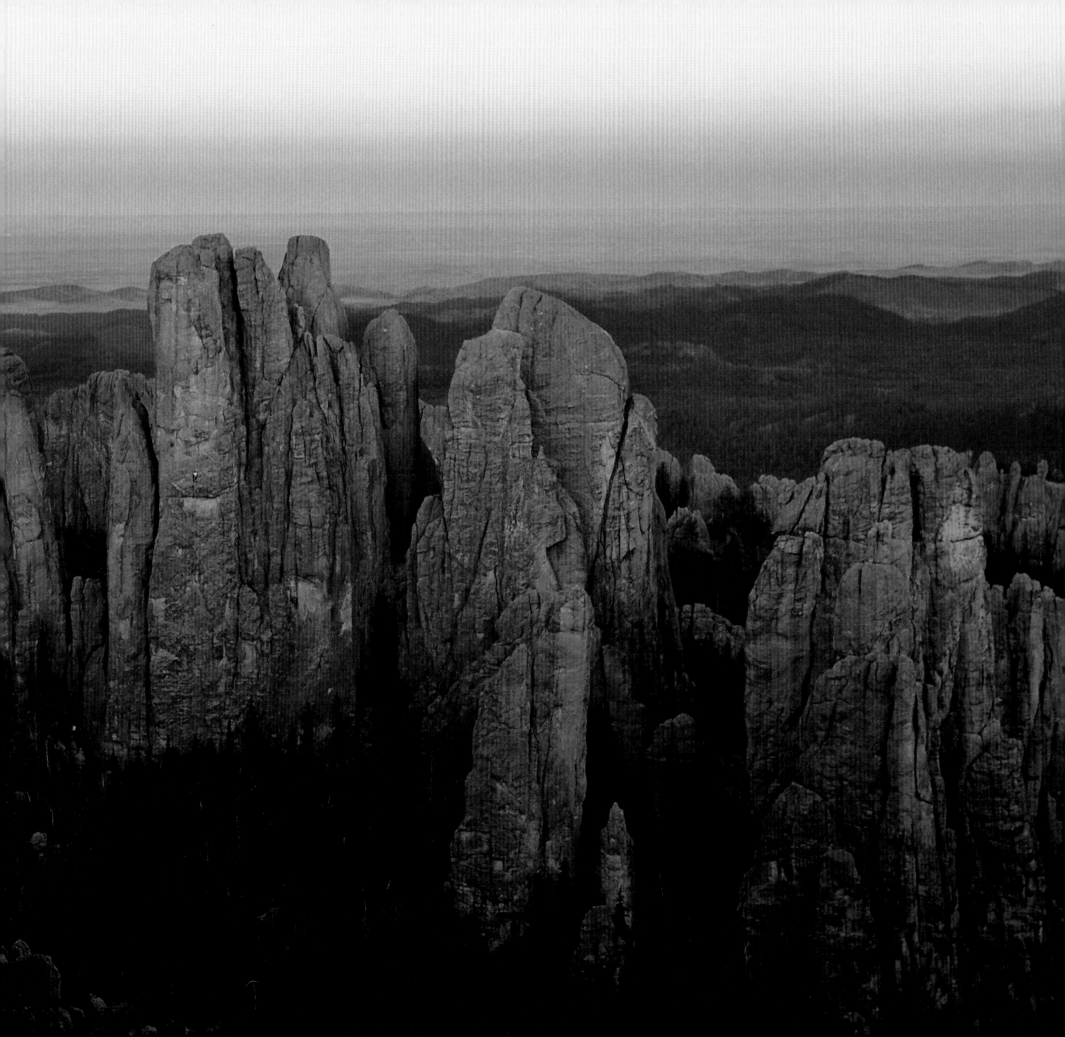

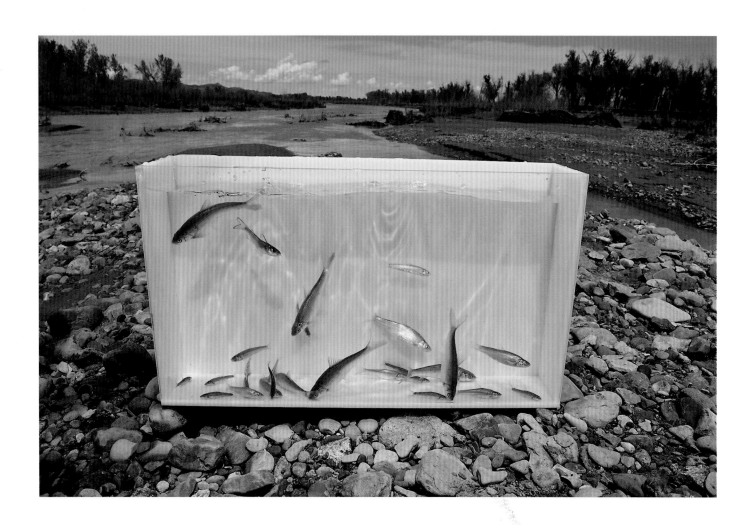

SHERIDAN COUNTY, WYOMING

Right: A growing network of roads supporting coal-bed methane development reach toward the Powder River in northeastern Wyoming.

Above: On a gravel bar in the Powder River, a Wyoming Game and Fish seining crew helps display six native fish species. A major tributary of the Yellowstone, the Powder has remained undammed and supports a diverse native fish community. Until recently, it was considered a healthy remnant of a once unspoiled river ecosystem. Today, scientists are studying the impacts of large-scale coal-bed methane mining on the system.

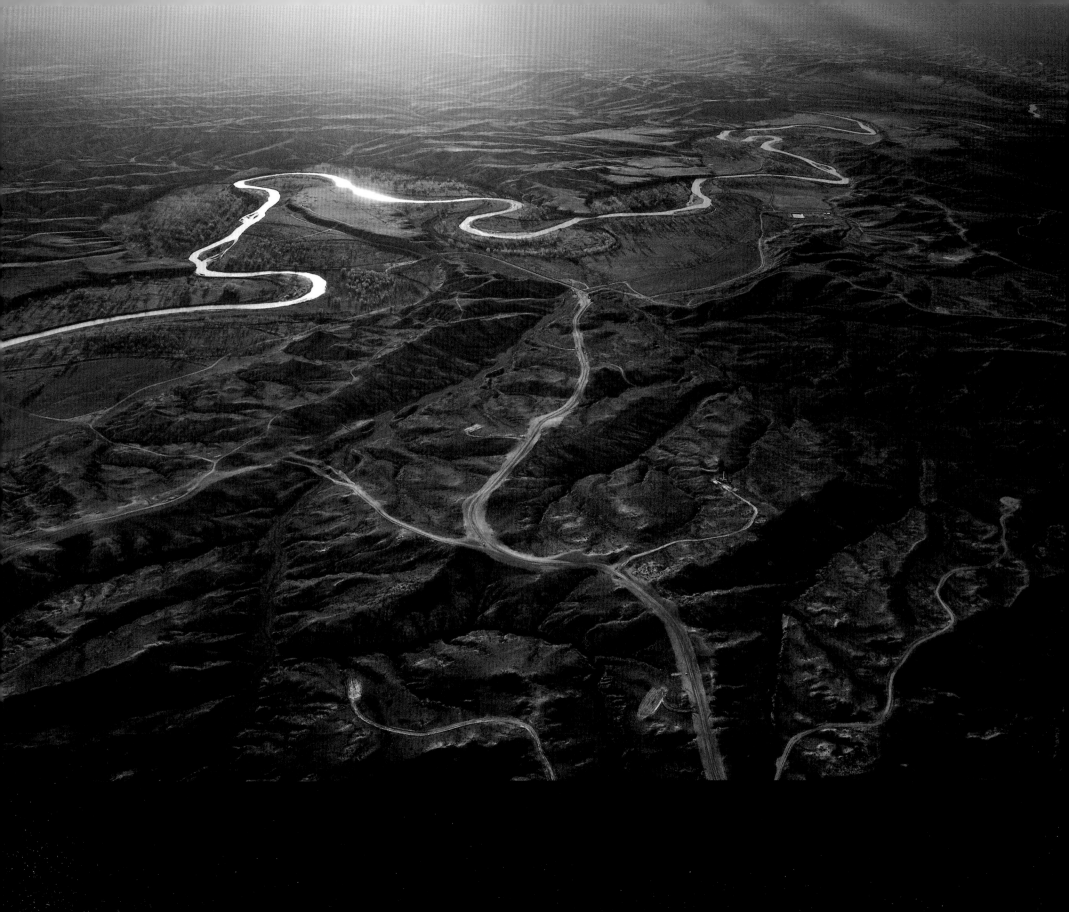

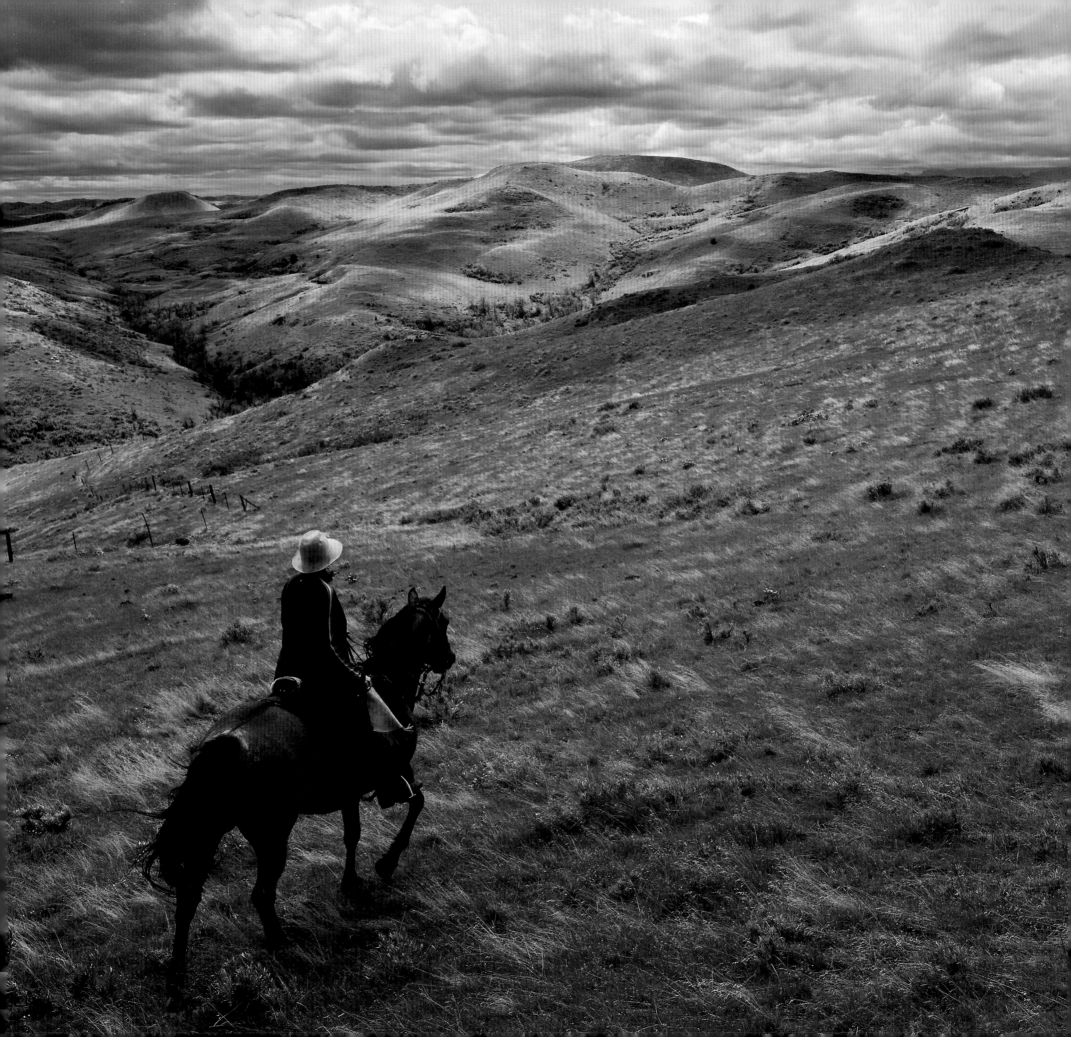

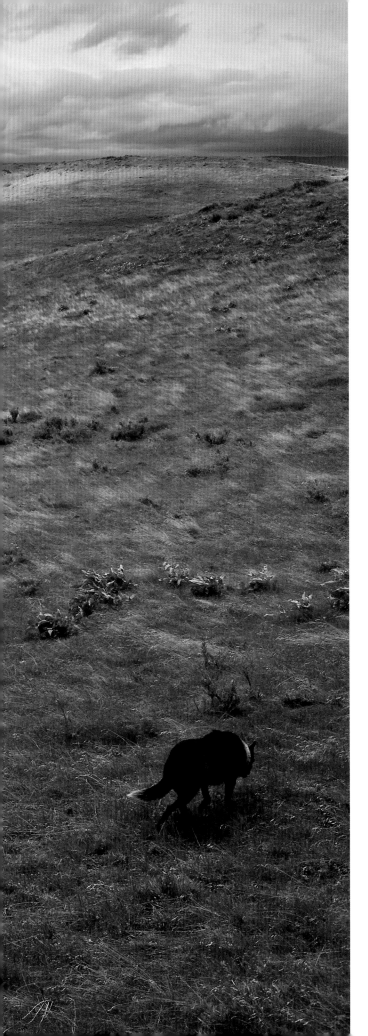

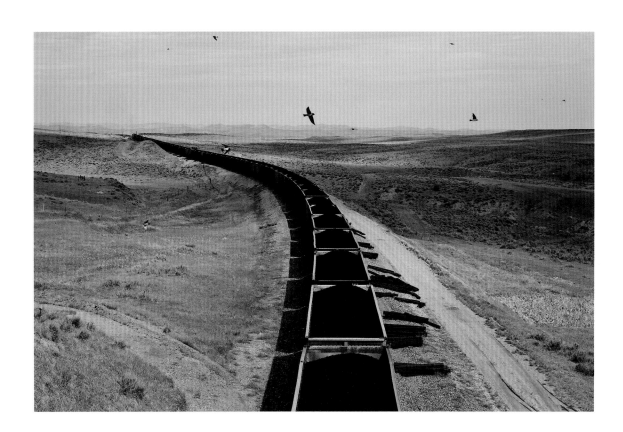

SHERIDAN COUNTY, WYOMING

Left: Rancher and community organizer Jill Morrison surveys a sweeping range of hills on the family land. In many areas of the Plains, landowners do not own the subsurface rights on their properties. Morrison and others with the Powder River Basin Resource Council are giving voice to concerned citizens worried about the impact to both private and public land by continued energy development.

Above: A loaded train hauls 10,000 tons of coal east through the Powder River Basin. Energy-rich Wyoming ranks number one in the country in coal production.

Right: **SHERIDAN COUNTY, WYOMING**
Pronghorn calves *(Antilocapra americana)* usually wait for their mothers in quiet solitude. Today, coal-bed methane compressor stations like this one are part of a growing challenge to that quiet, as are heavy service trucks that kick up dust across freshly minted roads.

Above: **BOWDOIN NATIONAL WILDLIFE REFUGE, MONTANA**
After delivering insect food to its chicks, a secretive Sprague's pipit *(Anthus spragueii)* emerges from its dome-shaped nest deep in the thatch. Endemic grassland birds are declining faster than any other avian group in North America, but efforts to keep large grasslands intact may reverse the trend.

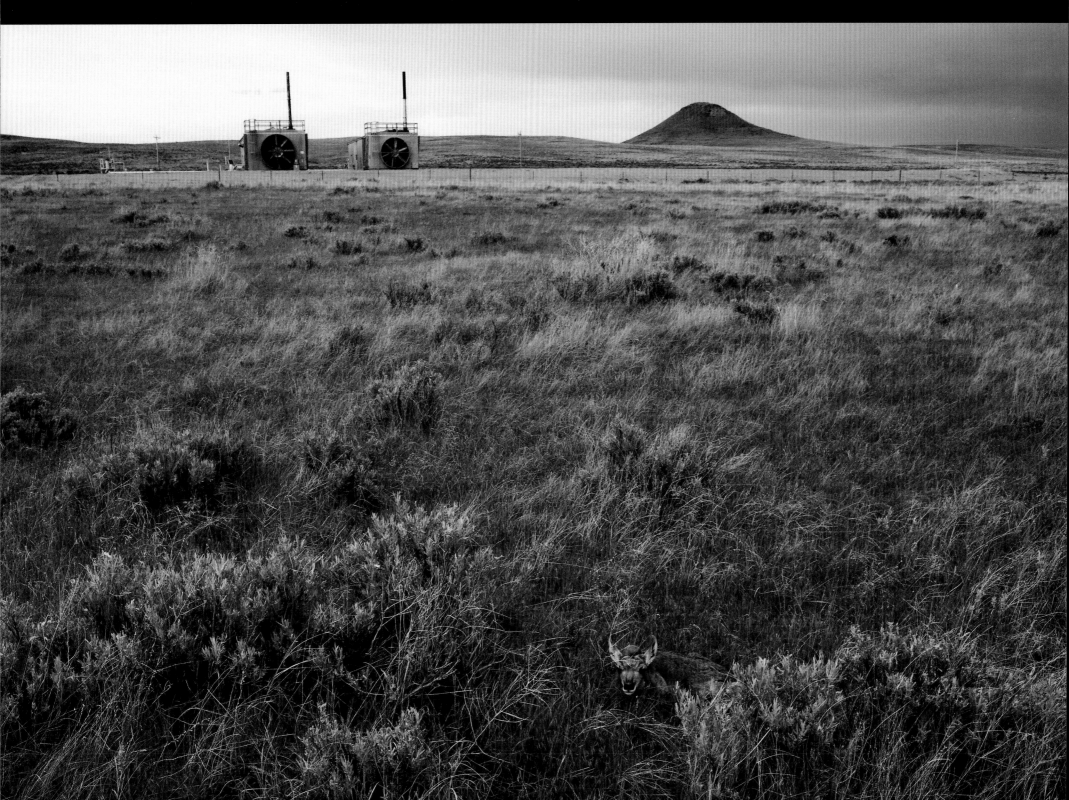

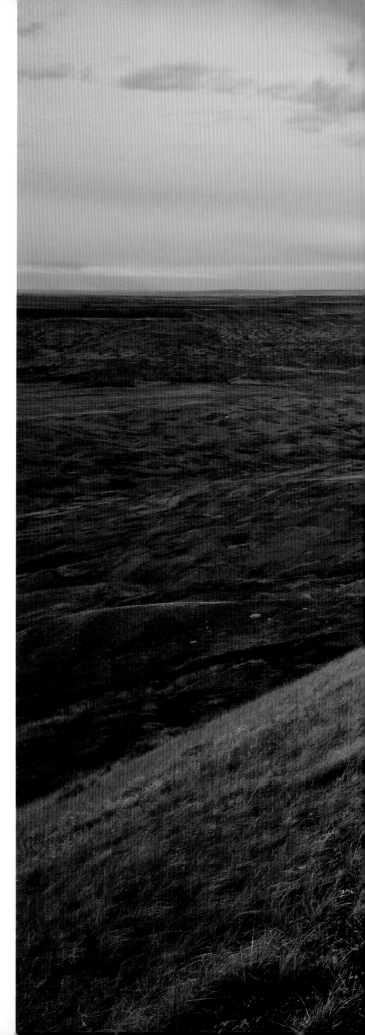

Right: **GRASSLANDS NATIONAL PARK, SASKATCHEWAN**

From the summit of 70 Mile Butte, the deeply dissected plateaus and coulees formed by an ancient glacial meltwater channel stretch to the horizon. Located in southwestern Saskatchewan along the Montana border, the park protects one of the largest tracts of mixed-grass prairie in Canada.

Above: **PEIGAN CREEK CONSERVATION SITE, ALBERTA**

A prairie rattlesnake *(Crotalus viridis)* guards the young in its hillside den. During their reproductive cycles, females may go as long as 20 months without food. In the Northern Plains, this species migrates farther than any other terrestrial snake in the world—up to 32 miles roundtrip.

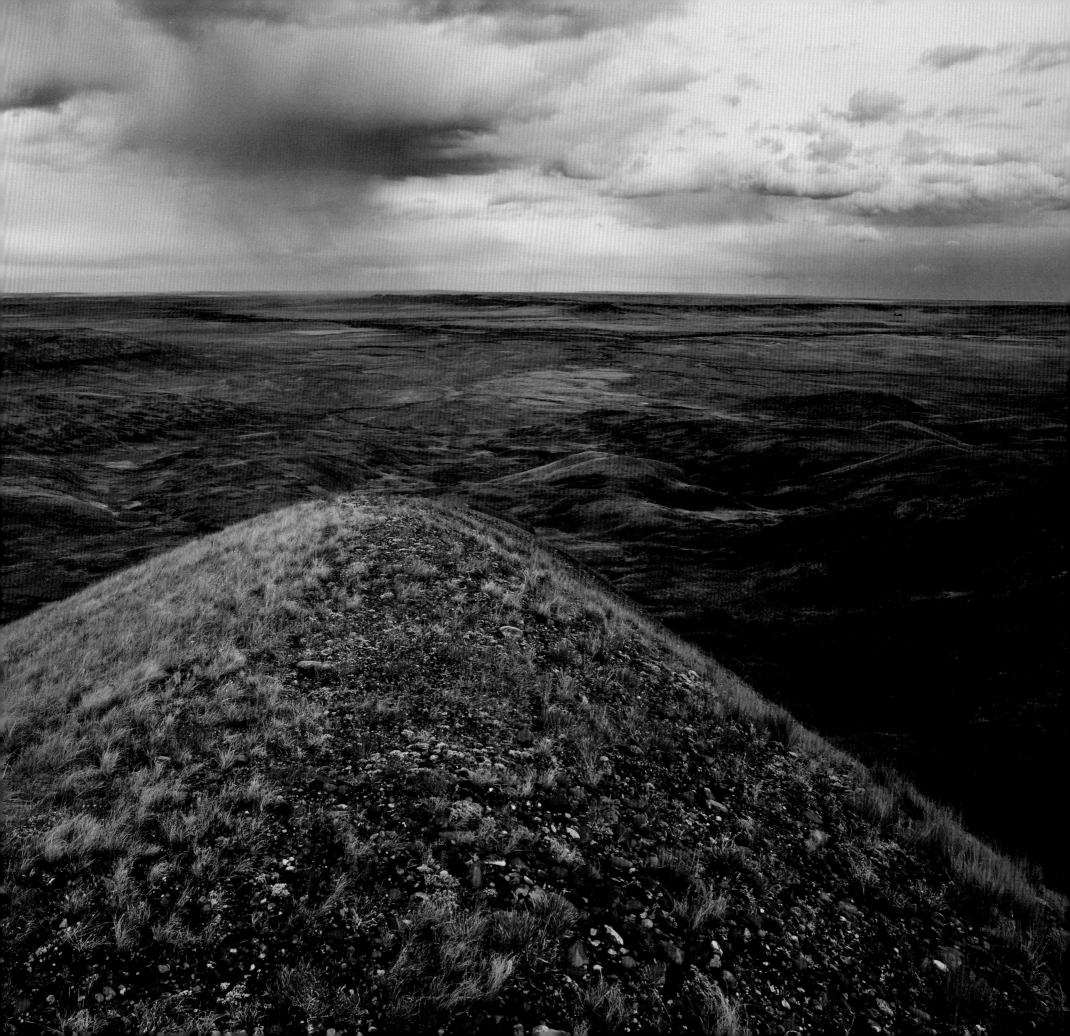

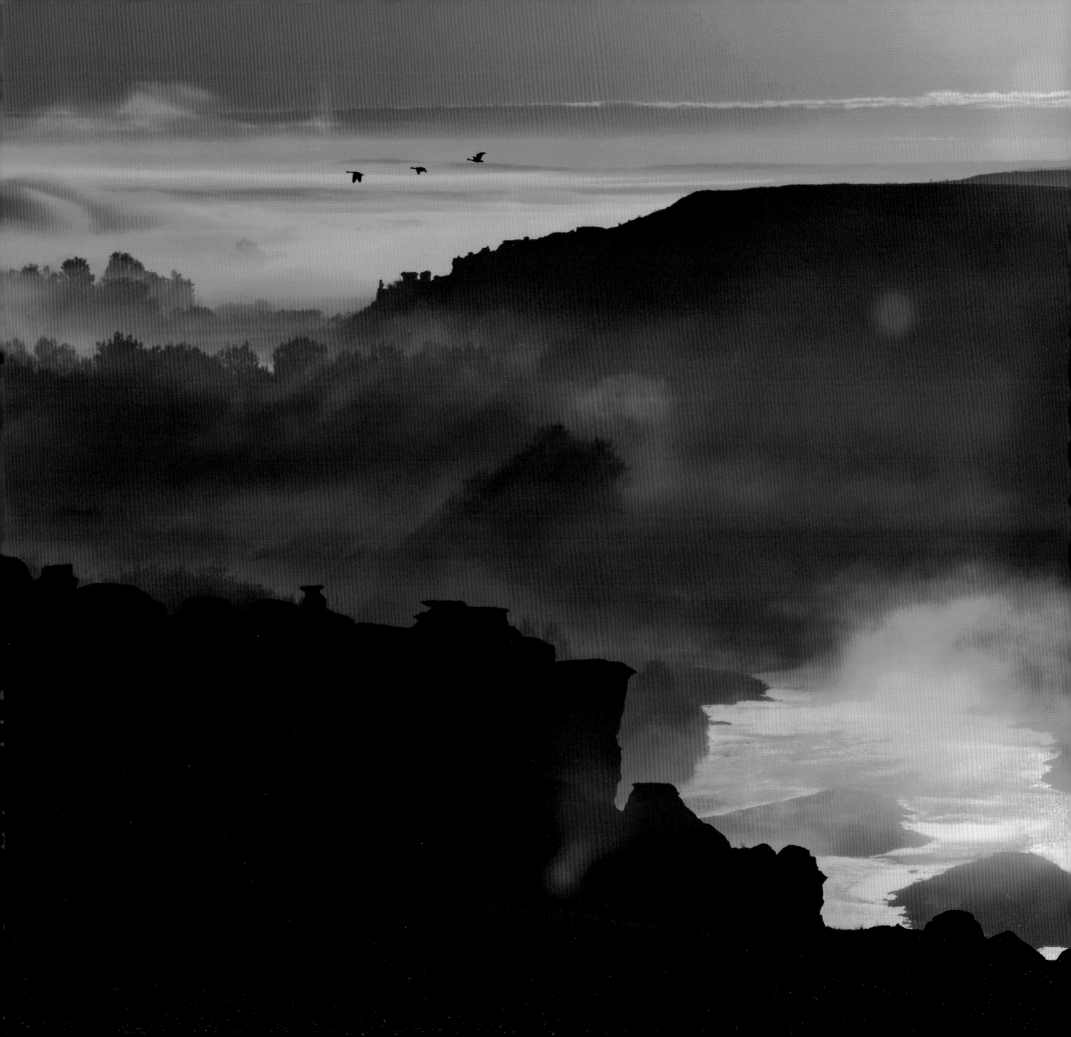

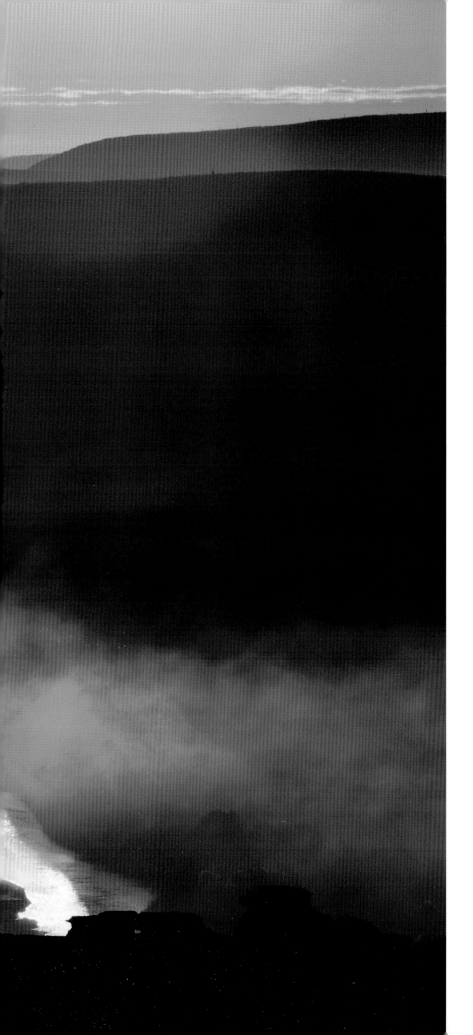

WRITING ON STONE PROVINCIAL PARK, CANADA

In the mist of an early fall sunrise, Canada geese *(Branta canadensis)* dot the sky above the Milk River Valley. The river gets its name from Meriwether Lewis, who described it as "being about the colour of a cup of tea with the admixture of a tablespoon of milk." Native cultures have inhabited this sacred landscape for 9,000 years, and their petroglyphs and pictographs are etched into the protected sandstone walls of the park.

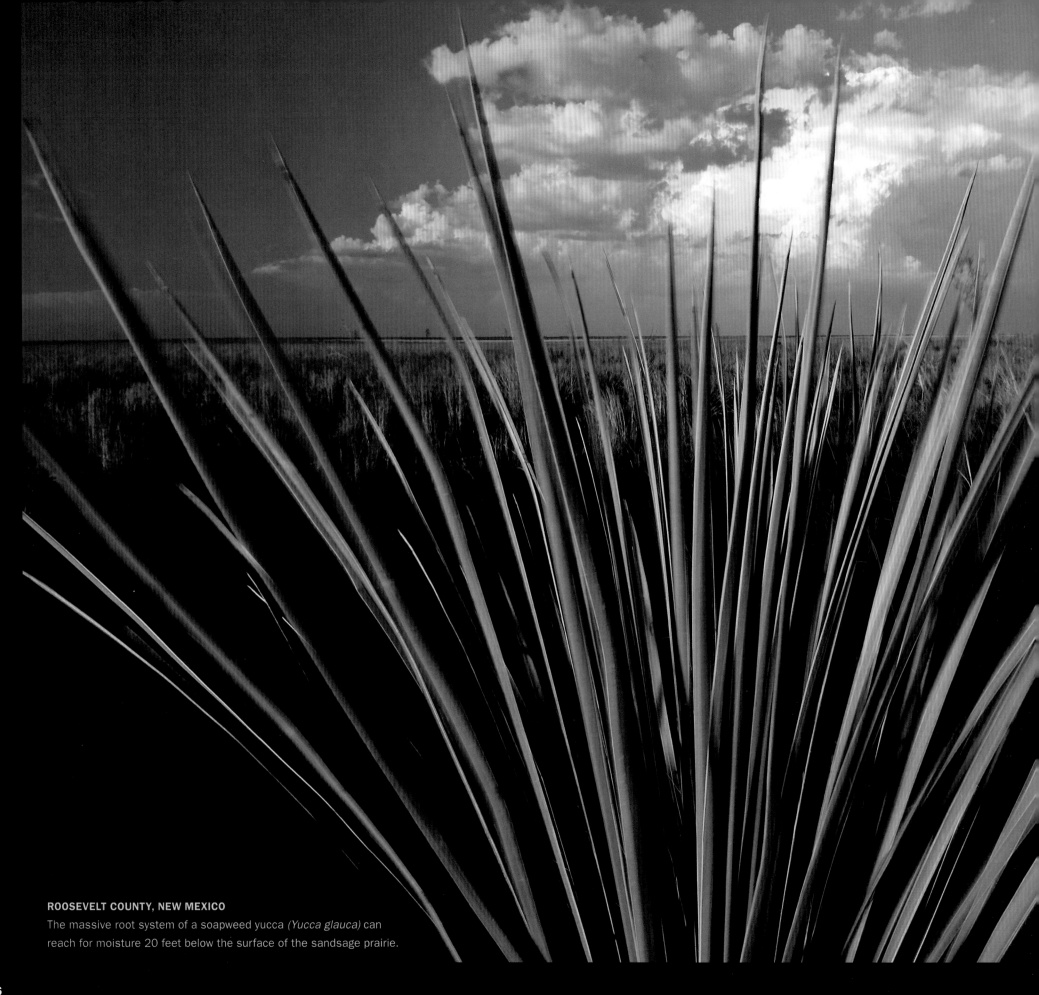

ROOSEVELT COUNTY, NEW MEXICO
The massive root system of a soapweed yucca *(Yucca glauca)* can
reach for moisture 20 feet below the surface of the sandsage prairie.

Next Year Country

IN THE EARLY 1960s geographer Tom Saarinen interviewed more than a hundred wheat farmers from the High Plains of Nebraska, Colorado, Kansas, and Oklahoma in an effort to understand their perceptions of the drought hazard. To a person, they underestimated the frequency and severity of past droughts and exaggerated the occurrence of good years. This optimistic "next year country" attitude, a combination of pragmatism and self-delusion together with a reluctance to learn from the past, is characteristic of the European-Americans who have settled the Southern Plains and who, over the last century and a half, have seen as many failures as successes.

The High Plains, stretching from the northern reaches of Nebraska through the Llano Estacado tableland of the Texas Panhandle, form the heart of the southern Great Plains. The main variation in their terrain comes from numerous shallow playa lakes—21,000 on the Llano Estacado alone. These ephemeral wetland depressions are the primary wildlife habitat in an ecosystem that has been substantially simplified by farming, the once diverse grassland replaced by a monoculture.

Shortgrass prairie, the original vegetation on the High Plains, sustained millions of bison in the early 19th century. Within a few decades, though, the endless bison herds had been virtually eliminated. Overhunting by European-Americans, competition from their horses and cattle for the forage bison needed to survive, and the truncation of the bison's migration patterns by railroads and fences all contributed to the animals' rapid decline.

Indians too were cleared from the Southern Plains to make room for European-Americans. Their treatment was especially brutal in Texas, which simply eradicated resident Indians or expelled them. That is why Texas is almost a blank on the contemporary national map of Indian reservations. In fact, there are few reservations anywhere on the Southern Plains. To the west, the High Plains were opened up in 1867, when the once mighty Kiowas, Arapahos, Cheyennes, and Comanches signed the Treaty of Medicine Lodge Creek and relocated to reservations in Indian Territory (later eastern Oklahoma). In the 1870s and 1880s most of the Indians of eastern Kansas and Nebraska—Poncas, Pawnees, Otoe-Missourias, and Kaws—were also forced to move to Indian Territory.

Even Oklahoma now has only the Osage Reservation. The others were dissolved in the late 19th and early 20th centuries, when the Indians were forced to settle on individual allotments in an effort to break up their communal societies.

In the late 1860s cattlemen filled the space vacated by the removed Indians and

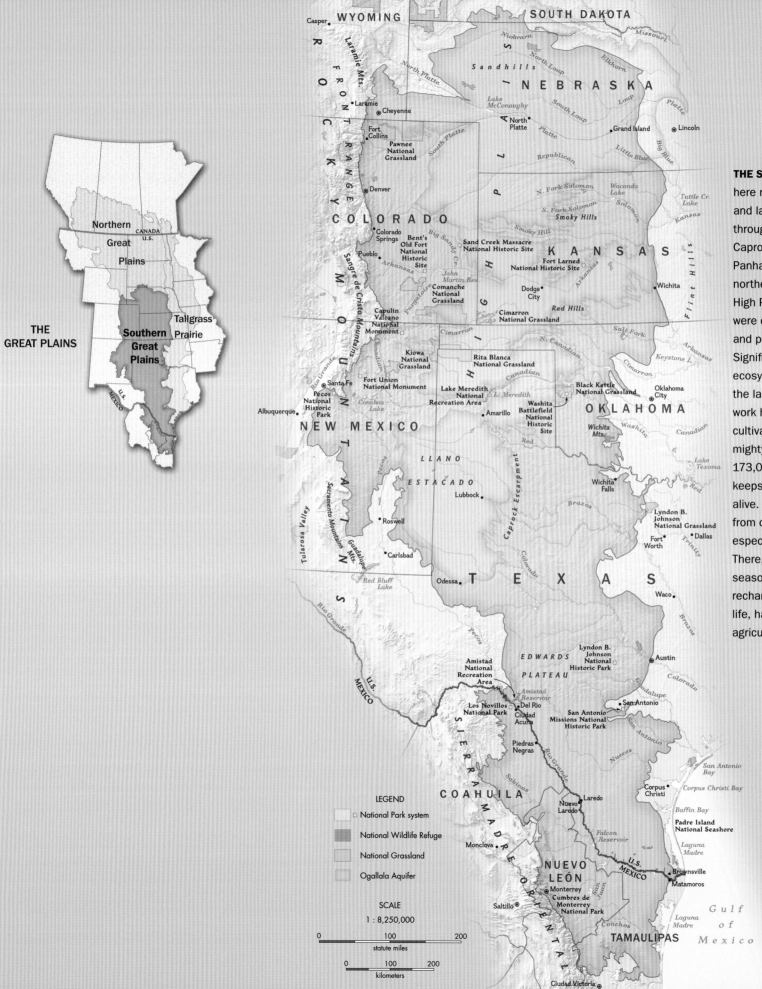

THE SOUTHERN PLAINS as delineated here run south from the rolling prairies and lakes of the Nebraska Sandhills through the Llano Estacado and the Caprock Escarpment of the Texas Panhandle to the desert grasslands of northern Mexico. At their heart lie the High Plains, whose shortgrass prairies were once grazed by millions of buffalo and pocked by vast prairie dog towns. Significant portions of this grassland ecosystem have been lost to the plow in the last century. But farming is optimistic work here, with periodic droughts turning cultivated land into a dust bowl. The mighty Ogallala Aquifer, which underlies 173,000 square miles of the region, keeps large-scale, irrigated agriculture alive. Yet, it too is dwindling in areas from overuse and lack of replenishment, especially in the southern reaches. There, many of the roughly 25,000 seasonal playa lakes that capture rain, recharging the aquifer and supporting life, have been altered or silted in by agricultural runoff.

THE GREAT PLAINS

Northern Great Plains

CANADA
U.S.

Tallgrass Prairie

Southern Great Plains

U.S.
MEXICO

LEGEND

National Park system

National Wildlife Refuge

National Grassland

Ogallala Aquifer

SCALE

1 : 8,250,000

0 100 200
statute miles

0 100 200
kilometers

the diminishing bison herds. They pushed aside the *pastores*, Hispanic sheepherders who had moved onto the plains of Texas and New Mexico at the same time. For the next two decades the Great Plains were integrated south to north by the six million steers that over that period were driven from Texas to railhead towns in Kansas and Nebraska, then on to eastern markets or the fattening ranges of the Northern Plains.

Though it has thrived in the popular imagination, this open range cattle kingdom was only an interlude in the settlement of the Great Plains. Land laws aimed to accommodate not cattlemen but homesteaders and full settlement of the region. Some cattlemen adjusted and secured large holdings by manipulating land laws to gain control of scarce water and therefore the grasslands in between.

By 1870 the railroad grid was thickening in eastern Kansas and Nebraska, allowing settlers to move away from the Missouri River Valley and up onto the fringes of the High Plains. That was where, according to historian Walter Prescott Webb, they halted for a generation, daunted by the semiarid, treeless plains until adjustments — such as barbed wire, which solved the fencing problem, and the self-governing windmill, which turned to face the prevailing wind — were made.

The settlers came with little — in fact that's why they came. Where else could they legally acquire 480 acres of fertile land for only $200, thanks to the Preemption, Homestead, and Timber Culture Acts? They chose land near streams and slowly moved onto the uplands. Wise settlers would arrive in the spring and plant a few acres in corn and potatoes to see them through the winter. Success depended on luck as much as effort: Those who started in seasons of high rainfall and strong crop prices could build a cushion of reserves against the hard times that would inevitably ensue. In the late 1860s and early 1870s conditions were good and rainfall plentiful, and the landscapes of eastern and central Nebraska and Kansas were transformed into a patchwork of farms and small towns. Then, starting in 1873 and continuing for five years, the entire area was desiccated by drought and ravaged by grasshoppers that reduced fields of ripening corn to stalks within minutes. Many settlers gave up and returned East.

Optimism rebounded in 1878 with the return of steady rains and the waning of the grasshopper plagues. Settlers moved up the river valleys and out onto the unfurling plains of western Kansas and Nebraska. Increasingly, they relied on wheat, especially the drought-resistant winter variety, Turkey Red, which had been introduced into Kansas by Russian Mennonites in 1874. There was a brief setback in the dry years of 1881 and 1882, but then, with the railroads in place, settlers advanced rapidly to the western limits of Kansas and Nebraska and beyond into eastern Colorado, the driest section of the Great Plains. "It was almost miraculous," wrote agricultural historian Gilbert Fite, "how a few good rains could change the attitude and outlook of people in an entire region."

There followed a decade of beneficent rains, convincing settlers that the very acts of plowing the earth and planting trees were accelerating the transpiration of moisture into the atmosphere and increasing precipitation. So firm was the conviction "rainfall follows the plow" that many settlers located on the dry uplands, waiting for water to come to them. The experts at the Colorado Farmer journal knew better: They mocked the "rainbelters" and waited for them to fail.

The maximum cultivated acreage in this phase of settlement on the High Plains was reached in 1893, the year a deep drought began and lasted until 1896. Towns only recently full of people and hope were reduced to parallel rows of crumbled foundations and fire hydrants marking the corners of disappeared streets. In the countryside abandoned sod houses were reclaimed by the earth.

After the rains returned in 1897, settlement expanded again, and, like eastern Montana in the north, the panhandles of Texas and Oklahoma became the new frontiers of the early 20th century. At the beginning of the century less than a quarter of the Southern Plains was plowed over, but the increasing availability of less expensive, gasoline-powered tractors after 1910 hastened the plow-up, and the introduction of combines in the 1920s allowed vast acreages of wheat to be harvested quickly. High crop prices during World War One provided additional incentive to plant. Settlers with automobiles became "suitcase farmers" with scattered tracts of land, spreading their risks in a land of spasmodic rainfall and further separating the process of farming the land from any attachment to place.

According to environmental historian Donald Worster, by 1919 11 million acres of native grassland in the area that would become the Dust Bowl had been turned over for wheat cultivation. The plow-up continued in the 1920s even as crop prices fell. When the rains stopped falling in 1930, 33 million acres of bare soil lay exposed to the wind. By 1938 ten million acres had lost five inches of topsoil to the dust storms, and two and a half inches had been scoured off an additional 13 million acres.

People blew away, too: Over the decade of the '30s Oklahoma led the nation with a net migration loss of 440,000, almost a fifth of its 1930 population. "Okies" famously followed Route 66 west, lured by the fruit orchards and vegetable fields of California. The Southern Plains had become the nation's problem region.

The catastrophe of the Dust Bowl — Worster called it "the worst environmental disaster in American history" — prompted federal government intervention in Great Plains farming and land management. The 1933 Agricultural Adjustment Act, which paid farmers not to plant, was the beginning of crop-support programs that have continued in various forms to the present. The Soil Conservation Service subsidized contour plowing, to reduce soil run-off; and listing, in which farmers furrowed their fields counter to the prevailing winds to stabilize the soil. The US Forest Service planted 18,500 miles of shelterbelts to reduce wind

speeds and shield homes and crops. Many of the original shelterbelts survived for decades, providing refuge and corridors for wildlife. Most were taken out in the fencerow-to-fencerow farming frenzy of the 1970s. The 1934 Taylor Grazing Act closed off the range to homesteading and established grazing districts and policies that, in amended form, are still in effect today. In all, during the 1930s the Southern Plains, conventionally hostile to big government, received more federal aid per capita than any other region in America.

When the rains returned after 1940, land was put back in dryland wheat and also increasingly planted in irrigated corn and cotton, courtesy of Ogallala Aquifer water. The Ogallala Aquifer — 2,908 million acre-feet of water underlying 173,000 square miles of the Great Plains from southern South Dakota to West Texas — had been " discovered" by geologists N. H. Darton and Willard Johnson at the turn of the century. Settlers' windmills tapped into it, but they could only draw water from a depth of 30 feet belowground and irrigate 10 acres at most. Around 1940, though, new drilling and pump technology allowed water to be taken from a depth of 300 feet. The amount of irrigated land on the Southern Plains increased from 2.1 million acres in 1940 to 13.7 million acres in 1980, a total that has not changed significantly since.

Southwest Kansas and other large sections of the Southern Plains have been metamorphosed by this "climate-free" farming. Center pivot systems extract and distribute water from the aquifer at a rate of a thousand gallons a minute, creating circular fields of green in an otherwise tawny landscape. Soils long since drained of their natural fertility are now just a medium for fertilizer application. Roads are congested with trucks carrying grain, cattle, farm equipment, and anhydrous ammonia tanks for fertilizing. Massive feedlots furnish cattle to nearby packing plants. And Hispanics, and to a lesser extent Asians, provide cheap and willing labor in the plants and increase the population and ethnic diversity in the towns.

The Ogallala Aquifer is fossil water, an endowment from streams that millions of years ago extended from the Rocky Mountains into the Plains. The aquifer's natural recharge from rivers and from drainage through the cracked-clay bottoms of playa lakes is about one acre-foot a year, far less than the amount extracted for irrigation. Essentially a nonrenewable resource, the aquifer was diminished by about 6 percent of its stored drainable water from 1940 to 2000.

It is the geographic specifics of this depletion that are of consequence. Nebraska, where the aquifer is deepest and nearest the surface, actually experienced an increase in stored drainable water from 1950 to 2000, mainly because of seepage from irrigation flow. But in the Texas Panhandle over the same period, stored drainable water declined by 124 million acre-feet. The falling water table in the Texas Panhandle and in adjacent New Mexico is now more than 300 feet below ground level, and the deeper the well the higher the energy costs required

to draw water to the surface. Irrigation here clearly has a limited future.

At the regional scale, the depletion is occurring from south to north, reflecting the length of time irrigation has been practiced in a given area. Locally, there is great variation in the accessibility of groundwater, giving rise to oases of agriculture, industry, and population growth where the water is available and large depopulated expanses where it is not. In the places where the water table has fallen, wetlands dry up and groves of cottonwoods are literally left high and dry, looking like skeletons on the land.

The rate of aquifer recharge also may be decreasing because of the demise of the playa lakes. The playas depend on localized spring and summer thunderstorms for their water. They collect about 90 percent of the precipitation runoff and supply about 80 percent of the aquifer recharge in the Texas Panhandle. But they are rapidly being filled by sediment from surrounding cropland. If this is allowed to continue, then the playas could all be gone within a century. This would be disastrous not only for the Ogallala Aquifer but also for the 246 plant species, 37 mammal species, and almost 200 bird species that are associated with the playas, including the estimated 2 million ducks, 600,000 geese, and 500,000 Sandhill cranes that winter over in wet years. Efforts to preserve the integrity of the playas include contour farming to reduce soil displacement, sheltering the lakes in the Cropland Reserve Program, and creating surrounding buffers of natural vegetation. With almost all the playas located on private land, their conservation ultimately depends on the decisions of individuals.

Farmers and other residents of the southern reaches of the region are well aware the water that has sustained them for 70 years is running out. In fact, western Kansas's groundwater districts have long followed a policy of "planned depletion." Water consumption has been cut, as restrictions have been placed on the installation and spacing of new wells, and improved delivery methods, such as irrigation scheduling and low-pressure overhead sprinkling, have been introduced. Conservation groups like the Playa Lakes Joint Venture, working with Ducks Unlimited and The Nature Conservancy, are dedicated to preventing the elimination of these essential wetlands.

Caught in the pressing demands of the short run, many farmers oppose restricting water consumption. Meanwhile, ethanol plants, which use from three to six gallons of water to produce a single gallon of ethanol, are being constructed throughout the High Plains. To exacerbate the situation further, climate models predict future declines in soil moisture over the Southern Plains in coming years. That will encourage a more intensified use of the aquifer while further reducing recharge. It seems that, like the open-range cattle kingdom, the era of widespread aquifer irrigation may prove to be only a spectacular interlude in the settlement of the Southern Plains.

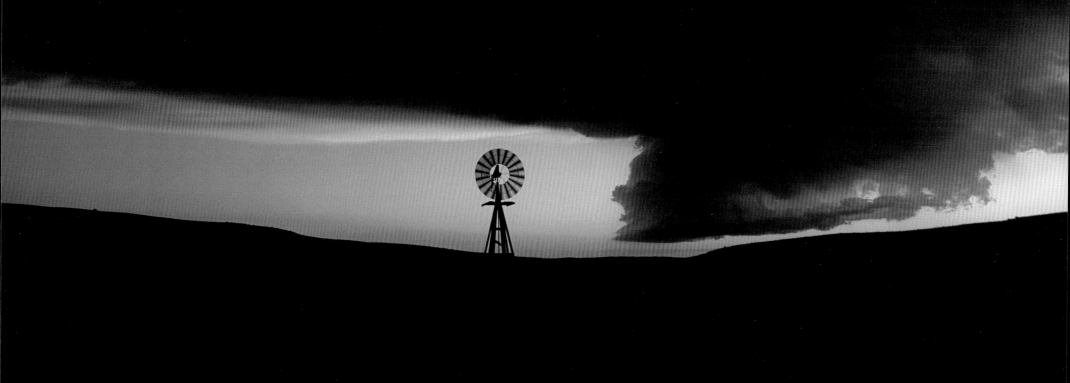

GRANT COUNTY, NEBRASKA

In the Nebraska Sandhills, a gust front rushes forward from a wall cloud and sets a windmill spinning. Wall clouds warn of intense storms on their way and often spawn tornadoes.

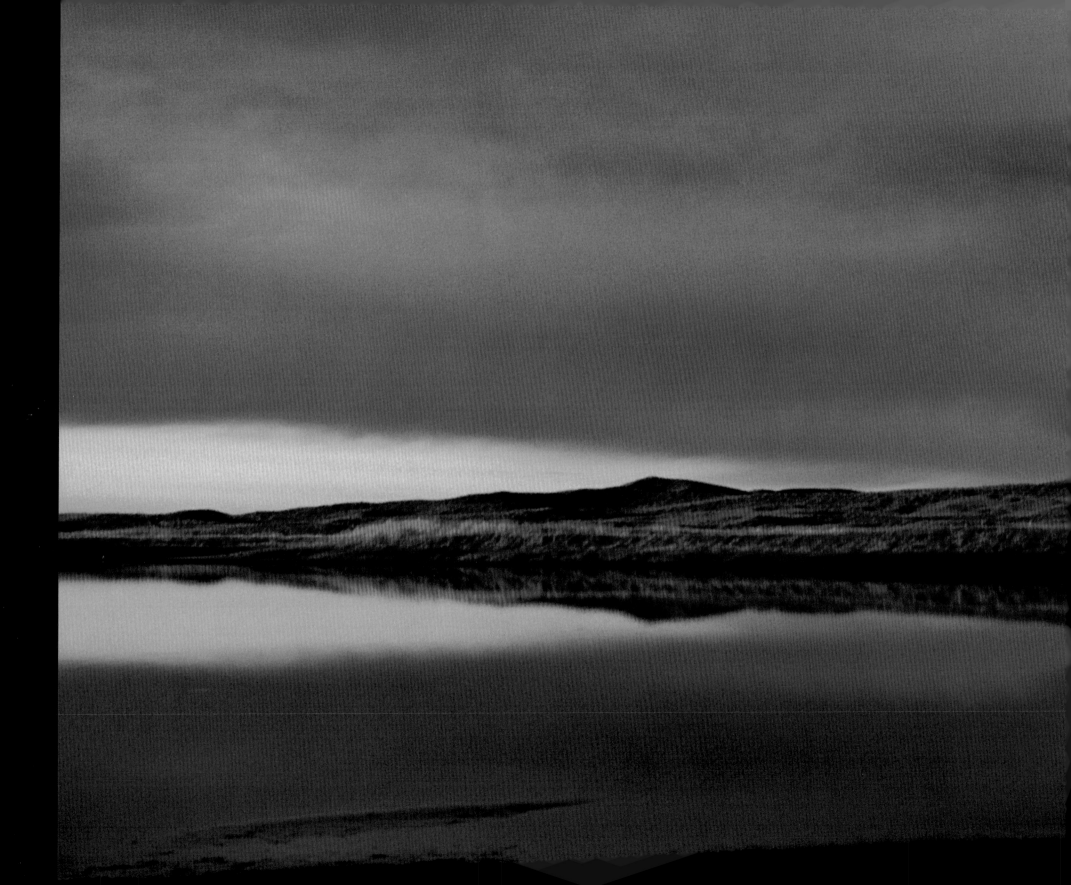

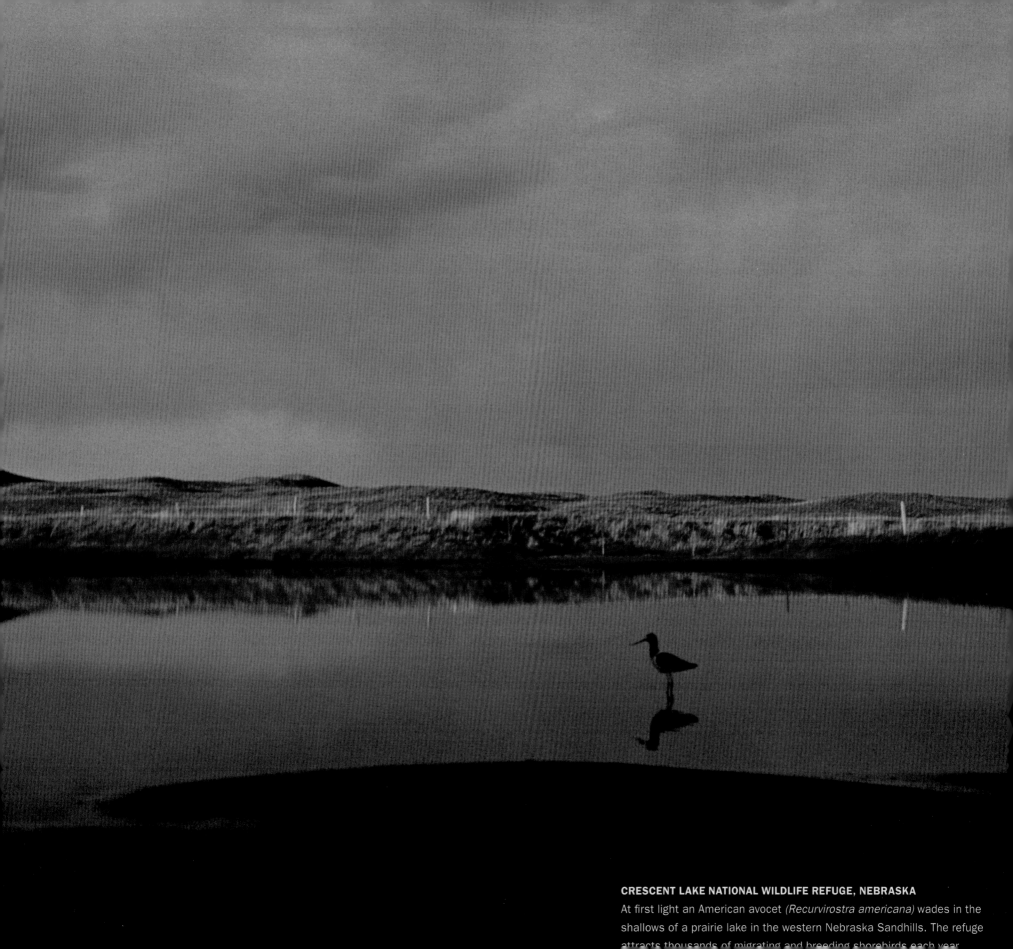

CRESCENT LAKE NATIONAL WILDLIFE REFUGE, NEBRASKA
At first light an American avocet *(Recurvirostra americana)* wades in the
shallows of a prairie lake in the western Nebraska Sandhills. The refuge
attracts thousands of migrating and breeding shorebirds each year.

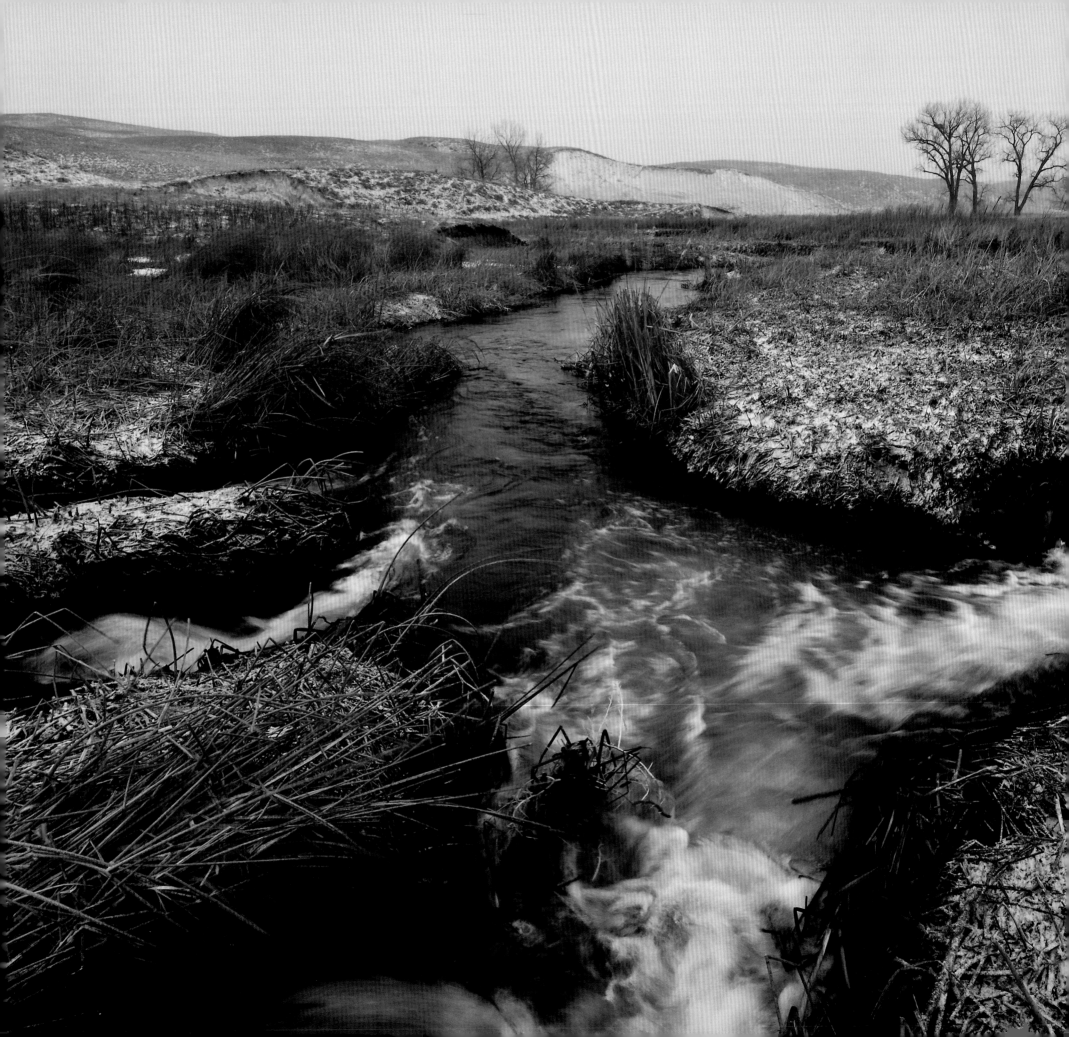

Field Journal: Blue Creek
NEBRASKA SANDHILLS

FEBRUARY 21, 2008

6:30 PM Whenever I come off the high flat and drop down into the Blue Creek Valley, I can usually spot the glow of the Peterson ranch house welcoming me. I've been friends with Myron and Kay Peterson for a dozen years, but tonight I'm not in their warm house. I'm in a small blind, a one-person bivy shelter that I've anchored in tall grass along the edge of a high bank on their land, looking down on Blue Creek. It's overcast and cold, but a lot of animals are coming to the water this evening.

A half hour before sunset, four whitetailed deer come trotting down a grassy draw and into a ring of trees. A coyote that had been howling earlier finally shows up, following a scent along the meander of the creek. At one point it's so close I can hear each footfall crunch in the snow. At twilight the cackling Canadas come in. The smallest race of Canada geese, they're not much bigger than a mallard, but they come roaring in like a squadron of jets. Sideslipping overhead, they tilt their wings to dump air quickly and lose altitude on their way to the dark waters of the creek.

8:00 PM It's been quiet the last hour, but I just heard a solitary trumpet from a swan far downstream. I sit up and peer out the hole in the blind. Finally, I can just make out six huge white shapes descending like angels in the night.

1:10 AM Nothing but darkness now. I can hear the occasional plaintive notes of the swans, the murmurings of geese, and the chatter and whistle of ducks that together rise and fall throughout the night on the roost. Around midnight there had been a particularly large splash and a flurry of wings, but by the time I sat up and looked out of a small hole in the blind, the only thing I could see was the Big Dipper balancing on the eastern horizon, its reflection shimmering in the water from the commotion.

6:30 AM Slept hard till about 6 am. When I wake up, frost coats everything inside the blind, and fog lies so thick on the water that it turns the world to gray. Then, for an instant the fog brightens and glows pink. In the half-light of dawn, three trumpeters appear out of the foggy haze. They are surrounded by geese, bathing and drying their wings, preparing for their morning flight.

Left: Running water fed by powerful springs from the Ogallala Aquifer cascades along Blue Creek in the western Nebraska Sandhills, where the aquifer is at its deepest. *Above:* A Canada goose (*Branta canadensis*) stretches its wings.

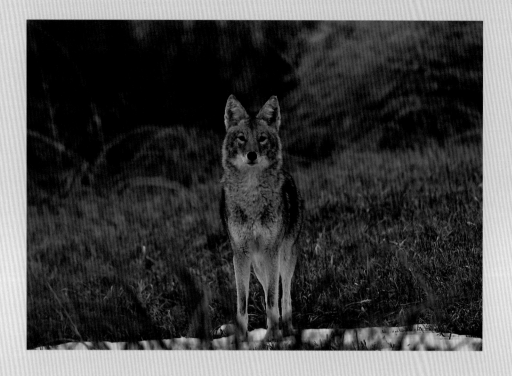

Canada geese *(Branta canadensis)* and a common merganser *(Mergus merganser)* mingle on the roost during an icy morning in early January (right). Open water in winter draws ample wildlife, including predators like this coyote *(Canis latrans)*.

winter, the curlews herald the coming of spring. As tall as a large hawk, they have long, cartoon-like curved beaks that look better engineered for probing in the surf of their wintering grounds on the Texas Gulf Coast than for stabbing at grasshoppers in the prairies of the Great Plains.

"When the curlews show up, you can just about count on three more snowstorms," I remember Myron telling me once. "But we like them anyway. When they're here, we know it's about spring."

FEBRUARY 23

12:24 AM I've fallen off to sleep when the wind wakes me. I can hear more flocks of Canadas flying in from high in the sky. They circle above, calling and calling, listening for a reply. Usually one lone goose among the roosting flock calls out to them in response. When the geese overhead hear it, they call back. Then their voices volley back and forth between ground and sky until the sound is muffled by the swoosh of incoming wings. As the newcomers splash into the water, a choir of voices rises in crescendo, as if welcoming their kin home.

6:40 AM The wind is a constant roar as it rolls over the hills, coming in surges like waves pounding the prairie sea. With just enough light to see, I look out on the roost. It has grown to at least three times the size it was last evening. I recognize many of the individual geese from the night before by their markings—the one with the white band across its breast, the one with the white spot on the right side of its neck. But the rest are strangers to me, weary travelers sequestered in their own flocks, scattered around the creek.

FEBRUARY 25

Yesterday afternoon bigger flocks of waterfowl started to gather on the pasture near the creek. The pattern continues this morning. The Canada geese are behaving with the sense of urgency I have seen before with migrating flocks of Sandhill cranes on the Platte River, just before they decide to continue their migratory journey to northern breeding grounds. Myron notices it, too. He thinks the geese will be gone soon. They're usually gone by early March, about the time the curlews begin to arrive. The first sighting of curlews is a noteworthy day for ranchers. Just as the fall flocks of migrating geese are harbingers of

DECEMBER 8

I've gotten a call from Myron's wife, Kay, saying the geese have just come in and the trumpeter swans have been around about a week. It's snowing and frigid out—zero degrees, ten below with the wind chill—but I head to the Peterson's ranch. A day later I'm standing in the pasture overlooking Blue Creek. I can count 18 swans up and down the creek, half of them adults, half juveniles. Myron says they're roosting mostly on Rattlesnake Pond, east of the ranch house. Fed by springs, the pond water stays open for a while in early winter. But with the kind of temperatures we're having, it will freeze soon.

I spend the midmorning putting in a small makeshift blind concocted of garden fencing and prairie grass at the edge of the pond. It's just big enough for me to sit in and curl up to keep warm. The swans and geese are off feeding somewhere along the creek, and when I finish the blind, I sit in it the rest of the day, waiting

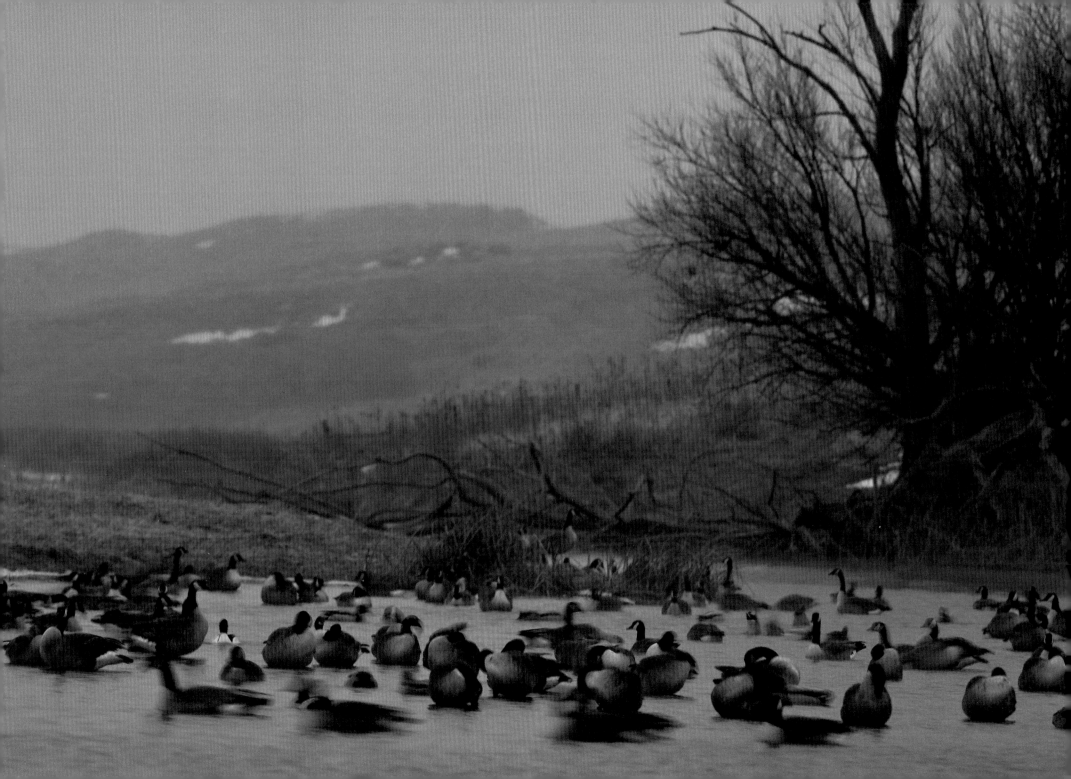

Fog envelopes trumpeter swans *(Cygnus buccinator)* and Canada geese *(Branta canadensis)* at first light. At four feet tall and up to 35 pounds with a wingspan of seven feet, trumpeter swans are the largest waterfowl species native to North America. Early protection measures and recent recovery efforts have helped them make a comeback in parts of their range. *Right:* Harbinger of spring, a long-billed curlew *(Nemenius americanus)* moves through the Sandhills prairie during a late season snowstorm.

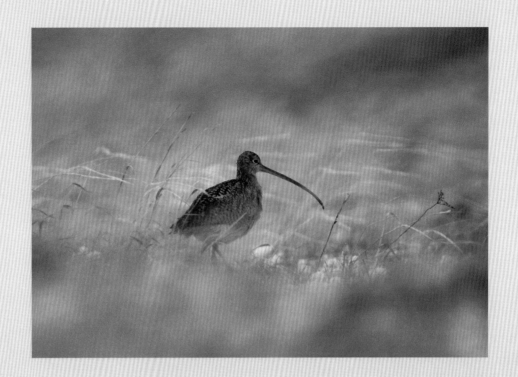

for them to return. And waiting. The sun sets and my hands are numb, but the pond is still empty. When it's near dark, I give up and head back to my truck just as the swans glide in, cutting through the thick, ice-cold air right above me.

DECEMBER 9

At first light I work down a draw and belly crawl into the blind. I can see eleven swans roosting. Yesterday, the blind was in a perfect position, right on the intersection of the ice and open water—the place swans typically like to roost at night and loaf midday. But now the blind is nowhere near that spot. The continued subzero cold has marched the ice margin all the way west across the pond, 20 feet beyond where it was last night. Only a small hole of open water is left, about ten feet by ten feet across, and the swans are roosting around that opening. The blind is useless now. The only way I can see the birds is to crawl outside the blind and lay on my belly in the snow, shooting through the prairie grass and bullrush along the high bank. So that is where I lie and wait.

Once the sun rises above the eastern horizon, fog starts to form and creep across the frozen pond like dry ice does on a theatre stage. In the gathering light, the swans begin to stir, and I watch a solo performance.

One young swan rises up from the ballet of roosting swans and wades into the open water. For a full five minutes it works in clockwise fashion around the edges of the hole, splashing water over itself, submerging and re-emerging, pressing its breast and feet on the edge of the ice and breaking off chunks, as if it were trying to make the hole bigger. Then it shakes itself off, hops up on the ice, preens its feathers, and sits back down next to the rest of its sleeping kin, tucking its head underneath its wing.

With that drama over, I suddenly realize how cold I am. Parts of my hands, arms, and feet are starting to sting, and what isn't stinging is numb. Then, as if my body were making a final attempt to stay warm, a sudden flush runs through my extremities all the way to my fingers and toes, like someone running warm water down a pipe. It only lasts for a moment, but that is enough to warn me it's time to leave.

Trying hard not to make a sound, I belly crawl in a series of stops and starts, backing away from the pond down the gentle slope of the prairie. When I reach a shallow draw that hides me from the swans, I stand up and look back at my tracks in the snow. They're something like the tracks a sea turtle leaves on the beach. As I dig snow out of my cuffs and boots, the sun comes out. Back at the pond, I can hear the swans splashing, trumpeting in the new day.

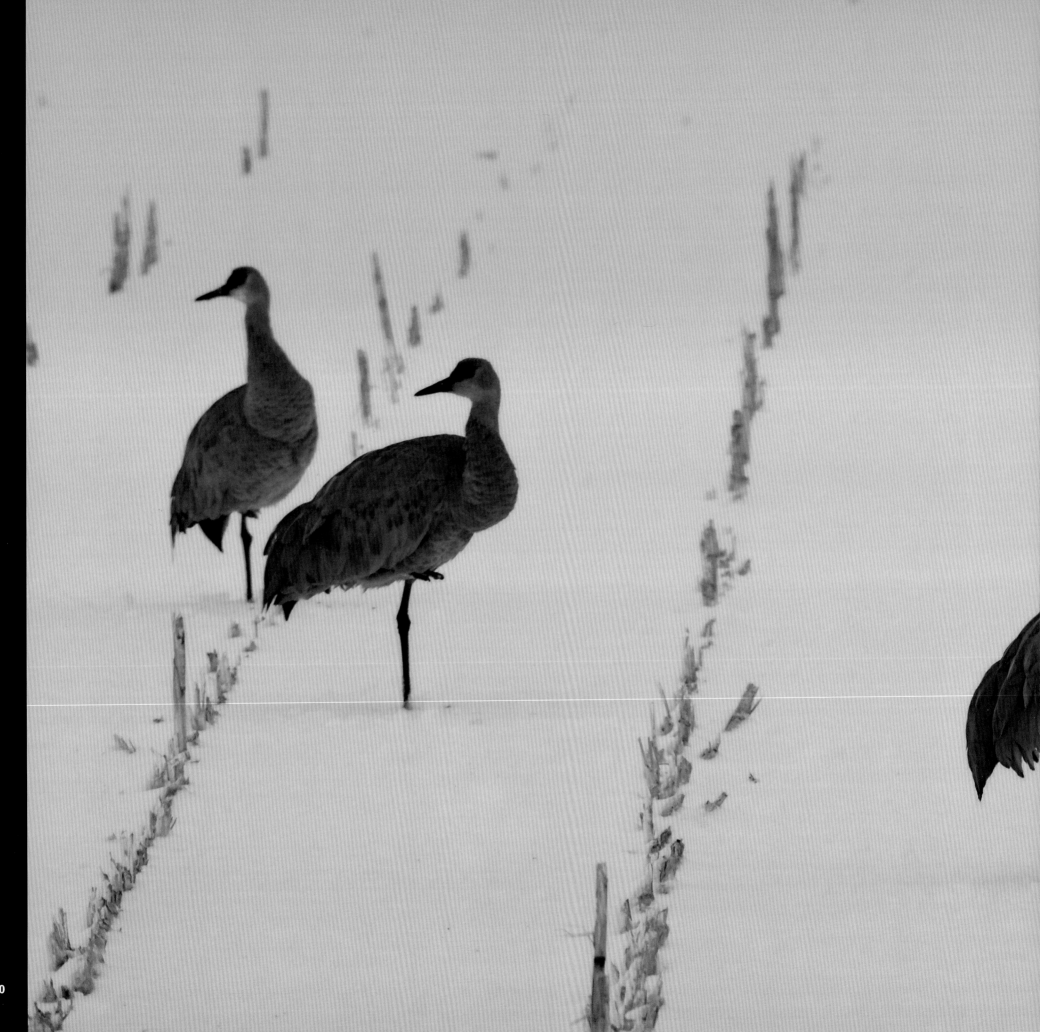

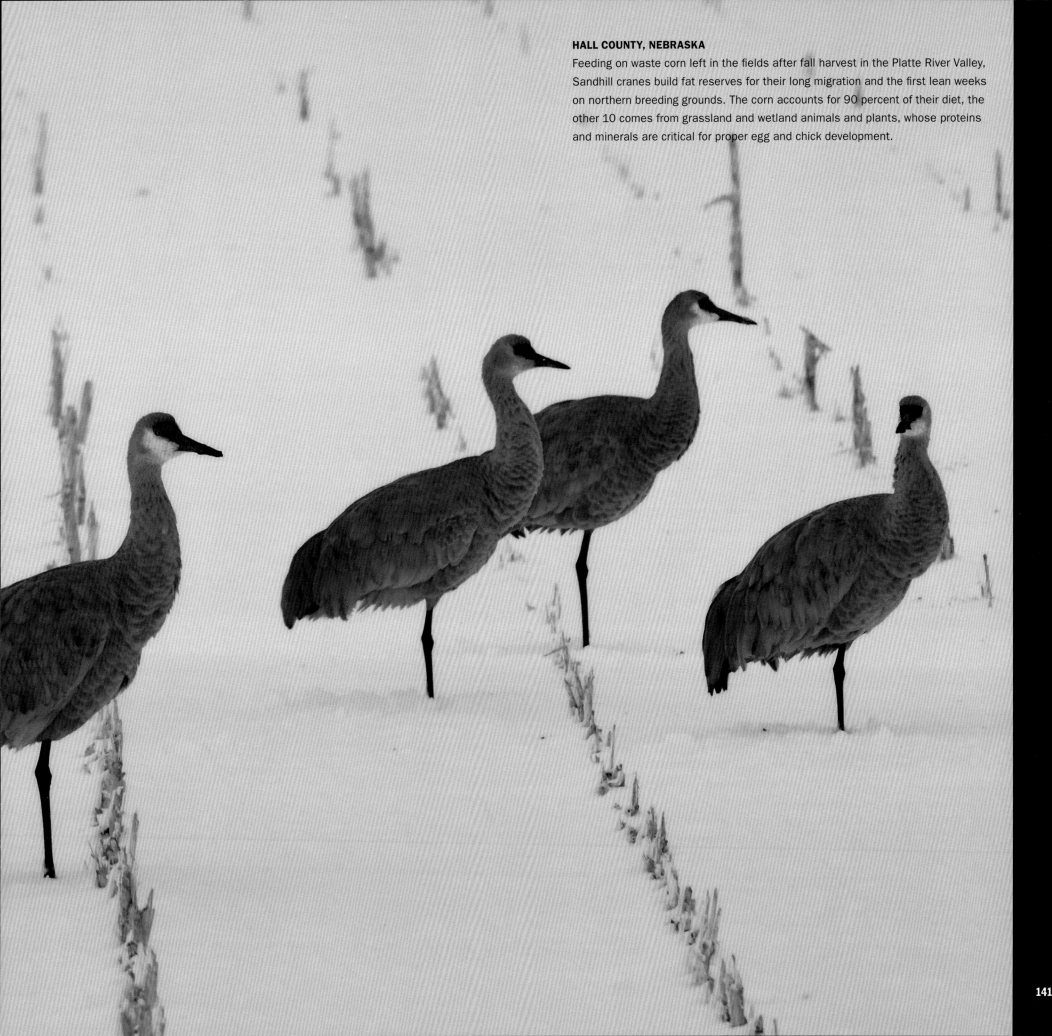

Feeding on waste corn left in the fields after fall harvest in the Platte River Valley, Sandhill cranes build fat reserves for their long migration and the first lean weeks on northern breeding grounds. The corn accounts for 90 percent of their diet, the other 10 comes from grassland and wetland animals and plants, whose proteins and minerals are critical for proper egg and chick development.

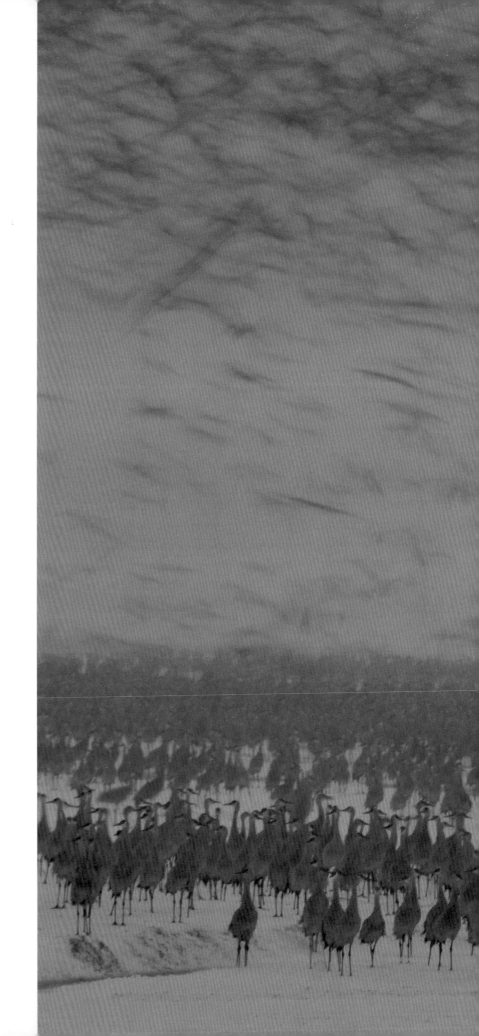

AUDUBON ROWE SANCTUARY, NEBRASKA

As a blizzard dumps three feet of snow, thousands of Sandhill cranes *(Grus canadensis)*
rise and fall in successive waves, trying to leave their roost on the frozen Platte River.
Over half a million of these cranes (roughly 80 percent of the species' population) gather
in the Platte River Valley for about a month in early spring, resting and refueling before
continuing their migration to northern breeding grounds as far away as eastern Siberia.

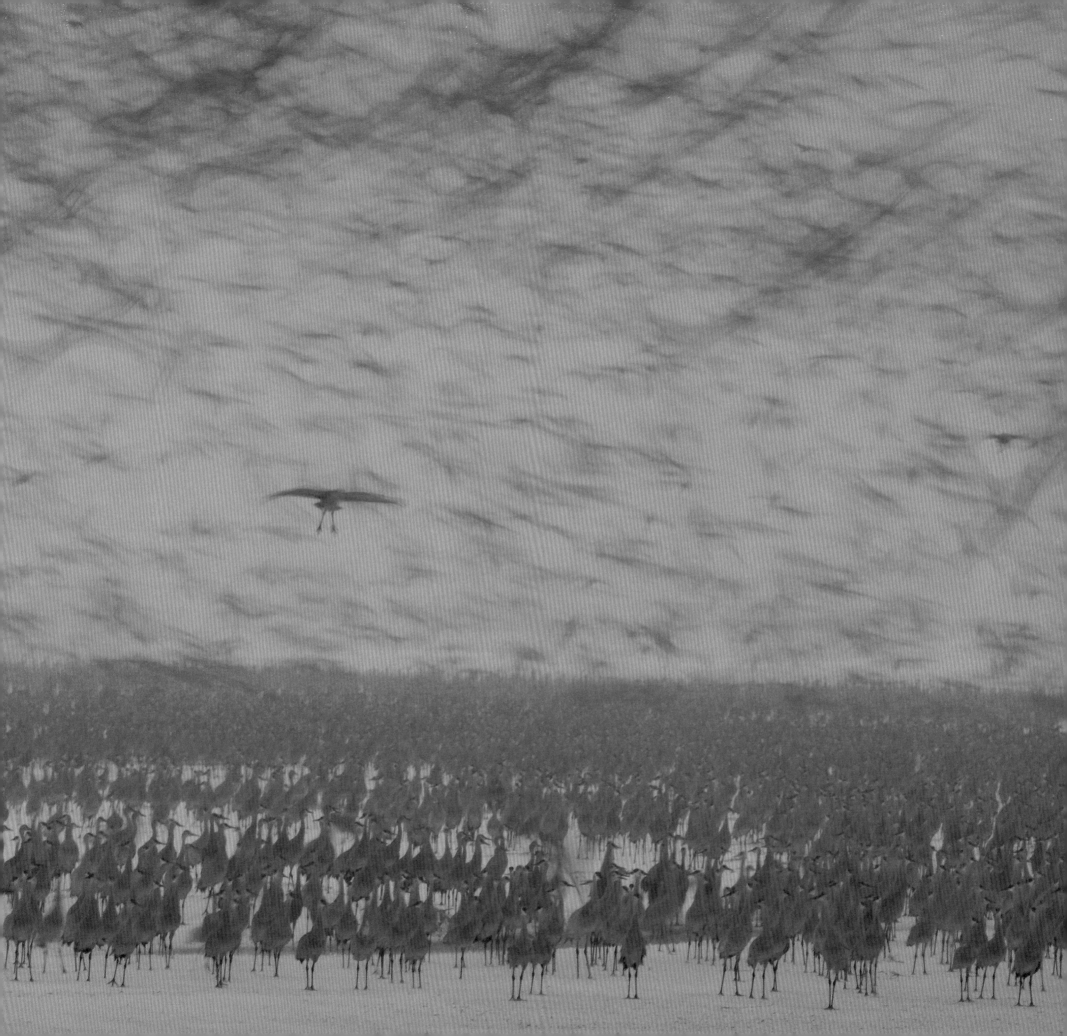

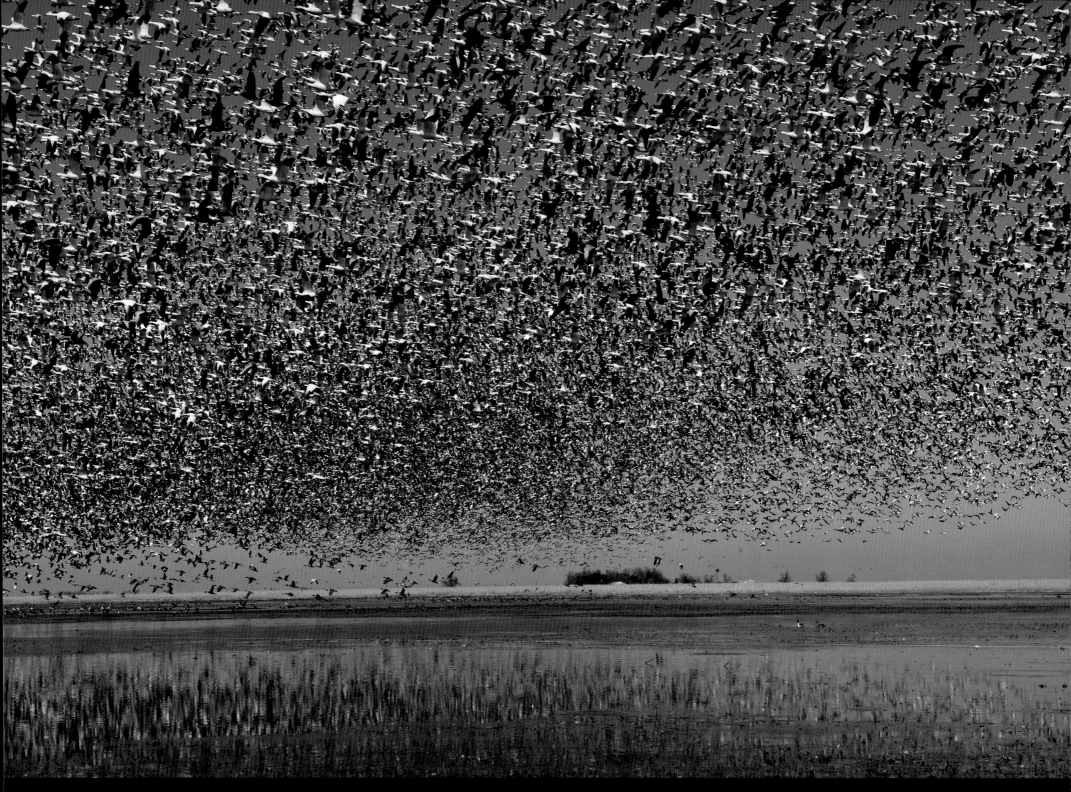

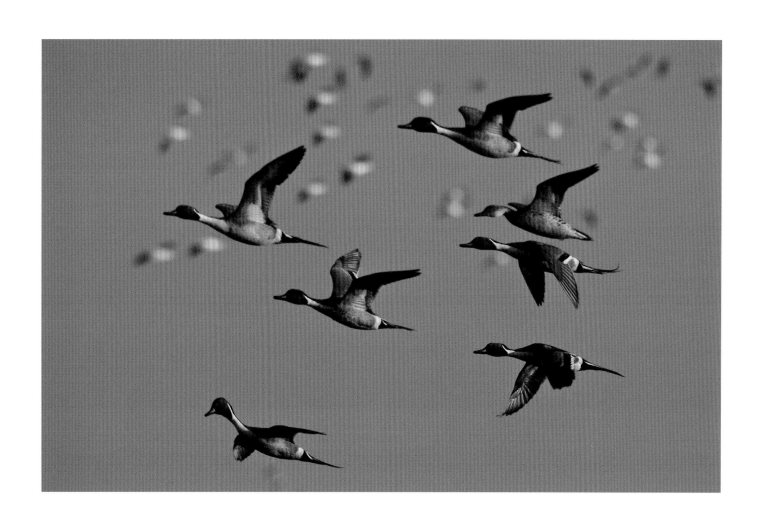

HULTINE WATERFOWL PRODUCTION AREA, NEBRASKA

Left: Lesser snow geese *(Anser caerulescens caerulescens)* on their way to the
Canadian Arctic lift off from a Rainwater Basin wetland, while northern pintail drakes
(Anus acuta) escort a female during a courtship flight (above). Critical habitat for
millions of waterfowl and shorebirds during spring migration, these shallow wetlands in
south-central Nebraska fill with water from rainfall and snowmelt and frequently go dry.
The majority have been drained and plowed under for agriculture, but those remaining
are carefully managed for conservation.

JOHN J. DINAN MEMORIAL BIRD CONSERVATION AREA, NEBRASKA

A piping plover *(Charadrius melodus)* broods a day-old chick at its nest on a restored island in the Platte River. Once a wide, braided prairie river, the Platte channel has been reduced by 70 percent in the last century. As part of a public/private conservation project, several nesting islands were completed in 2006 and have since attracted endangered whooping cranes, least terns, and the threatened piping plover.

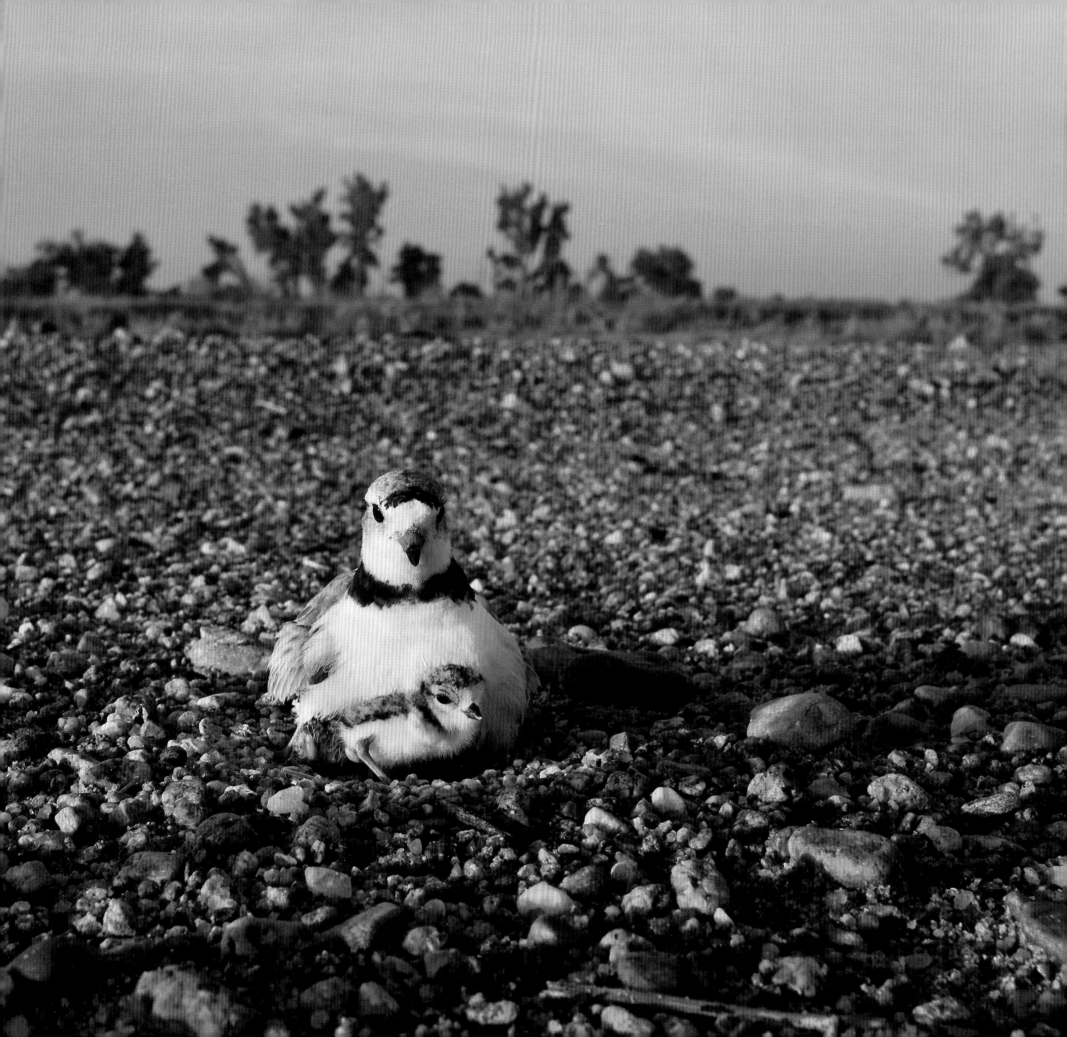

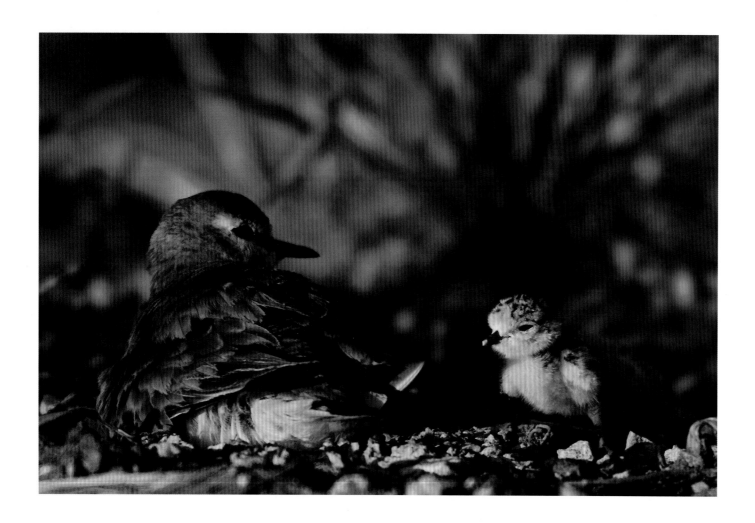

Right: **SCOTTS BLUFF COUNTY, NEBRASKA**
Dryland wheat and fallow rotational agriculture predominate on the windswept
High Plains of the southern Nebraska Panhandle.

Above: **KIMBALL COUNTY, NEBRASKA**
With an ability to hide in plain sight, the mountain plover *(Charadrius montanus)* and its
newly hatched chick soak in evening sun at their nest in a fallow wheat field. Despite
the name, mountain plovers are actually endemic species of arid grasslands and now
often nest in plowed agricultural fields.

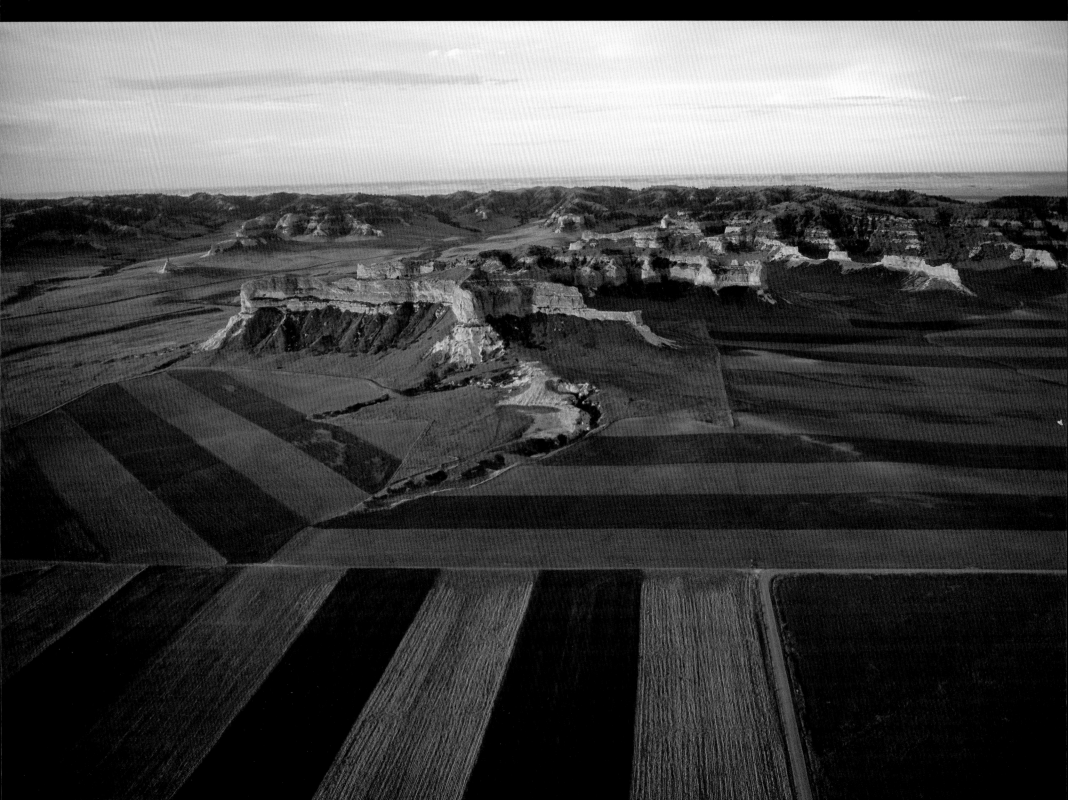

CEDAR CANYON WILDLIFE MANAGEMENT AREA, NEBRASKA

Needing rugged country for escape cover and grasslands for grazing, a band of bighorn sheep *(Ovis canadensis)* rests on a grassy ledge in the rugged Wildcat Hills. By the early 1900s overhunting, degradation of their habitat, and diseases carried by domestic livestock had eliminated bighorn populations in the Great Plains. Today reintroduction projects are underway, restoring herds and habitats to certain areas of the Plains.

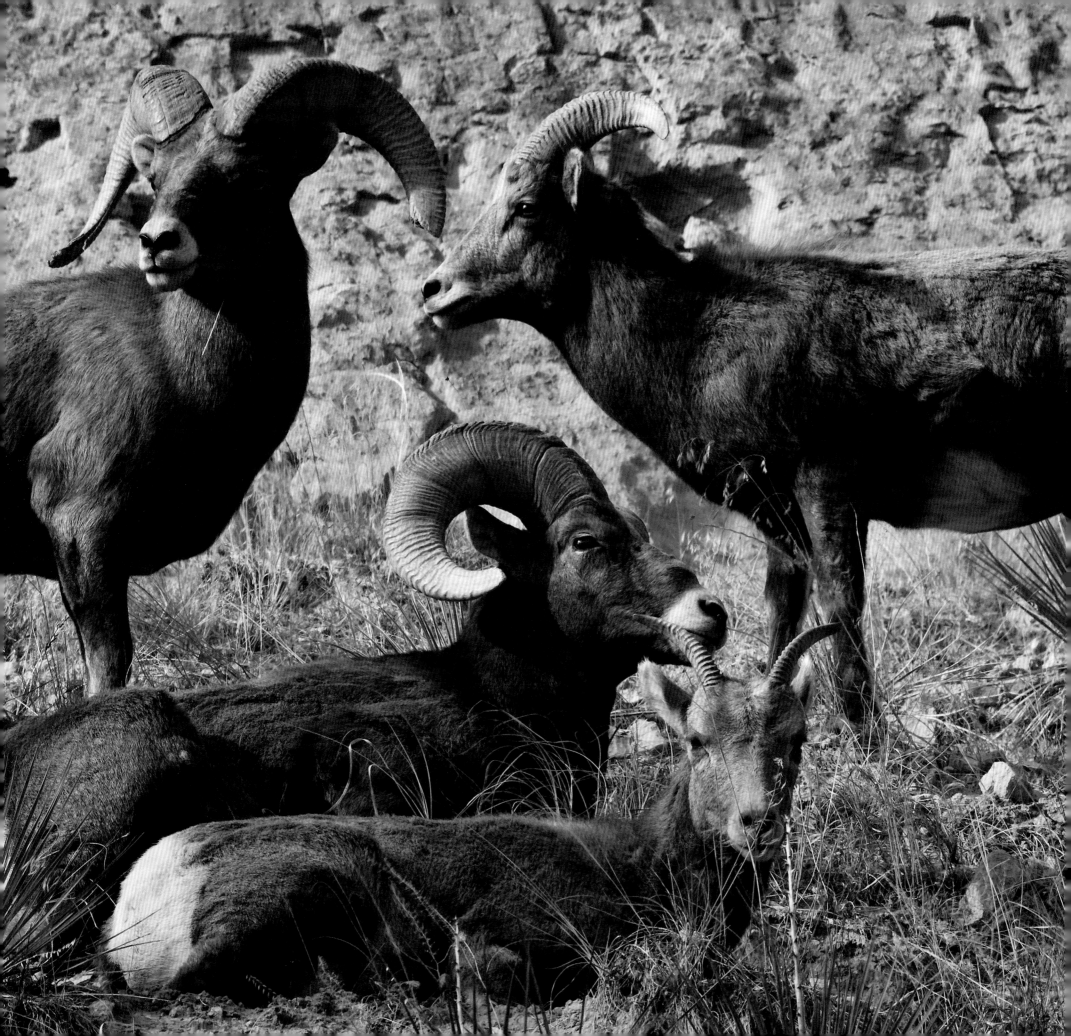

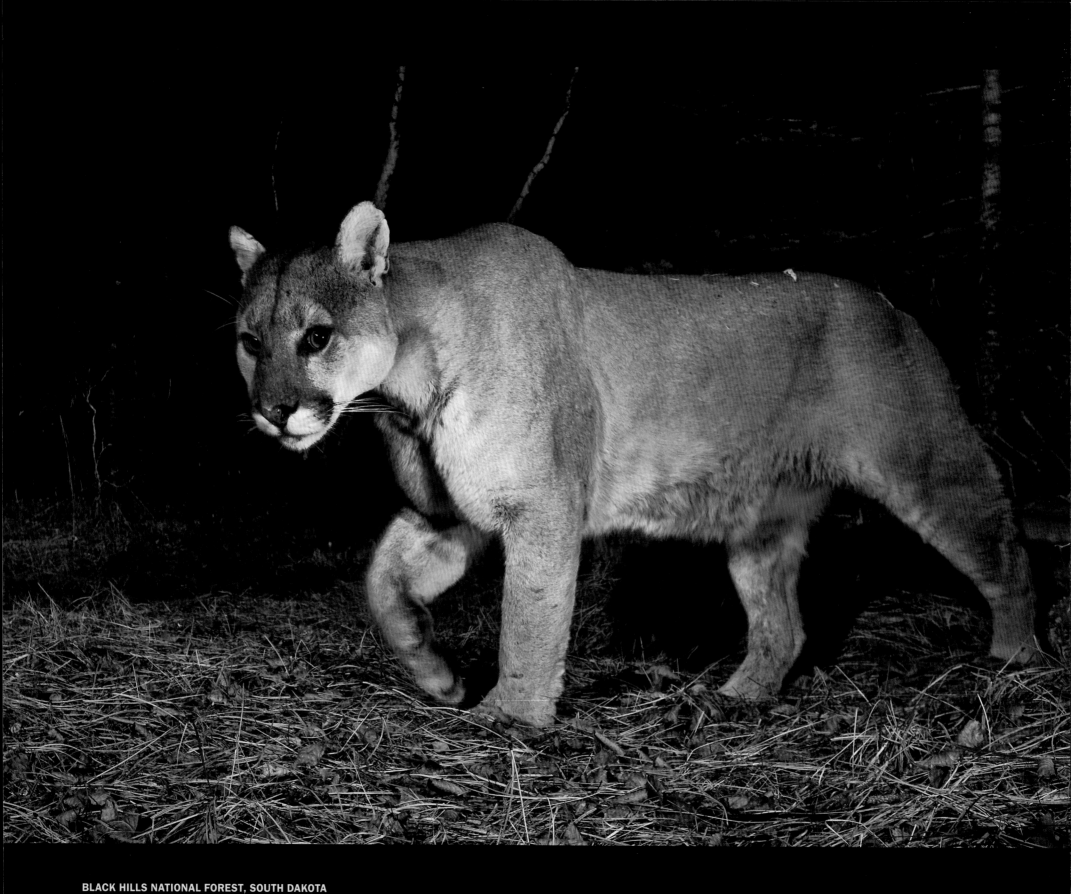

BLACK HILLS NATIONAL FOREST, SOUTH DAKOTA
North America's largest cat, the cougar *(Puma concolor)*

LION

Dan O'Brien

MIKE HAS REALLY NIFTY equipment for taking pictures of things that sneak around at night. The camera is a Canon, and it's incased in a weatherproof box that's connected to a laser trigger by little cables. He has a bunch of Nikon flashes and an array of mounts and tripods that can be used to anchor all this equipment to trees or rocks or the Earth herself. He has camouflage duct tape that he uses to make it all invisible.

In a motel room, laid out on the bed, the equipment looks very effective, high-tech, bulletproof. Mike loves it and caresses it as if it were one of his children. He believes in the potential of this technology. Of course, I am skeptical. The things that sneak around at night are professionals at detecting strange objects, unfamiliar smells, things that go snap in the dark. It seems to me that, without looking through a viewfinder, the possibility of getting a photograph of a nightwalker up to the quality that Mike demands is a real long shot. At this point I don't know the sort of nightwalker he has in mind. "So what are we after? An elk? A badger?"

"No, no," he waves my guess away and goes back to fiddling with his gear. "A lion," he says. "This stuff is to photograph a mountain lion."

Now, I've spent most of my life outdoors on the Great Plains and I've never even caught a glimpse of a mountain lion, let alone seen one long enough to take a picture. Of course, it's common knowledge that they are experiencing a slight comeback in portions of their former range. But, in relative terms, mountain lions — like all predators — were never plentiful. Its simple math: You need a lot of prey species to feed a single predator. All the big predators were killed off by humans, who saw the animals' activities as a competitive threat. On the Great Plains, mountain lions ate mostly deer, and it took a lot of deer to sustain even a small population. When the settlers killed the deer, the lions turned to cattle and particularly to horses. In the cowboy culture of the Great Plains, eating horses is a capital offence. Mountain lions have been on the edge of oblivion ever since that first horse was found partly devoured. But Mike still has faith that he is going to get a picture of one.

I've seen a few pictures of mountain lions, but they're not up to Mike's standards. They're mostly caramel-colored blurs taken at great distances. "I want to photograph one's eyes," Mike says. He wants to see what's inside.

The next morning we're packing back into a not-so-remote ridge lined with western red cedar. I check the hair on the back of my neck and find no indication of a lion observing me. Mike is looking down at the ground as if he knows what he's doing and I'm thinking that he couldn't track a locomotive to the train station. But I'm quiet. I am only a porter in this expedition; my lack of faith excludes me from participating in tactical decisions.

Mike stops and looks at a small outcropping of granite. "I'll bet they walk right along here," he says. It looks like a million other places I've walked. There are no tracks, no exotic scent, no mysterious aura whatsoever. He's trying to talk the big cats back into existence, trying to create them through the power of positive thinking.

The spot seems chosen at random, but I'm supportive. I carefully unload wires and batteries and flashes and rainproof cases. Mike stands back and holds his hands out to visualize the background of his imaginary picture. His belief strikes me as a little sad, but I do as I'm told. I uncoil the cables. Affix flashes to trees with wire ties. Mike picks his spot and lines up the laser eyes that will trigger the camera screwed solidly to a stout tripod. It is all very substantial, and I try a joke about how large a cat it would take to swallow the Canon.

The joke is barely acknowledged, because Mike is lying on the ground, sighting through the camera to the exact spot where the phantom cat will appear, the precise juncture where it must cross the laser trigger. "Could you crawl through there?" He points, "Right where the lion is going to come?"

I thought for an instant about what he had just said. "Crawl through where the lion is going to come." And I am thinking: on my hands and knees, vulnerable? But what the hell, Mike is so focused on what he is doing that I go ahead and pretend I'm a mountain lion. I crawl through the invisible plane and the lights and camera snap. "Again," Mike says. "A little different angle." He is making tiny adjustments. "Just crawl through about the speed of a strolling lion."

He is serious, so I crawl through the laser again. More lights and snapping. A few adjustments and I crawl through again. And again. And again. We've been there several hours and Mike, wrapped up in focus, angles, background, and composition is paying no attention to me. I crawl through again.

"Step over that little branch," he says. "Raise one foot." The foot he is talking

Mike tests a camera trap he set up in a creek drainage.

about is my hand. It is sore from the strolling, and my knees too are beginning to hurt. I step over the branch, snarl, and take a playful swipe at the camera as it snaps. I know there would never be a mountain lion caught in this situation, but I imagine how high it might leap if the lights snapped on and the shutter clicked. It cracks me up to compare a 120-pound mountain lion to our house cat, who could jump as high as the top of the refrigerator if you frightened him just right.

I am in my own little world, crawling back and forth—the stunt double for an imaginary mountain lion that is starring in Mike's imaginary movie.

Somehow he never sees the humor in the situation, but a few weeks later I get a wordless e-mail from him. It is nothing but a couple of pictures. They are both lit perfectly and the backdrops are identical, hazy and aesthetically exquisite. The first picture is of me, crawling through the laser, one hand swiping at the camera and an inane snarl on my face. The second picture is of a mountain lion, moving out of the same backdrop that I had crawled through a dozen times. There is no silliness on its face, no sense of being startled by any of it. This cat is simply moving through, back from the foggy edge of extinction and into the bright scrutiny of the modern world.

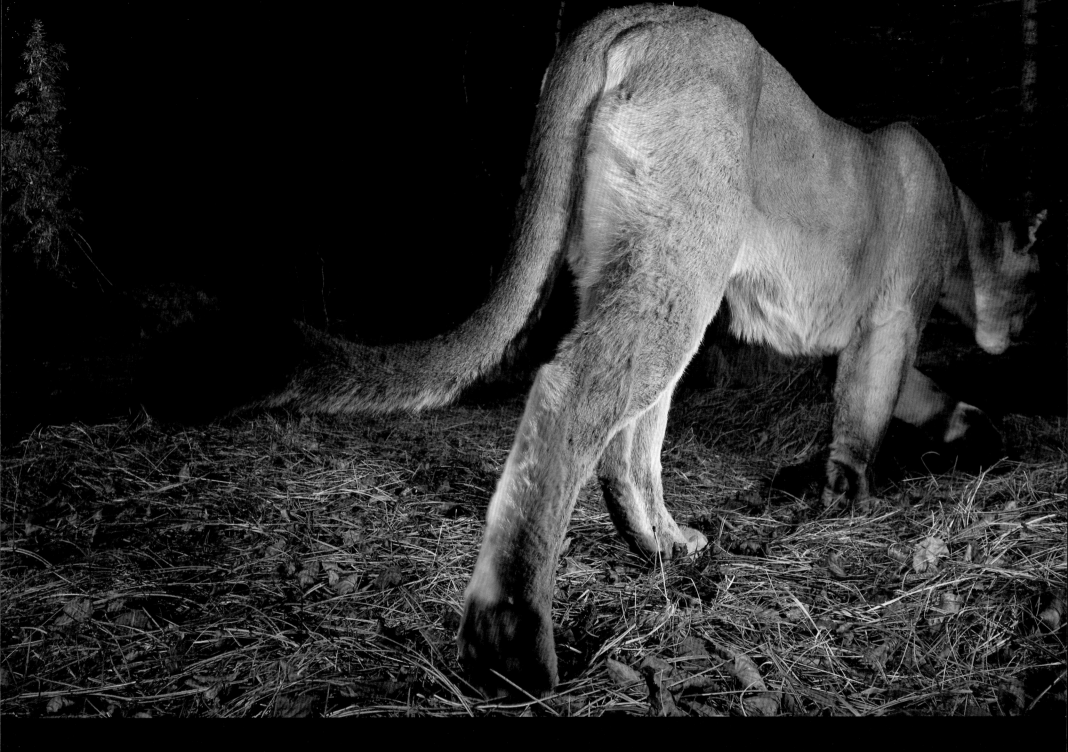

The cougar was once the widest ranging mammal in the Western Hemisphere.
Today viable cougar populations exist primarily in the more remote regions of the
western U.S.

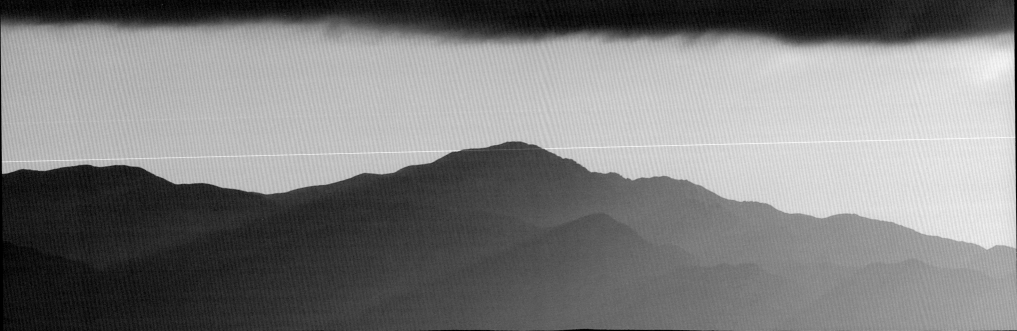

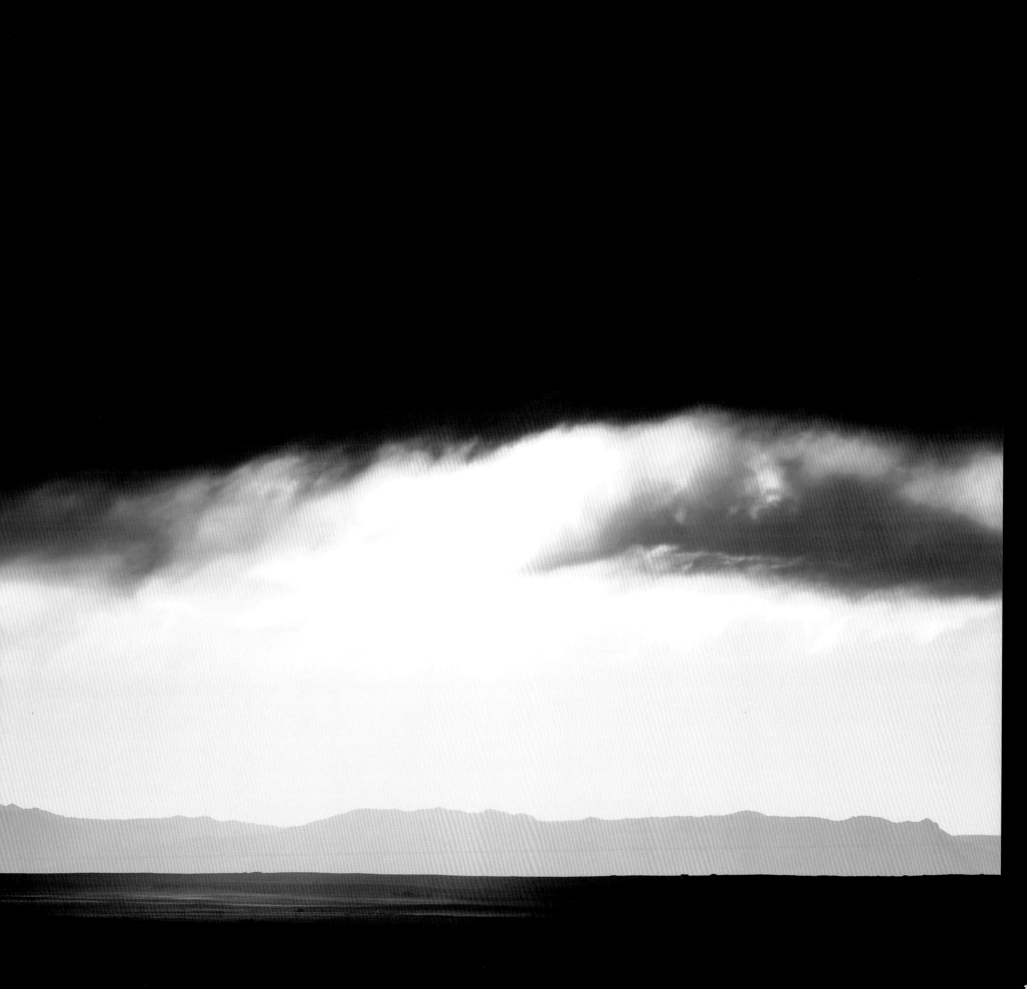

BOX BUTTE COUNTY, NEBRASKA

Two-month-old swift fox kits *(Vulpes velox)* play outside their den on the shortgrass prairie in the summer twilight. Standing only a foot high and weighing three to six pounds, swift foxes are the Plains' smallest canids, but they're among the fastest, reaching speeds of 25 miles per hour. Now threatened or endangered in several Great Plains states, they've suffered greatly from loss of habitat and trapping and poisoning programs aimed at coyotes and prairie dogs.

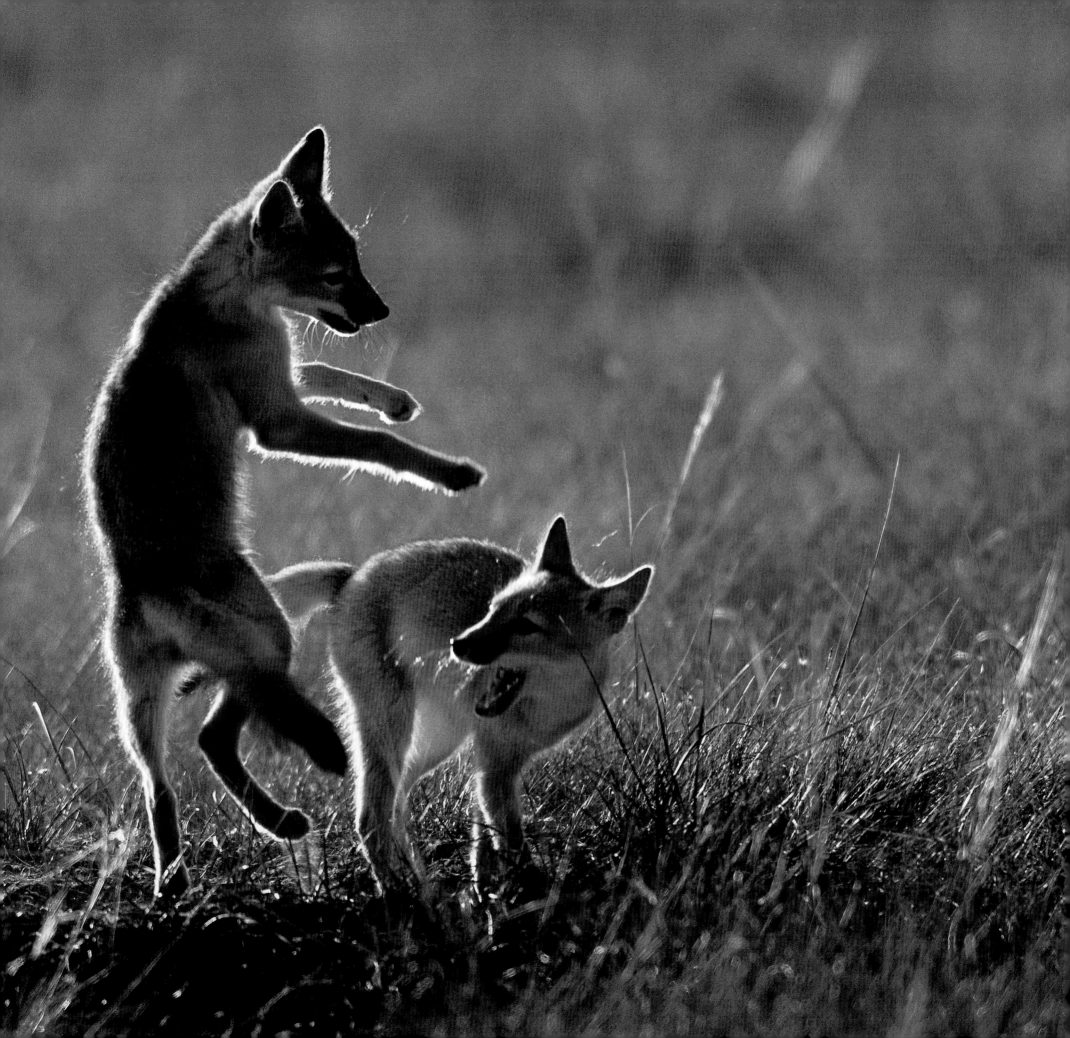

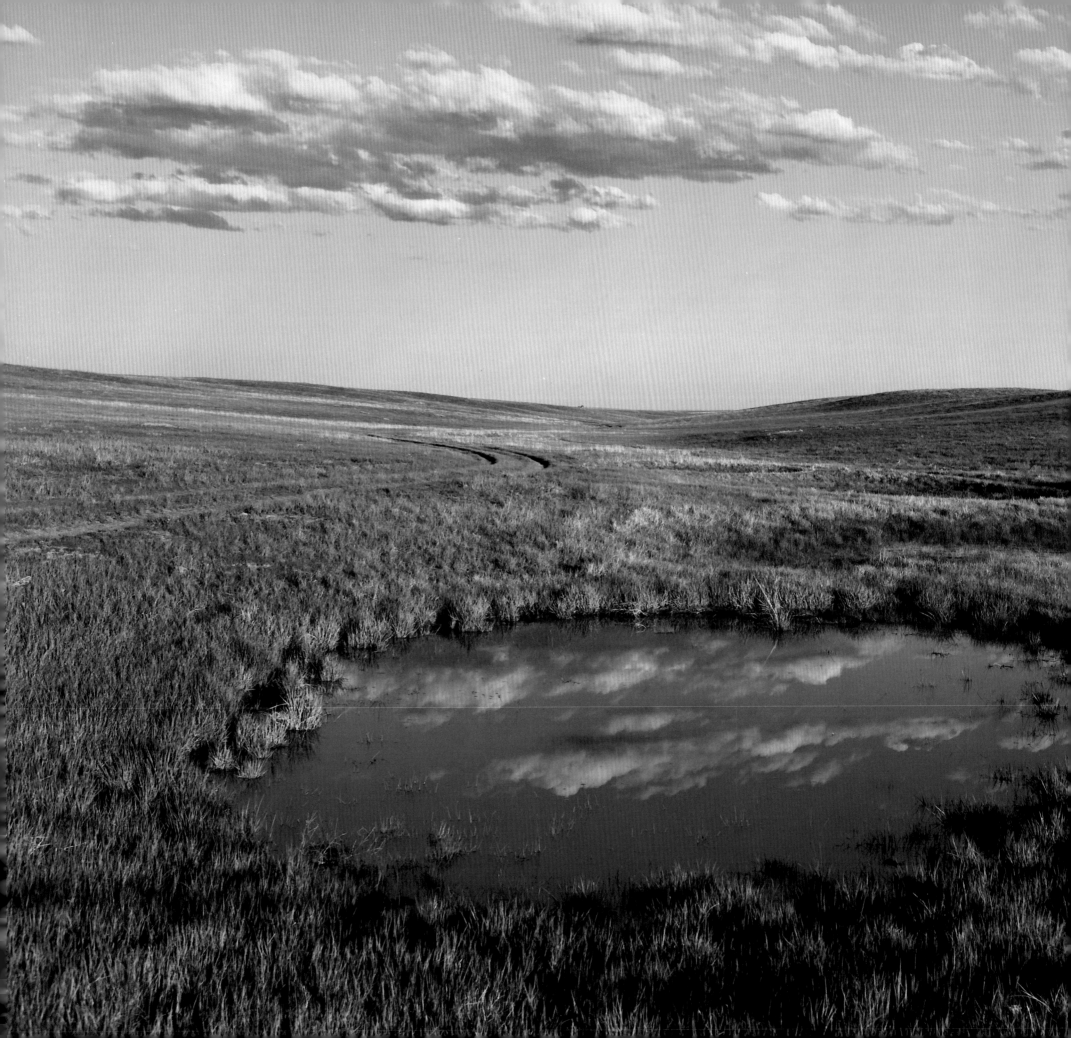

LARIMER COUNTY, COLORADO

Heavy rains fill a buffalo wallow-size depression that serves as a breeding ground for amphibians like the tiny chorus frog *(Pseudacris maculata)*, one of the first amphibians to emerge in spring. These shallow, rain-filled depressions quickly bring to life dormant ecosystems. When the water dries up, the ecosystems go on hiatus—for weeks, months, or even years.

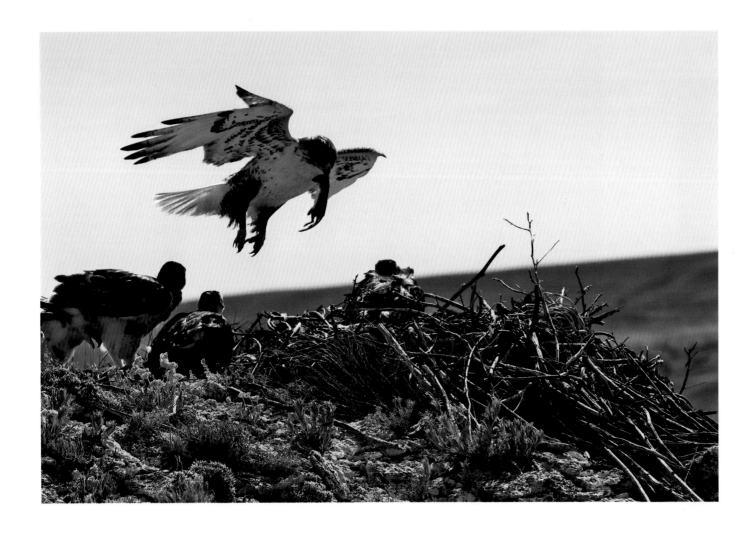

Right: **LARIMER COUNTY, COLORADO**
A prairie falcon *(Falco mexicanus)* leaves its chicks in an aerie overlooking Meadow Springs Ranch.
The ranch is one piece in a public/private conservation partnership in the 400,000-acre Laramie
Foothills, which connect the mountains and plains along the rapidly developing Front Range.

Above: **MORRILL COUNTY, NEBRASKA**
A ferruginous hawk *(Buteo regalis)*, the largest hawk in North America, brings a thirteen-lined
ground squirrel *(Spermophilus tridecemlineatus)* to its chicks. Grassland raptors depend on large,
intact native landscapes to thrive.

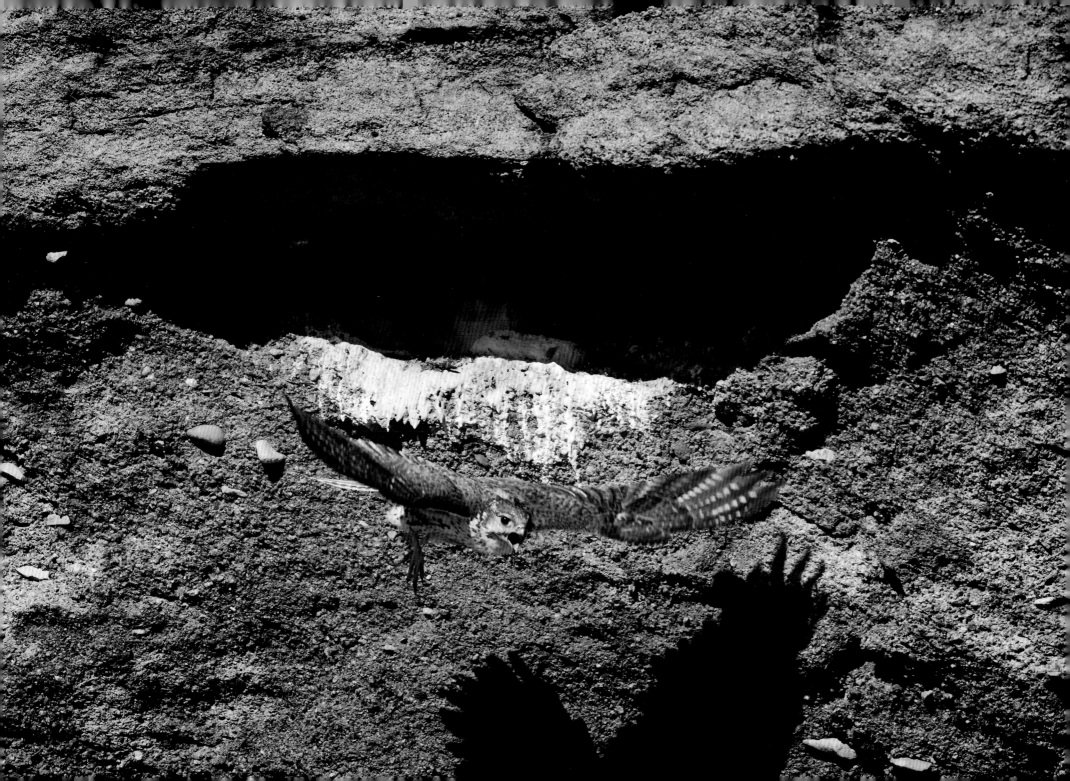

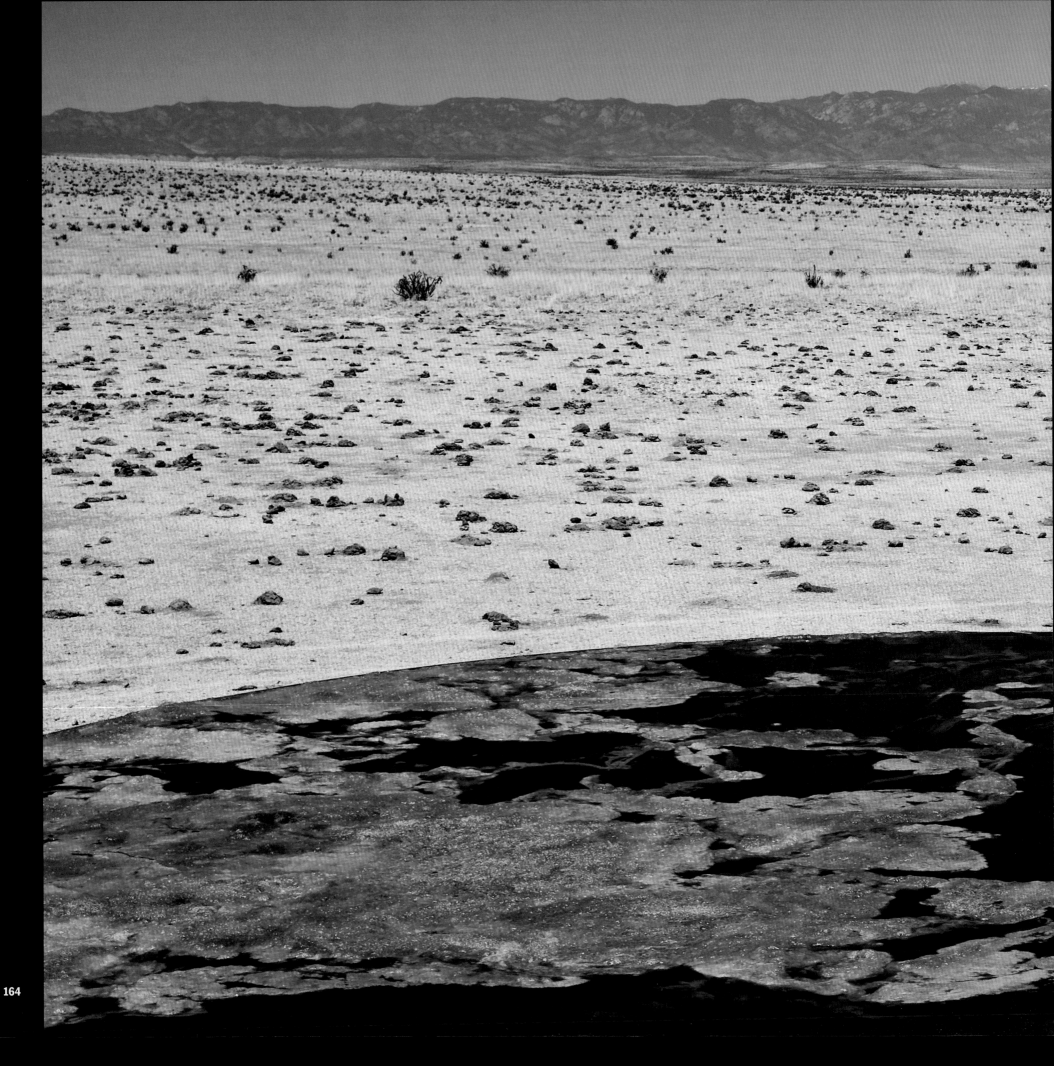

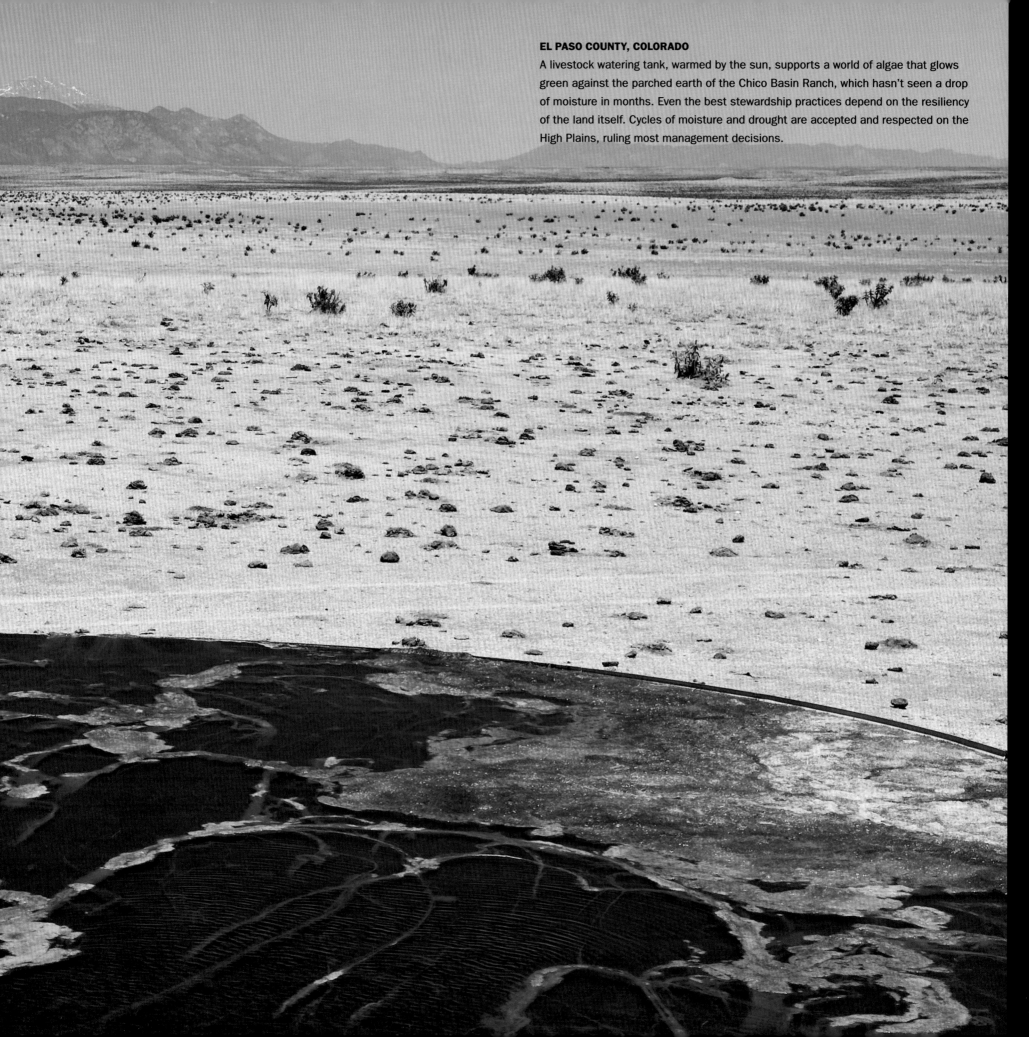

EL PASO COUNTY, COLORADO
A livestock watering tank, warmed by the sun, supports a world of algae that glows green against the parched earth of the Chico Basin Ranch, which hasn't seen a drop of moisture in months. Even the best stewardship practices depend on the resiliency of the land itself. Cycles of moisture and drought are accepted and respected on the High Plains, ruling most management decisions.

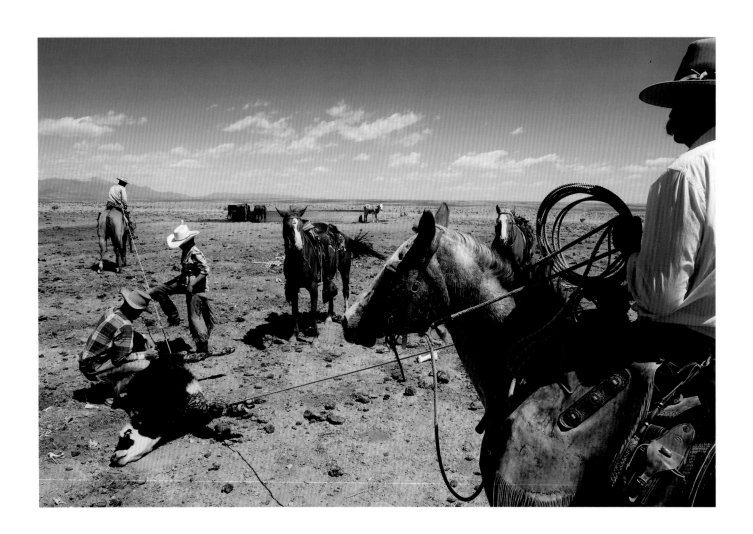

EL PASO COUNTY, COLORADO

Miles out on the range of the Chico Basin Ranch, rancher Duke Phillips, his youngest daughter Grace, and their crew spend time in early May doctoring calves. Carrying a young calf left behind by the herd, Grace (right) also leads a reluctant horse. "It's easier to live with the land when families work together. It's also easier to build strength inside the family if we work together to look after the land and the animals entrusted into our care," Duke says.

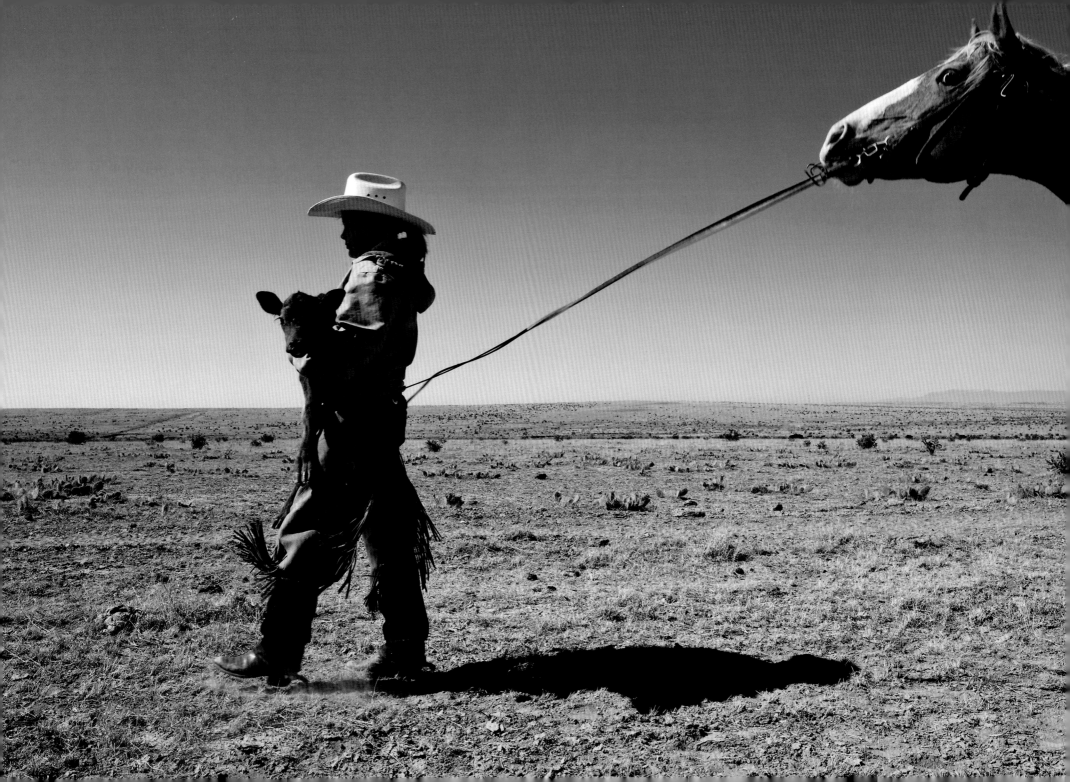

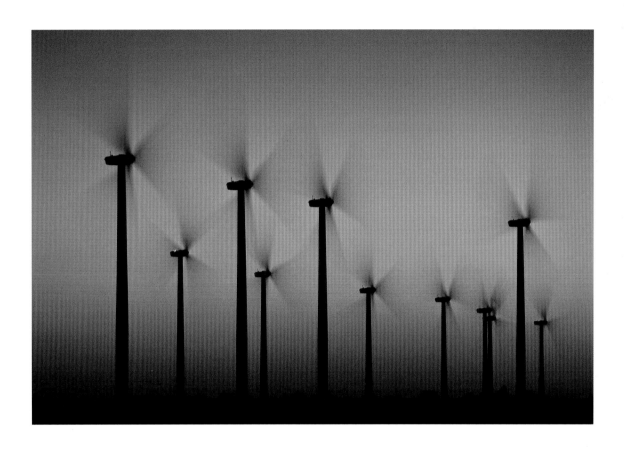

Left: **EL PASO COUNTY, COLORADO**
The continuous creep of suburban sprawl from Colorado Springs now lights up the once dark prairie sky east of the Front Range.

Above: **WOODWARD COUNTY, OKLAHOMA**
The strong, steady winds of the Great Plains have drawn the attention of energy developers, who plan to construct hundreds of wind farms to help meet the nation's growing demand for renewable energy. Site selection is critical. A wind farm's wide footprint of tall turbines, transmission lines, and roads can have negative consequences for already imperiled wildlife, particularly migrating and ground-nesting birds and bats.

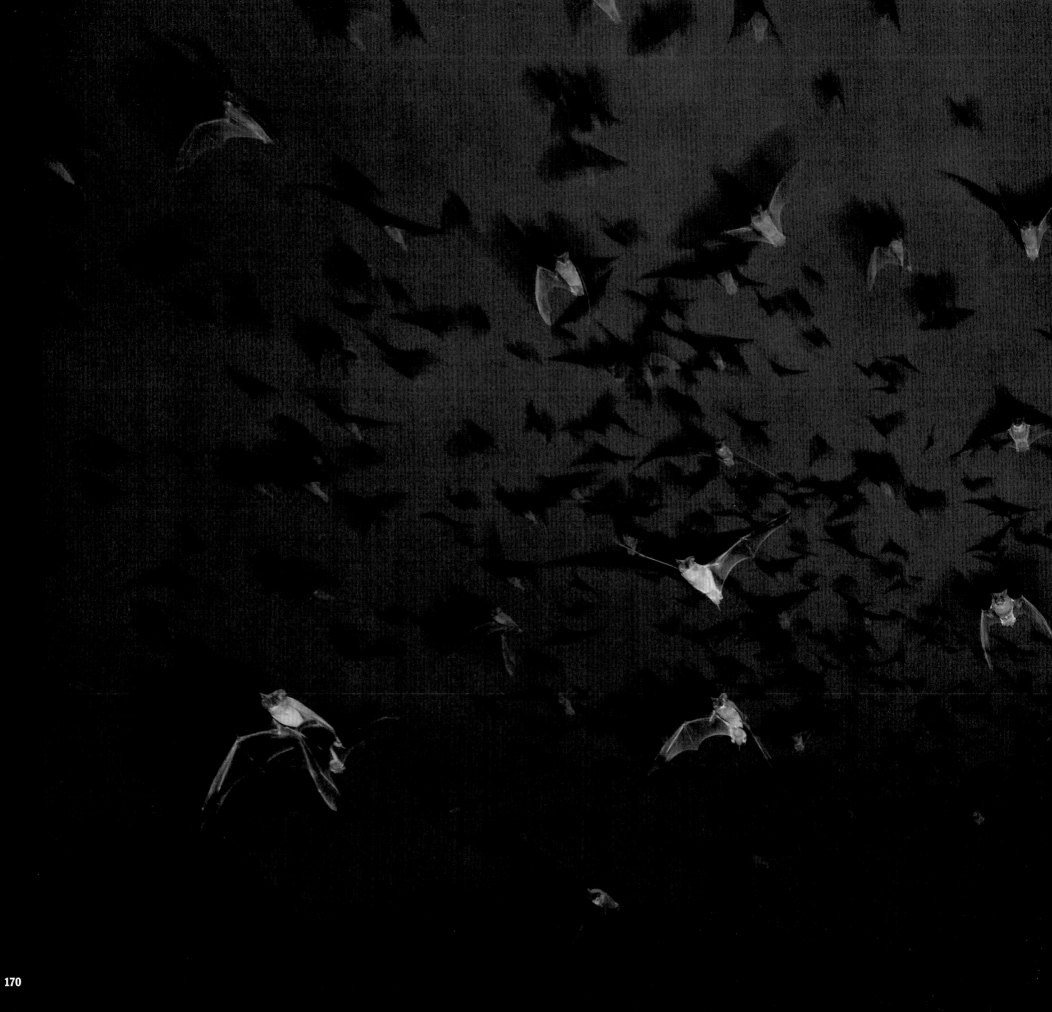

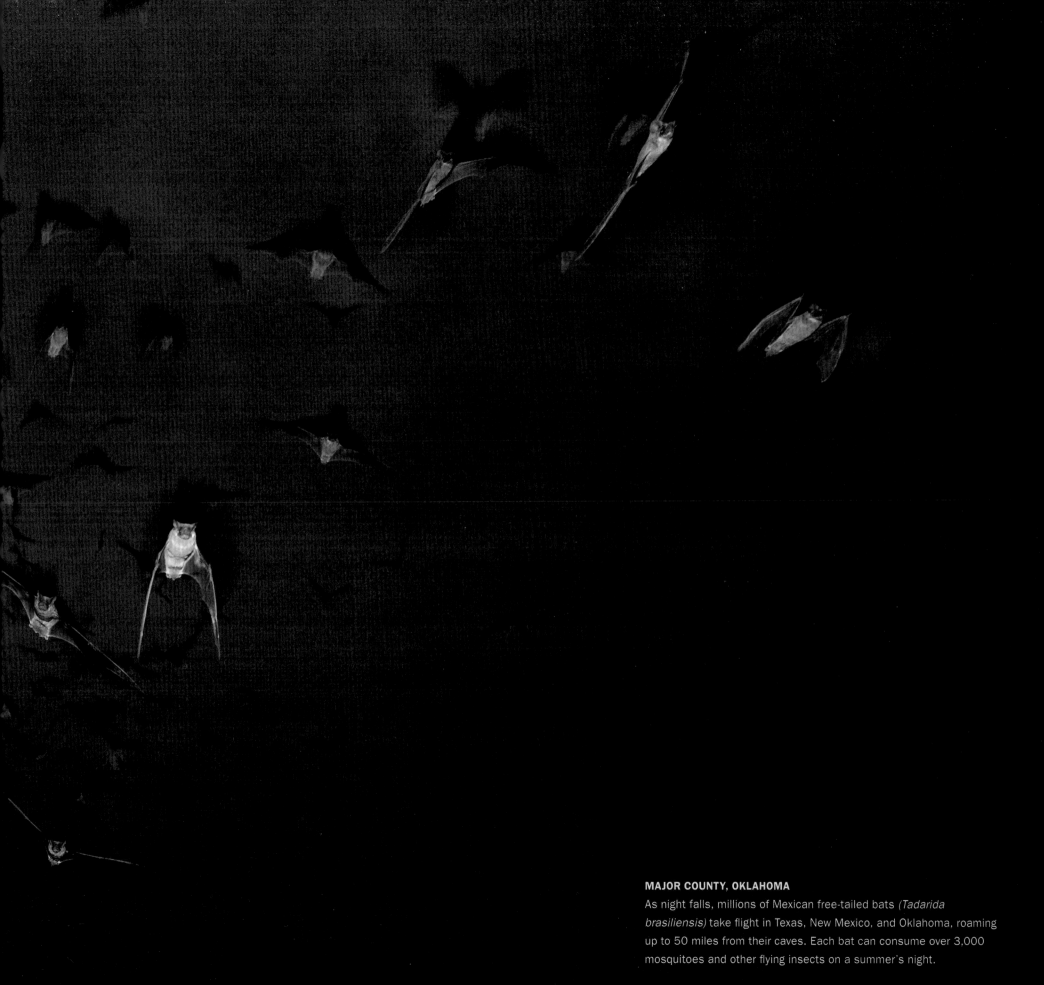

MAJOR COUNTY, OKLAHOMA
As night falls, millions of Mexican free-tailed bats *(Tadarida brasiliensis)* take flight in Texas, New Mexico, and Oklahoma, roaming up to 50 miles from their caves. Each bat can consume over 3,000 mosquitoes and other flying insects on a summer's night.

HARDING COUNTY, NEW MEXICO

A snow squall rolls in over the spine of the Cimarron Range as evening settles across the Kiowa National Grassland on New Mexico's High Plains.

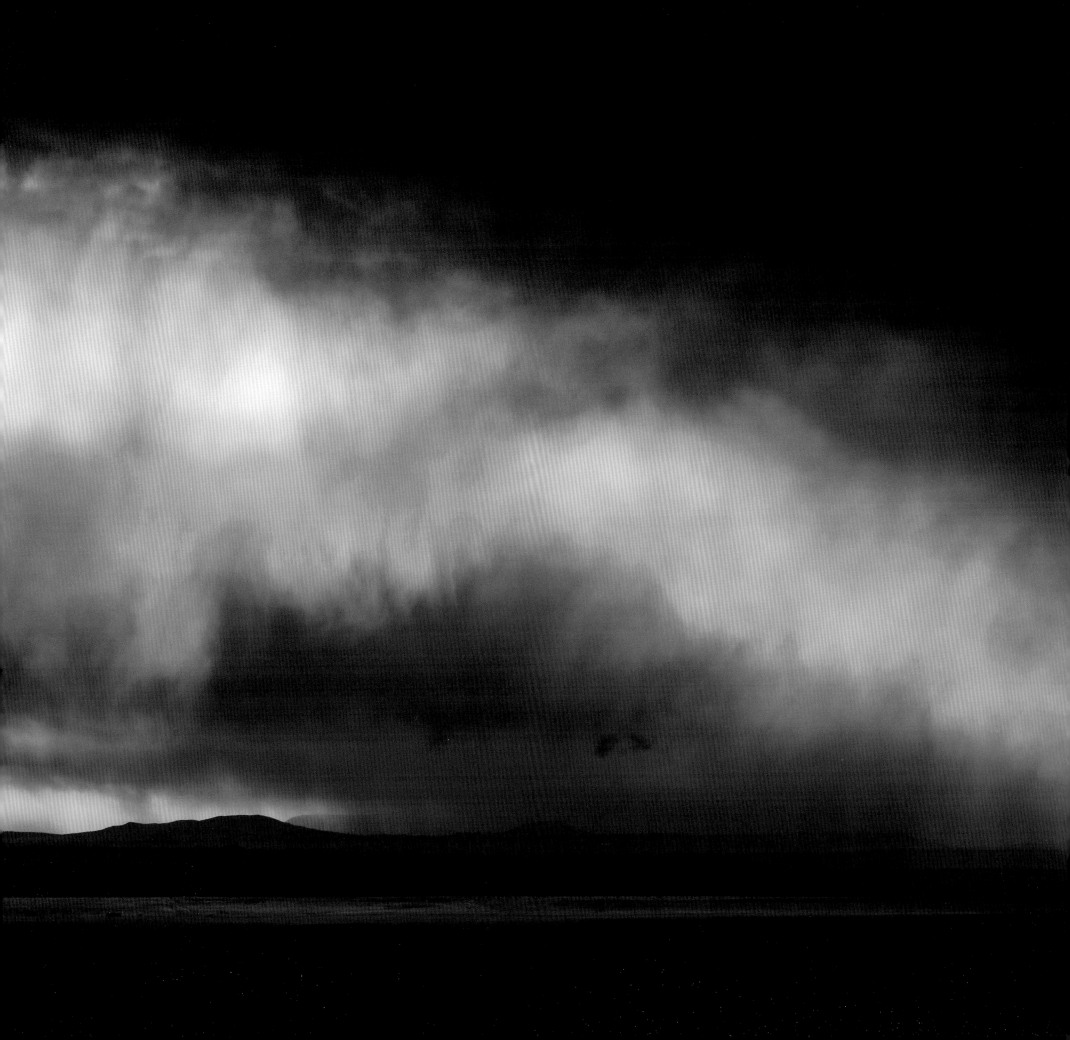

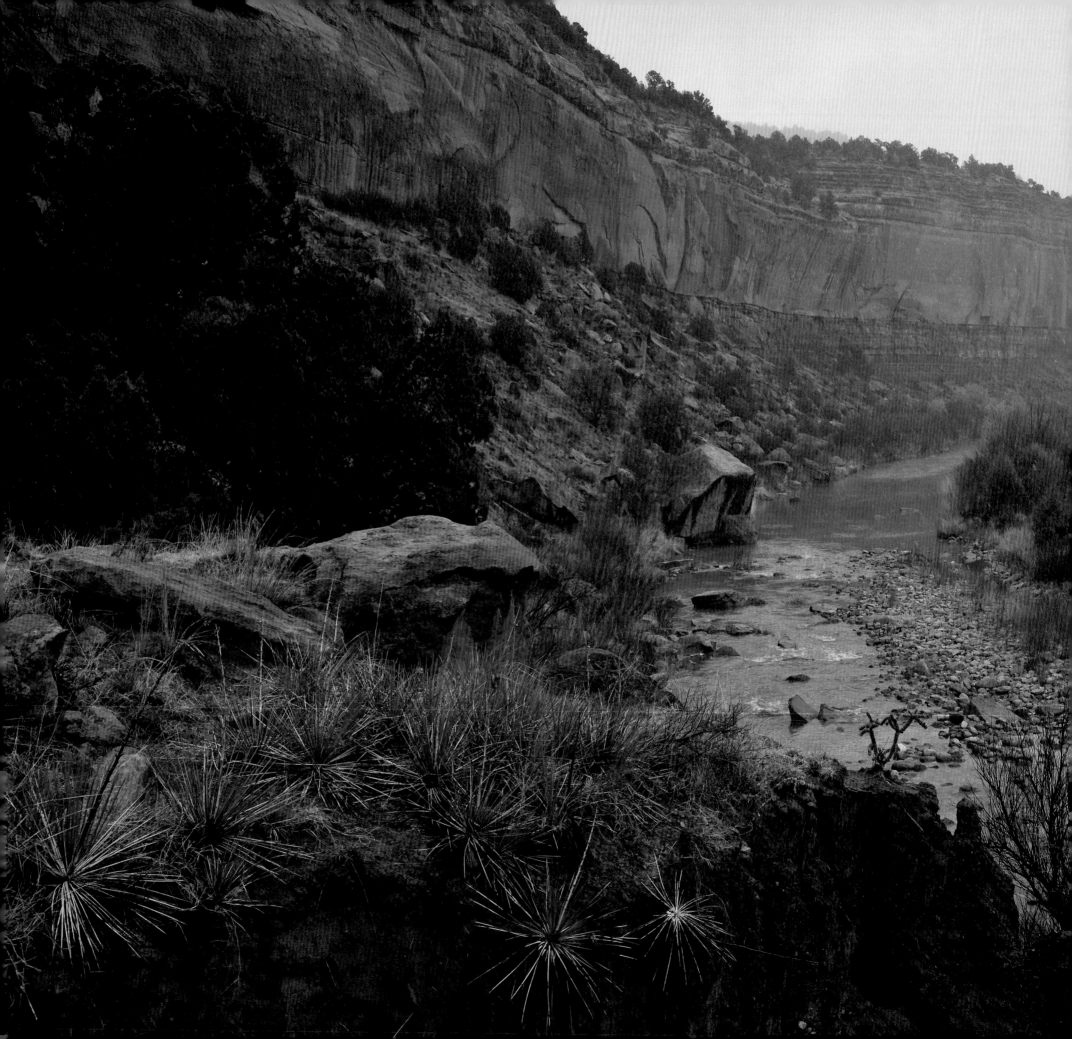

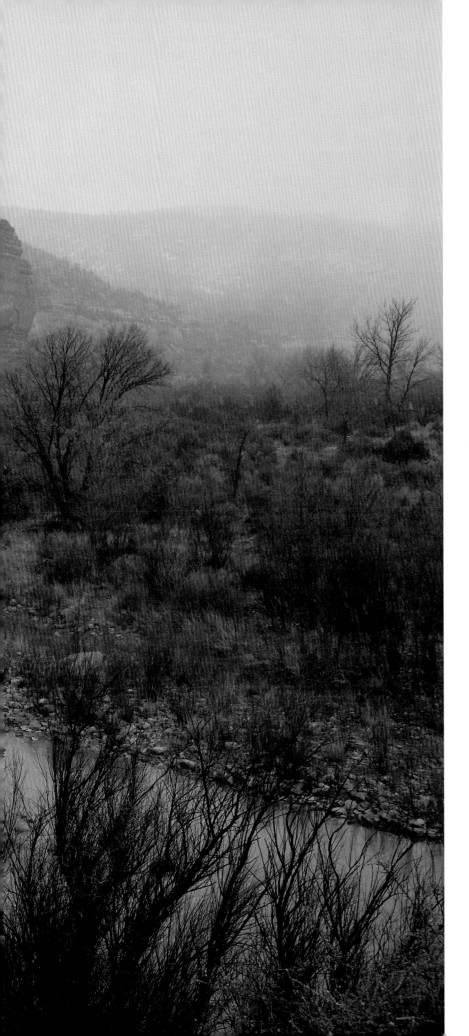

Left: **KIOWA NATIONAL GRASSLAND, NEW MEXICO**
Born in the Colorado Rockies, the 900-mile-long Canadian River carves deep, remote canyons like Mills Canyon in northeastern New Mexico, then continues across the Texas Panhandle to join the Arkansas River in Oklahoma.

Above: **EL PASO COUNTY, COLORADO**
Its vision compromised by molting, a coachwhip snake *(Masticophis flagellum)* seeks refuge in the deep shade. Coachwhips can reach six feet or more and often move through the grasslands with their heads high above the vegetation, on the lookout for a meal.

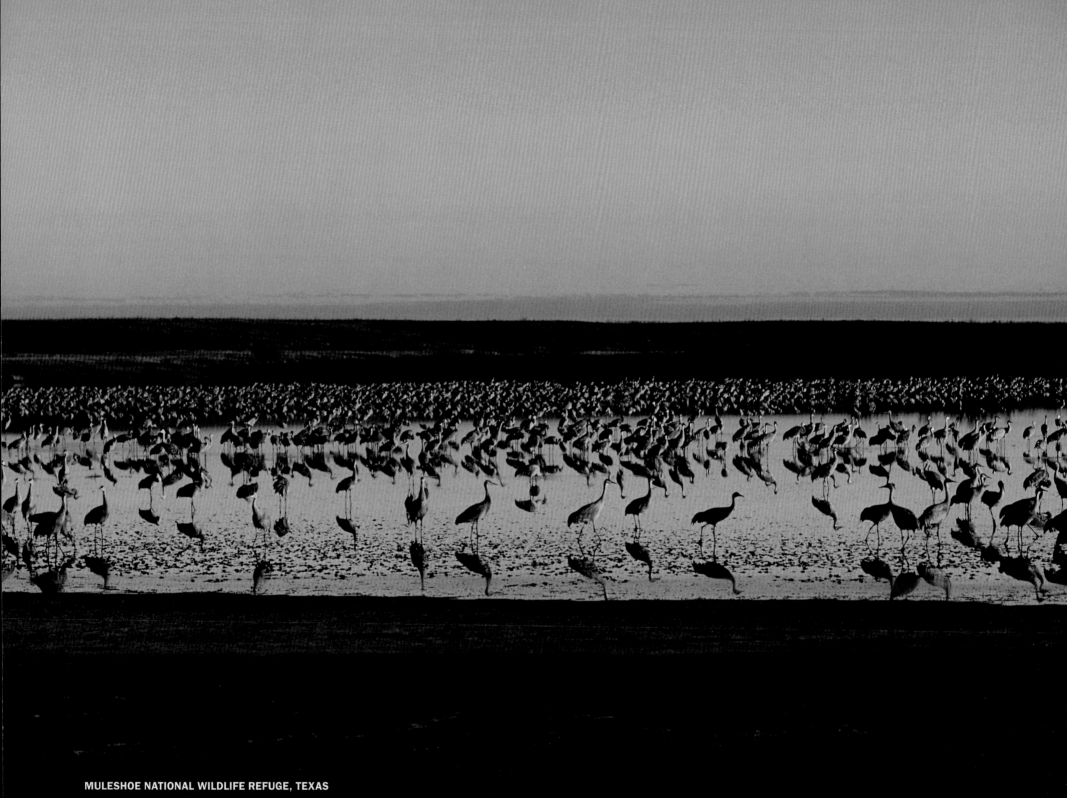

MULESHOE NATIONAL WILDLIFE REFUGE, TEXAS

For millennia lesser Sandhill cranes *(Grus canadensis)* have used the saline lakes of the southern
High Plains. In recent years, many of these spring-fed lakes have dried up as the Ogallala Aquifer
has declined, forcing cranes to alter their migratory and wintering locations.

THE OCEAN BELOW THE GRASS

Dan O'Brien

AMONG THE GREAT IRONIES of the natural world is the fact that just below one of Earth's driest agricultural regions lies a 173,000- square-mile ocean. That huge expanse of pure, sweet water has been a selling point for a parade of flimflammers who sold and resold the Plains to gullible immigrants and to dreamers of every sort. The underground ocean is the Ogallala Aquifer. If those hucksters missed the irony of the aquifer's juxtaposition to the arid land above, then they likely also missed the crueler irony of naming it for the dispossessed people of Chief Red Cloud and Crazy Horse.

The existence of that water has always been a blessing and a comfort to the people who lived on, and loved, the land above. My wife Jill and I have marveled, with a quiet reverence, at Ogallala water rushing from the ground with enough volume to provide habitat for rainbow trout in the Sandhills of Nebraska. We've lain in the shade of cottonwoods on the Staked Plains of Texas, where such trees could never have grown without the tiny spring that somehow found its way to the surface from far below. Every time we come across these astounding incongruities made possible by the Ogallala Aquifer, we feel a kinship to the people who came before us and we're astounded all over again.

It is hard to say what the Native Americans and the early settlers would have done with the knowledge that the isolated water they saw on the Plains was connected to an ancient reservoir, tens of millions of years old, that, if brought to the surface, would cover the core of the Great Plains with a flood 30 feet deep. That's 3.5 billion acre-feet of water, more than any Plains Indian was likely to have seen in a lifetime. We don't know what if anything Red Cloud and Crazy Horse would have done with that knowledge, but we do know what the homesteaders and industrialists have done. They have done their best to use it to fulfill their fantasy of turning the world's grandest grassland into a densely populated farmer's paradise.

One pumping scheme after another has taken aim at the Ogallala Aquifer. First it was simple subsistence water for homesteaders, then community water to build railroad towns, then to irrigate the ruined rangeland after the Dustbowl. At present there are more than 200,000 irrigation wells drilled into the Ogallala Aquifer and still the farmers are hanging on by their fingernails. Innocents and cynics have danced the Ogallala jig for a century, and the upshot has been a 200-foot fall in the water level along the southern part of the subterranean aquifer and an ecological disaster on the surface.

The exploitation of the Great Plains' legitimate water source is earmarked with monumental hubris, greed, and lack of common sense. But the latest manifestation of the drive to extract, and spray into the atmosphere, the most important element of life on the Great Plains seems the most cynical.

Jill and I witnessed that drive on a trip to the Llano Estacado, the High Plains region engulfing most of the panhandles of Texas and Oklahoma and parts of Kansas, New Mexico, and Colorado. It is a flat and tormented country, the subject of Timothy Egan's award-winning book, *The Worst Hard Time*. I used to travel there with my falcons to hunt lesser prairie-chickens. There were hundreds of thousands of chickens not 25 years ago, and it was glorious to watch the falcons careen through the skies over the pastures that were only then beginning to make a recovery from the abuse of the homestead era. I have been a visitor to this area for decades and a witness to pivot irrigators being erected in pastures as plows turned the second-growth grass wrong-side up.

Now the prairie-chickens are almost gone. They have fallen victim, at least in part, to the subsidizing of corn and cotton in a world already awash in those commodities. When Jill and I visited the Llano, we had to content ourselves with watching the falcons chase the pigeons that hang around the enormous dairies springing up on the landscape faster than farm crops ever did.

Industrial, warm-climate dairies make fantastic pigeon habitat. The open loafing sheds are perfect for roosting and nesting. The spilled grain from the feed bunks insures a constant supply of food, so the pigeons are fat and plentiful. Pigeons showed up in large numbers on the Llano 15 years ago when the dairies started coming in, but since I prefer remote pastures for my excursions, I had never paid much attention to pigeons or dairies. On this trip, though, I had a young bird that liked to chase oddball game, so the dairy pigeons of the Llano Estacado became our target.

It is difficult to catch much of anything with a falcon, and wild pigeons are particularly tough, but Jill and I and the bird set out driving toward each set of distant light poles that indicated a new dairy had just been built. It was amazing how many dairies were out there where over the years I had seen only failed

homesteads being absorbed into battling pastures. Accompanying the dairies were miles of circle irrigators, and I could see by the equipment they were watering grain and alfalfa for the dairies. I was swearing at that and searching for pigeons, so I didn't pay enough attention to Jill. Having been raised on a traditional dairy farm, she was amazed at the operations we were passing.

These brand-new dairies were of incredible size but situated on dirt roads, far from any population centers. They were multimillion-dollar operations and there were lots of them. Jill was saying things like, "Wow, look at that," or "There's a sick one," and "Boy, these places don't smell like our farm did."

I had to agree that the dairies smelled bad, but there were lots of pigeons around. "That whole pen full of cows are tailless!" Jill said. I was trying to find a bunch of birds far enough from the buildings to give the falcon a chance at catching one, so I was still barely listening when she said, "Oh, my God. There's a pile of dead calves."

When I looked at her, I saw the discomfort in her face. There was indeed a pile of dead calves along the side of the road. "I've seen a dozen dead ones," she said. "But that's the first pile." We were just passing one of the pens and I looked out at the hundreds of cows confined there. "There's something wrong with those cows," Jill said. "Their udders must be infected!"

I forgot about the pigeons. "I don't think so,' I said. "I think they've been bred for big udders. More milk."

"What about the tails?"

I had read about such things, but I hesitated to tell her what I thought was happening. "I think they cut them off on purpose."

"The farmers cut the tails off?" She looked at me as if such a notion was impossible.

I had a hard time coming up with something to say. Finally, "These aren't farmers."

We drove in silence past another few pens of gaunt Holsteins with gigantic udders. "Well, no shit," she said.

The pigeon hunting was over. We drove on, but only to confirm that what Jill had been seeing was true at all the dairies we passed. We found thousands and thousands of tall, deformed dairy cattle, obviously genetically selected to do nothing but produce milk and to survive in the squalor of confinement. The selection process was obviously still going on, some being selected out.

Jill kept asking me questions that I did not want to answer. "When do they get out to pasture? What happens to their calves? Who drinks this milk? How did all these dairies get out here?"

The last question I can answer. They came from other states that tightened their regulations. They came for the water.

It takes an enormous amount of water to run dairies of the size now found on the southern Great Plains. It takes even more water to grow the corn that is forced down those cows' throats. For a while yet, the Ogallala Aquifer has that much water, and getting to it is easy in states that are too hungry for development to worry much about regulation. The water is being pumped out willy-nilly, every dairy racing its neighbor to the bottom. Sanitation is shaky. Most workers are undocumented. The landlords are absent, still in California or Wisconsin or South America where they either depleted the land under the original farm or sold it off for development. It is the Wild West of Water: Take what you can get as fast as you can, because the next phase of the drying up of the Plains might be the worst. That will come in the form of water for urban centers. Denver is eyeing Nebraska. T. Boone Pickens is angling for permits to drill and pipe the Ogallala from the Panhandle to Dallas.

On the way back to the little cabin where we always stay when we visit the Llano Estacado, we drove past a small playa lake that is almost always dry. One day a dozen years ago I found a thousand green-headed mallards crammed on the tiny pond that had appeared miraculously after a rare, hard rain. Playa lakes have a mysterious relationship to the Ogallala Aquifer. Every few years, these natural indentations on the prairie gather a little water from the sky and filter it down to mother Ogallala as a sort of thank you. The day we came to understand about the dairies of the southern High Plains the playa was dry and cockleburs grew in its bed.

COCHRAN COUNTY, TEXAS
The ghost of a lost playa still outlines land now under cultivation. Despite occupying only 2 percent of the landscape, the 25,000 remaining playa wetlands of the southern High Plains are considered keystone ecosystems that support myriad kinds of life. Critical for groundwater recharge, the playas are filling in with eroded soil from the surrounding agricultural landscape.

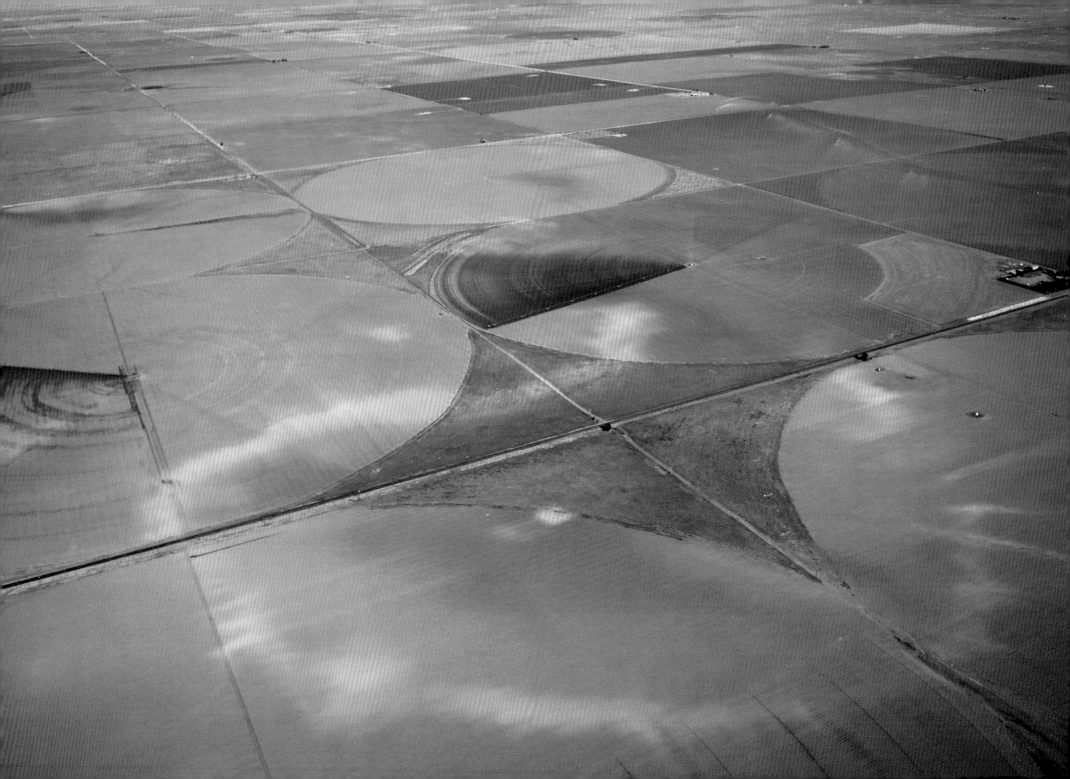

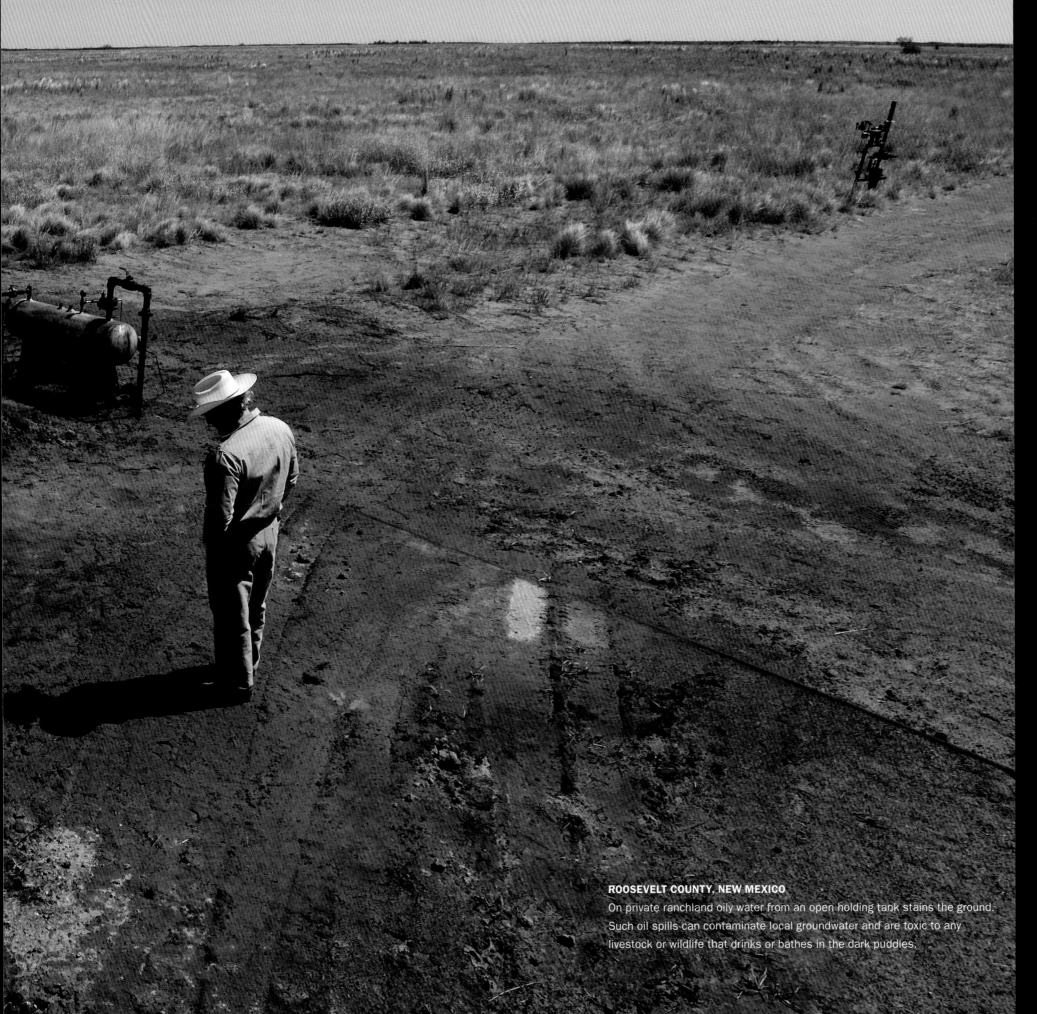

ROOSEVELT COUNTY, NEW MEXICO
On private ranchland oily water from an open holding tank stains the ground.
Such oil spills can contaminate local groundwater and are toxic to any
livestock or wildlife that drinks or bathes in the dark puddles.

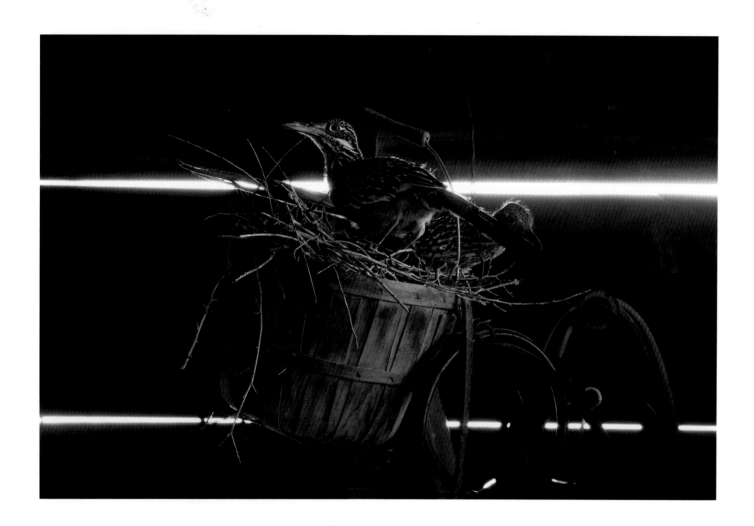

ROOSEVELT COUNTY, NEW MEXICO

A hardy Siberian elm *(Ulmus pumila)*, battered by cattle and wind after its home place was abandoned in the 1970s, now provides shade only for ghosts. Protected from the elements in an unused shop building on the property, a pair of greater roadrunners *(Geococcyx californianus)* nest in an old peach basket, even though barn owls are nesting in the loft above them.

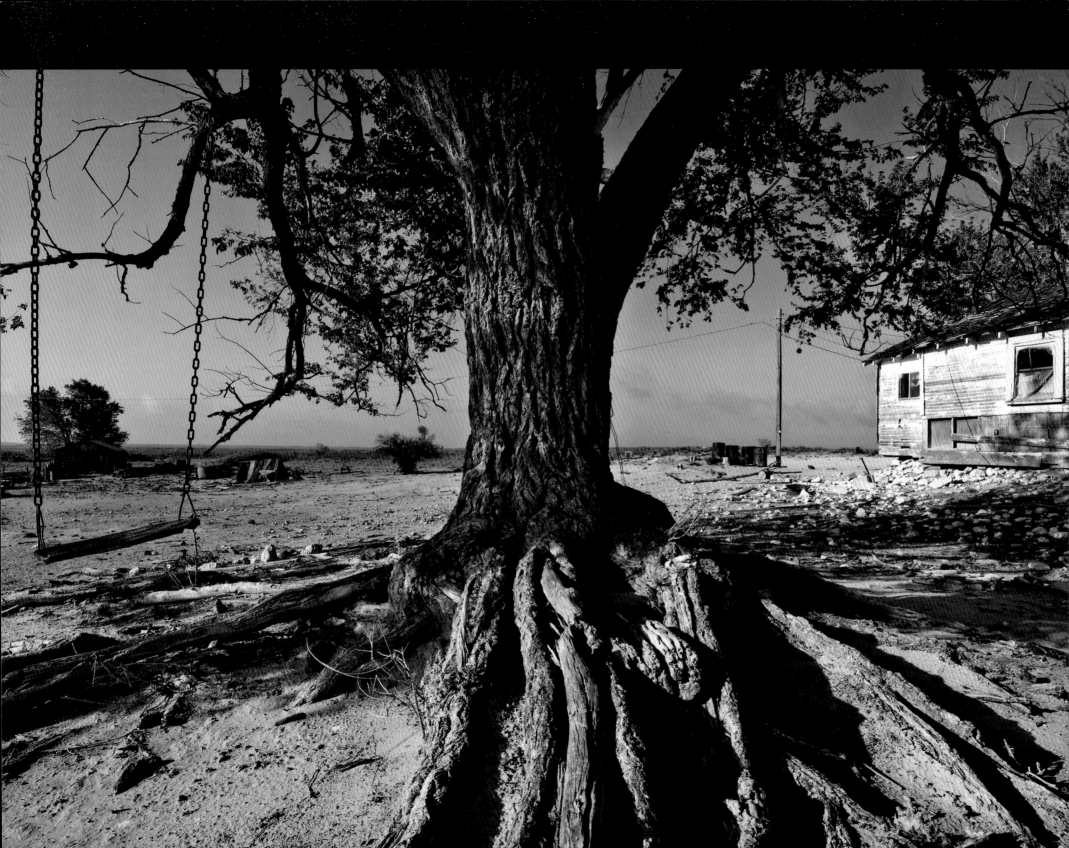

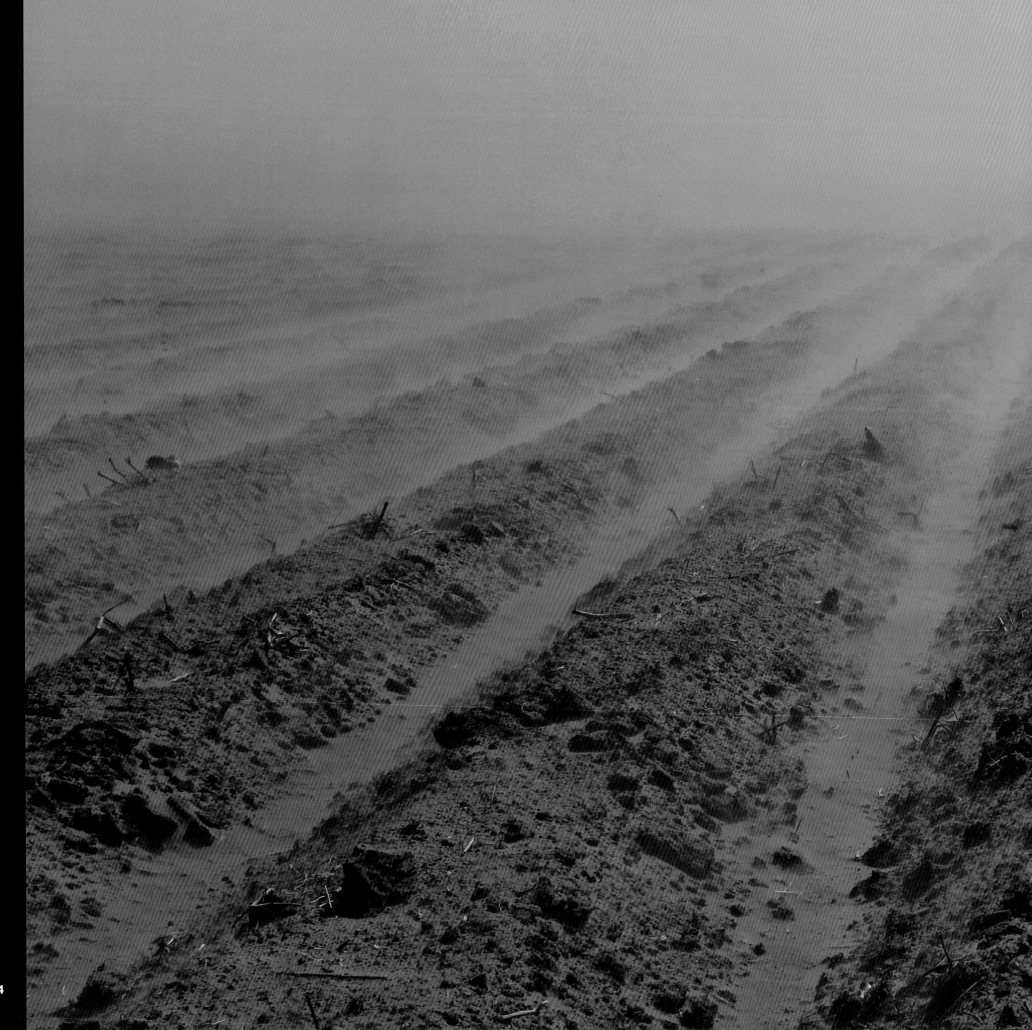

COCHRAN COUNTY, TEXAS
Cropland like this cotton field is listed into deep furrows to try and hold the soil in place. Despite a farmer's best efforts, the high winds of spring in the Southern Plains can fill the furrows in a day and carry more soil away.

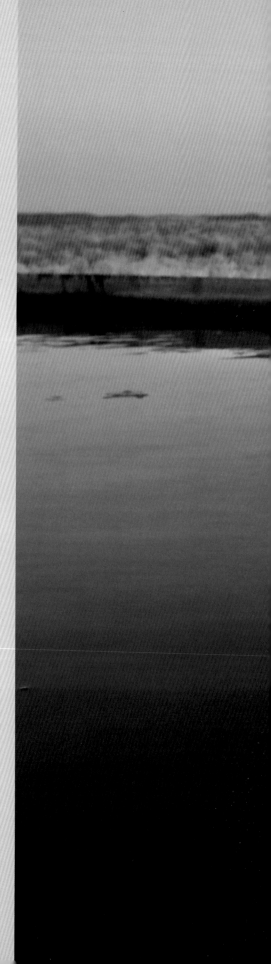

Field Journal: Lesser Prairie-Chickens
TNC MILNESAND PRAIRIE PRESERVE, NEW MEXICO

APRIL 4, 2008

The females arrive just before dawn—plump shadowy figures that seem to materialize out of the New Mexico prairie. They walk in silence across the hardpan soil to a stock tank in the center of an abandoned oil drill pad that now serves as their courtship stage, their lek. On most days this stock tank waters cattle, but today it was watering prairie-chickens.

Balancing on the lip of the tank a few at a time, they drink deep the cool, clear water drawn up from the Ogallala Aquifer far beneath these drought-stricken plains. Lesser prairie-chickens are not known for needing surface water to survive—they can get moisture from green vegetation and dew. But since last August, a local rancher tells me, the area has not seen a drop of rain.

The male grouse had been on the lek early too, somewhat subdued until the females finished drinking and decided to mingle. Then all at once this little open bare spot on the sandsage prairie becomes a singles bar, dance floor, and boxing ring. As the females move through their territories, the males sidle up to them and begin to dance, stomping their feet, thumping the earth in rapid drumbeat. Their orange neck sacks inflate and deflate as they call out with their yodels and gobbles, cackles and whistles. The long feathers on their neck stand on end. Their tail feathers spread out like a fan. Sometimes the males square off in crouched territorial poses, taunt each other and even exchange blows, fighting to defend their turf and a right to mate.

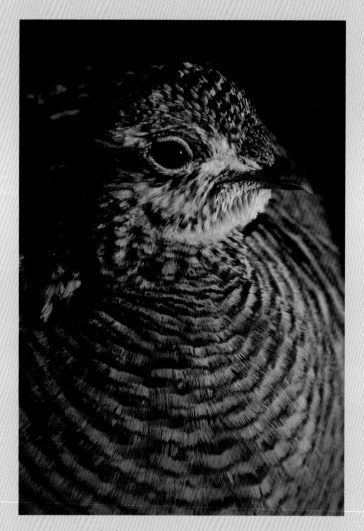

Lesser prairie-chickens (*Tympanuchus pallidicinctus*) generally do not require free water, but during droughts when no morning dew or high-moisture vegetation is available, they'll frequently drink from surface water sources, including stock tanks.

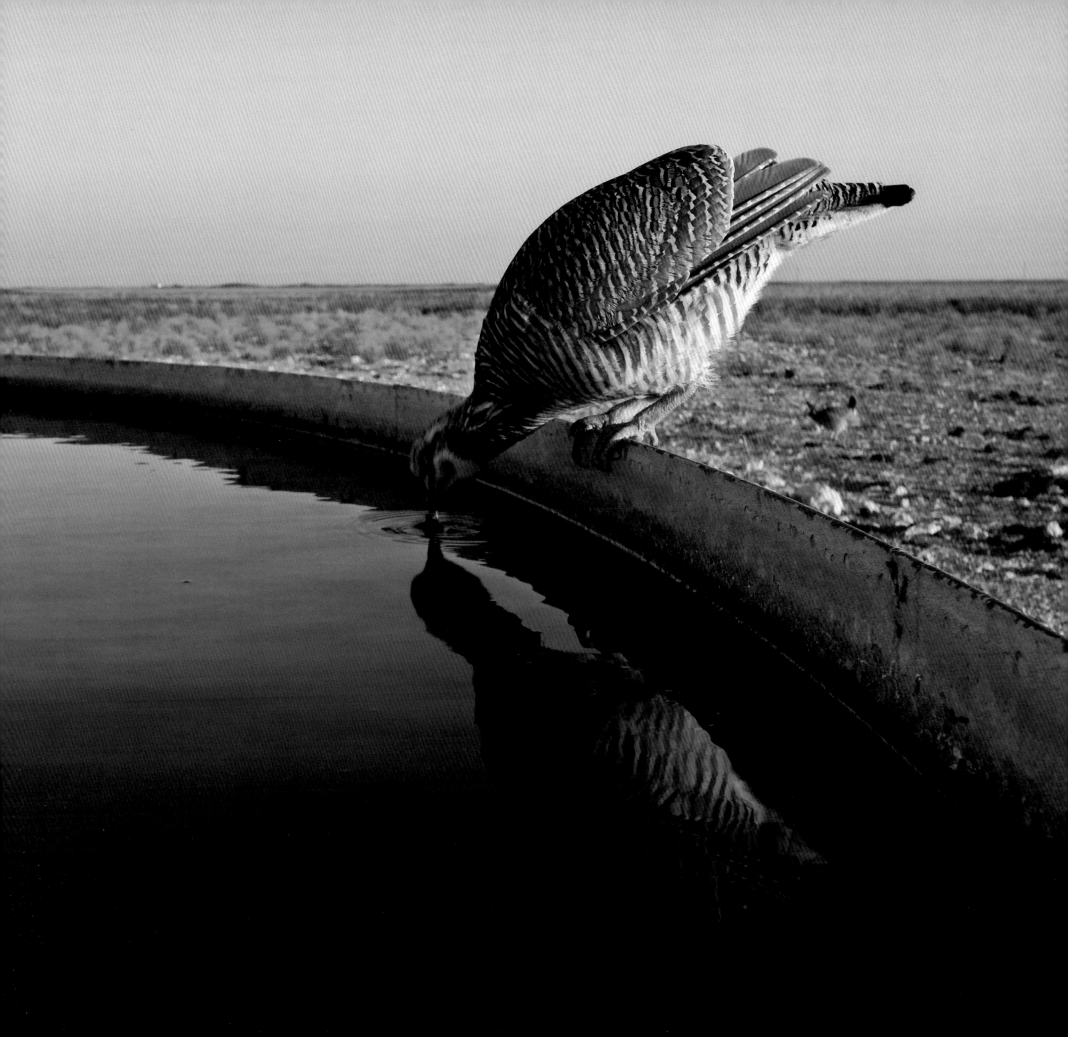

The aggressor attacks the other bird from behind.

A third prairie-chicken joins the fight.

The winner drums its feet in a courtship display.

After about an hour of intense courtship, the males on the lek begin to drink from the stock tank, too. Several times I watch pairs of battling males suddenly disengage, as if a bell had rung at the end of a boxing round and the two fighters were retreating to their respective corners of the ring. They walk directly to the tank and drink, rest for several minutes, then drink one last time before hopping down to re-engage. It's something I've never seen.

Many of the confrontations I've seen on these leks are mock battles, with a lot more posturing than direct contact. But this morning there is as intense a fight as I've ever witnessed. Just after sunrise, I hear behind me a collision of bodies and a furious flapping of wings. When any prairie grouse species fights, it can be a violent affair. The birds launch and collide in midair and bite and kick and jab each other with their wings. Usually the fights last only a few seconds, but this fight behind me persists. It sounds more intense than others, and it looks it.

My blind is anchored and set up to photograph facing west, so I have to cut a small slit in the wall to look east. Backlit by the rising sun, I see dust and feathers flying everywhere, as two males attack each other in a series of repeated collisions. They look like a pair of extreme fighters in the ring.

It quickly becomes obvious that one of the fighters is gaining the upper hand. He keeps trying to pin the other bird down by jumping on top of his opponent, biting the back of its neck and driving it into the ground with his wings and feet. A couple of times he succeeds in pinning his opponent, mantling it like a raptor does its prey, trying to hold it down with his own weight and covering it with his wings. Each time that the weaker bird escapes, the aggressor attacks again.

Most of what I can see through the viewfinder is just a cloud of dirt and thrashing silhouettes moving so fast I can hardly follow them in the frame. The attack is relentless, but the weaker chicken keeps fighting back. When the fight spills over into a third prairie chicken's territory, that bird immediately joins the fray, which throws off the aggressor. The weaker bird makes one last attempt at retreat, and this time gets away.

The winner immediately returns to its territory and wastes no time getting back to the business of courtship display. His defeated opponent, badly beaten, stumbles away out of the lek and back into the sage. I assume that will be the end of the bird. But about an hour later, after most other males have left the arena for the morning, he reappears

on the very far edge of the lek, assumes his booming posture, and weakly calls to any females that may still be lingering on the edge of the sage.

As fragile as the lesser prairie-chicken population is today, the spirit of this battle, with its struggles to survive and perpetuate the species, is emblematic of so many of the conservation challenges in the Southern Plains. Over the years these birds have taken an incredible beating, and so have their increasingly depleted, fragmented, and poorly managed sandsage and shinnery oak habitats. Yet somehow, these prairie grouse—and the people who work to protect them and their grasslands—keep fighting.

The bird on the edge of the lek lingers for awhile but it is calling out to an empty stage. Then a harrier flies in low and flushes the grouse away. Now all that is left on the lek are feathers strewn across the hardpan or caught midair by sprigs of sage, like tickertape after a parade. By late afternoon the lek will be swept clean by the south wind and the stage set for another day.

Right: A lesser prairie-chicken leaps above its opponent to engage in battle.

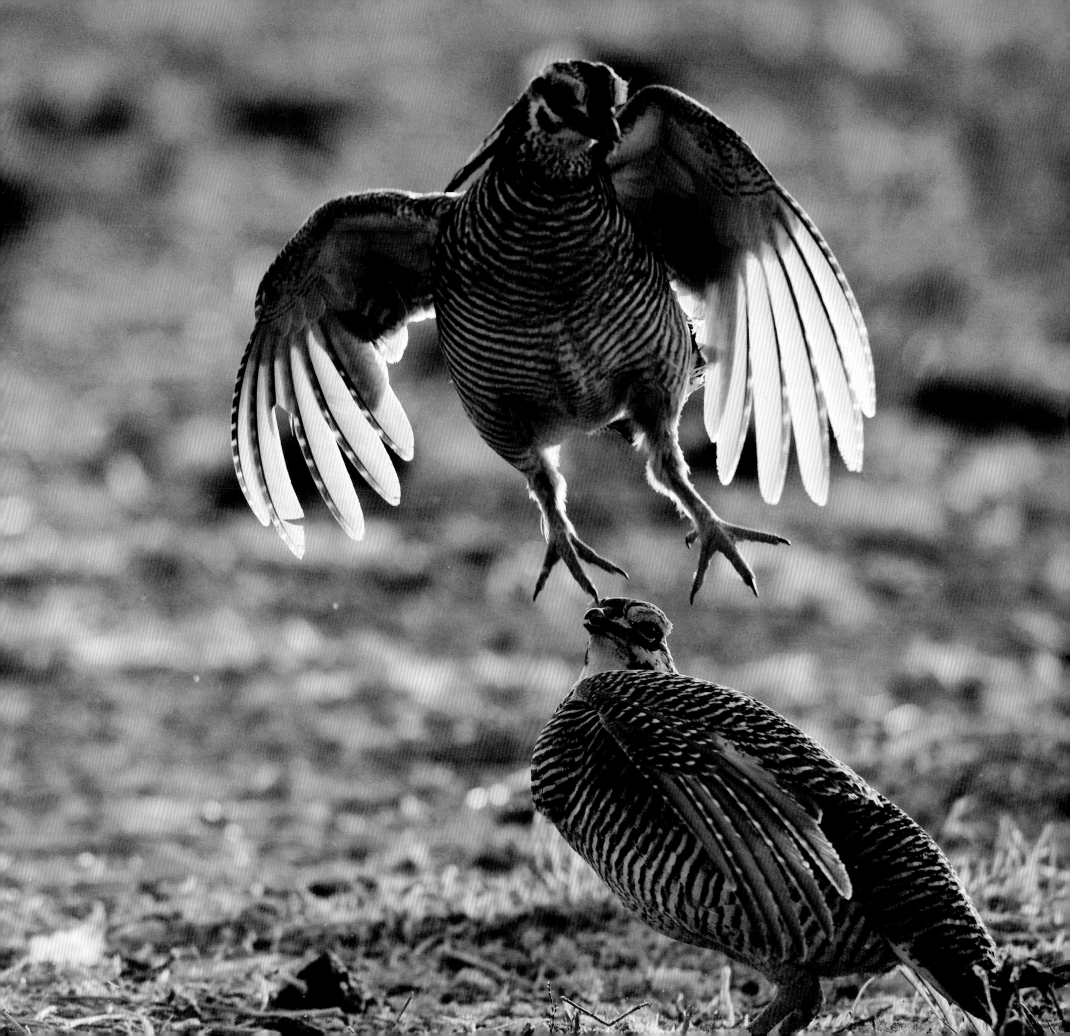

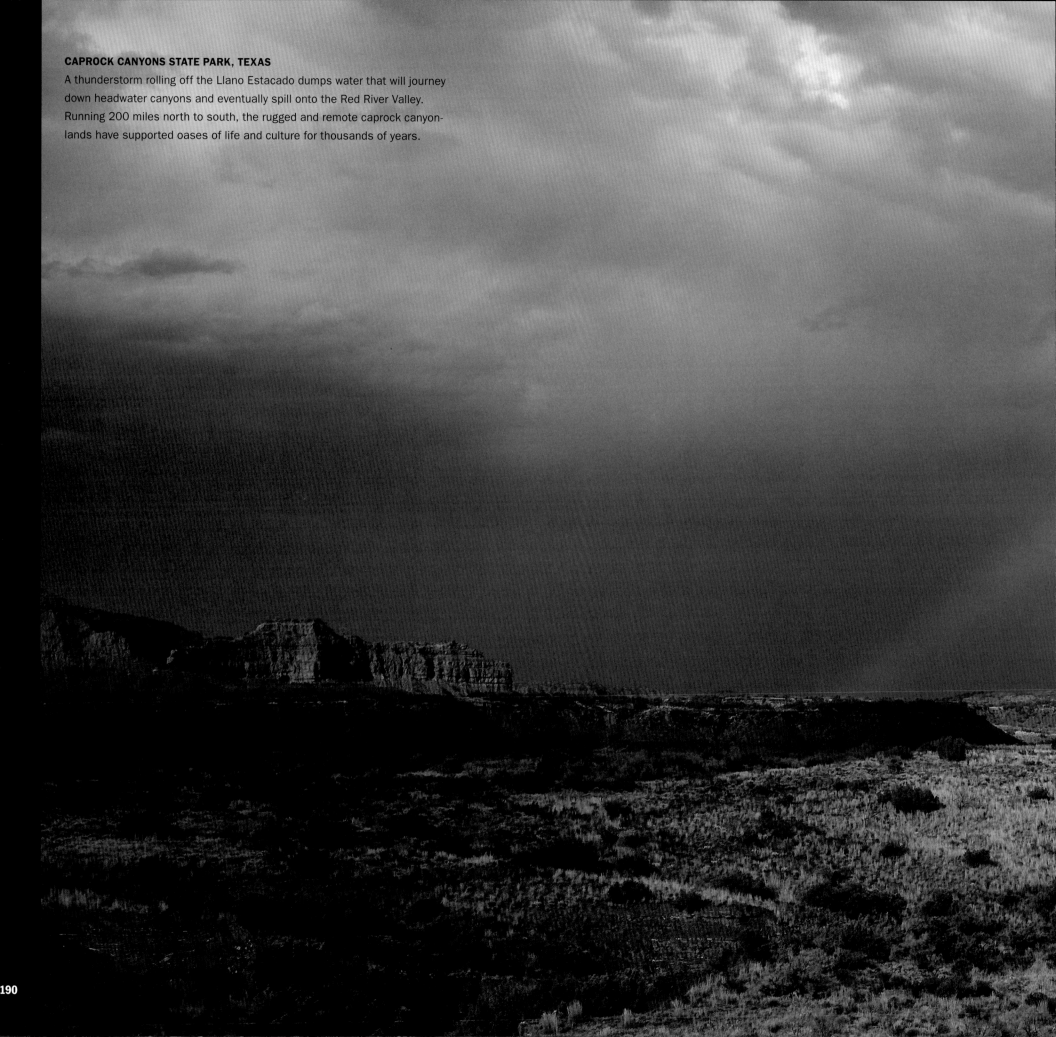

CAPROCK CANYONS STATE PARK, TEXAS
A thunderstorm rolling off the Llano Estacado dumps water that will journey down headwater canyons and eventually spill onto the Red River Valley. Running 200 miles north to south, the rugged and remote caprock canyon-lands have supported oases of life and culture for thousands of years.

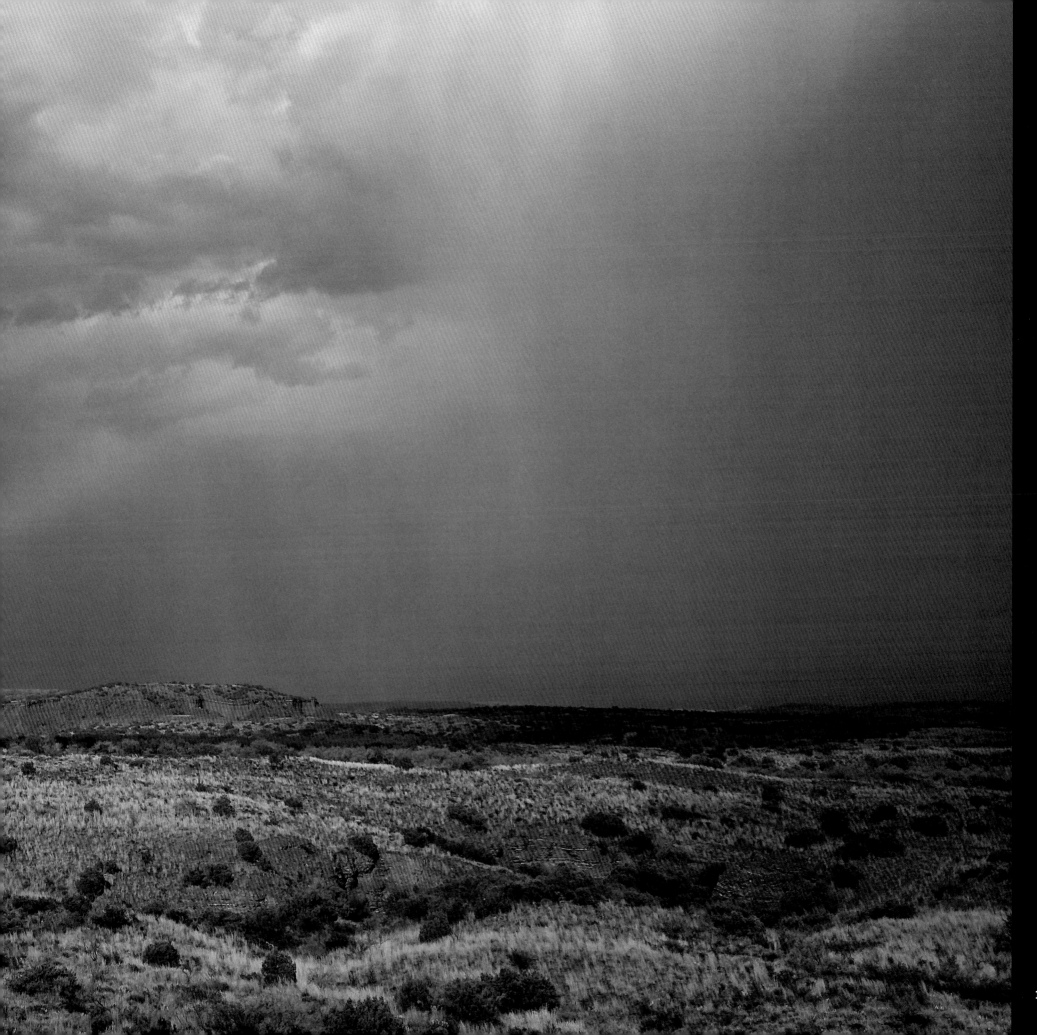

Left: **BRISCOE COUNTY, TEXAS**

Carved by water and polished by time, the Narrows cuts through sandstone walls in Los Lingos Canyon. One of many remote canyon systems along the Caprock Escarpment, Los Lingos connects the high, flat tableland of the Llano Estacado to the Red River Valley's rolling plains.

Above: **CAPROCK CANYONS STATE PARK, TEXAS**

A Blanchard's cricket frog *(Acris crepitans blanchardi)* blends with the color of the sand in the clear spring-fed shallows of South Prong Creek. About the size of a quarter, these tiny nonclimbing members of the tree frog family can jump a remarkable three feet to escape danger.

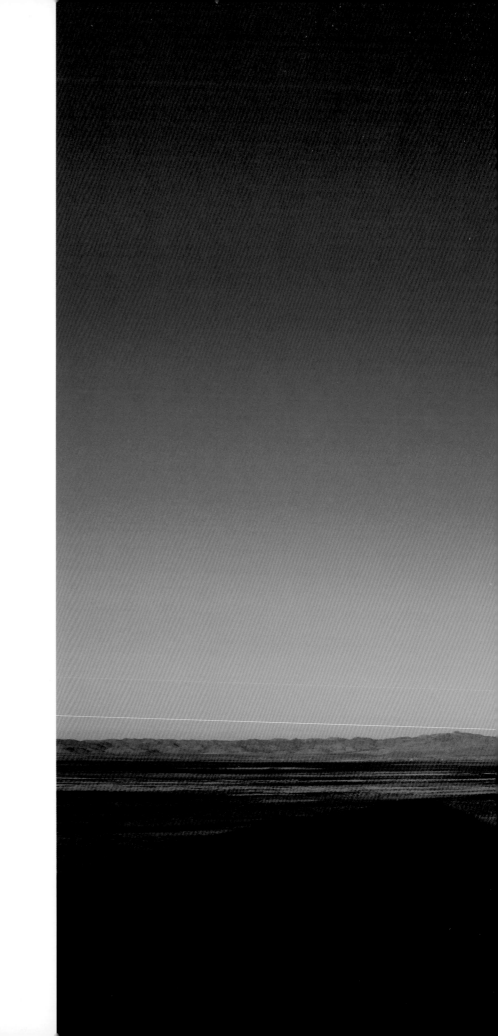

TNC RANCHO EL UNO, CHIHUAHUA

Sunrise silhouettes a desert spoon *(Dasylirion wheeleri)* rising above the sprawling Janos Valley. Threatened by conversion to cropland, groundwater mining, and overgrazing, many of northern Mexico's desert grasslands are now in crisis and so is the life they harbor. They contain some of the richest plant diversity in North America. Most grassland birds in the Great Plains migrate here during the nonbreeding period.

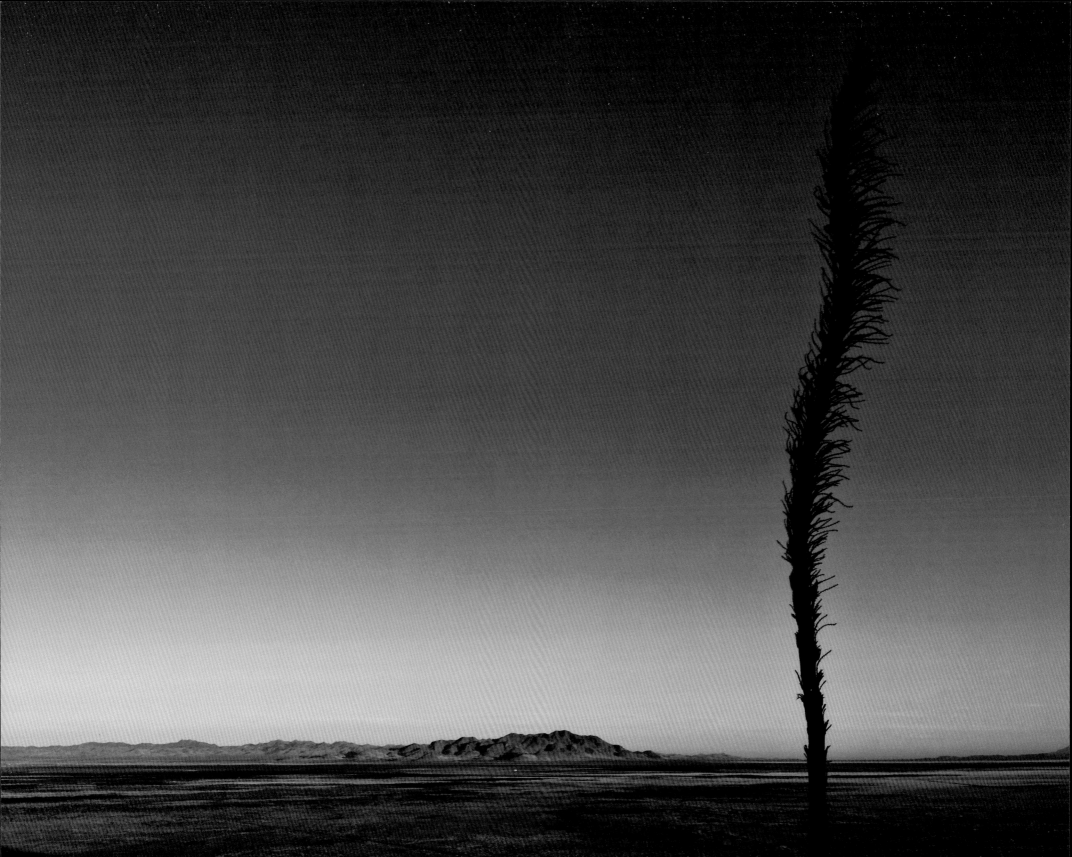

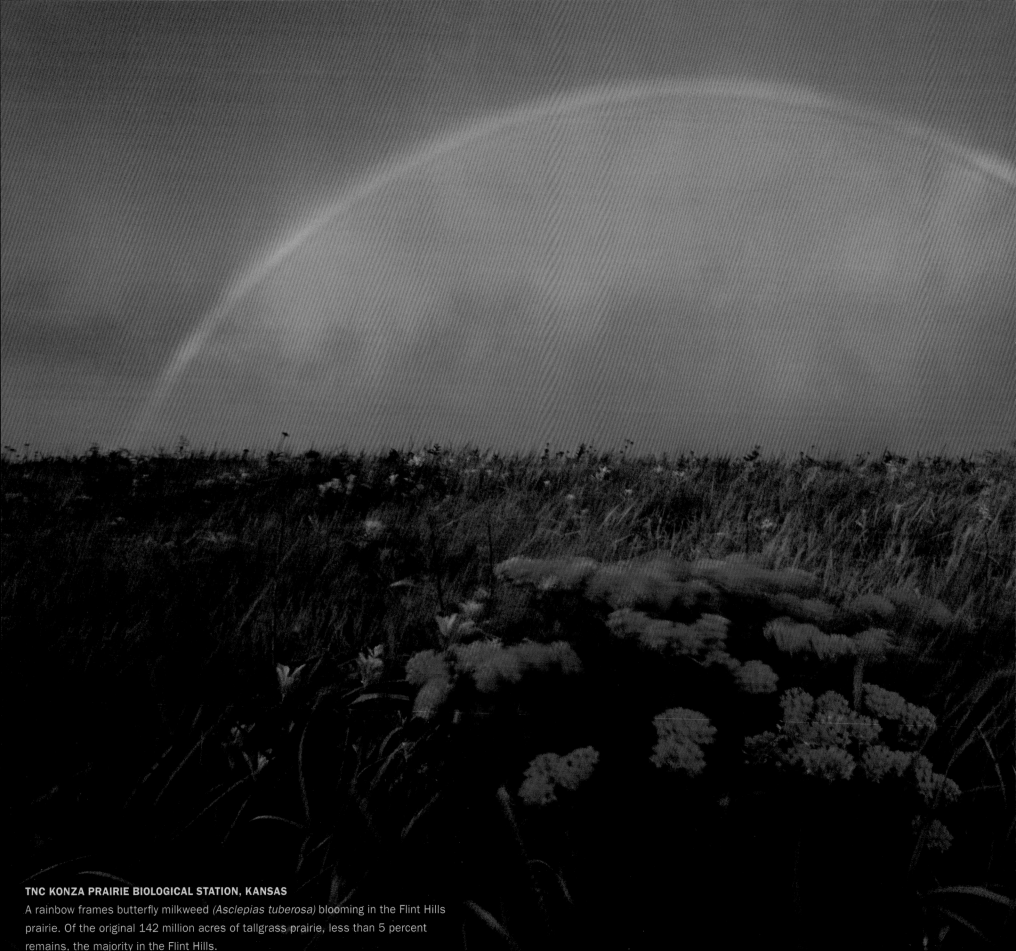

TNC KONZA PRAIRIE BIOLOGICAL STATION, KANSAS
A rainbow frames butterfly milkweed *(Asclepias tuberosa)* blooming in the Flint Hills
prairie. Of the original 142 million acres of tallgrass prairie, less than 5 percent
remains, the majority in the Flint Hills.

Tallgrass Remains

COMMENCING WITH SMALL "OAK OPENINGS" in Indiana, the tallgrass prairie once spread through much of the American heartland, covering Iowa, southern Minnesota, the eastern portions of the Dakotas, Nebraska, Kansas, Oklahoma, Texas, northwestern Missouri, and north into south-central Manitoba. To the west, with decreasing rainfall the tallgrass gave way to mixed-grass, and the woodland diminished to slender fingers of cottonwood and willow, reaching out into the heart of the Great Plains.

The tallgrass prairie must have been a sight to behold. Early travelers struggled to capture in words its immensity and diversity, its fragrance, its teeming wildlife, its strangeness. William Clark of the Lewis and Clark Expedition frequently wrote about this plentitude in his journal. On July 30, 1804, Clark climbed the bluffs of the Missouri River Valley in what is now Washington County, Nebraska, to gain a view of the country. Before him he saw "the most butifull prospects imaginable," a seemingly boundless upland prairie of little bluestem, needlegrass, and prairie dropseed, with big bluestem on the lower slopes. "Nature appears to have exerted itself to butify the scenery by the variety of flours," Clark wrote. He specifically noted bright yellow sunflowers ten feet high, but he also would have seen slender white prairie clover, silvery leadplant, bushes of purple aster, and many of the other 250 varieties of forbs (flowering herbaceous plants) that added profusion and color to each square mile of the prairie.

In the dense vine-strewn woodlands on the Missouri River floodplain, Clark identified stands of cottonwood, mulberry, ash, elm, hickory, oak, Kentucky coffee tree, and sycamore, as well as abundant species of wild fruits—plums, grapes, gooseberries, currants, raspberries, chokecherries, and tart red buffalo berries. The wildlife Clark observed—and sometimes shot—included bison and beaver in great numbers (even in the immediate vicinity of an Omaha Indian village), prairie dogs, badgers, elk, antelope, and deer, which were "as plentiful as hogs about a farm." At one point the Missouri River was coated from bank to bank for three miles with a layer of white feathers, the source of which, the explorers eventually discovered, was an immense gathering of pelicans on a sandbar. Nearby, the explorers threw a net into a creek and pulled out 318 pike, bass, freshwater drum, catfish, crayfish, and mussels.

Lewis and Clark, like European explorers and particularly the French before them, hoped on their westward passage to encounter the "Garden," a mythical earthly paradise of fertility and tranquility. In the verdant tallgrass prairies they believed they had found it. They, and the Indians who preceded them by thousands of years, were fortunate to see the tallgrass prairie in its prime. In the following two centuries the

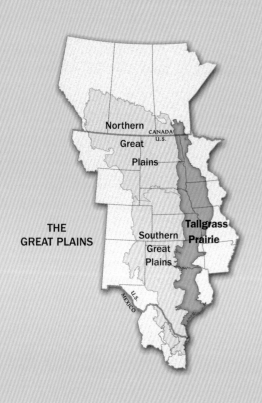

THE
GREAT PLAINS

Northern

Great

Plains

Southern

Great

Plains

Tallgrass
Prairie

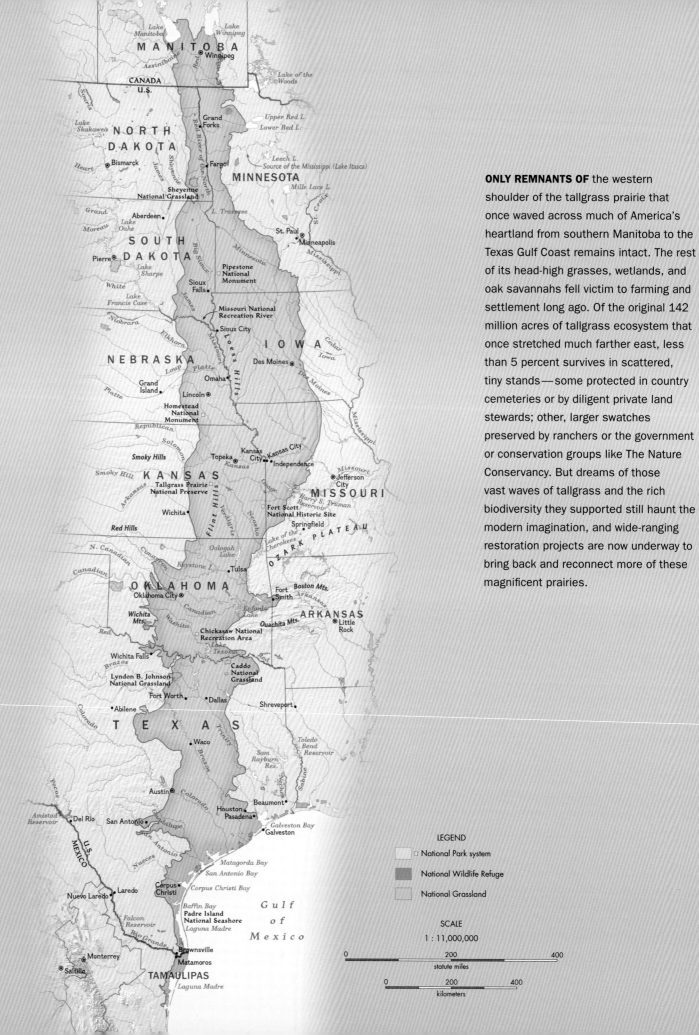

ONLY REMNANTS OF the western shoulder of the tallgrass prairie that once waved across much of America's heartland from southern Manitoba to the Texas Gulf Coast remains intact. The rest of its head-high grasses, wetlands, and oak savannahs fell victim to farming and settlement long ago. Of the original 142 million acres of tallgrass ecosystem that once stretched much farther east, less than 5 percent survives in scattered, tiny stands—some protected in country cemeteries or by diligent private land stewards; other, larger swatches preserved by ranchers or the government or conservation groups like The Nature Conservancy. But dreams of those vast waves of tallgrass and the rich biodiversity they supported still haunt the modern imagination, and wide-ranging restoration projects are now underway to bring back and reconnect more of these magnificent prairies.

LEGEND

☐ National Park system

◼ National Wildlife Refuge

☐ National Grassland

SCALE

1 : 11,000,000

| 0 | 200 | 400 |

statute miles

| 0 | 200 | 400 |

kilometers

grasslands and floodplain woodlands were all but lost to crops, cities, and roads.

The prairie Lewis and Clark saw was not untouched by human hands. Indians frequently burned the grass to signal their presence, to control mosquitoes, and drive game, and in the fall as a conservation measure to ensure vigorous growth in the spring, when their horses desperately needed forage. This induced burning, as well as prairie fires set by lightning, consumed plant debris from the previous year, opening up the ground to sunlight and stimulating new growth.

The Plains' abundant game led some Indians to hunt without any pretense of conservation. Around Christmas 1804, for example, in what is now central North Dakota, Canadian fur trader Charles McKenzie watched the Hidatsa Indians kill "whole herds" of bison and take only the greatest delicacy, their tongues, leaving the carcasses to rot on the ground.

Things changed dramatically with the arrival of the American fur traders in the early 19th century. They encouraged the Indians to trap and hunt for an external market. By 1833, when German naturalist Prince Maximilian of Wied-Neuwied traveled up the Missouri River, "wild beast and other animals whose skins are valuable in the fur trade" had "diminished greatly in number."

The most drastic alteration of the tallgrass prairie came with the advent of European-American agricultural settlement, beginning in Iowa in the 1840s and in southwestern Minnesota and eastern Kansas, Nebraska, and Dakota Territory in the 1860s and '70s. In each area, settlement followed the same the sequence: The timbered valleys first, the dry upland prairies next, and the wet prairies much later. Settlers chose to locate in the wooded valleys or at the junction of the woodland and prairie. They needed timber for their log cabins and other farm buildings, for furniture and fuel, and, in greatest amounts, for the zigzagging split-rail fences that confined livestock and demarcated property. Oak and walnut, the preferred fencing woods, were probably depleted first. The wooded valleys also offered proximity to water and shelter from Plains winds and sun. Even when settlers moved out onto the prairie, they often retained woodlots in the valleys.

The prairie was heralded by settlers as a beautiful landscape but distrusted as a potential home. They feared the frequent lightning fires and blinding blizzards and disliked the sense of exposure, the feeling of having nothing to hide behind. There were practical problems of turning the sod, and suspicions that wheat and corn would not thrive on prairie soils. Fencing was a major problem for the first two generations of settlers, because improvised solutions like turf walls and Osage orange hedgerows did not work well, and hauling rails from increasingly distant woodlots was too costly. In any case, there was not enough wood in the valleys to provide for the fencing of the prairie. Even in the late 1850s, in Story County, Iowa, settlers preferred to pay 8 to 15 dollars an acre for wooded land rather than the public land price of $1.25 an acre for unoccupied prairie.

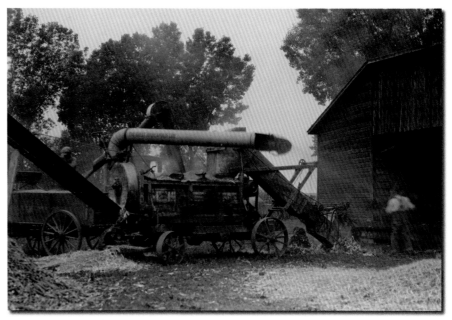

SHENANDOAH, IOWA
Threshing corn took place on family farms like Earl Fishbaugh's in the 1920s.

But gradually, settlers moved out onto the prairie. Unclaimed areas were initially used as open range. Railroads, which had lagged behind settlement in eastern Iowa, caught up in the 1860s, bridging the distances across the open spaces. The mass production of barbed wire in the 1870s solved the fencing problem, and settlers found that they could break the prairie sod with their two-horse steel plows, or else pay to have the job done at a cost of about three dollars an acre. Their crops, especially corn, flourished on the rich prairie soils.

There were still extensive areas of wet prairie to be reclaimed. Geographer Leslie Hewes identified an original arc of wet prairie reaching from southeastern Iowa through eastern North Dakota to southern Manitoba. Within this arc, which included much of the prairie pothole region, at least 10 percent of the land was poorly drained. In north-central Iowa and the Red River Valley, at the border of Minnesota and North Dakota, the proportion climbed to one-third of the total area.

The wet prairie was a product of glaciation and poorly developed river systems. Where glacial debris had been deposited, kettle lakes filled the shallow depressions; on flat glacial outwash plains, where the soil was composed of silt and clay or underlain by an impervious clay bed, water pooled over extensive areas for all or part of each year. You could identify wetlands by their vegetation — slough grass, sedges, cattails, and on the fringes big bluestem — and by roads that meandered around ponds and marshes in an unusual departure from the grid. The coal-black, nutrient-rich wetland soils were also waterlogged and oxygen-deprived, preventing roots from penetrating deeply and stunting crop growth. Wet areas

also swarmed with insects and were associated with malaria. The federal government was so convinced the wetlands were worthless that they donated them to the states through a series of swamp acts.

The wet prairie was avoided until all other lands were taken. If they were used at all, it was for livestock grazing and wild hay. Draining the wetlands began slowly, as individual farmers dug ditches by hand. The pace of wetland use accelerated in the late 19th century with the establishment of factories where the same clay that hampered drainage was manufactured into cylindrical tiles. These were laid end-to-end at the bottom of mechanically excavated trenches that ran in lines four feet or more underground, channeling excess water into streams. This activity increased after 1900 as farmers and counties cooperated in large-scale drainage enterprises. As a result, by 1950 the amount of land in crops in Story County had increased to 70 percent of the total area. In one 36 square-mile township there were 500 miles of tile drains.

The former wet prairie became indistinguishable from the former dry prairie, whether by types of crops, crop yields, field shapes, road patterns, or land prices. It was an extraordinary alteration of an ecosystem, from the diverse biomass and distinctive places of the original prairie to a bucolic but standardized landscape of rotated monoculture, with corn predominanting. And the means by which it was achieved, tile drainage, is hardly evident on the surface of the land.

Farmers were rightly proud of their accomplishment in transforming "unimproved" virgin prairie into the Corn Belt, one of the most successful agricultural regions in the world. No one seemed to have considered it a loss. Native Americans, who had rapidly become strangers in their own land, saw it differently. In 1882 Joseph LaFlesche, hereditary chief of the Omahas, recalled a time when he used to see Indians "and think they were the only people." But then Americans and Europeans came, "just as the blackbirds do, and spread over the country." Forty years later another Omaha chief, White Horse, lamented, "Now the face of the land is changed and sad. The living creatures are gone....Sometimes I wake in the night and feel as though I should suffocate from this awful feeling of loneliness." In time many scientists and members of the general public would also see the effacement of the tallgrass prairie in a different light.

Draining the wet prairie has continued right up to the present. In Iowa about 98 percent of the prairie potholes have been consumed by cultivation, and in eastern Nebraska almost all of the clay-bottomed wetlands of the Rainwater Basin—so essential for waterfowl during their spring migration—have been drained or degraded. The sprawl of cities in the tallgrass region, the most densely populated part of the Great Plains, is also replacing surviving prairie, as is the case around Lincoln, Nebraska, where rare saline wetlands are threatened.

As geographer Hugh Prince explained, what had been seen until the 1950s as

problematic "wet lands" to be eliminated for farming became precious "wetlands" to be preserved for their intrinsic value as aquatic ecosystems, wildlife habitat, and distinctive places. Government policy switched from subsidizing drainage projects to supporting wetland protection and restoration through agencies like the US Fish and Wildlife Service. The key, according to that service, is to encourage the coexistence of agriculture and wetlands for the benefit of all. This is difficult to accomplish, however, when only about one percent of the land in this rich agricultural area is actually owned by "all," that is the federal government.

Portions of the tallgrass prairie have survived only in places that are too steep, sandy, or stony for cultivation, as in the Loess Hills of Iowa and the Flint Hills of Kansas, though many of these grasslands have been significantly altered by overgrazing and the suppression of natural fires. And in recent years, throughout the former tallgrass country, small parcels of prairie have been protected or are being restored. The 11,000-acre Tallgrass Prairie National Preserve in the Flint Hills was established in 1996 as the first prairie component of the national park system. It is now operated as a public/private partnership of The Nature Conservancy, the National Park Service, and the Kansas Park Trust. The Nature Conservancy also operates the Tallgrass Prairie Preserve in northeastern Oklahoma, which, at 39,000 acres, is the largest protected prairie remnant in North America. Some 2,500 bison graze 23,000 acres of the preserve in rotational patterns. Bison have a nearly all-grass diet, allowing forbs to thrive in abundance, and bison manure fertilizes the soil and disseminates seeds. The preserve is burned in random patches at different times of year, mimicking the conditions that produced the richness and biodiversity of the original prairie. Prescribed burning is also used to maintain the integrity of the grasslands in the 5,000-acre Manitoba Tallgrass Prairie Preserve near Gardenton, where 90 species of birds nest and more than 200 plant species grow, including the endangered small white lady's slipper orchid and the western prairie fringed orchid.

Throughout the prairie, tallgrass restoration projects are underway. In western Minnesota The Nature Conservancy has partnered with the Fish and Wildlife Service, local landowners, and others on the Glacier Ridge Project, the most ambitious tallgrass restoration project yet undertaken. Eventually, 38,000 acres will be returned to native grasses and wetlands and protected in the Glacier Ridge National Wildlife Refuge.

Despite these ongoing efforts, only fragmented reminders of the original tallgrass prairie remain. It fell victim to its own fertility, too valuable for agriculture to escape the plow. The fragments are now refuges for plants and wildlife that have been eradicated elsewhere, living museums that recall the past and honor it. They are also places where the mind can soar, taking you back to 1804 and William Clark, gazing out over the tallgrass prairie in all its uninterrupted glory.

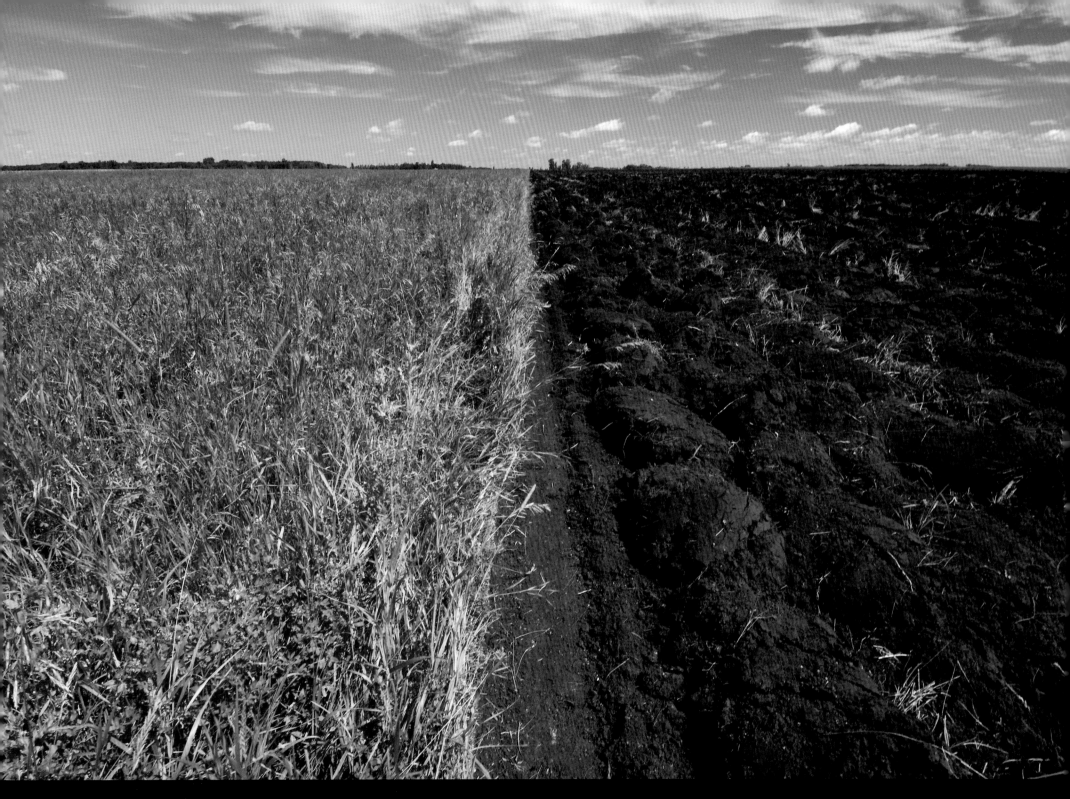

POLK COUNTY, MINNESOTA
In mid-July, grassland is plowed under to be put back into cropland—another tract
leaving the Conservation Reserve Program (CRP). As commodity prices have risen
along with corn ethanol production, more grassland is lost, some of it virgin prairie.

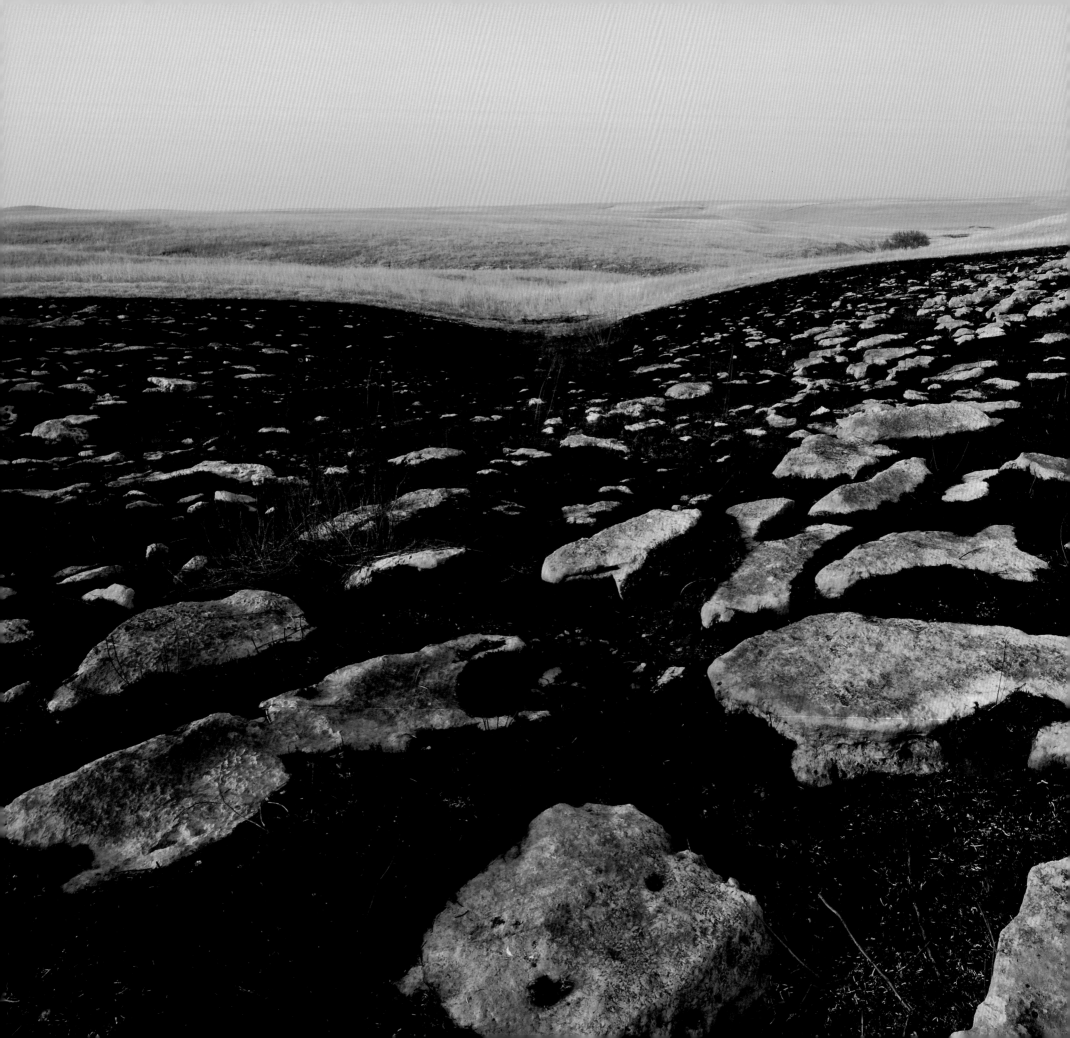

TALLGRASS PRAIRIE NATIONAL PRESERVE, KANSAS
Large limestone slabs lie exposed after a prescribed burn on tallgrass prairie in the
Flint Hills. Seasonal fires and grazing stimulate growth in grasslands and were key
shapers in the pre-settlement ecology of the Great Plains. Above, two prescribed fires
merge at night on a cattle ranch near Cottonwood Falls. Some Native Americans
called these fires rolling across the landscape "red buffalo."

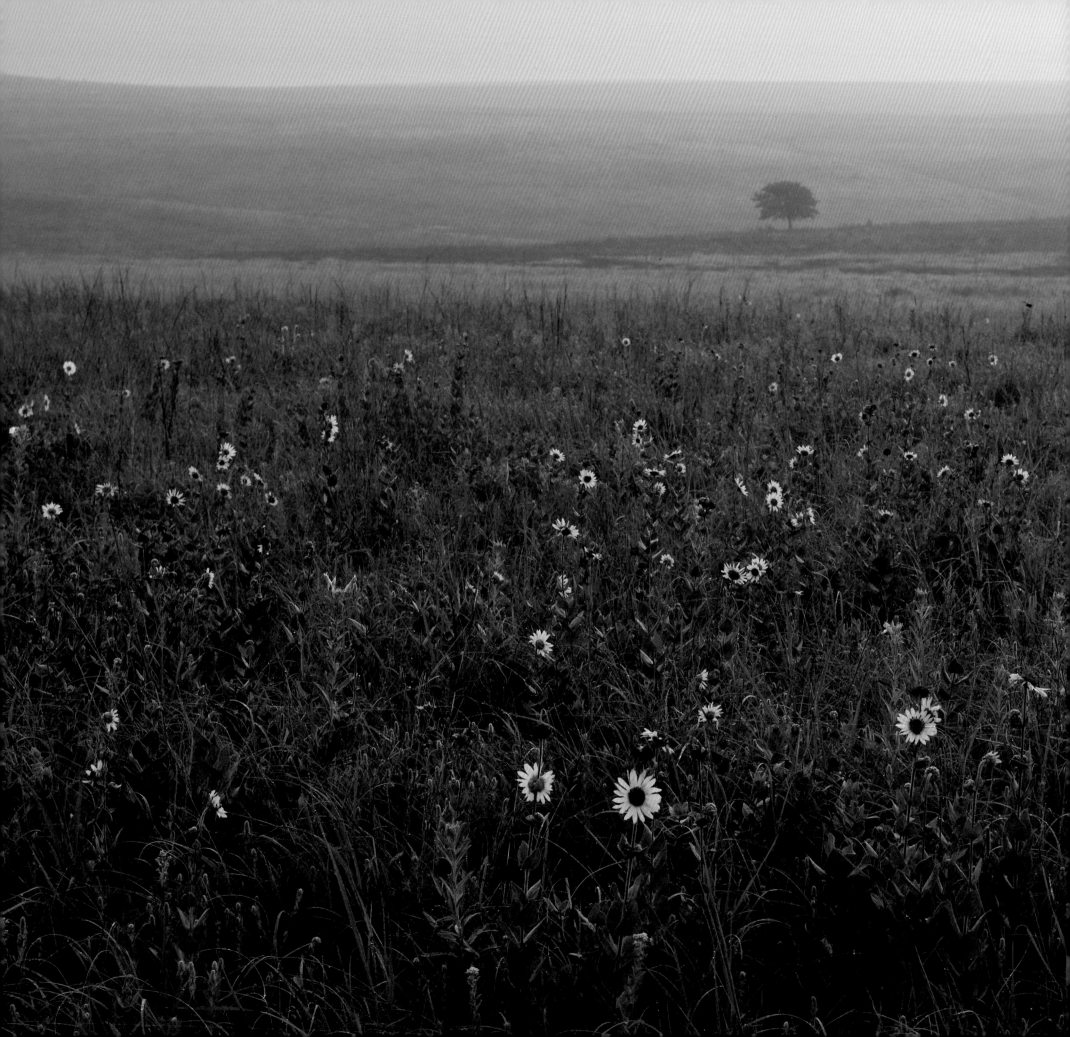

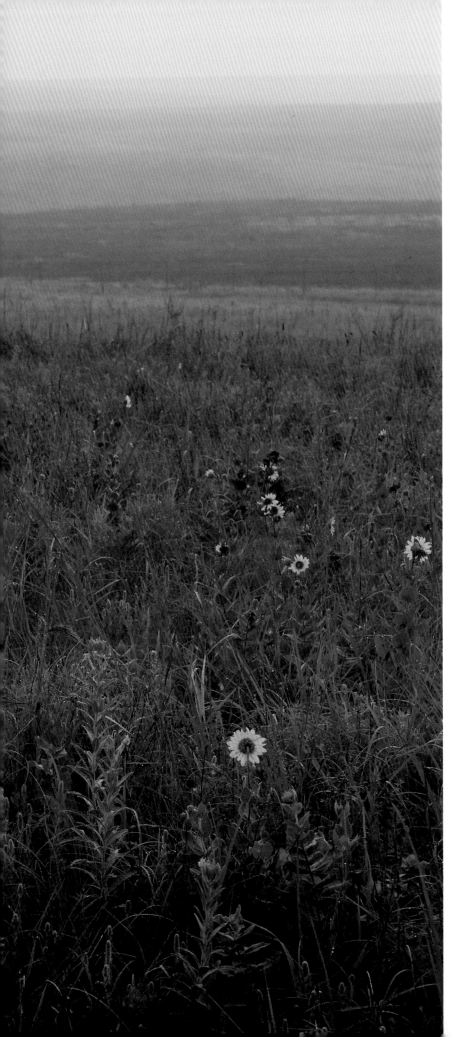

TNC TALLGRASS PRAIRIE PRESERVE, OKLAHOMA

The largest protected remnant of tallgrass prairie on Earth, this 39,000-acre Nature Conservancy preserve flourishes under a year-round "patch burn grazing" regimen that attempts to mimic the natural interaction between fire and native grazers. Some 2,500 bison roam free here, and unlike cattle, forage almost entirely on native grasses, leaving plains sunflowers *(Helianthus petiolaris)* and other forbs alone. The result is a shaggy, shifting prairie mosaic with some 750 species of plants, which support a diverse animal community aboveground and below.

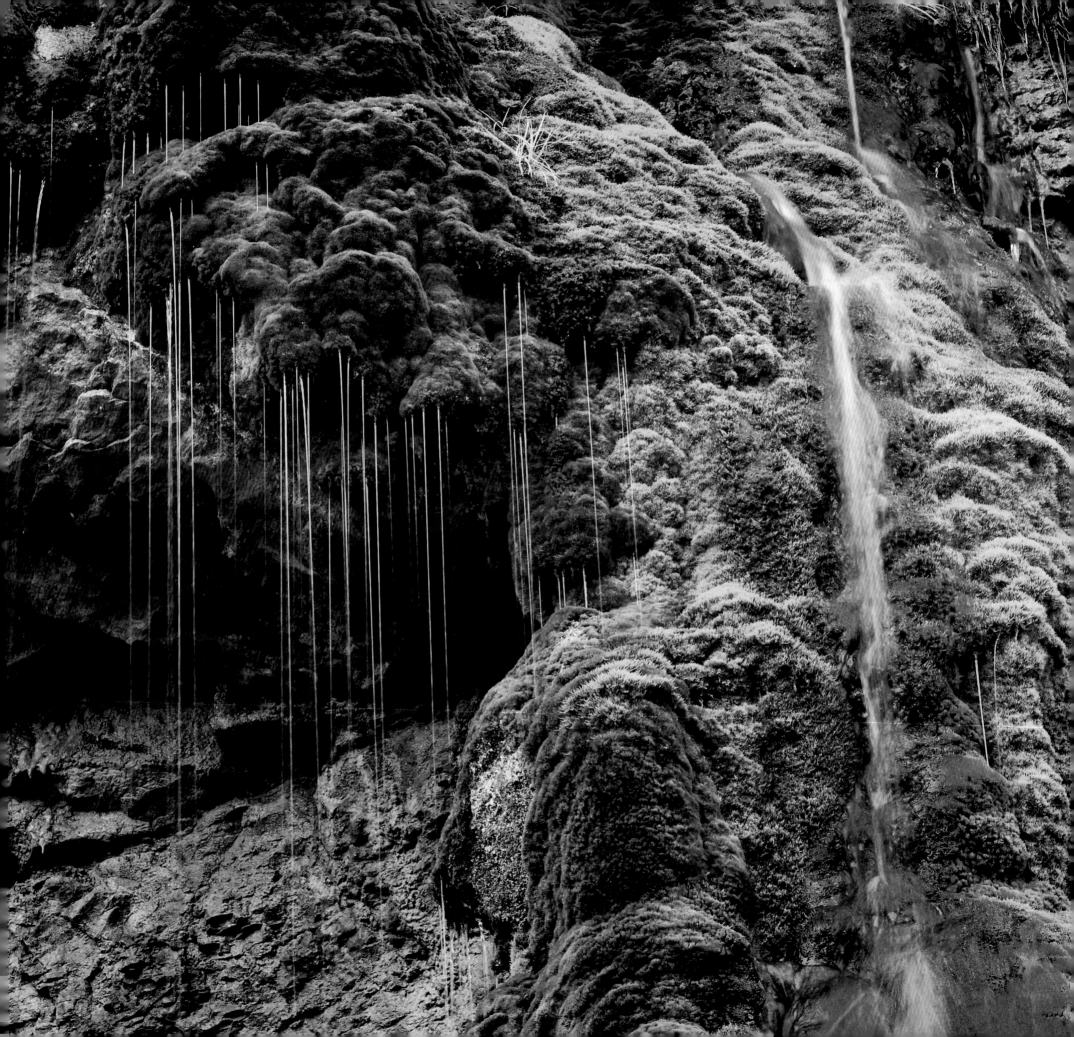

Field Journal: Illinois Creek
FLINT HILLS, KANSAS

JULY 8, 2007

Today is my third day photographing underwater in the Land of Oz. I am trying to capture on camera the small, beautiful native fish that live out their lives in the clear streams rolling off the tallgrass tabletops of the Flint Hills in eastern Kansas. These are the streams and creeks most people seldom notice or think about as they drive over them on a country road. But I'll never *not* notice them again.

The water of these creeks is arguably clearer than any in the Great Plains, thanks to the creeks' limestone bottoms and to the still intact tallgrass prairie surrounding them. Entering their underwater realm is like entering another world. First, a supreme silence envelopes you with a feeling as comforting as a warm blanket on a cold winter night. Then, there's the soft, almost buttery quality of the light, refracted by the water above and reflected by the cream-colored limestone below. Finally, you notice the rich diversity of the life itself, which is everywhere.

Submerged just below the surface in a few feet of water, pushing off the bottom with my hands and propelling myself forward ever so slowly and quietly, I move from pool to riffle to pool. I can see crayfish backpedal into dark corners, mossy-backed turtles lurking on the edge of undercut banks, and schools of fish no bigger than my pinkie darting this way and that, in and out of the current. Their magnificent colors flash every time they hit a spotlight of noonday sun streaking through the canopy of trees.

I have spent an hour or so in the water, when I surface to defog my mask and readjust a plate-size slab of limestone I had shoved into the front of my wet suit as ballast. I look up and see a man wearing a cowboy hat and boots standing on the high bank staring down at me. Through my fog-stained mask, I can see he's tall, lean, and weathered by the sun. He has a fence-fixing tool in one hand and a roll of bailing wire in the other.

"Hi," I say.

"Hello," he says back with a nod and a puzzled look on his face.

"I bet you don't see someone in a wet suit and mask snorkeling in this creek every day," I offer, not knowing what else to say.

"Nope."

"Then I suppose you're wondering what the heck I'm doing?" I say as I pull myself up on a gravel bar near the bank and take off my mask so he can see my face.

"You could say that."

"Well, I'm photographing fish."

He looks at me funny then and takes a step back.

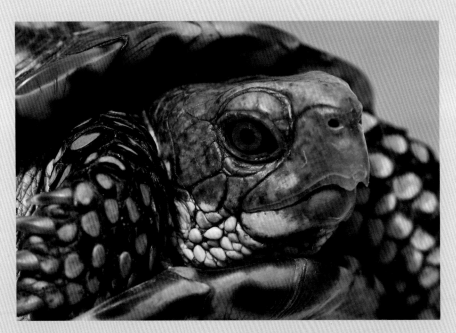

Left: Spring water from an all-prairie watershed cascades down a wall of moss-covered limestone on its way to Illinois Creek. *Above:* Red eyes distinguish the male ornate box turtle *(Terrapene ornate)* from the female, whose eyes are light brown.

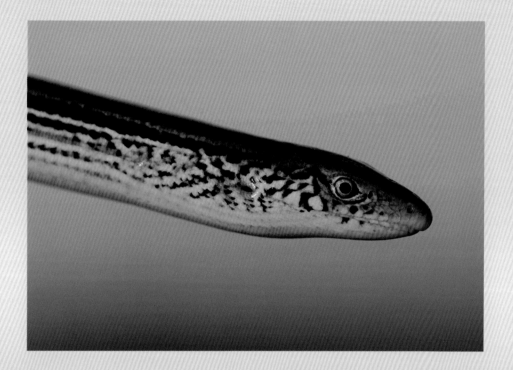

At the head of a deep pool in Illinois Creek, a feeding shoal of southern redbelly daces *(Phoxinus erythrogaster)*, rosyface shiners *(Notropis rubellus)*, and common shiners *(Luxilus cornutus)* generate a swirl of color. *Left:* Snakelike, the reclusive western slender glass lizard *(Ophisaurus attenuatus)* lacks limbs and has ear openings.

"You mean suckers?" He asks, using the generic angler's term for any fish not worth catching.

"Well, yea there are probably a couple suckers in here, but I'm trying to photograph other fish: like daces and darters, sunfish and shiners, even Topeka shiners, the endangered ones—the natives that are supposed to be in these prairie streams."

"Hmm," he says with a nod. Then there's an awkward silence. I don't think he believes me.

"Would you like to see a few pictures?"

"Um, okay." He says somewhat surprised. He takes a step forward.

I shake off some water and meet him halfway up the bank. Taking the digital camera out of the underwater housing, I show him some images on the back of the screen. The fish, which today are schooled up in the current at the head of a couple of deep pools, are in prime spawning colors and every bit as colorful as a rainbow or a coral reef. He takes a long look.

"Those are in this creek?" he asks as his face creases with a slight grin.

"Yep, there, and over there." I point to the places in the stream I had just taken the photographs.

"Pretty cool, huh?" I say.

"Yea. What are those fish again?"

So I tell him I've just learned what these fish are myself and that I honestly don't know much about fish other than what I can catch with a worm and bobber. I also admit that I've rarely photographed underwater before, but I explain that here in the prairies we tend to think a lot about birds and grass and the land above but not much about fish and the waters below. That these native fish species are here and thriving is a sign of water quality, I explain, and that translates in large measure to the good stewardship of the ranchers in these hills. People like him.

"So you live around here?" I ask.

"We lease the pasture over there. My family has been around here for many generations."

"So was your family one of the first to settle in this area?"

"Not the first but pretty close. Probably been here about as long as that old tree." He points to a huge old cedar guarding the edge of a rock face on the opposite bank, where a thin waterfall cascades into the creek.

Our conversation quickly fades as we stand there, looking at the old tree and watching the water slide down the rock wall and trying to imagine the fish in the deep dark pools of the creek.

"Well, I should fix that fence," he says. "High water pushed it over last week."

"Need any help?" I offer.

"Nope. But thanks."

With that, he walks back to his pickup to grab another tool, and I put on my mask and slide down the bank into the creek. For the next several minutes, I can hear the muffled tamping sounds of fence posts being reset into the creek as I search underwater for the brilliant-colored, long-eared sunfish lurking around their spawning beds near the crown of a fallen tree.

A moment later, the tamping sounds stop. I emerge again to defog my mask and look downstream. The fence is fixed, the rancher gone.

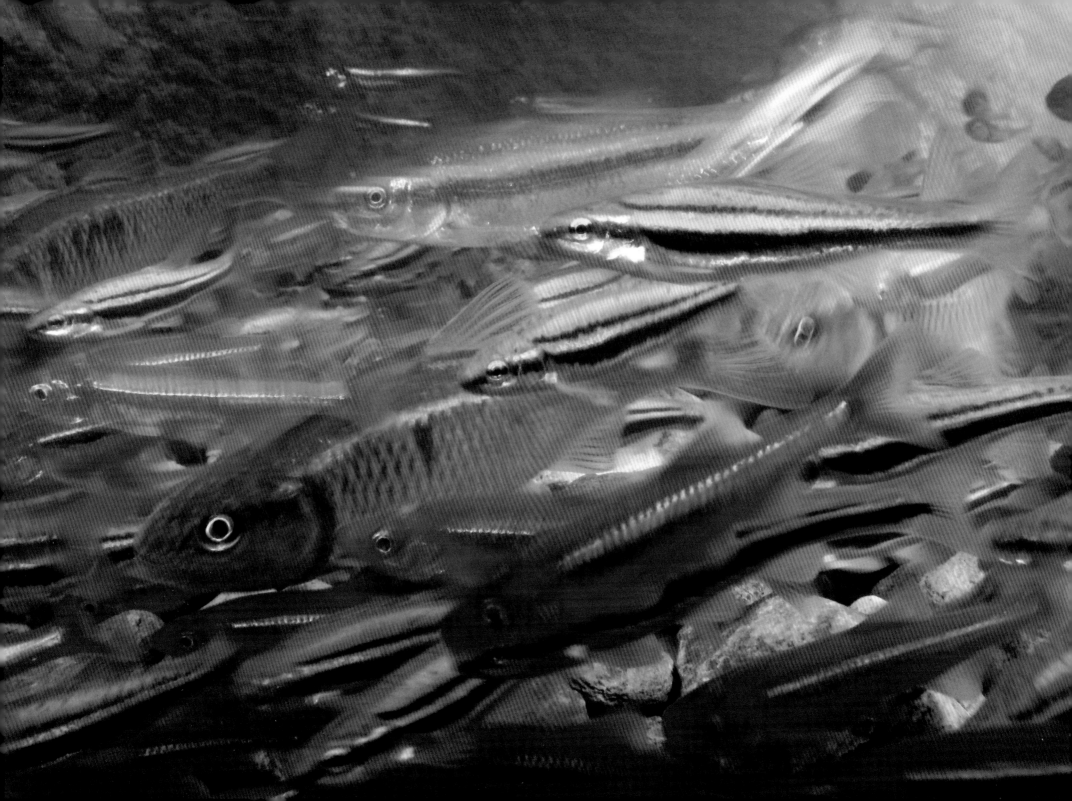

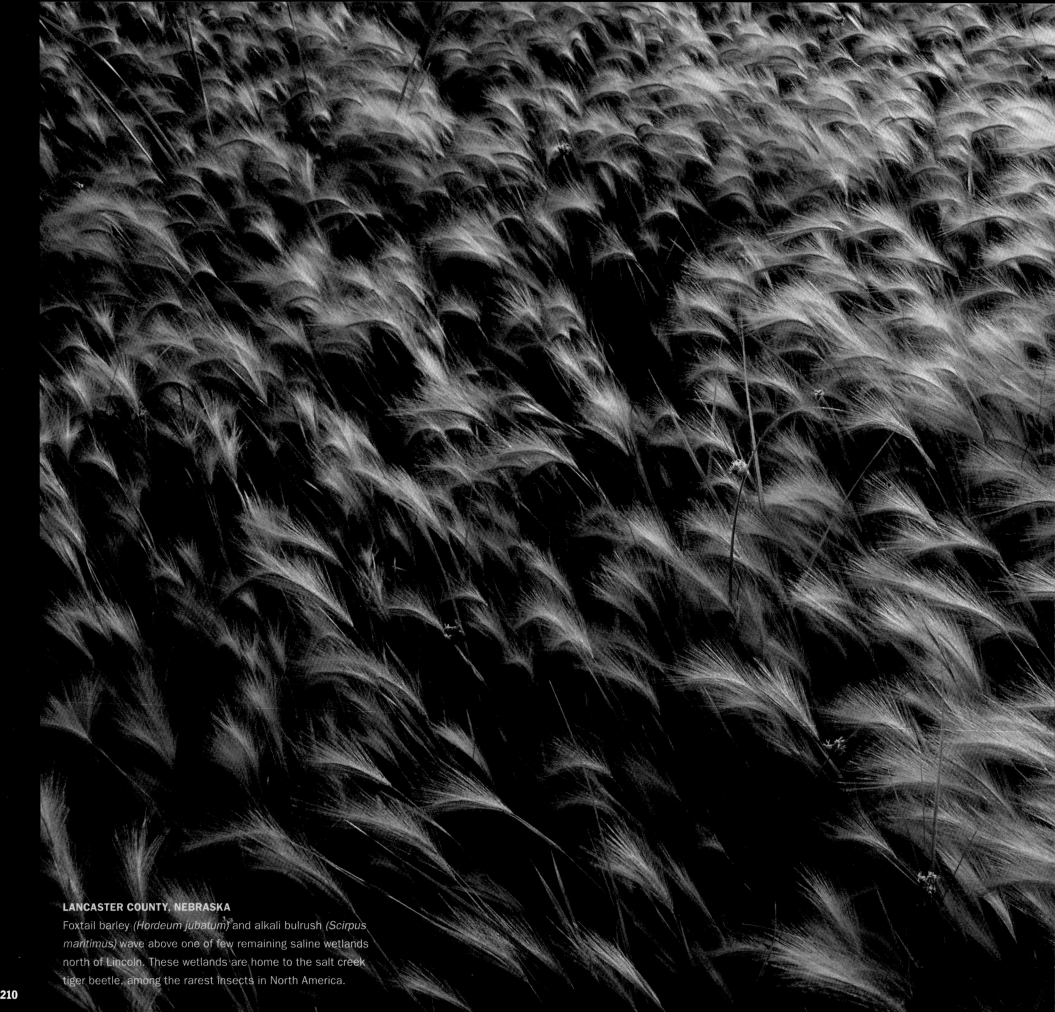

LANCASTER COUNTY, NEBRASKA
Foxtail barley *(Hordeum jubatum)* and alkali bulrush *(Scirpus maritimus)* wave above one of few remaining saline wetlands north of Lincoln. These wetlands are home to the salt creek tiger beetle, among the rarest insects in North America.

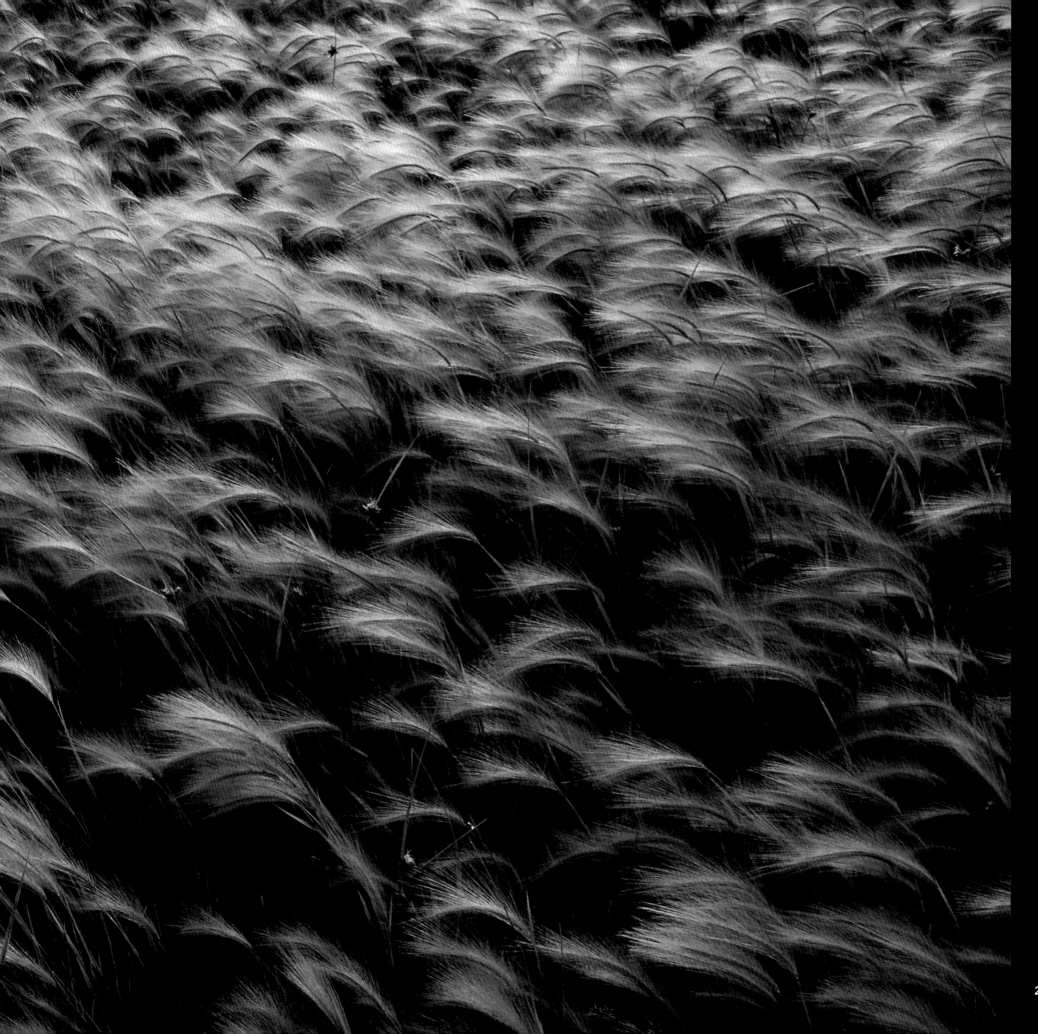

211

HALL COUNTY, NEBRASKA

A biologist (above) harvests seeds from a restored prairie at The Nature Conservancy's Dahms Tract in the Platte River Valley. Seed mixes (right) for prairie restorations commonly include 200 plant species. In eastern portions of the Great Plains, where prairies remain mostly in small fragments, reseeding agricultural lands with diverse native prairie species is the only hope of restoring many native plant and animal communities and reconnecting isolated fragments on a larger scale.

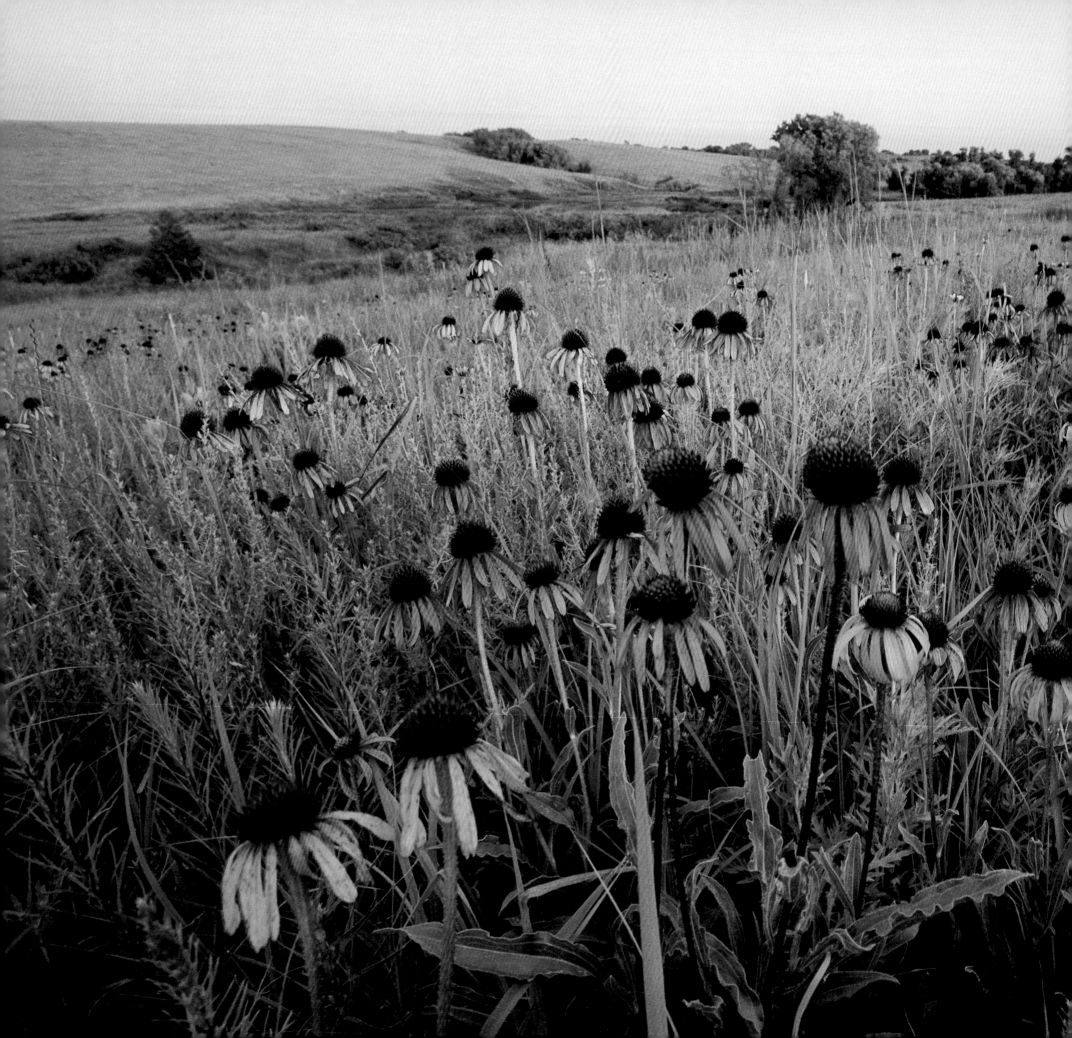

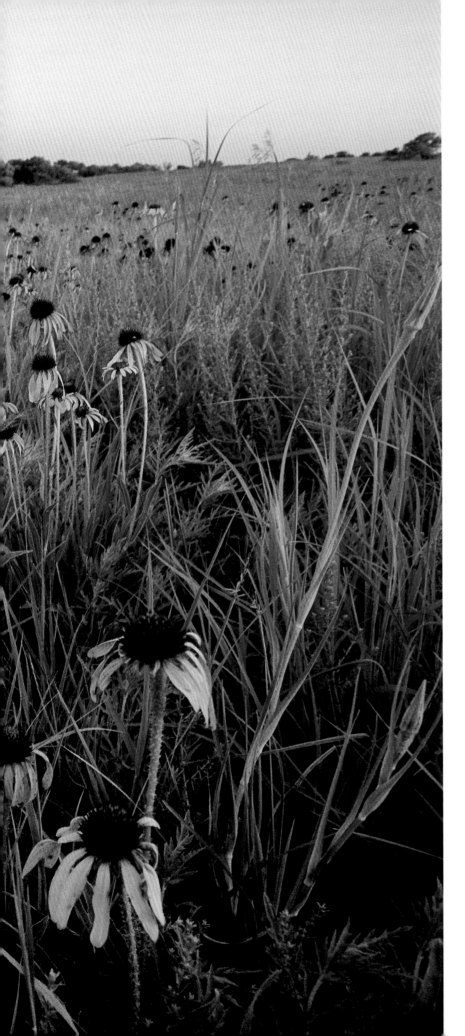

AUDUBON SPRING CREEK PRAIRIE, NEBRASKA

Left: Purple prairie coneflowers *(Echinacea angustifolia)* color a hillside burned earlier in the spring by land managers on this 808-acre tallgrass prairie preserve.

Above: In early October a pod of common milkweed *(Asclepias syriaca)* bursts open to disperse its seeds to the wind.

215

TNC RULO BLUFFS PRESERVE, NEBRASKA

With a drip torch, a biologist moves a prescribed fire through a wooded ravine, hoping to restore an oak woodland on the Missouri River bluffs. Prior to European-American settlement, frequent fires—set by Native Americans or caused by lightning strikes—maintained an open understory in oak woodlands.

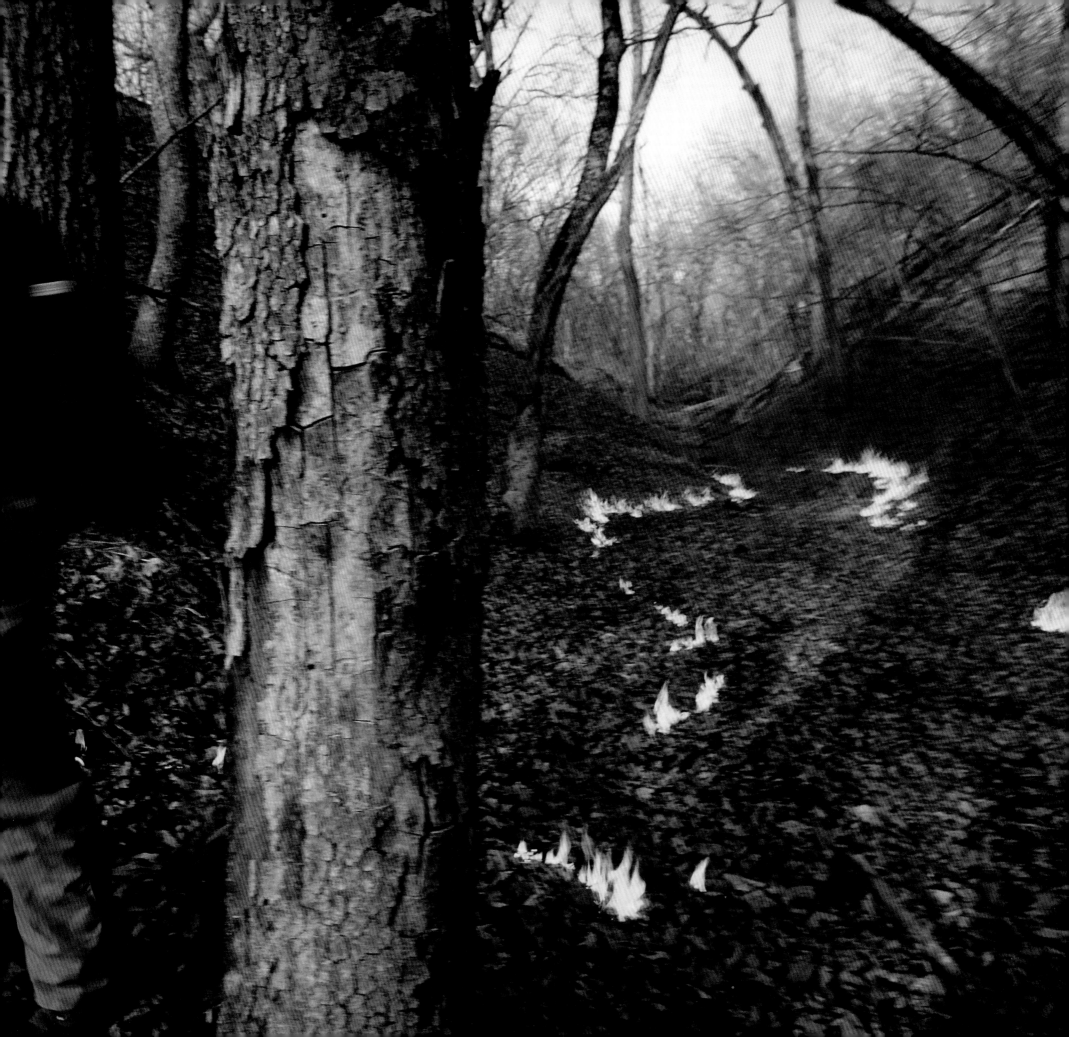

LINCOLN, NEBRASKA

Right: Urban forests now stand where prairie once claimed the land. As woodlands have moved farther west, some colorful woodland bird species have moved west as well, funneling into the shaded cities where they find refuge and breed.

Above: A male northern cardinal *(Cardinalis cardinalis)* pauses with its hungry chicks at a nest built in the clematis-covered trellis of a front porch.

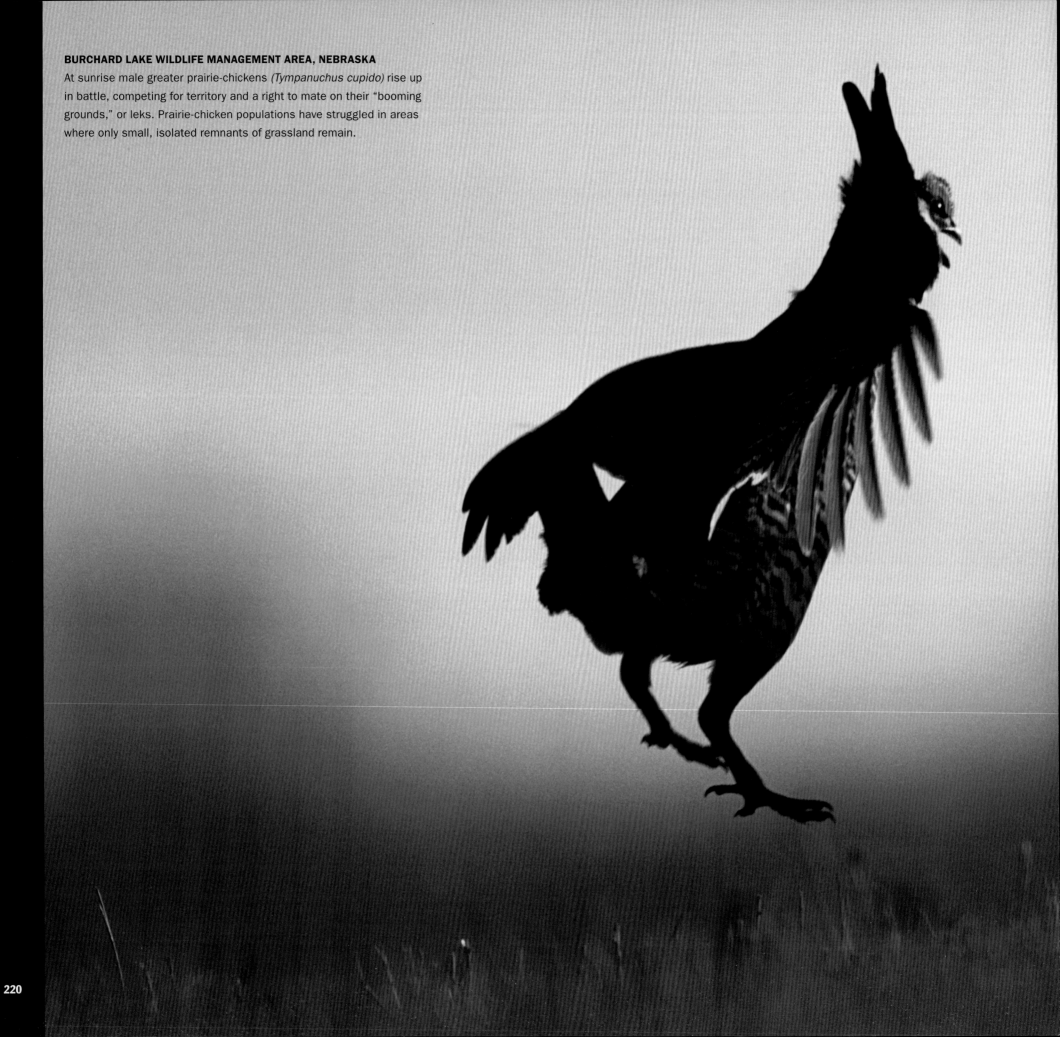

BURCHARD LAKE WILDLIFE MANAGEMENT AREA, NEBRASKA
At sunrise male greater prairie-chickens *(Tympanuchus cupido)* rise up in battle, competing for territory and a right to mate on their "booming grounds," or leks. Prairie-chicken populations have struggled in areas where only small, isolated remnants of grassland remain.

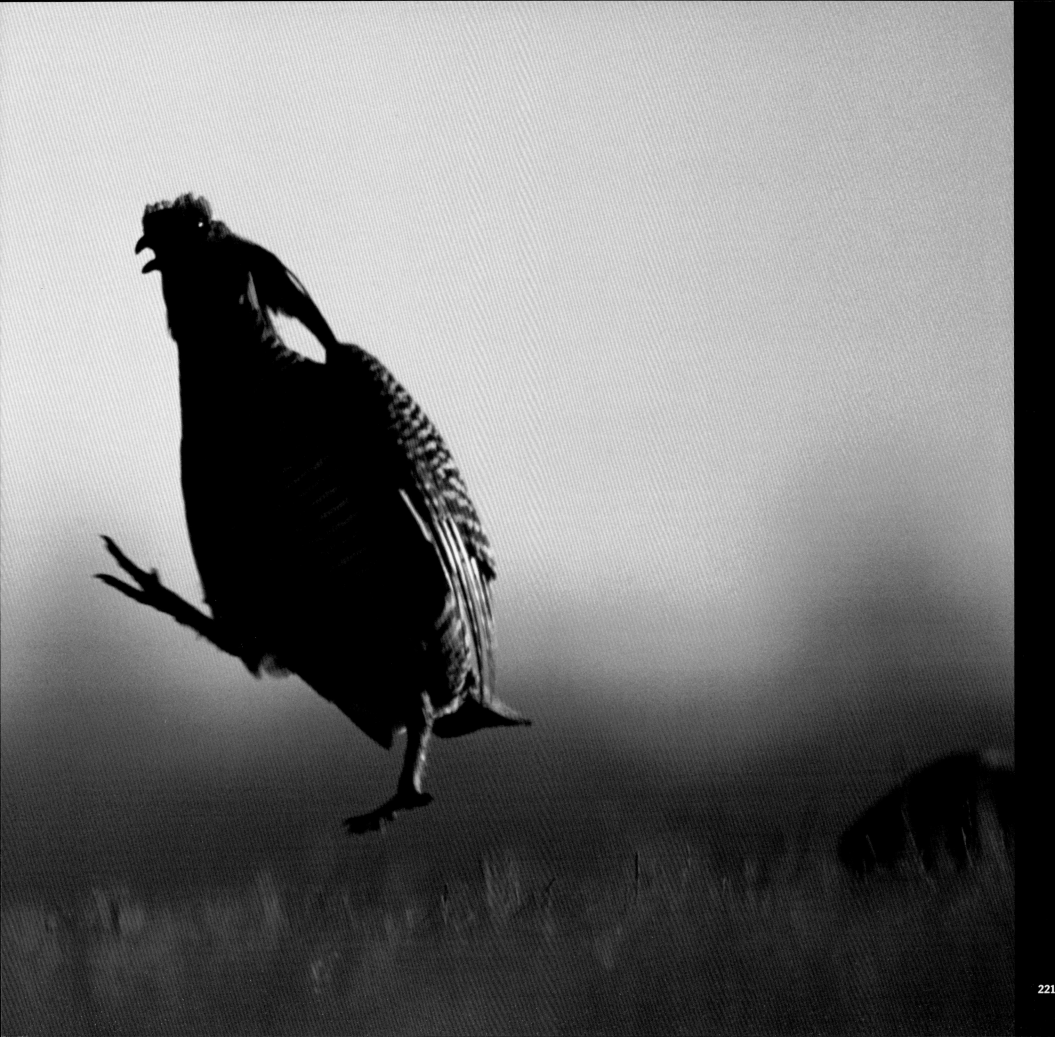

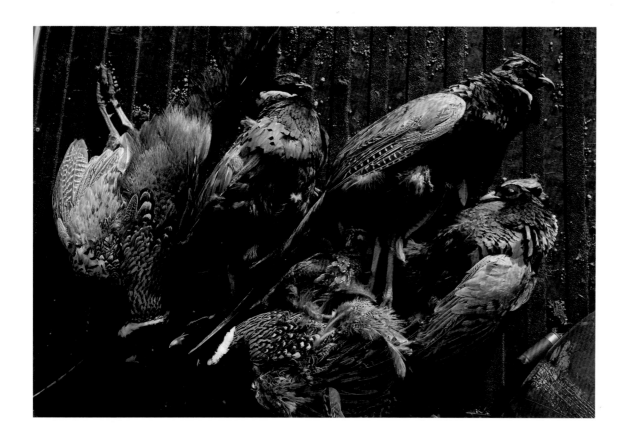

GAGE COUNTY, NEBRASKA

On a crisp fall day a hunter scans for pheasant. Across much of the Great Plains, upland bird hunting boosts economic activity in rural areas and provides extra incentive for landowners to restore grassland through the CRP. When bird populations are thriving on these grasslands, a daily bag of ring-necked pheasants *(Phasianus colchicus)* like the one above is not uncommon.

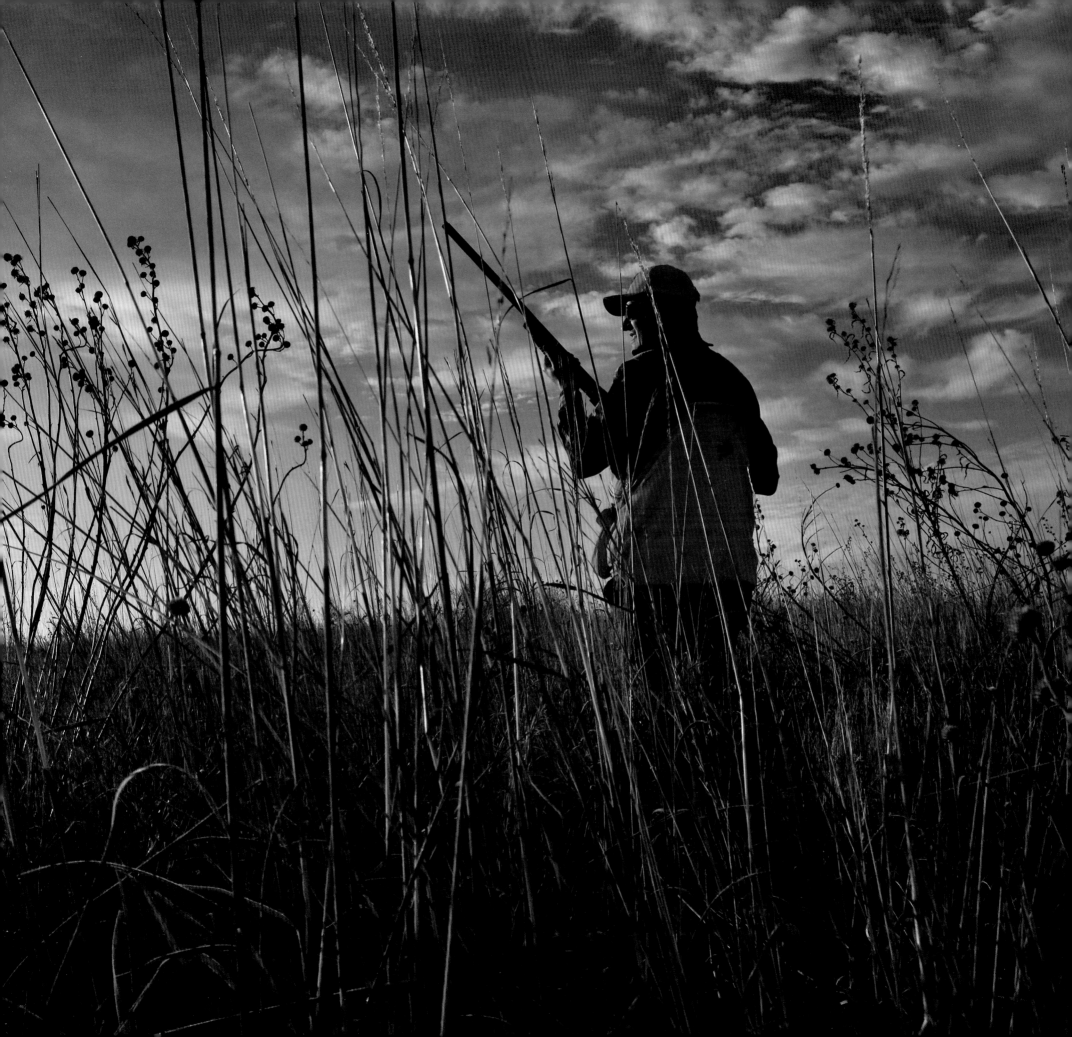

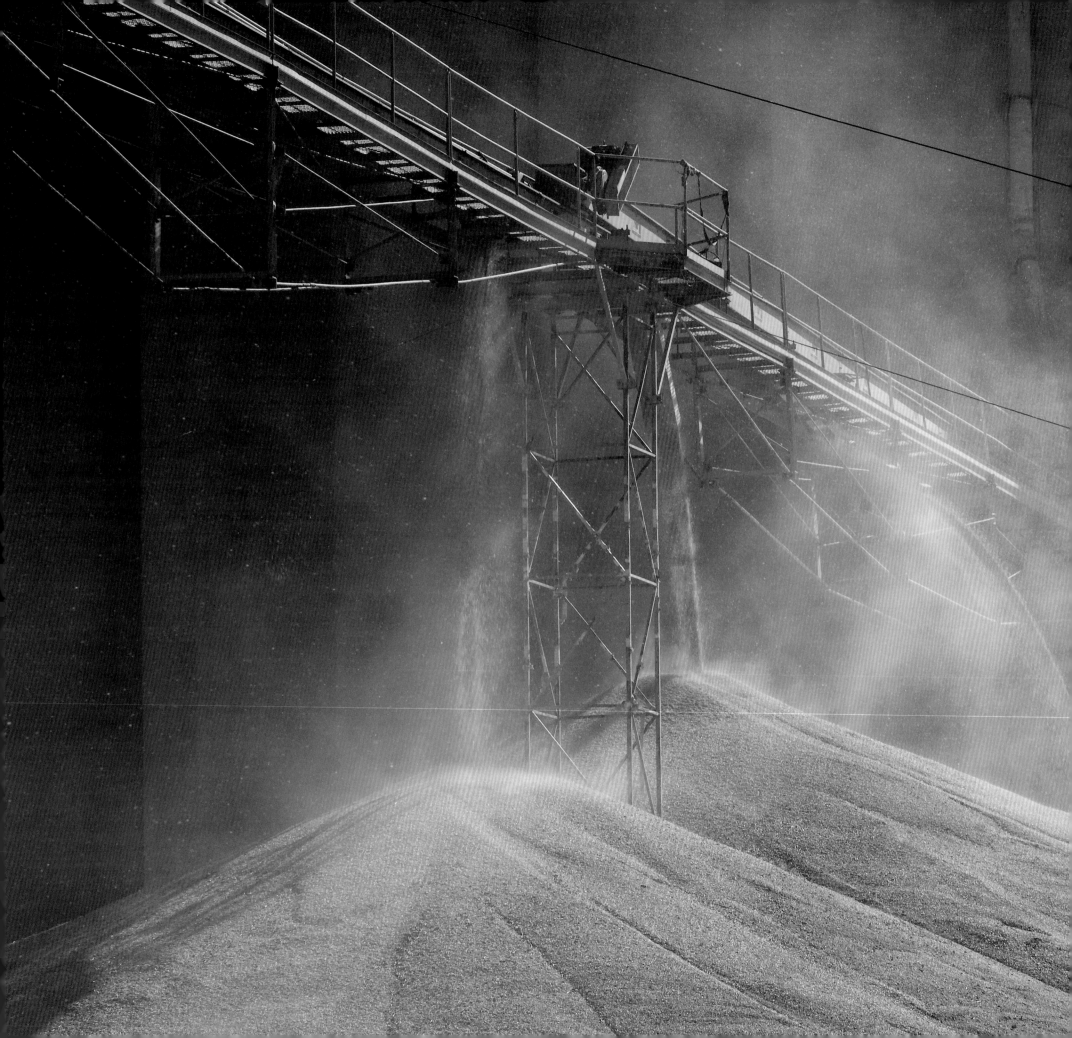

DODGE COUNTY, NEBRASKA

Corn from fall harvest piles up outside a grain elevator. The recent demand for corn to fuel ethanol plants has dramatically increased the economic incentives to plow up native rangeland and other grassland. But the development of cellulosic ethanol may one day provide an alternative. Supplied by harvesting grassland biomass, the technology could result in millions of acres of cropland being restored to grassland once again.

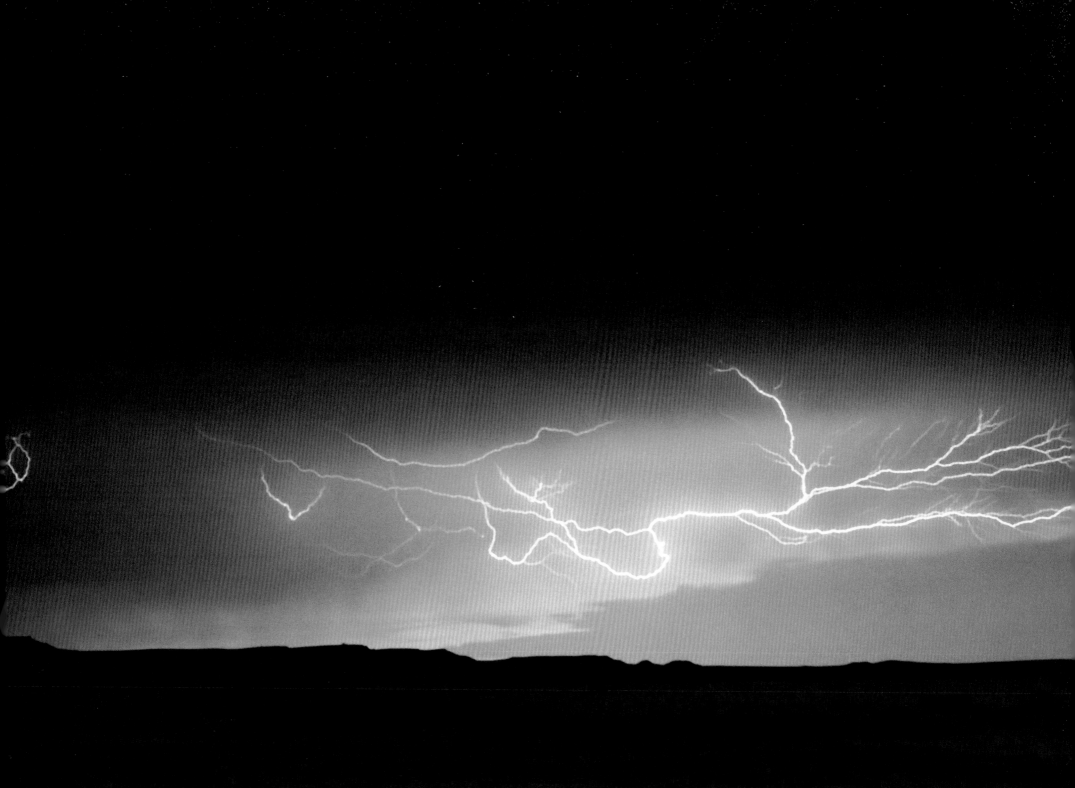

CUSTER COUNTY, SOUTH DAKOTA

A bison herd *(Bison bison)* calmly grazes as a summer lightning storm lights the night sky.
Fire, grazing, and drought are essential components of the Great Plains ecosystem.

BUFFALO IN THE TALLGRASS
Dan O'Brien

IN THE SPRING OF 2008 I went to Afton, Minnesota, to participate in a buffalo release. Afton is on the St. Croix River, a half-hour drive from downtown St. Paul, and I have to admit that I felt slightly disingenuous accepting a stipend for speaking at the repatriation of 25 yearling buffalo (technically American bison) to what amounted to a clearing in the suburbs of the Twin Cities.

I was contacted months before the release by the executive director of a "nature preserve" called Belwin, which had recently transformed itself from private to a non-profit. When he called me, the director, Steve Hobbes, spoke earnestly about open spaces and the efforts to restore the tallgrass prairie that had dominated this landscape when Europeans first cast their acquisitive gaze over what they saw as potential farm ground. He was historically and environmentally knowledgeable and obviously dedicated to the cause of Belwin's reclamation. But I had been in that country between the Twin Cities and Wisconsin and I knew what those European farmers had done to it. They did the same thing at other places I have visited: Northfield, Minnesota; Grinnell and Council Bluffs, Iowa; and along the southern stretches of the Missouri River. In all that country—indeed on the entire continent—the tallgrass is gone, except for a few remnants in graveyards and along railroad tracks where plows were prohibited. In place of the switchgrass, big bluestem, and Indian grass were all manner of thorny, invasive brush, weedy plants from the steppes of Europe and Asia, and cultivated trees. Where the endless vistas of grass that greeted 19th-century immigrants had been there were now closed-in, overhanging acreages cluttered with homes. It seemed a poor place for buffalo.

When I heard that all of Belwin was only 1,300 acres—a fraction of what I see when I look out the front windows of my ranch—I had my doubts. I almost declined to speak, but Steve seemed a professional conservationist, and his dedication came through the phone at me in such a way that I agreed to come. Of course there was also that stipend, and it occurred to me that my acquisitiveness about that might not be much different from that of the Norwegian farmers who had plundered the breaks of the St. Croix River 200 years ago.

As the date of the buffalo release came closer, I had time to think about what I, an advocate of big-scale conservation of mostly intact, prairie landscapes, could say to the Twin Cities suburbanites. I am used to thinking in terms of tens of thousands of acres; of what can be done to preserve, forever, the burrowing owl, the sideoats grama grass, the solitude, and the endless sky that surround me. The tallgrass prairies are foreign to me. Where does one begin when he looks around and finds so little left? Where is the hope?

My whole life I have been blessed to walk over selected prairies from Canada to Mexico and cover my boots with much the same vegetation that covered moccasins for thousands of years. Daily I see animals that evolved to thrive on these grasslands. Most hours of most days I enjoy the peace that comes with "empty" spaces. It is not the experience of Steve Hobbes or of the people who live in the suburbs of St. Paul or a thousand other places much like it. I lose sleep thinking that my land could go the way of that St. Croix River country.

And I lost sleep trying to think of what to say to those people who were bringing 25 small buffalo to those devastated 1,300 acres of Belwin. I couldn't help thinking that the resources and energy to restore what we have ruined might well be a waste when what we should do is use those resources to protect what, due to serendipity, we still possess. Where does a nation draw the line? Where do a people cut their losses? It was a long drive to the Twin Cities. What to say when that sorry little herd of buffalo stumbled out of the trailer that was bringing them from somewhere in Wisconsin?

My hosts put me up at the Afton Inn, a quaint and aged gathering spot on the St. Croix. I was up early walking its banks, and to my amazement I had the river pretty much to myself. My only companions were sea gulls and a single old couple, fishing a quarter mile out in the middle of more fresh water than I had seen for years.

When I got back to the inn, I asked the cleaning man there to make a pot of coffee, and he asked what I was doing in town. He was a swarthy man who could have been Italian. He wore an apron and leaned on his mop as I explained. I told him I was there to say a few words at the buffalo release then give a longer talk to the members of the Belwin preserve. He nodded to show me he knew of Belwin, but he didn't say anything. He stared intently, and I felt pressure to explain that I was a writer and that I raised buffalo on a ranch near the Black Hills. He nodded again, "You're going to turn buffalo loose at Belwin?"

"Well, not me. The board of Belwin."

His head continued to nod, and I knew he was in deep thought. When he spoke, he was brief. "That's about the neatest God-damned thing I've ever heard," he said. "Good for you guys."

When I drove out to meet Steve Hobbes, I had to fight a rush of claustrophobia as the alien trees closed in around me. I actually got lost trying to find the site of the buffalo release and in the process met several of Belwin's employees: An older lady who helped with the educational programs and who called me sweetheart; the maintenance man who was proud to have built the fence that would surround the buffalo; a bright young woman who was in charge of the restoration of Belwin's vegetation. They were thrilled to be part of bringing buffalo back to Belwin. I helped load a few tables into a pickup in exchange for a ride to the release site.

The sky was trying to rain when we got to the site, but already there was a surprising crowd. I searched for Steve among groups of school kids and interested citizens, and when I found him, I was again surprised. He wore a straw cowboy hat and smiled at me through a healthy mustache. He was older than I had imagined. We shook hands warmly, and I picked up on a twinkle in his eyes that was decidedly conspiratorial and hinted at the wisdom known only to guerrilla conservationists. "There's going to be a crowd," he said. "All the TV stations are sending folks." Only then did the potential of an event that I would ordinarily call "token" begin to come clear to me. There was still an hour to go before the buffalo would be released, and people were already streaming in from the Twin Cities and the surrounding countryside.

I met the board of directors and the family who had started Belwin many years before as a private nature preserve. The matriarch was an elegant older woman who squeezed my hand and thanked me for coming to help. Help with what? I asked myself.

From the gooseneck trailer that would serve as a stage for the brief remarks preceding the release, I looked down the county road and realized the answer to my own question. This was not so much an effort to reestablish buffalo in a degraded landscape—this was a foot in the door of the only force that could actually help in serious restoration. This was a step in a long-term strategy to educate.

I watched the cars streaming down the road toward the buffalo release, heard the mothers explaining rudimentary conservation to their children, saw old couples bending stiffly to feel the grass that would sustain the buffalo. By the time the animals arrived in a long trailer, driven by a quiet, sincere, and knowledgeable man who raises buffalo, rival groups of children were chanting,

"Let them loose! Let them loose! Let them loose!" The television cameras were rolling. Hundreds of people had turned out to see the trailer door open and the buffalo step out onto Belwin's prairie, and I was scrambling to rewrite my comments in my mind.

I may be a sort of conservationist snob, but I can count and I can add. There were more people standing around the tiny buffalo paddock waiting to see the gang of 25 than had seen my 300 head of buffalo on their thousands of acres in 15 years. The economic and philanthropic power that spread out before the stage was immense. Here, in this land that is often written off in terms of conservation potential, was real strength. Judging by the numbers that had sacrificed their Saturday morning, I had miscalculated the importance of this event. But there was no time to rethink. Only time to react to what I felt. I stepped to the microphone and began my remarks. "You are standing on sacred ground," I said. "It is about to become more sacred."

CROOK COUNTY, WYOMING Native Americans' intimate knowledge and reverence for bison are reflected in their petroglyphs. The age and tribal affiliation of this petroglyph in the Black Hills are unknown, but native peoples have inhabited the area for 11,000 years.

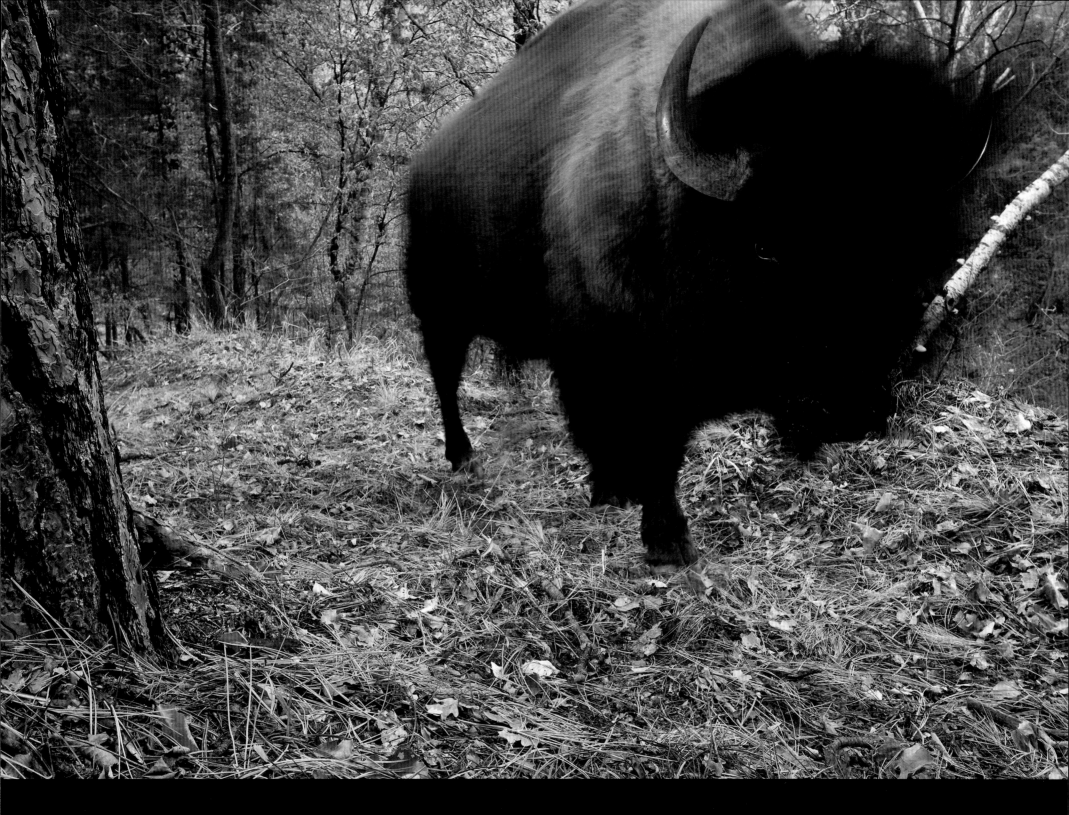

TNC NIOBRARA VALLEY PRESERVE, NEBRASKA
Six feet high at the shoulder and weighing up to a ton, a bison bull *(Bison bison)* is the

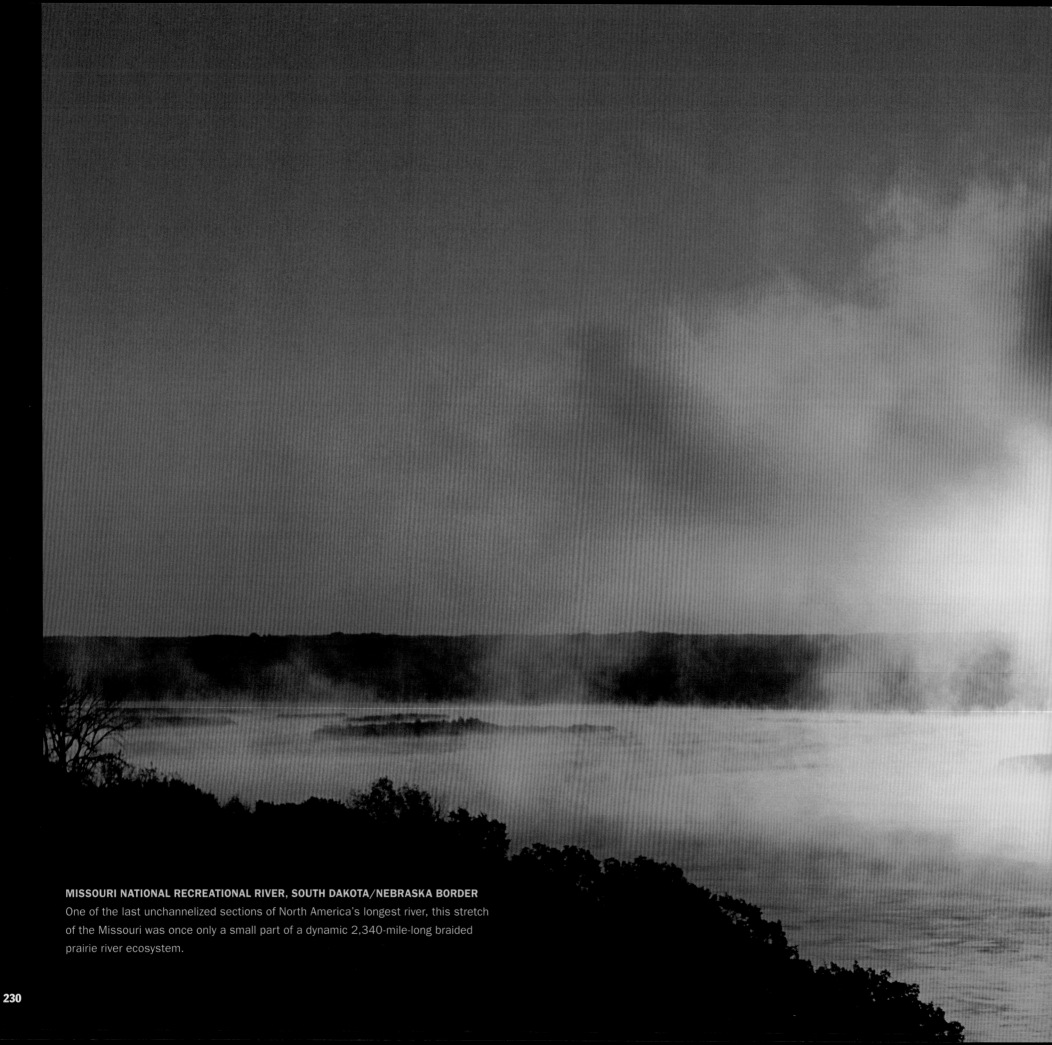

MISSOURI NATIONAL RECREATIONAL RIVER, SOUTH DAKOTA/NEBRASKA BORDER
One of the last unchannelized sections of North America's longest river, this stretch
of the Missouri was once only a small part of a dynamic 2,340-mile-long braided
prairie river ecosystem.

231

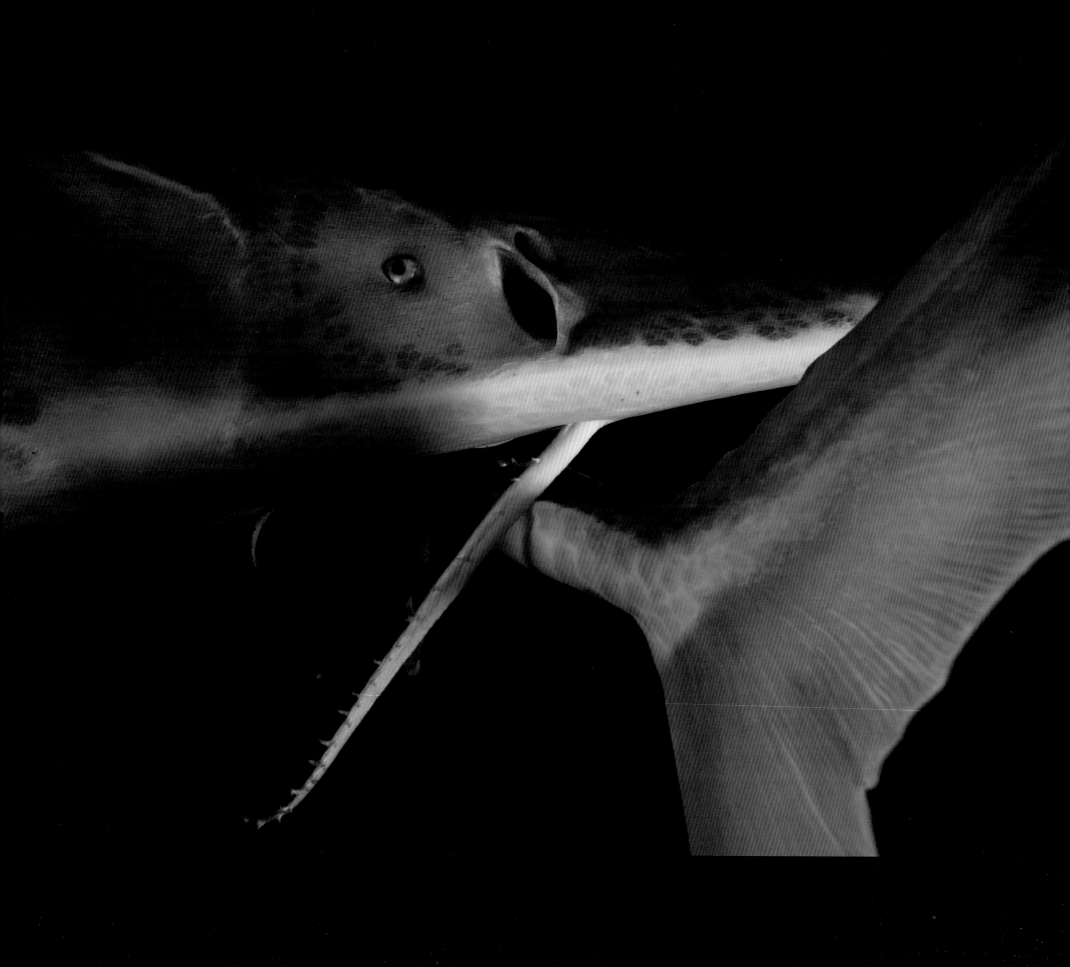

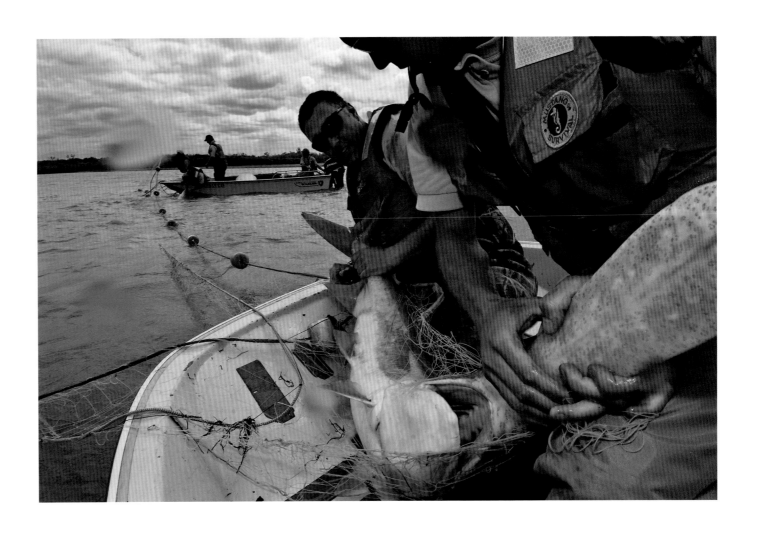

GAVINS POINT NATIONAL FISH HATCHERY, SOUTH DAKOTA

Left: Five-foot-long endangered pallid sturgeon *(Scaphirhynchus albus)* cross paths in a tank where they're held for spawning then returned to the wild. Primarily bottom feeders built for big, dynamic river systems like the historic Missouri, the ancient fish now reproduce mostly in captivity under a sophisticated program that helps keep them from becoming extinct while recovery efforts continue.

Above: Fishery crews wrangle a large paddlefish *(Polyodon spathula)*, another Missouri River species of concern. After capture, adult fish are transported to the Gavins Point hatchery for spawning. Their young are reared, tagged, and stocked back into the Missouri to help restore depleted populations.

MISSOURI RIVER BETWEEN THE NEBRASKA/SOUTH DAKOTA BORDER

Right: Large sandbar islands are key nesting sites for colonies of federally endangered interior least terns *(Sterna antillarum)* and threatened piping plovers *(Charadrius melodus).* But in recent years water levels have been raised before the birds fledge to allow a handful of grain barges to navigate the river. Such ill-timed flooding yields scenes like this: A young least tern chick (above) fights for its life after floating downstream and washing up on a shrinking sandbar.

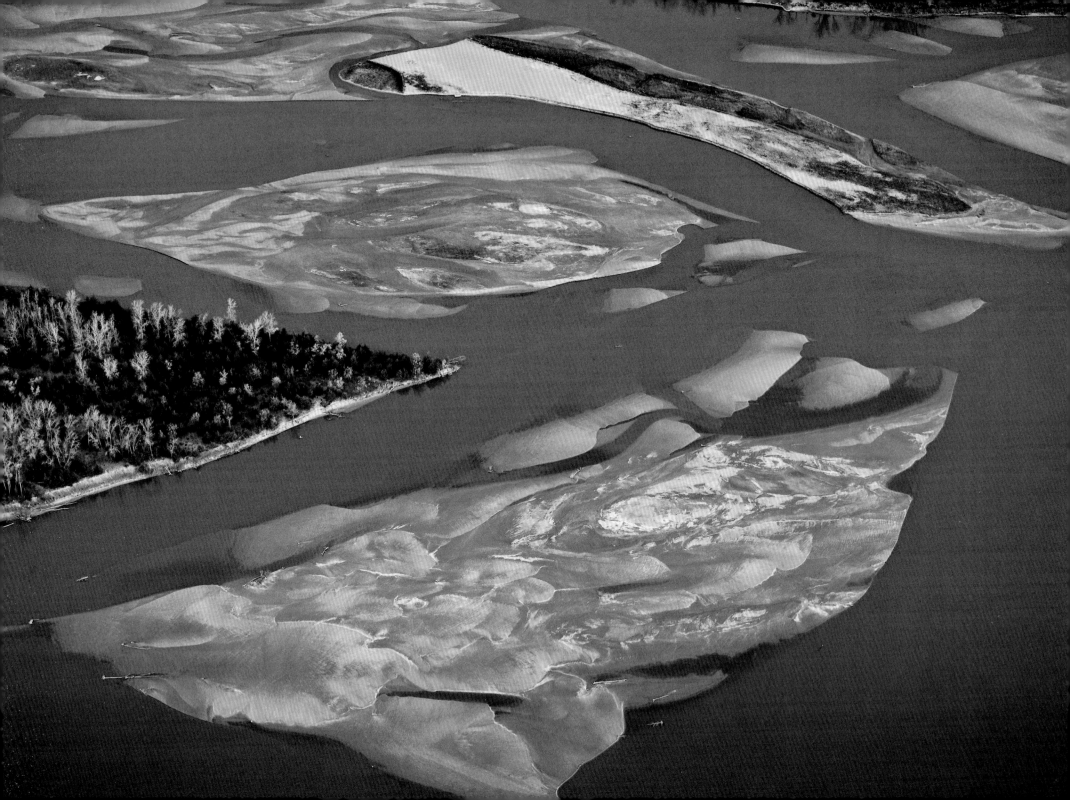

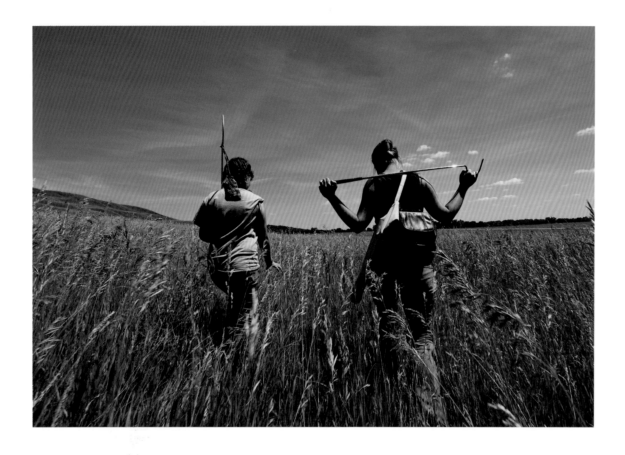

TNC BROKEN KETTLE PRESERVE, IOWA

Right: Born with lungs as well as gills, this tiger salamander *(Ambystoma tigrinum)* is still in its larval stage but close to metamorphosis. Healthy populations of amphibians and reptiles reflect the health of the grasslands they inhabit.

Above: In the Loess Hills of western Iowa, volunteers keep snake hooks handy as they help out in a long-term population-monitoring study of prairie rattlesnakes *(Crotalus viridis)*.

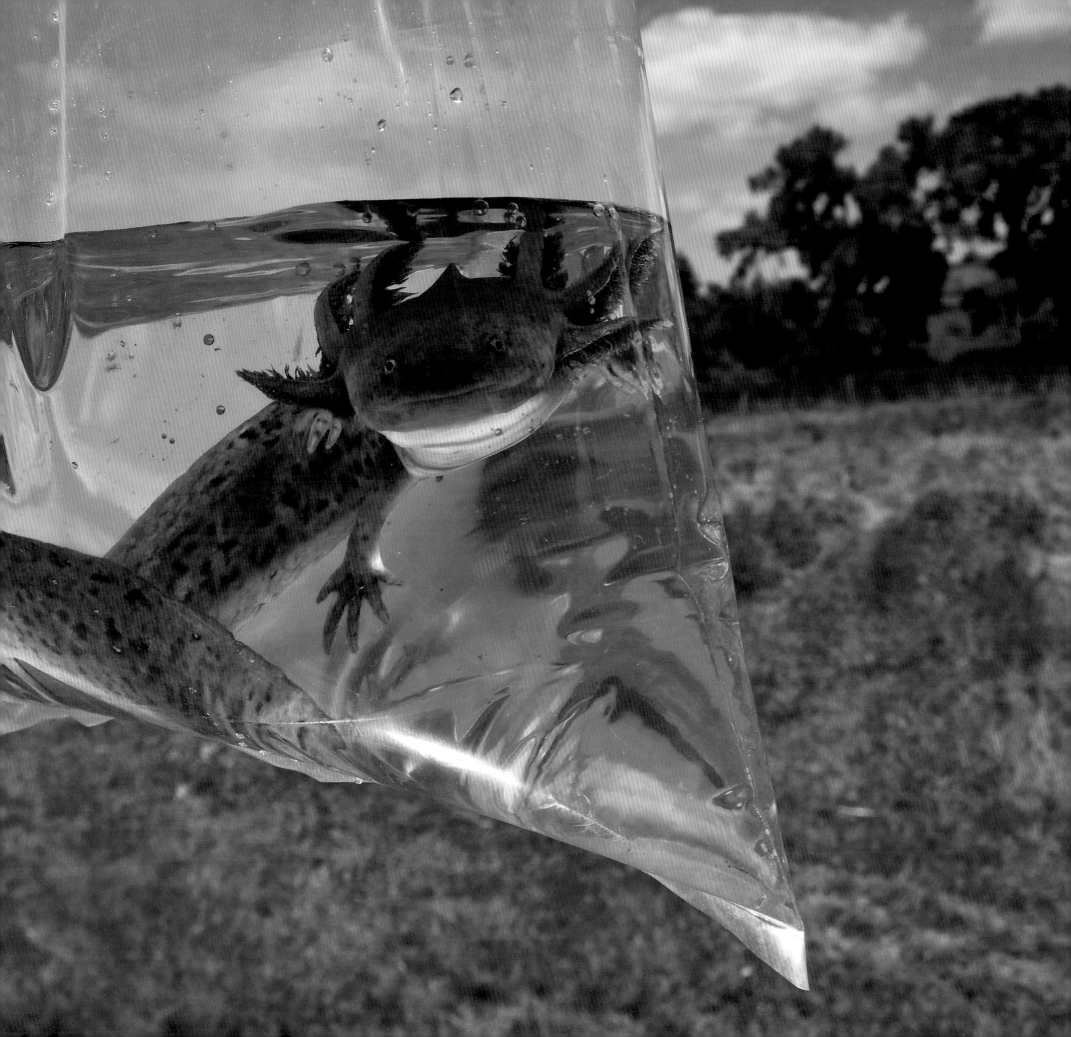

HANCOCK COUNTY, IOWA

As long ago as 1894 naturalist Rudolph Anderson recorded perhaps the last whooping crane *(Grus americana)* nest in the lower 48 states near this spot, roughly three miles north of Hayfield in the eastern Prairie Pothole Region. The only wild flock of endangered whooping cranes left now nests in the remote wetlands of Wood Buffalo National Park in Canada's Northwest Territories.

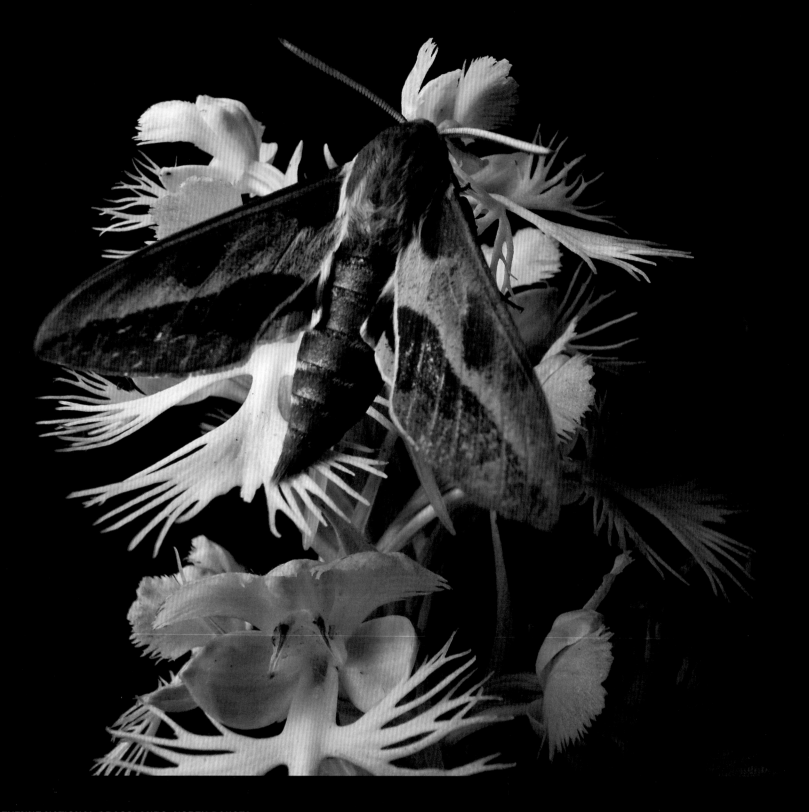

SHEYENNE NATIONAL GRASSLANDS, NORTH DAKOTA

Near midnight, a spurge hawkmoth *(Hyles euphorbiae)* hovers near a western prairie fringed orchid *(Platanthera praeclara)*. Threatened species, these orchids rely solely on the night-flying hawkmoths to pollinate them. To attract the moths, the flowers emit a vanilla-like scent and stand out white against the prairie darkness.

CEMETERY

Dan O'Brien

IN THE MIDDLE OF IOWA, not far from the town of Grinnell, there is a tiny graveyard with weathered tombstones bent at odd angles by the heave of frost and the pounding of eternal winds. I want to visit the graveyard because I've been told it is one of the very few places left where the old tallgrass prairie can still be seen. I'm interested in the grasses that I might find there, but what I really want to find is the drab, once common, prairie butterfly called the Dakota skipper.

I'll probably never go to that cemetery, and even if I did, there is little chance that I would actually find a Dakota skipper because they're very rare. Of the millions that once fluttered from one prairie flower to the next over a vast, 200,000-square-mile range, only a few remain. The reasons for this great decline are fairly clear. An estimated 99.9 percent of the Dakota skipper's habitat has been destroyed, and even the remaining 0.1 percent is under siege. I became aware of that little cemetery long after the great plow-up of the 20th century, right in the middle of a new plow-up driven by the ethanol boom. For years I have visited the cemetery only in my mind, but as I walk from tombstone to tombstone, the huge John Deere tractors nibble at the field edges, trying to find a few more acres on which to plant their corn.

The only reason there is still native grass in the cemetery is out of respect for the human dead who lie there beneath the undisturbed sod. There are also still a few road ditches and railroad right-of-ways where the grasses have found sanctuary—left alone out of respect for government entities and large corporations.

I visited Grinnell College for a few weeks in the winter of 2005 as a temporary instructor, and I felt at home in the little prairie town with the four bars, the locally owned bank, and the town square. The winter weather and the monochromatic pallor of the countryside kept me focused on the college community. I ventured into that countryside only once, and when I did, I got the feeling of walking across the deck of an oceangoing ship that had somehow come loose from its moorings.

In winter the town of Grinnell is surrounded by deep-tilled black soil, highlighted only by the miniature snowdrifts behind each dirt clod. It is a world that has indeed been turned upside down. What for hundreds of thousands of years had been a thriving forest of grass had had, relatively recently, its roots turned skyward and the leaves plowed under for mulch to feed corn. It was not a good time to go in search of grasses, and all that farming was too odd for me, so after that first and only winter trip into the Iowa countryside, I kept to the town and myself. The classrooms, the library, one of the four bars.

It was during that Iowa winter that I first learned of the Dakota skipper. I found out they rarely move more than a mile from where they are born, that they're known for their elusiveness, that they're very likely important pollinators of particular prairie plants, and that they're mostly dependent on the tallgrass prairies that are already nearly gone. In fact, the Dakota skipper is a candidate for endangered species status. I found a photograph of one and stared hard at it in the dim, Iowa winter light coming through library windows. A simple brown butterfly that would pass for a moth, streaks of rust on the wings, and a light antennae. This was not a bald eagle, not a polar bear, not a peregrine falcon stooping at 200 miles per hour. It was no unicorn. Its plainness startled me and I knew immediately that its humbleness would doom it to extinction. When you do the math, you find out that no matter what the value of this little butterfly, no one is going to piece together enough remnant prairies or restore enough cornfields to grass to build bridges for Dakota skippers to search out mates and perpetuate their species.

For a full year I lived with an image of that little lovesick butterfly, shy and evasive, genetically unprepared to cross the miles of barren cornfields to find a mate. I dreamed of one day going back to Iowa and finding that little cemetery where there might be a lonely skipper. I wanted to gaze on it. I wanted to wander about the tiny cemetery with its tombstones thrusting up through the remnant native grass, search the stems of the Indian grass, the dropseed, compass plant, blazing star, coneflower, aster, and goldenrod. I wanted to ask the sunflowers, junegrass, and bluestems if they had seen a skipper. Did one pass this way? Was it desperate? Weak with the drive to survive?

The thought of that cemetery and the imaginary last Dakota skipper haunted me. I would dream of the tallgrass against my thighs and see the names

chiseled on imaginary tombstones: Angela Swenson 1807-1855; Oliver Petersen 1842-1879; Lilly and Michael Edberg 1856-7. I would wake from my bed and stand with my hands on the windowsill, staring at the four o'clock sky and thinking of all that has been lost. It was not until the winter of 2008 that the nightmares stopped. Finally, the other cares of the world crowded out my early morning vigil for the Dakota skipper.

I was fine until I got a call from Mike Forsberg in July. I knew he had been on a photographing swing in the tallgrass. He was after photographs of endangered and threatened species: searching for western prairie fringed orchids in eastern North Dakota and western Minnesota, then back along the Missouri to get some shots of hatching least terns and piping plovers. As naturalists go, Mike has always been one of the most positive and hopeful. Over the years he has always been a counterbalance for my pessimism and cynicism. But when I heard his hello, I knew that something had changed. He was angry and feeling defeated.

With the help of researchers from North Dakota State University, he had been staked out for several nights beside a few western prairie fringed orchids in hopes of catching them in the process of being pollinated. This particular threatened orchid was only pollinated at night and only by the hawkmoth, and Mike had spent the last few nights sitting on a bucket in a road ditch, trying to stay alert and awake to see if one appeared. He was dirty and tired by the time he got his picture.

A few days later, he met tern and plover biologists on the Missouri River and waded with them on the fragile sandbars that the birds absolutely need to breed. Along much of its course, the Missouri is hardly a river anymore. It has been dammed and channelized for irrigation, flood control, and barge traffic, which has dwindled in recent years. So have the sandbars, but they're so vital to the terns and plovers that the federal government has been compelled to build a few artificial ones to help keep the species viable.

Mike had planned his visit carefully so he could get some pictures of the tiny birds being flooded out of their nests. The Corps of Engineers had been releasing water from the upstream dam to raise the level enough to accommodate a barge on its way with a load of turkey feed for a farm downriver. The scene was near hopeless—frenzied Corps biologists doing their best to save what chicks they could from the rising water. "A lot of them drowned," Mike said. His familiar buoyancy was defeated. He had retreated to his vehicle to make some sense of what he had seen when he got a call saying a mowing crew had just come down the road he had camped on the last few nights.

"They mowed the ditches," he said. "The orchids are gone."

The line went silent on both ends. Gone, I thought.

Since then, the dream is back. I am awakened as the light builds before sunrise by the gentle patter of butterfly wings against the window screen. I go to the window but there is nothing to see. When I return to bed, the sound comes again. It gives me no peace. I believe it is the last Dakota skipper— seeking refuge.

Above: The spurge hawkmoth *(Hyles euphorbiae)*—introduced from Europe as a control agent for leafy spurge, a noxious weed—is one of six known hawkmoth species that pollinate western prairie fringed orchids.

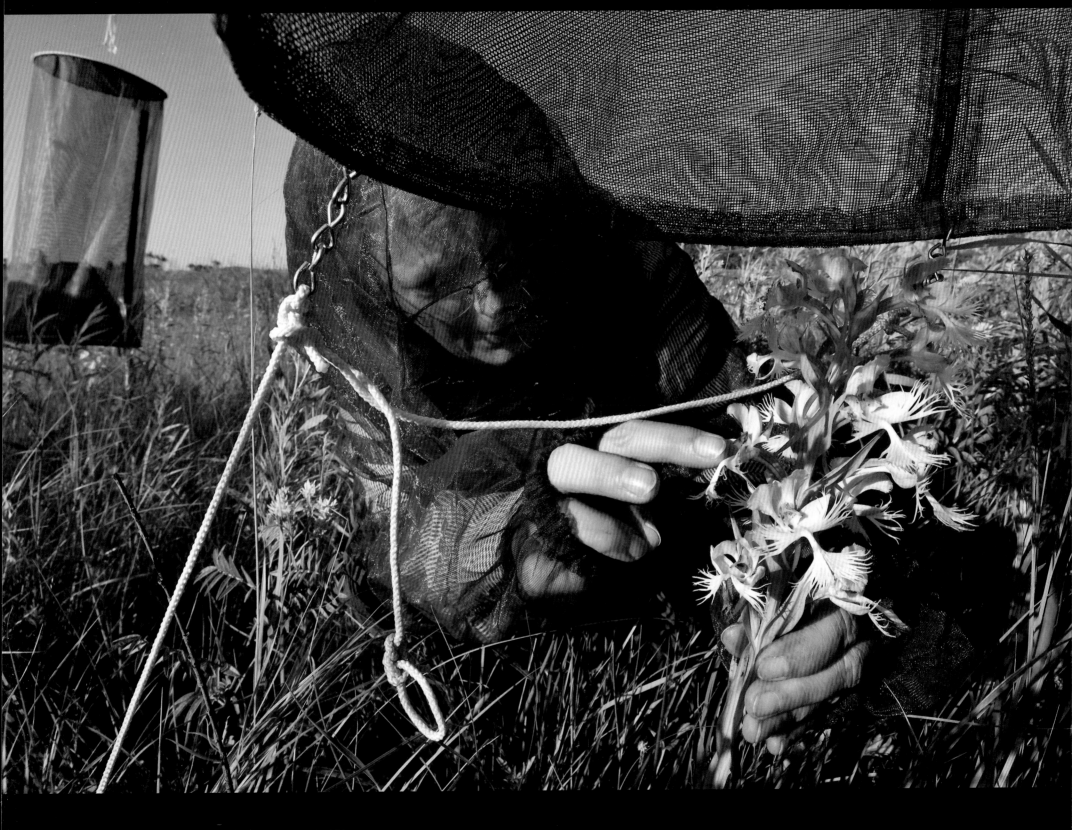

SHEYENNE NATIONAL GRASSLANDS, NORTH DAKOTA
An entomologist inspects a net trap placed above a western prairie fringed
orchid (Platanthera praeclara) to see what insects are cutting into its nectar
spur and stealing nectar. The culprit—a bumblebee.

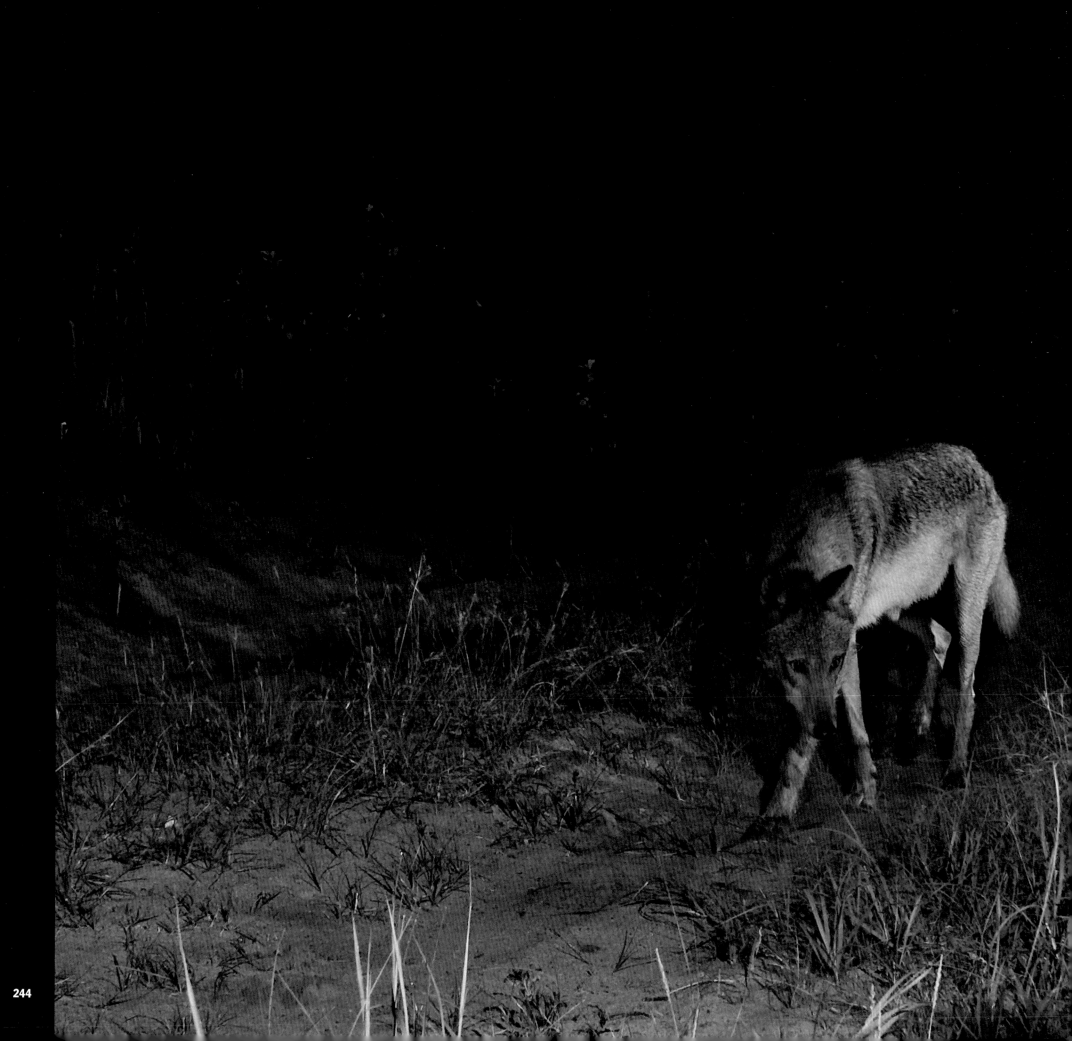

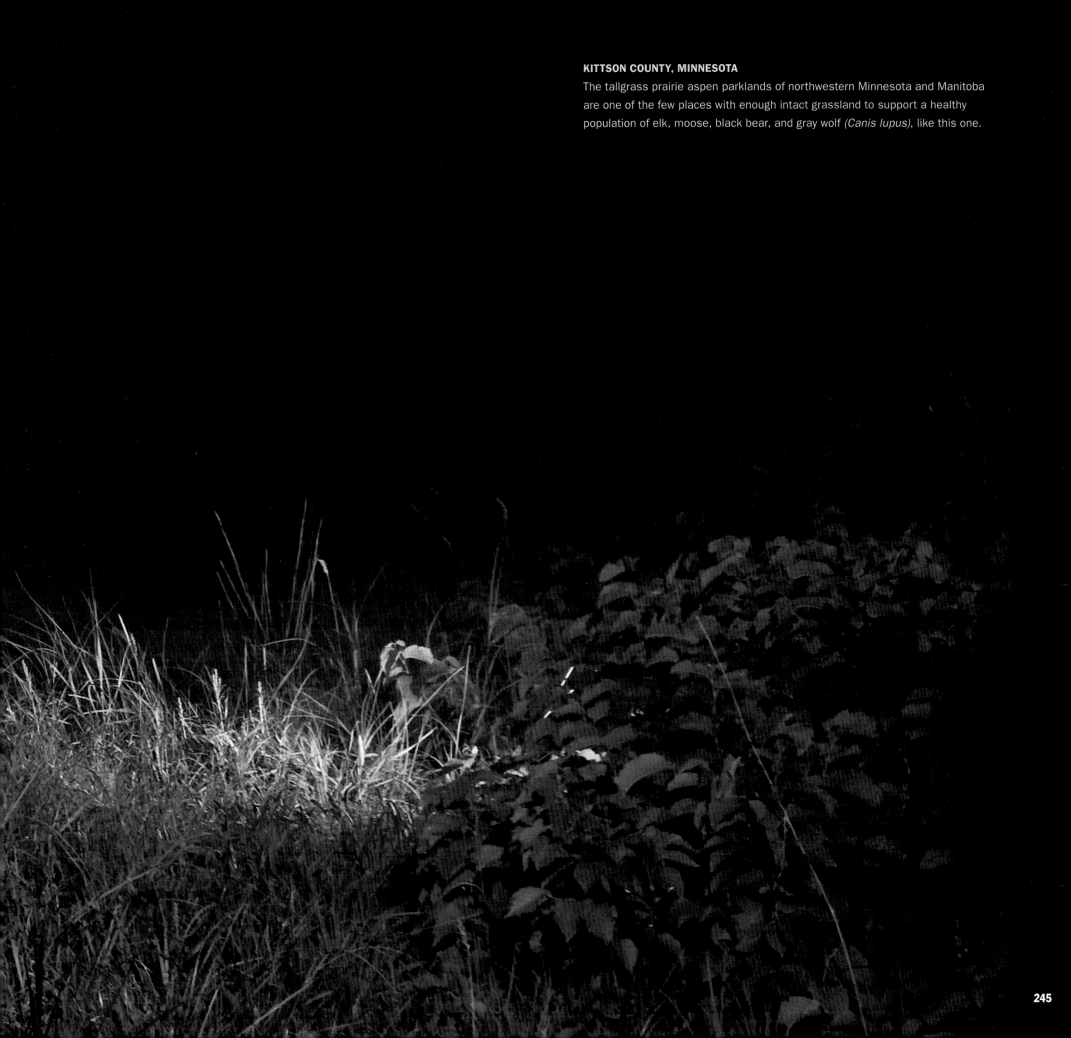

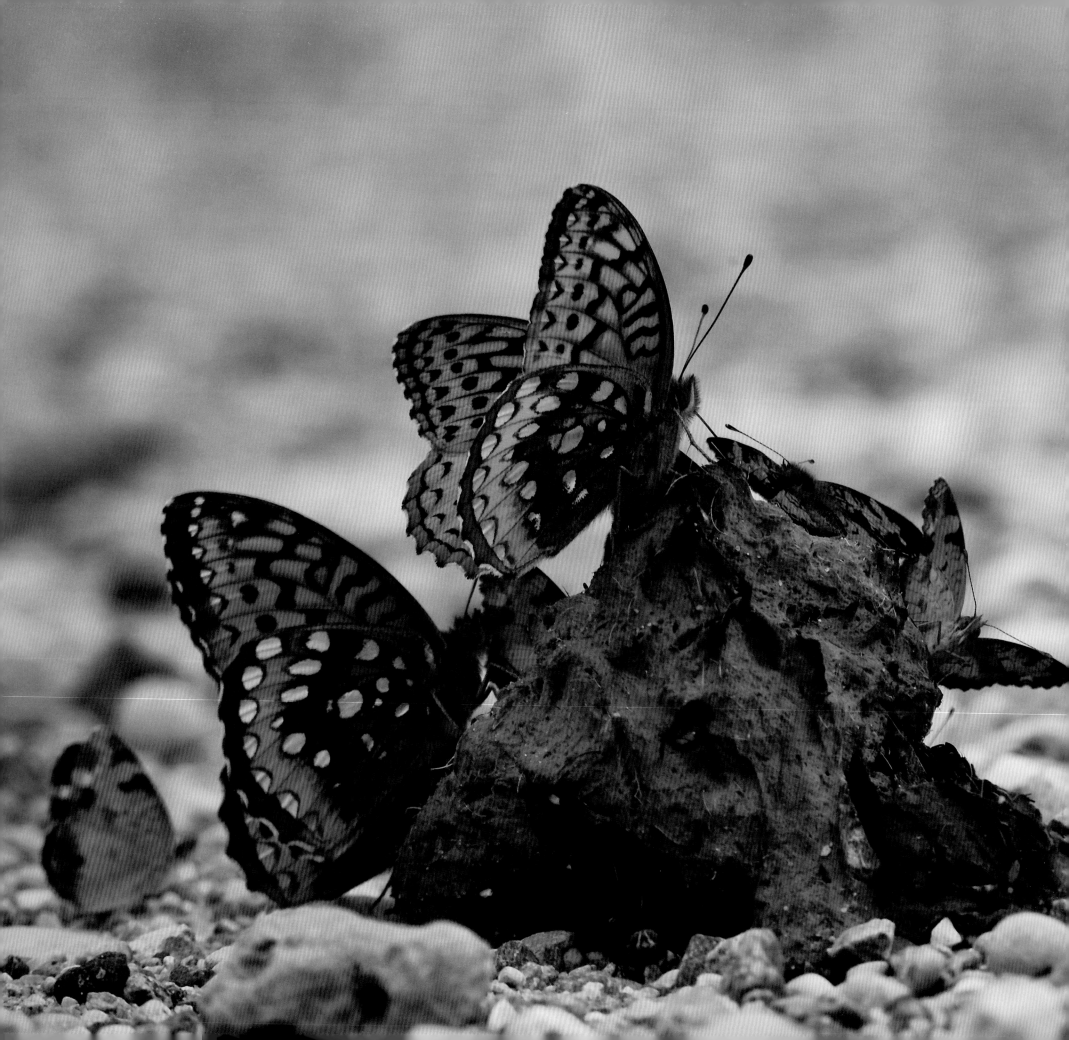

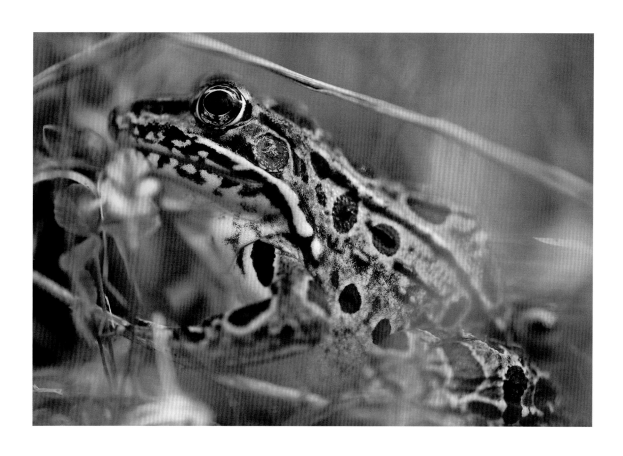

Left: **KITTSON COUNTY, MINNESOTA**
A gathering of male great spangled fritillary *(Speyeria cybele)* and northern crescent *(Phyciodes cocyta)* butterflies draw in nutrients—primarily amino acids and salts—from wolf scat.

Above: **GLACIAL RIDGE NATIONAL WILDLIFE REFUGE, MINNESOTA**
A northern leopard frog *(Rana pipiens)* lingers near the bank of a prairie slough in the 35,000-acre project area, considered the largest tallgrass prairie and wetland restoration in U.S. history. To date, The Nature Conservancy has restored 11,500 acres of prairie and 212 wetlands, greatly reviving natural communities and reducing flood damage to human communities downstream.

Right: **TNC PEMBINA TRAIL PRESERVE, MINNESOTA**

Small but mighty, an orb weaver spider captures a damselfly in its dew-soaked web on the edge of a sedge meadow.

Above: **FARGO, NORTH DAKOTA**

Biodiversity in a box, this small colorful selection of insects represents the more than 800 identified species that can be found on one patch of healthy northern tallgrass prairie. Scientists continue to discover new prairie insect and arthropod species, and most believe the true number is in the thousands.

NORTH DAKOTA STATE INSECT REFERENCE COLLECTION, NORTH DAKOTA STATE UNIVERSITY, FARGO, NORTH DAKOTA

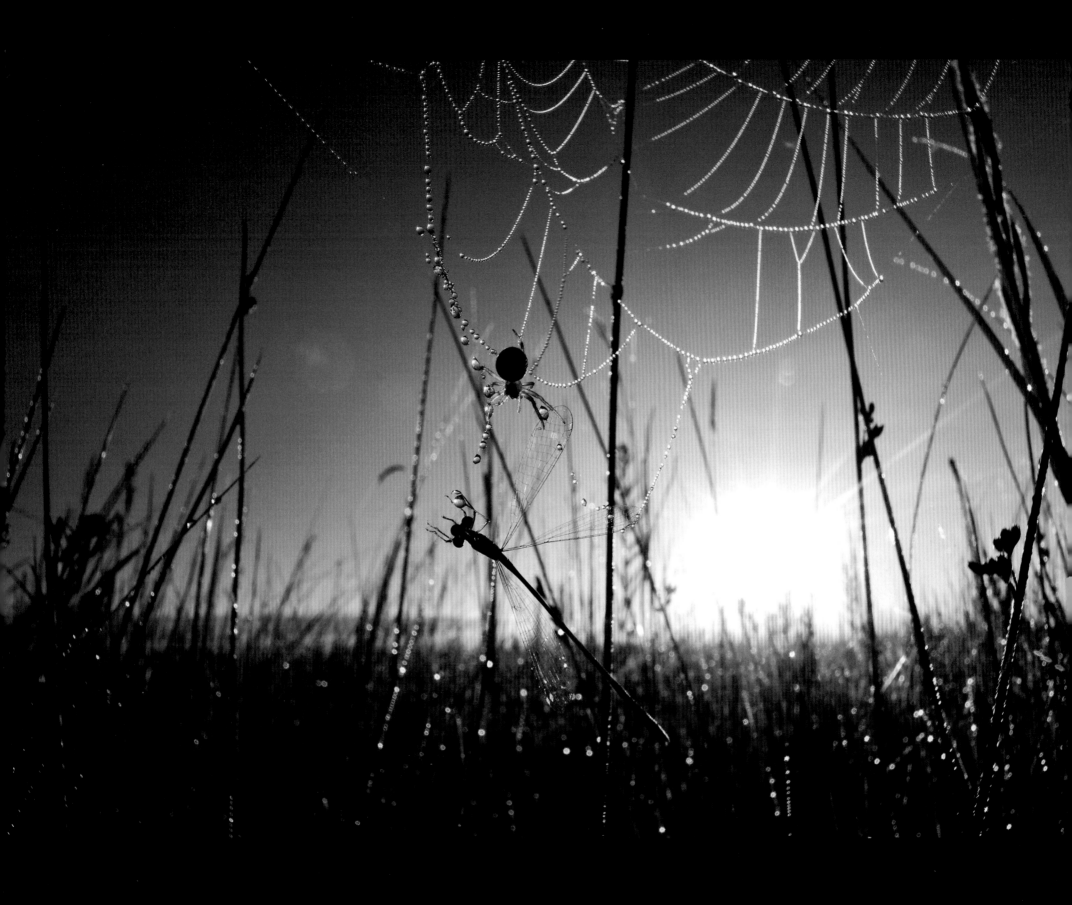

DOUGLAS COUNTY, MINNESOTA

A black tern *(Chlidonias niger)* glides gracefully over bulrush on Lake Christina in western Minnesota. In the eastern portion of the Prairie Pothole Region, many small pothole wetlands have been lost to agricultural conversion, but larger shallow lakes like Christina remain vital to migrating waterfowl.

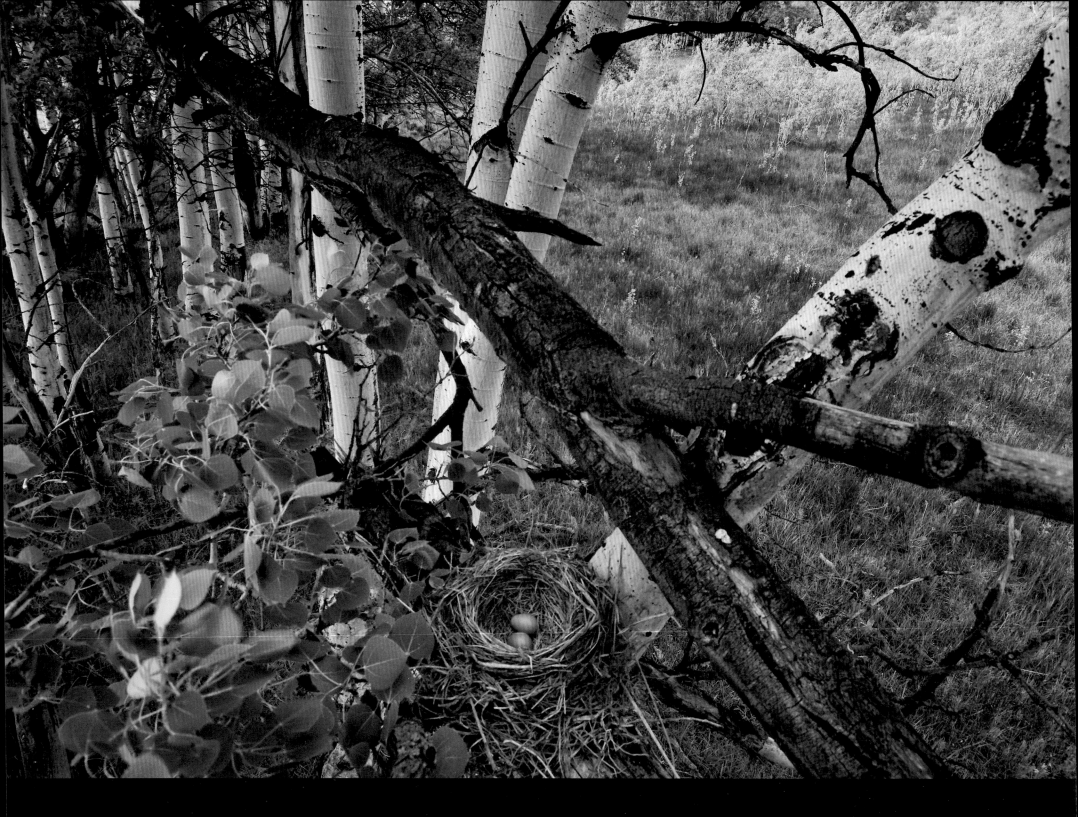

TNC PINE BUTTE SWAMP PRESERVE, MONTANA
Promise of rebirth, the eggs of two American robins *(Turdus migratorius)* are held secure
in the sturdy cup of their nest, high up in an aspen stand on the edge of the prairie.

INHERITING THE LAND

Dan O'Brien

IT'S GOOD TO REMEMBER that nothing is permanent except change. It goes for our personal lives, and it goes for the ecosystems in which we live. It's something all of us who live on the Great Plains know—even if we don't admit it.

On the Plains the agents of change have often been invasion and immigration. This morning I watched English sparrows—very new to this part of the country—chase goldfinches and tree sparrows away from the bird feeder with their snapping beaks. Some of the pastures on our ranch are infested with crested wheatgrass originally introduced by 18th-century settlers who hoped it would out-compete the native needlegrass. It did. Our buffalo don't eat much of the crested wheatgrass, but their ancestors thrived on the needlegrass for thousands of years.

Loss of species diversity and wildness is probably the most dramatic and troubling change. I would like to argue that the tree sparrows, goldfinches, and needlegrass need an ecosystem free of invaders. But, as my cousin once gently explained to me, "There are no needs but human needs." He was a professor of philosophy at Brandeis University, and I was young and a little hotheaded. I refused to agree with his pronouncement back then, but now I'm not so sure. Maybe the history and ecology of the Great Plains are really only about *Homo sapiens*. If that's true, then it's up to us.

Long before humans kept good records, invasion and immigration were changing the Plains. One of the first good accounts of that process was recorded in 1804, when Lewis and Clark met with the Oto and Missouri Indians in what would become southwestern Iowa. A pattern was set that day that continues to this. The Indians were told the invaders were not there to take over their land but to make their lives better by improving their economy. They were addressed as children and told that it would be in their interest to obey powers based far away in a region without buffalo, grass, or an understanding of either.

The fact that the outsiders ended up controlling and exploiting the land has been noted by each subsequent landholder in the Great Plains. The belief that everyone lusts for control of the land is the main source of paranoia in the Plains. It is the reason that environmentalists, industrialists, corporations, and government agencies are opposed to one another as a matter of course. In a country where one of the main attractions is solitude, distance, and a private relationship to the plants and animals that live here, control of the land is everything.

This book project took three years of fieldwork, and for most of that time Mike and I traveled the length and breadth of the Great Plains together. We've lived out here for a total of almost 90 years combined, so we know that the people of the Plains are mixed and complicated. We try hard not to lump everyone together, but because of who we are, Mike tends to see people as agents for solving the problem of the loss of wildness on the Great Plains. I tend to see them mostly as the problem.

Maybe our neighbors are no more mixed and complicated than the people of other regions of the country, but something about the terrain makes the contrasts between attitudes leap out. I suspect it has to do with the mythology of the Great Plains, the idea that here is a place with immense appeal and promise. The existence of millions of acres of public land exacerbates the problem. It gives everyone in the U.S. a say in the health of the Plains. And the fact that our national identity owes a huge debt to the myth of cowboys, Indians, pioneers, and explorers gives every American a stake in the future of the country's midsection.

The Great Plains have always been viewed as a land of distance and elbow room, where a man's or woman's ideas and deeds can count for something. The myth has always been that a man can succeed with just the force of his personality and his willingness to work. Class, education, and conformity were never necessary attributes for success in the myth of the Great Plains. Mike sees this as a formula for the egalitarian, Jeffersonian ideal of America—industrious individuals working tirelessly on the land. I see it as a way to attract and concentrate a group of classless, uneducated, nonconformists.

Over the years of this project Mike has resisted my cynicism and hasn't moved an inch from his hopeful stance. But I have moved considerably in his direction. Despite what I might feel on my worst days, I know that consensus among the residents of the Great Plains is the best chance to save the diversity and wildness that is the soul of the land I love.

Early farmers and ranchers on the Great Plains were truly in the backwater of the world. For a hundred years what went on out here barely registered on the wider human radar screen. That's the main reason our flawed relationship to the land was glorified in a national myth of homesteaders conquering the prairie, and one of the reasons we didn't see the Dust Bowl coming. Not until Black Sunday—April 14, 1935—when a gigantic dust cloud representing most of the topsoil from a million acres rose up and rolled eastward did we begin to understand that our old perceptions were dangerously defective. The dust cloud made it all the way to Washington, D.C., and even settled on ships in the Atlantic Ocean. Dr. Hugh Bennett—who became known as the father of soil conservation and was at the vanguard of progressive thinking about the human relationship with the land—declared, "When people along the eastern seaboard began to taste fresh soil from the plains two thousand miles away, many of them realized for the first time that somewhere, something had gone wrong with the land."

The realization that we had abused our responsibility to the land could have begun in earnest in 1935. Instead, we're still working toward a true understanding of that responsibility. Recent scientific revelations and the shortages of the 21st century have put even more pressure on us to change our ways.

The solitary, independent, and mythic yeoman farmers were tough, and the idea of them dies hard. But in the modern, global world there is really no such thing as solitude or independence. Since the realizations of the Dust Bowl visionaries, a genuine Great Plains land ethic has begun to emerge. Positive and a little bookish, this new land ethic—as Aldo Leopold first called it—is based in reality and science. Its proponents are inheriting the land.

In Montana Mike and I found one woman advocating the revolutionary grazing techniques of an immigrant Rhodesian. Another was nose to nose with energy companies that were battering and fragmenting her sagebrush in search of coal-bed methane. On the Southern Plains an ex-priest had returned home to his family's irrigated farm and now lives with his wife in an energy-efficient house beside a restored playa. They are applying their good minds and educations to the problem of understanding the land in a way their ancestors never had the knowledge to.

We found ranchers banded together to protect rattlesnakes in the name of species diversity, and on the Llano Estacado we found a local rivalry between a less-than-honest land developer and a man who is raising his family on a grassland ranch. The rancher is doing all he can to promote wildlife diversity, wildness, and restoration. The developer buys dryland ranches on credit, drills irrigation wells that help deplete the Ogallala Aquifer, then sells the land as irrigated farms eligible for government subsidies. He's made a lot of money and has nearly surrounded the rancher with sterile and bogus "progress." The twist in this story is that the developer was born and raised on that land, and the rancher moved in from New York.

As akin to sausage-making as democracy is itself, the Great Plains land ethic is full of debate and confrontation. There is no good demographic predictor of which side of a given land-use question a stakeholder might make his stand, but people seem to fall into two broad camps: Those who see the Great Plains as a way to make a living (maybe a big one) and those who see the Great Plains as a life. The good news is that Mike and I found the "lifers" in ascendance.

Most of the people we met believed that the situation was dire, important, and worth fighting for. Almost no one truly believed that laissez-faire land management was still possible. The overwhelming attitude was distilled by the words of a very old Iowa farmer: "We all got skin in this game." Farmers, ranchers, biologists, community leaders, and interest groups of all kinds are coming together across the Great Plains in an effort to impose some kind of order to the change that is inevitable. We met an aviation-industry engineer back on the family ranch and full of ideas about sustainability and workable relationships with neighbors and government agencies that he says his father would never have considered. We met philanthropists who were funding inquiries into what had gone wrong on the Plains and how it might be fixed. We met city folks who moved to the Great Plains to lend their hands in what has been called the "Revolution on the Range."

We also met at least one young rancher who was sure that the national grasslands were secretly owned by the United Nations. When I questioned how in the world the UN got hold of such a big chunk of public land, he looked at me as if he pitied my stupidity. "They bought it from Castro," he said. But he was an exception. What we mostly found was a strong desire that scientific and practical reason be applied firmly in this new Great Plains land ethic and an insistence that human beings be figured into the equation like everything else.

The obstacles to reasonable change still exist, but only the most radical, frightened, and ignorant of those we met still believed in the status quo. After these three years of traveling up and down the Great Plains, I'm happy to admit that Mike's vision of hope has more traction than my cynical outlook. The old guard, though still present in the form of outrageous individuals and callous corporations, is thinning. Public opinion, attrition, and education are on Mike's side. People are talking about solutions, and legions are forming.

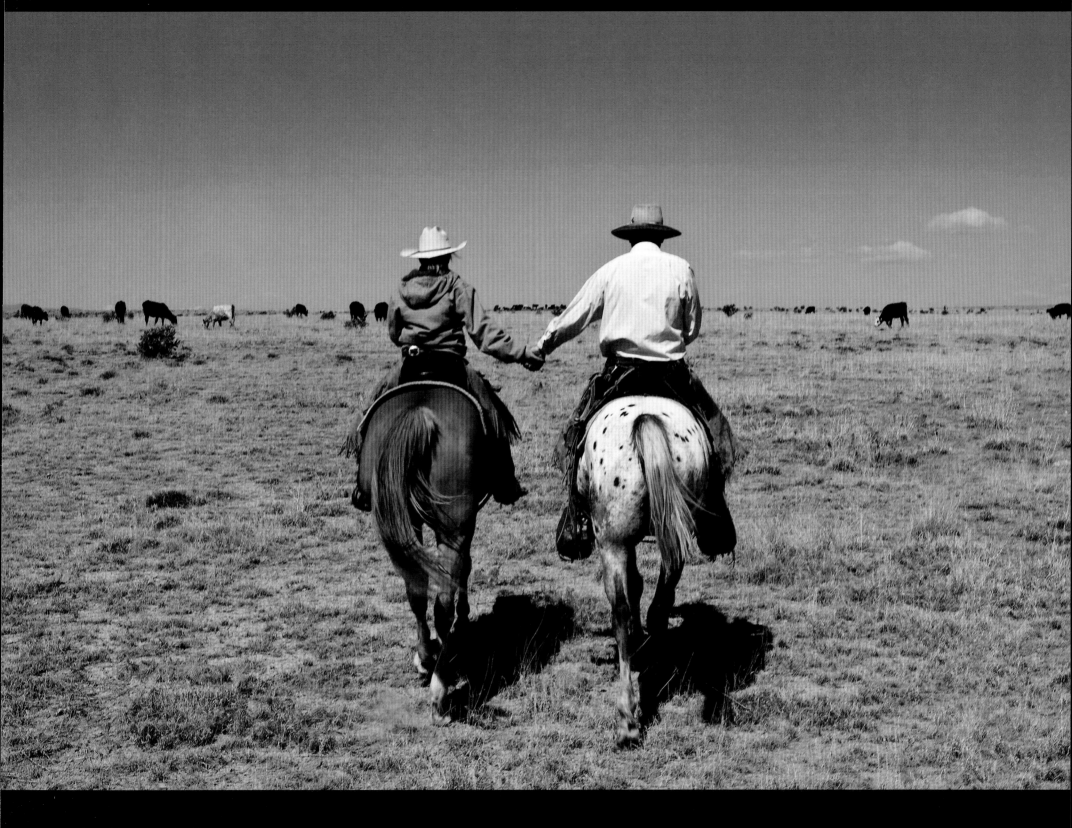

EL PASO COUNTY, COLORADO
Holding hands is an important part of the job for rancher Duke Phillips and his 12-year-old
daughter, Grace, who work together to preserve their ranch's parched prairie wilderness.

PHOTOGRAPHER'S NOTES

It is June 2007, and I am sitting in a motel room in Malta, Montana, with my forehead resting in my hands. I'm trying to figure out how to fix a remote video-eye camera system that has been devised to help me photograph shy little grassland songbirds like Sprague's pipits. Somewhere a connection on the camera has become disconnected, and now I have wires, cords, batteries, and tools scattered across the floor. I've been to the Radio Shack once, the hardware store twice, and the motel office three times—buying, begging, or borrowing tools. I'm also trouble-shooting via e-mail with photo-engineering whiz Nathan Williamson, who is trying to help me find and fix the problem from 2,000 miles away. At home, my wife, Patty, does the electrical work. What in the world was I thinking? I was in over my head. Two days later the problem is solved, the camera system jerry-rigged back together with aluminum foil and duct tape, and I'm back in business. In the end, I get a handful of the pictures I was hoping for. Thank goodness.

A photographer and his equipment are akin to a carpenter and his tools. I knew if I wanted to attempt to create a collection of intimate photographs that portrayed the diversity of life in the Great Plains—a place where many animals have evolved with great eyesight, run fast, live in holes in the ground and have learned to avoid humans—it would require some special tools I had not used before but needed to learn and embrace quickly.

One of those tools was a video-eye system that attached to the back of a camera. It would allow me to see through the viewfinder and trigger the camera remotely from a long distance away, with minimal disturbance to the animals. I used that system on certain small ground-nesting birds and near burrows on prairie dog towns. I also needed to use equipment that I could set up to take pictures when I was away, even for weeks at a time. These "camera traps," which are triggered by an infrared beam, sometimes required months of effort on my part part and the assistance of others to help keep the cameras operating, but they captured images of large, solitary predators like mountain lions, grizzly bears, and wolves.

I also photographed underwater for the first time while working on this book. I used a traditional underwater camera system that fit a standard SLR camera. In tight spots with small fish, I used a small point-and-shoot camera with its own underwater housing.

But the vast majority of the fieldwork was done simply—with a camera in hand, a daypack on my back, and a tripod slung over my shoulder, hiking off into the prairie or paddling down a river for several hours or several days. I relied on two cameras and a spare body with an assortment of lenses. The longest lens was 500f4 with a 1.4 teleconverter. The widest was a 18mm. Almost all the equipment I used performed well and never let me down. In fact, I lost a lens in late May riding horseback on a ranch high in the Powder River country of eastern Wyoming and thought it was gone forever. Five months later it arrived in the mail with a note from the rancher who had found it out on the prairie: "Mike, It's a little weathered. Hope it still works." I thought it would be relegated to a Nikon paperweight, but it still works fine.

For this project I drove everywhere I went. When I started in 2005, gas was below two dollars a gallon. When I was wrapping up fieldwork in late 2008, it had blown my budget and doubled to over four dollars a gallon (and over five in Canada). I used a Suburban that was purchased with 60,000 miles on it. Two sets of ten-ply, steel-sidewall, puncture-proof tires and two wheel bearing assemblies later, it now has over 160,000 miles.

I was in the field roughly six months a year over the last three-plus years. Early on, I would unpack the Sub each time I got back from a trip. But as time went on, I just left it packed with everything from blinds, pelican cases, sleeping bags, wet suits, waders, camo gear, tents, backpacks, climbing gear, weather radio, shovels, tool boxes, cable ties, camp stoves, water jugs, MREs, deer sausage—well, you get the idea.

When I had to shoot aerials to gain perspective on these wide-open spaces, I was lucky to fly with ten really great pilots. On flights, I always brought two cameras with two zoom lenses—a 28-70mm and a 70-200mm—and polarizing filters for each to cut glare and haze.

Speaking of pilots, early on in this project I met Bill Hager. He was a soon-to-be-retired career helicopter pilot and instructor for the Nebraska National Guard. Bill had spent most of his life in the outdoors and was a good photographer. He volunteered to help me when he could in the field. He traveled with me often. His steady assistance, knowledge, and common sense were invaluable. He kept the mood light, helped me through some tough spots, and often pushed me beyond my own limits and made me better. I am honored to be considered his friend. Thanks, Bill.

A MUDDY DAY'S WORK WITH AMPHIBIAN RESEARCHERS, POWDER RIVER, WYOMING

HOMEMADE BLIND FOR WINTER WATERFOWL IN NEBRASKA SANDHILLS

DRESSING UP A REMOTE CAMERA WITH PRAIRIE GRASS IN NORTH DAKOTA

ACKNOWLEDGMENTS

This project could never have been completed without the generosity and expertise of hundreds of people during the past several years. The completed book is as much a product of their collective talents, labor, passion, and commitment as it is mine. Like the Great Plains we call home, this is our book together, created by a community of people that I am humbled and honored to be associated with. To everyone who helped, my most sincere thanks. I especially want to recognize and thank the following individuals: Margery Nicolson, who continues to support my work and our family in so many ways. A simple thank you is never enough. We love you, Margery. Angus and Margaret Wurtele, who enthusiastically embraced this project from day one with great generosity and continued their support all the way through. Jim and Chris Weaver, who gave us security and confidence when we needed it most and expected it least. The Nature Conservancy's Rob McKim, Vince Shay, Renee King, Mace Hack, Deb Stone, and Bob Paulson—each in their own way believed in the idea of this work. They never looked away and helped enable the project to move forward.

Patty Forsberg, whose many talents, million-dollar smile, and tireless work behind the scenes was the glue that held everything together the last four years. Dan O'Brien. The only thing I like more than his writing is the man himself. For me there was simply no better voice for this book, and I am grateful to have traveled this road with him. Joel Sartore, National Geographic photographer, neighbor, colleague, and dear friend, who gets to what matters most more quickly than anyone I have ever met. Thank you for looking at almost every single image I shot and for your honesty, clarity, guidance, and unbridled enthusiasm. Bill Hager, who was my field assistant a good many of the 100,000 miles traveled. Simply put, your help was invaluable, your friendship a great gift.

Lisa Lytton, talented designer, packager, and friend, who has been much more than those titles describe. She nurtured this book as it took shape and has carried its production squarely on her shoulders and kept us moving forward and on target. Karen Kostyal, text editor, whose superb editorial talents enabled different personalities and voices to come together with clarity and strength. Kathy Moran, photo editor. Her discerning eye and expertise have made this book much better. I am ever grateful. Christie Henry, University of Chicago Press executive editor, for believing in this book and finding it a home. David Wishart, my undergraduate advisor at the University of Nebraska, who taught me that geography was more than just places on a map, and whom I have continued to learn from through his work on this project. Ted Kooser, for caring about this book and lending his clear poetic voice.

Carl Mehler, National Geographic Society cartographer whose expertise and thoroughness helped create maps that are smart, thoughtful, and beautiful.

Steve Chaplin, The Nature Conservancy senior scientist and advisor, who came in at the eleventh hour to help us complete a graphic. Michael Jones and West Coast Imaging for the skillful craftsmanship that made these images come alive and kept them true to the landscape itself. Jason McNees and Margaret Ormes of NatureServe for their quick help and hard work with data analysis. Tom White, for being a confidant and lending his voice to help introduce the book. John Carter, Nebraska Historical Society photo archivist, for helping craft a historical narrative in pictures. Margaret Johnson, historical photo researcher, who navigated the halls of the National Archives and found just what we were looking for. Nathan Williamson for his masterful work building remote-cameras systems. Katie Joseph, for being an ace in the hole with technical advice when no one else could figure it out. Jean Bruneau, Aquatica technical advisor. The staff at Nikon Professional Services. The staff at Trailmaster Trail Monitors.

To the numerous scientists, land managers, and ranchers who helped shape content and fact check the captions in this book, your input was invaluable. To our staff past and present at the Michael Forsberg Gallery—Kristen Bailey, Mariel Harding, Sue Meranda, Barb Sullivan, Nick Altadonna, Jen Birdsall, Jen Schultz, and Crystal Matthews. And to all those organizations, agencies, and private citizens who shared with me their time, talents, knowledge, homes, and lives to help me accomplish fieldwork or research, my sincerest thanks. I would especially like to thank Bob Paulson, Scott Stephens, the Weaver family, Willard Heck, Bob and Marlene Grier, Dave Hanna, Randy Matchett, Randy Greibel, Brian Martin, Dennis Jorgensen, Chris Helzer, Brian Obermeyer, Greg and Dina Wingfield, Chris Hise, Brian Winter, Darryl and Joann Birkenfeld, Stuart Schneider, Jill Maguire, Derrick and Jackie Keim, Myron and Kay Peterson, Jill Morrison, Duke and Janet Phillips, Phil and Lynette Barefield.

Finally, I want to thank my immediate family and extended families. First to my wife Patty—the love of my life, and our precious daughters Elsa and Emme, thank you for putting up with my frequent long absences and making those absences hurt less with your funny notes, hidden pictures in my luggage, and your voices on the other end of the line at the end of most days. I know it was not always easy. I love you. And thank you to my folks, Larry and Nancy; my sister, Michelle; my in-laws, Jerry and Linda Springer; and my brother-in-laws Michael, Chad, and Vance Springer, and their families for surrounding us with care and support.

Thanks also to the following:

Canada—Barbara Mitchell, Annie Bullman, Sheridan Bullman; Pat and Karen Fargey, Grasslands National Park; Ken and Johanna Jensen, Michael Suitor, University of Calgary; Joel Nicholson, Alberta Fish and Wildlife. **Montana**—TNC field staff, especially Dave Hanna, Brian Martin, Linda Poole; USFWS staff, especially Randy Matchett, Paula Gouse, Matt Derosier; Montana Fish, Wildlife and Parks, especially Mike Madel, Mark Sullivan; World Wildlife Fund staff, especially Dennis Jorgensen, Martha Kauffman. American Prairie Foundation staff, especially Bill and Dolly Wilcutt; Andrew Jakes, University of Calgary; Mark Schafer, Upper Missouri River Breaks National Monument; pilot Dixon Hitch, Malta; Lighthawk pilot Chris Boyer, Bozeman; pilot Charlie Rodgers, Lewistown. Karl and Terri Rappold; Dusty and Danelle Crary; the Peebles family; the community of Malta. **North Dakota**—Ducks Unlimited staff, especially Scott Stephens; Marion Harris, Gerald Fauske, Kristina Fox, North Dakota State University; Dave Brandt; pilot Pete Finley; USFWS staff, especially Natoma Buskness; Woodworth Café. **Minnesota**—TNC staff, especially Brian Winter, Russ Reisz, Jonathan Eerkes; Jason Ekstein; Donovan Pietruszewski, Minnesota Dept. of Natural Resources; Nate Emery, University of North Dakota. **Wyoming**—Powder River Basin Resource Council, especially Jill Morrison; Ucross Foundation, especially Sharon Dynak; Wyoming Game and Fish Dept., especially Bud Stewart, Mark Gocke; Larry Gerard, Bureau of Land Management; Hanna Griscom, University of Wyoming; Don Spellman; Donley and Nancy Darnell; Ecoflight pilot Bruce Gordon; Linea Sundstrom; Zac Sexton; Camp Guernsey Joint Training Center. **South Dakota**—TNC staff, especially Bob Paulson; USFS staff, especially Randy Griebel, Doug Sargent; Jill Maguire, Gervase Hittle, Ernie Hersman; National Park Service staff, especially Dan Roddy, Rick Mossman; Travis Livieri, Prairie Wildlife Research; David Eads, University of Missouri; Dayton Hyde, Black Hills Wild Horse Sanctuary; USFWS staff, especially David Jachowski, Herb Bollig, and Gavins Point National Fish Hatchery crew, Wayne Nelson Stastny; Joe Riis; Ernie the bus driver; Larry and Elaine Ebbert. **Iowa**—TNC staff, especially Scott Moats, David DeGeus; Bill and Dotty Zales; Stephen Dinsmore, Iowa State University. **Nebraska**—TNC staff, especially Chris Helzer, Mace Hack, Jim Luchsinger, Jason Skold; Myron and Kay Peterson family; Derrick and Jackie Keim family; Bruce and Sue Ann Switzer family; Bob Price and family; Gary and Sara Radil and Coffee families; Rick and Lori Rasmussen; Scott Schafer; the Kalkowski family, Larry Snyder, Rocky Mountain Bird Observatory; Wayne Mollhoff; Bob and Marlene Grier; Dan Fogell; Nebraska Game and Parks Commission staff, especially Jon Farrar, Gerry Steinauer, Ted LaGrange, Gene Zuerlein; Al Hanson, Todd Nordeen, Jennifer Sherwood; University of Nebraska–Lincoln, especially Jim Stubbendieck, Paul Johnsgard, Jim Swinehart; pilot Franz Muller; NPS staff, especially Stuart Schneider, Wayne Werkmeister; USFWS staff, especially Martha Tacha, Kenny Dinan; Platte River Trust staff, especially Felipe Chavez Ramirez, Donna Narber, Daniel Kim; Audubon Rowe Sanctuary staff, especially Bill Taddicken, Kent Skaggs, Keanna Leonard; Audubon Spring Creek Prairie staff, especially Marion Langan, Deb Hauswald; Prairie Plains Resource Institute staff; Cliff Hollestelle; Miles Fiscus; Tom Olson; Michael Farrell; pilot Mike Springer of Lincoln; Scooters; The Mill. **Colorado**—Duke and Janet Phillips family, Michael and Dawn Moon family; TNC staff Frogard Ryan, Alexandra Larson; Rocky Mountain Bird Observatory staff, especially Arvind Punjabi; Stephen Weaver, Colorado College. **Kansas**—TNC staff, especially Brian Obermeyer, Greg Wingfield, Tom Van Slyke; NPS staff, especially Steve Miller; Ron and Kelly Lockton; Josh Hoy and family; Jane Koger; Michael Stubbs; David Edds, Emporia State University; Bryan Simmons, Kansas Wildlife and Parks; pilot Don Tevis of Emporia. **Oklahoma**—TNC staff, especially Chris Hise, Bob Hamilton, Matthew Poole; Gary Inman, Whitlock Ranch. **New Mexico**—TNC staff, especially Tish McDaniel; Jim and Kris Weaver family; Willard Heck, Grasslans Charitable Foundation; USFS staff, especially Dan Garcia. **Texas**—Darryl and Joann Birkenfeld; Phil and Lynette Barefield; Ted Daugherty; Father Jim Schmitmeyer; pilot Taos Weldon; USFWS staff, especially John Hughes; Dave Haukos, Texas Tech University; Texas Parks and Wildlife, especially Caprock Canyon State Park staff. **Mexico**—TNC staff Nelida Barajas, Bob McCready.

RESOURCES

Besides the short list below, there are numerous state wildlife and natural resource agencies, and many other academic institutions, environmental organizations, and private enterprises throughout the region dedicated to education, conservation, and land stewardship in the Plains.

THE NATURE CONSERVANCY
Worldwide Office
4245 North Fairfax Drive, Suite 100
Arlington, VA 22203-1606
703-841-5300
www.nature.org

THE NATURE CONSERVANCY
Nebraska Field Office
1025 Leavenworth Street, Suite 150
Omaha, NE 68102
402-342-0282
www.nature.org/wherewework/
northamerica/states/nebraska

SANDHILLS TASK FORCE
P.O. Box 1686
Kearney, NE 68848
308-236-5015
www.sandhillstaskforce.org

**UNIVERSITY OF NEBRASKA CENTER
FOR GREAT PLAINS STUDIES**
University of Nebraska—Lincoln
1155 Q Street, Hewit Place
P.O. Box 880214
Lincoln, NE 68588-0214
402-472-3082
www.unl.edu/plains

**POWDER RIVER BASIN
RESOURCE COUNCIL**
934 North Main Street
Sheridan WY 82801
307-672-5809
www.powderriverbasin.org

AMERICAN PRAIRIE FOUNDATION
P.O. Box 908
Bozeman, MT 59771
406-585-4600
www.americanprairie.org

WORLD WILDLIFE FUND
Northern Great Plains Program
202 S. Black Avenue, Suite 3
Bozeman, MT 59771
406-582-0236
www.worldwildlife.org/ngp

GRASSLANS CHARITABLE FOUNDATION
P.O. Box 23
Causey, NM 88113-0023
575-273-4360

**ROCKY MOUNTAIN BIRD
OBSERVATORY**
P.O. Box 1232
Brighton, CO 80601-1232
303-659-4348
www.rmbo.org

DUCKS UNLIMITED
Great Plains Regional Office
2525 River Road
Bismarck, ND 58503-9011
701-355-3500
www.ducks.org

PLAYA LAKES JOINT VENTURE
103 E. Simpson Street
Lafayette, CO 80026
303-926-0777
www.pljv.org

**USGS NORTHERN PRAIRIE WILDLIFE
RESEARCH CENTER**
U.S. Department of the Interior
U.S. Geologic Survey
8711 37th Street SE
Jamestown, ND 58401
701-253-5500
www.npwrc.usgs.gov

PRAIRIE PLAINS RESOURCE INSTITUTE
1307 L Street
Aurora, NE 68818
402-694-5535
www.prairieplains.org

OGALLALA COMMONS
P.O. Box 245, Nazareth, TX 79063
806-945-2255
www.ogallalacommons.org

**GEORGE MIKSCH SUTTON AVIAN
RESEARCH CENTER**
P.O. Box 2007
Bartlesville, OK, 74005-2007
918-336-7778
www.suttoncenter.org

XERCES SOCIETY
4828 SE Hawthorne Blvd.
Portland, OR 97215
503-232-6639
www.xerces.org

PRAIRIE WILDLIFE RESEARCH
P.O. Box 308, Wellington, CO 80549
970-219-1659
www.prairiewildlife.org

**USFS NATIONAL GRASSLANDS
VISITOR CENTER**
U.S. Department of Agriculture
U.S. Forest Service
708 Main St., Wall, SD 57790
605-279-2125
www.fs.fed.us

**PLATTE RIVER WHOOPING CRANE
MAINTENANCE TRUST**
6611 W. Whooping Crane Dr.
Wood River, NE 68883
308-384-4633
www.whoopingcrane.org

THE GROUNDWATER FOUNDATION
P.O. Box 22558
Lincoln, NE 68542-2558
1-800-858-4844
www.groundwater.org

**PLATTE RIVER RECOVERY
IMPLEMENTATION PROGRAM**
3710 Central Avenue, Suite E
Kearney, NE 68847
308-237-5728
www.platteriverprogram.org

**MISSOURI RIVER RECOVERY
PROGRAM**
www.moriverrecovery.org/mrrp/

LIGHTHAWK
304 Main Street, Suite 14
P.O. Box 653
Lander, WY 82520
307-332-3242
www.lighthawk.org

ECOFLIGHT
307 L'Aspen Airport Business Center
Aspen, CO 81611
970-429-1110
www.ecoflight.info

CANADIAN WILDLIFE SERVICE
Environment Canada
Ottawa, Ontario KIA OH3
819-997-2800
www.cws-scf.ec.gc.ca

PARKS CANADA
Parks Canada National Office
25 Eddy Street
Gatineau, Quebec, Canada K1A 0M5
905-566-4321
www.pc.gc.ca

NATIONAL PARK SERVICE
US Department of the Interior
1849 C Street NW
Washington, DC 20240
202-208-6843
www.nps.gov

US FISH AND WILDLIFE SERVICE
1849 C Street, NW
Washington, DC 20240
www.fws.gov

NATURESERVE
1101 Wilson Boulevard
15th Floor
Arlington, VA 22209
703-908-1800
www.natureserve.org

AUDUBON NEBRASKA
11700 SW 100th Street
P.O. Box 117
Denton, NE 68339
402-797-2301
www.nebraska.audubon.org

CHICO BASIN RANCH
22500 Peyton Highway South
Colorado Springs, CO 80928
719-683-7960
www.chicobasinranch.com

US BUREAU OF LAND MANAGEMENT
US Department of the Interior
1849 C Street NW, Rm.5665
Washington DC 20240
202-208-3801
www.blm.gov

**GAVINS POINT NATIONAL FISH
HATCHERY**
US Fish and Wildlife Service
31227 436th Avenue
Yankton, South Dakota 57078
605-665-3352
www.fws.gov/gavinspoint

GRASSLAND FOUNDATION
P.O. Box 22809
Lincoln, Nebraska, 68542-2809
402-477-2044
http://www.grasslandfoundation.org

QUIVIRA COALITION
1413 Second Street, Suite 1
Santa Fe, NM 87505
505-820-2544
www.quiviracoalition.org

GREAT PLAINS NATURE CENTER
6232 E. 29th Street North
Wichita, KS 67220-2200
316-683-5499
www.gpnc.org

NATURE CONSERVANCY OF CANADA
36 Eglinton Avenue West
Suite 400
Toronto, ON M4R 1A1
1-800-465-0029
www.natureconservancy.ca

**NORTH AMERICAN GROUSE
PARTNERSHIP**
1670 N 1/2 Road
Fruita, CO 81521
970-858-9659
www.grousepartners.org

LAND INSTITUTE
2440 E. Water Well Road
Salina, KS 67401
785-823-5376
www.landinstitute.org

CENTER FOR RURAL AFFAIRS
145 Main Street, P.O. Box 136
Lyons, NE 68038
402-687-2100
www.cfra.org

**SWITZER RANCH & CALAMUS
OUTFITTERS**
83720 Valleyview Avenue
Burwell, NE 68823
308-346-4697
www.switzerranch.com

INDEX

BIBLIOGRAPHY FOR CHAPTER INTROS

Bogue, Alan G. *From Prairie to Corn Belt: Farming on the Illinois and Iowa Prairies in the Nineteenth Century.* Chicago: University of Chicago Press, 1963.

Cunfer, Geoff. *On the Great Plains: Agriculture and Environment.* College Station: Texas A&M University Press, 2005.

Fite, Gilbert C. *The Farmers' Frontier, 1865-1900.* New York: Holt, Rinehart and Winston, 1966.

Frazier, Ian. *Great Plains.* New York: Farrar, Strauss and Giroux, 1989.

Great Plains Committee. *The Future of the Great Plains.* Washington DC: Government Printing Office, 1936.

Hewes, Leslie. *The Suitcase Farming Frontier: A Study in the Historical Geography of the Central Great Plains.* Lincoln and London: University of Nebraska Press, 1973.

Hewes, Leslie and Philip E. Frandson. "Occupying the Wet Prairie: The Role of Artificial Drainage in Story County, Iowa." *Annals of the Association of American Geographers* 41 (1952): 24-50.

Johnson, Willard D. *The High Plains and their Utilization.* Twenty-First Annual Report of the United States Geological Society. Washington DC: Government Printing Office, 1902.

McPhee, John. *Rising From the Plains.* New York: Farrar, Strauss, and Giroux, 1986.

McPhee, John. *Uncommon Carriers.* New York: Farrar, Strauss, and Giroux, 2006.

Malin, James C. *History and Ecology: Studies of the Grassland.* Edited by Robert P. Swierenga. Lincoln and London: University of Nebraska Press, 1984.

Moul, Francis. *The National Grasslands: A Guide to America's Undiscovered Treasures.* Lincoln and London: University of Nebraska Press, 2006.

Paradise, Viola D. *Maternity Care and the Welfare of Young Children in a Home-steading County in Montana.* Washington DC: Government Printing Office, 1919.

Prince, Hugh C. *Wetlands of the American Midwest: A Historical Geography of Changing Attitudes.* University of Chicago Research Paper No. 241. Chicago: University of Chicago Press, 1997.

Raban, Jonathan. *Bad Land: An American Romance.* New York: Vintage Books, 1996.

Rölvaag, O. E. *Giants in the Earth.* New York: Harper and Row, 1955.

Saarinen, Thomas Frederick. *Perception of the Drought Hazard on the Great Plains.* Department of Geography Research Paper No. 106. Chicago: University of Chicago Press, 1966.

Stegner, Wallace Earl. *Wolf Willow: A History, a Story, and a Memory of the Last Plains Frontier.* New York: Viking Press. 1962.

Webb, Walter Prescott. *The Great Plains.* New York: Grosset and Dunlap, 1931.

Wedel, Waldo R. "The High Plains and Their Utilization by the Indian," *American Antiquity* 29 (1963): 1-16.

Wishart, David J. *An Unspeakable Sadness: The Dispossession of the Nebraska Indians.* Lincoln and London: University of Nebraska Press, 1994.

Wishart, David J. *Encyclopedia of the Great Plains.* Lincoln and London: University of Nebraska Press, 2004.

Worster, Donald. *Dust Bowl: The Southern Plains in the 1930s.* New York and Oxford: Oxford University Press, 1979.

Archival Photographs: From the Collection of the National Archives: page 31, photo #77-HQ-264-847; page 37, top, photo #22-WB-825a; page 37, bottom, photo #22-WB-3929; page 39, photo no. NWDNS-114-G-080889

Page 34, top: Paul Simpson Collection, Box 3, American Heritage Center, University of Wyoming

Pages 29, 30, 33 top and bottom, 34 bottom, 38, 199: Courtesy of the Nebraska State Historical Society

Maps on pages 26, 44, 128, and 198: Great Plains Bioregion boundaries were modified by The Nature Conservancy based on ecoregional subsection lines originally from:

Bailey, R.G., P.E. Avers, T. King, and W.H. McNab, eds. 1994. Ecoregions and subregions of the United States (map). Washington DC: USDA Forest Service. 1:7,500,00. with supplementary table of map unit descriptions, compiled and edited by W.H. McNab and R.G. Bailey.

Page 69: Excerpt of poem entitled "Prairie," from *Cornhusker* by Carl Sandburg, published in 1918 by Henry Holt and Company, New York.

For my text, I relied heavily on a diverse array of published scientific and nonscientific materials, as well as many personal interviews and time spent with scientists, ranchers, land managers and other conservation-minded folks in the field and policy arenas. I also relied on my own simple observation and recorded what I saw. I have made a concerted effort to make sure that the information recorded in this book is accurate and as current as possible. I accept responsibility for any errors of fact or judgment. The opinions expressed in this book unless otherwise attributed are my own. MF

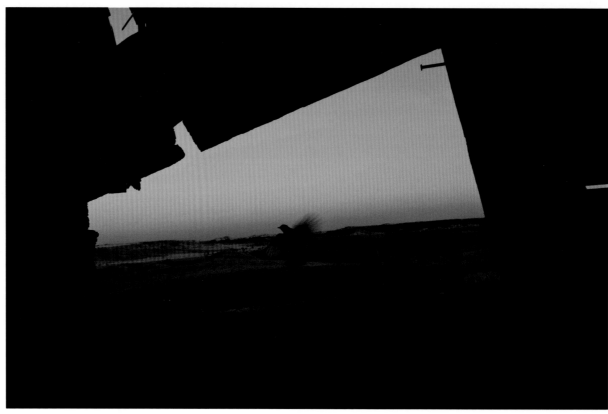

SAY'S PHOEBE, BUFFALO GAP NATIONAL GRASSLAND, SOUTH DAKOTA

STAFF FOR THIS BOOK:

Lisa Lytton, *Project Editor*

Karen M. Kostyal, *Text Editor*

Kathy Moran, *Photography Editor*

Joel Sartore, *Photography Advisor*

Carl Mehler, *Cartographer*

Margaret Johnson, *Archival Photograph Researcher*

John Carter, *Archival Photograph Researcher*

Rebecca Barns, *Release Editor*

The University of Chicago Press:

Christie Henry, *Executive Editor*

Mark Heineke, *Promotions Director*

Color separations by West Coast Imaging
Printed in China

Copyright © 2009 Michael Forsberg
ISBN-13: 978-0-226-25725-9
ISBN-10: 0-226-25725-8
Library of Congress information is available upon request.

DAN O'BRIEN has been a wildlife biologist and rancher in South Dakota for more than 30 years. Described by the *New York Times* as having "a keen and poetic eye," Dan is one of the most powerful literary voices on the Plains. He is a two-time winner of the National Endowment for the Arts individual artist's grant and a 2001 recipient of the Bush Creative Arts Fellowship. He received the 1999 Western Heritage Award for Fiction for *The Contract Surgeon* and again in 2001 for his memoir, *Buffalo for the Broken Heart*. He is the recipient of the Iowa Short Fiction Award for his short story collection, *Eminent Domain*. His novels are *The Spirit of the Hills*, *In the Center of the Nation*, *Brendan Prairie*, *The Contract Surgeon*, and *The Indian Agent*. Dan's nonfiction books are *The Rites Of Autumn*, *Equinox*, and *Buffalo for the Broken Heart*. To learn more about Dan's work, visit www.wildideabuffalo.com.

DAVID WISHART is Professor of Geography at the University of Nebraska, Lincoln, where he has taught for 34 years. He was Chair of the Department of Anthropology and Geography from 2002 to 2008. A historical geographer specializing in the dispossession of indigenous peoples and the Great Plains region, he is the author of more than 40 articles and book chapters. Among his books are *The Fur Trade of the American West, 1807-1840* and *An Unspeakable Sadness: The Dispossession of the Nebraska Indians*, which won the J. B. Jackson Prize for the best scholarly book in North American Geography. He is also the editor of the *Encyclopedia of the Great Plains* and the *Encyclopedia of Great Plains Indians*. His research has been funded by the Woodrow Wilson Foundation, the American Council for Learned Societies, the American Philosophical Society, and the National Endowment for the Humanities.

Michael Forsberg Photography
100 North 8th Street, Suite 150
Lincoln, NE 68508
402-477-5030
www.michaelforsberg.com
PHOTOGRAPHIC PRINTS ARE AVAILABLE FROM THE PHOTOGRAPHER